33RD PUBLICATION DESIGN ANNUAL

ROCKPORT
PUBLISHERS

The Gala

The Society wishes to thank The New York Times Company Foundation for its generosity to the New York Public Library, which has enabled the Society of Publication Designers to hold its annual awards Gala in this very special place.

The Sponsors

The Society thanks its corporate sponsors for their continuing support:

American Express Publishing
Apple Computers, Inc.
Condé Nast Publications, Inc.
Dow Jones & Company, Inc.
Hachette Filipacchi Magazines, Inc.
Hearst Magazines
McGraw Hill, Inc.
Meredith Corporation
The New York Times
Newsweek
Spectragraphics, Inc.
Wenner Media
Time Inc.
U.S. News & World Report
Westvaco Corporation
World Color

Special Thanks

Condé Nast Publications
Gala Brochure Printing: World Color
Gala Brochure Color Separations: Entertainment Weekly Imaging Department
Gala Cover Photography: Dan Winters
Gala Slide Presentation & Audio Visual Program: Show & Tell Anagraphics
Gala Technical Support: David Solin
Competition Photography: Mark Peterson
Competition Judges Portrait Photography: Gene Pierce
Competition: David Armario Richard Baker, Susan Barnett, Tom Bentkowski, Traci Churchill, Alexandra Conley, Michael Grossman, Chip Kidd, David Matt, Janet Waegel
Competition Co-Chairs: Janet Froelich, Art Director, The New York Times Magazine, Robert Newman Design Director, Details
Call for Entries Design & Gala Brochure: Robert Newman
Student Competition: Time Inc. Imaging Studio, Perry Printing, Westvaco Paper

The Society of Publication Designers, Inc.

60 East 42nd Street, Suite 721
New York, NY 10165
Telephone: (212) 983-8585
Fax: (212) 983-6043
Email: SPDNYC@aol.com
Web site: HTTP://www.SPD.ORG

The SPD 33rd Publication Design Annual

Jacket and book designed by Design Park, Inc.
Jacket photography by Dan Winters

First published
in the United States of America by:

Rockport Publishers, Inc.
33 Commercial Street
Gloucester, Massachusetts 01930
Telephone: (978) 282-9590
Fax: (978) 283-2742

Distributed to the book trade and art trade in the U.S. and Canada by:

North Light, an imprint of F & W Publications
1507 Dana Avenue
Cincinnati, OH 45207
Telephone: (800) 289-0963

Other Distribution by:
Rockport Publishers, Inc.
Gloucester, Massachusetts 01930

ISBN 1-56496-501-5

Printed in China

contents

Bride Whelan
Executive Director
The Society of Publication Designers

President
The Society of Publication Designers
Robert Altemus
A+W Design
Principal

Pub 33 Co-chair
Janet Froelich
The New York Times Magazine
Art Director

Pub 33 Co-chair
Robert Newman
Details
Design Director

● ABOUT THE SOCIETY

Established in 1965, the Society of Publication Designers was formed to acknowledge the role of the art director/designer in the visual understanding of the printed word. The art director as journalist brings a unique skill to the editorial mission of the publication and clarifies the editorial message. The specialized skills of the designer confront the challenges of technology within a constantly expanding industry.

The Society provides for its members Speaker Luncheons and Evenings, the monthly newsletter GRIDS, the publication design annual, the Design Exhibition and the annual SPOTS Competition and Exhibition for illustrators, and the SPD Auction and Awards Gala. It has developed a working network of opportunities for job seekers and student interns. It actively participates in related activities that bring together members of the numerous design communities in the New York area.

SPD WEST was formed this year to represent the many members and publications in California and the West Coast.

● PRESIDENT'S MESSAGE

Not long ago there was a closed and ancient order that controlled the publishing of image and word. One chapter of its faithful held high the banners of aesthetics, typography, and creativity. Another sect held close the incantations and mysteries of film densities, page imposition, and typesetting.

Then technology opened up the dusty process of publishing. Those previously secreted and technical abilities were made available to designers as well as a much broader group around the world. These abilities removed old restrictions and made the work of the designer freer. And gave the corporate secretary and the small entrepreneur the capability if not the sensibility to layout, typeset, and color separate.

Countless chapters in computer manuals endeavor to explain the zen like concepts of kerning to these acolytes of design. And as their technical knowledge grows, perhaps they understand that just because their computer programs will allow them to, it might not be such a good idea to put zoom drop shadows on their 9 point text. They look for inspiration and direction, by example, to the world around them. They look to places that they have always known, magazines.

Some see this movement as an encroachment on the traditional roles of the designer, or a degradation of the field and wonder what is the place of the art director in this new world? The Society believes it is even more important today that professional designers reaffirm their role as the standard bearers of quality and style. That it is our unique position to educate and nurture the newly found interests.

It is evident that now, more than ever, we need individuals who can create; individuals who can still push the standards upward, communicate, and think.

Our industry is still growing at a rapid rate. Membership in the SPD for example has doubled in the last two years. New publishers have unprecedented access to consumers and old line publishers have been able to streamline the publishing process.

As a result, new magazines pop-up more frequently than presidential trysts. More print magazines stuff the racks each day, and more and more digital magazines compete to push through the internet pipelines.

In the end, we are given new tools, opportunities and metaphors. What we are left with is that good design still shows. It rises above the noisy masses and as you will see in this volume, talent still shines brightly.

● PUB33

The judging this year was one of the most spirited in memory. Over 40 design professionals spent two days viewing 7,392 submissions. The show, with 619 merit awards, 58 silver awards, 21 gold awards, and the Magazine of the Year, is the result of their efforts.

This judging represents those many viewpoints. It is a subjective process, affected by style and contemporary taste, but we hope that certain universal values prevail, and that over time the work this group of judges has chosen will continue to represent high journalistic standards, innovative problem solving, and the pure pleasure of design.

● THE JUDGES (OPPOSITE PAGE)

Row One, left to right
Richard Baker, group leader, Art Director, Us
Syndi Becker, Art Director, Money
Tom Bentkowski, group leader,
Design Director, LIFE
Walter Bernard, Partner, WBMG, Inc.

Row Two, left to right
Miriam Campiz, Principal, M. Campiz Design
David Carson, Principal, David Carson Design
Art Chantry, Designer
Barron Claiborne, Photographer
Susan Dazzo, Art Director, Parenting

Row Three, left to right
Kelly Doe, Art Director, Washington Post Magazine
Theo Fels, Partner/Design Director,
Interactive Bureau
Bert Fox, Illustrations Editor, National Geographic
Christin Gangi, Art Director, Garden Design
Karen Lee Grant, Art Director, Carlson Partners

Row Four, left to right
Michael Grossman, group leader,
Partner/Creative Director,
Meigher Communications
David Herbick, Art Director, Forbes
Arthur Hochstein, Art Director, Time
Steven Hoffman, group leader,
Creative Director, Sports Illustrated
Chip Kidd, Designer, Knopf

Row Five, left to right
John Korpics, Design Director,
Entertainment Weekly
Kati Korpijaakko,
Art Director, Glamour
Barbara Kuhr, Creative Director,
Wired Ventures
Diana LaGuardia, group leader,
Art Director, House & Garden
Greg Leeds, Art Director, Special Projects,
The Wall Street Journal

The
Judges

Row One, left to right

Sue Llewellyn, Art Director
David Matt, Art Director, Premiere
Ross MacDonald, Illustrator, Typographer
J. Abbott Miller, Director, Design/Writing/Research
Barbara Nessim, Chairperson, Illustration Department, Parsons School of Design

Row Two, left to right

Chee Perlman, Editor in Chief, I.D.
Rhonda Rubinstein, group leader, Creative Director, Mother Jones
John Lyle Sanford, group leader, Creative Director, MSNBC
Audrey Schachnow, Director of Editorial Design, Scholastic Magazines
Peter Seidler, President/Creative Director, Avalanche Systems

Row Three, left to right

Helene Silverman, Hello Studio
Lynn Staley, group leader, Associate Managing Editor, Design, Newsweek
Gong Szeto, Creative Partner, i/o360 degrees
Melissa Tardiff, Interactive Media Director, Frankfurt Balkind Partners
Linda Weinman, Author, Educator, Designer

Row Four, left to right

Fo Wilson, President and Creative Director, Studio W
Herbert Winkler, Art Director, Wallpaper*
Dan Winters, Photographer
Fred Woodward, Art Director, Rolling Stone
Lloyd Ziff, Art Director, Time Inc. Custom Publishing

Photographs by **Gene Pierce**

design

magazine of the year

VISUAL \ CULTURE \ DOCUMENT

VOL 1 : NO 1

2wice

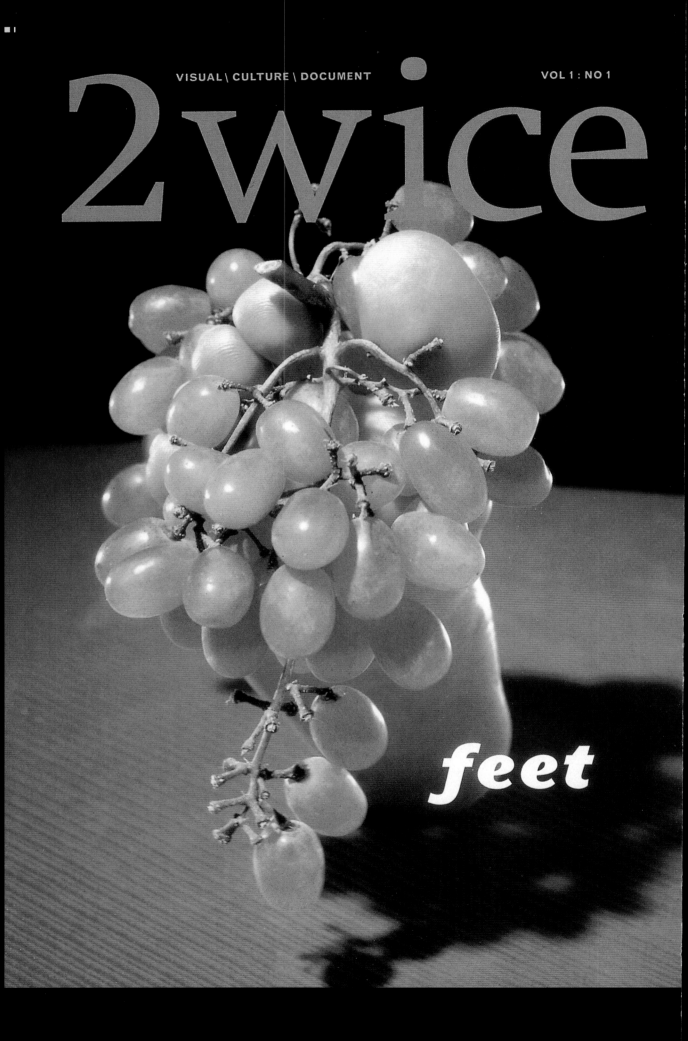

feet

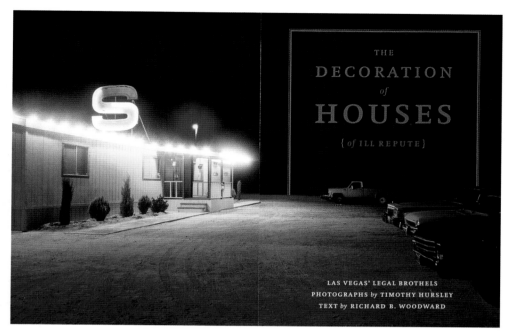

THE
DECORATION
of
HOUSES
{ *of* ILL REPUTE }

LAS VEGAS' LEGAL BROTHELS
PHOTOGRAPHS *by* TIMOTHY HURSLEY
TEXT *by* RICHARD B. WOODWARD

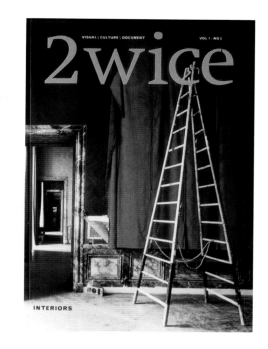

VISUAL \ CULTURE \ DOCUMENT VOL 1 \ NO 2

2wice

INTERIORS

ARCH RIVALS

LINDA O'KEEFFE

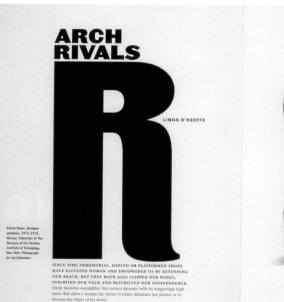

Fetish Shoes, Designer unknown, 1973-1975, Mexico. Collection of The Museum of the Fashion Institute of Technology, New York. Photograph by Jay Zukerhorn.

SINCE TIME IMMEMORIAL, HEELED OR PLATFORMED SHOES HAVE ELEVATED WOMEN AND EMPOWERED US BY EXTENDING OUR REACH, BUT THEY HAVE ALSO CLIPPED OUR WINGS, INHIBITED OUR WALK AND RESTRICTED OUR INDEPENDENCE. Fetish footwear exemplifies this curious dynamic with its staggeringly high heels that allow a woman the choice to either dominate her partner or to become the object of his desire.

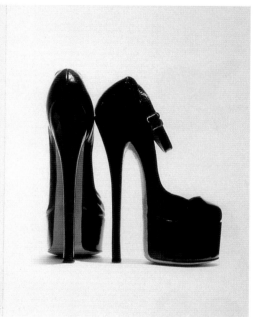

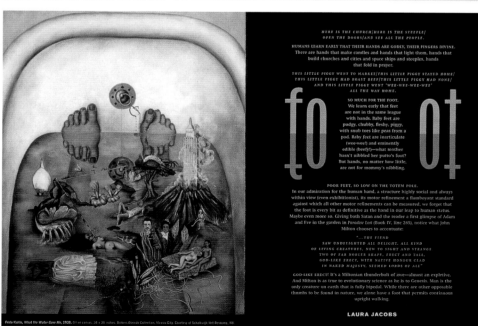

HERE IS THE CHURCH/HERE IS THE STEEPLE/
OPEN THE DOORS/AND SEE ALL THE PEOPLE.

HUMANS LEARN EARLY THAT THEIR HANDS ARE GODLY, THEIR FINGERS DIVINE.
There are hands that make candles and hands that light them, hands that
build churches and cities and space ships and steeples, hands
that fold in prayer.

THIS LITTLE PIGGY WENT TO MARKET/THIS LITTLE PIGGY STAYED HOME/
THIS LITTLE PIGGY HAD ROAST BEEF/THIS LITTLE PIGGY HAD NONE/
AND THIS LITTLE PIGGY WENT "WEE-WEE-WEE-WEE"
ALL THE WAY HOME.

{o ot

SO MUCH FOR THE FOOT.
We learn early that feet
are not in the same league
with hands. Baby feet are
pudgy, chubby, fleshy, piggy,
with snub toes like peas from a
pod. Baby feet are inarticulate
(wee-wee!) and eminently
edible (beefy!)—what mother
hasn't nibbled her putto's foot?
But hands, no matter how little,
are not for mommy's nibbling.

POOR FEET, SO LOW ON THE TOTEM POLE.
In our admiration for the human hand, a structure highly social and always
within view (even exhibitionist), its motor refinement a flamboyant standard
against which all other motor refinements can be measured, we forget that
the foot is every bit as definitive as the hand in our leap to human status.
Maybe even more so. Giving both Satan and the reader a first glimpse of Adam
and Eve in the garden in *Paradise Lost* (Book IV, line 285), notice what John
Milton chooses to accentuate:

"...THE FIEND
SAW UNDELIGHTED ALL DELIGHT, ALL KIND
OF LIVING CREATURES, NEW TO SIGHT AND STRANGE
TWO OF FAR NOBLER SHAPE, ERECT AND TALL,
GOD-LIKE ERECT, WITH NATIVE HONOUR CLAD
IN NAKED MAJESTY, SEEMED LORDS OF ALL"

GOD-LIKE ERECT! It's a Miltonian thunderbolt of awe—almost an expletive.
And Milton is as true to evolutionary science as he is to Genesis. Man is the
only creature on earth that is fully bipedal. While there are other opposable
thumbs to be found in nature, we alone have a foot that permits continuous
upright walking.

LAURA JACOBS

Frida Kahlo, *What the Water Gave Me*, 1938. Oil on canvas, 38 x 30 inches. Dolores Olmedo Collection, Mexico City. Courtesy of Schalkwijk Art Resource, NY.

■ I
Publication 2wice
Art Director J. Abbott Miller
Designers Paul Carlos, Luke Hayman
Photographer Jay Zukerhorn
Studio Design/Writing/Research, NY
Publisher Dance Ink Foundation
Issues May 1997, November 1997
Category Overall Design

The International Design Magazine
$8.50 US/$11 CAN JANUARY/FEBRUARY 1997

I.D. FORTY:
SPECIAL
WEST COAST
ISSUE

RIDE ON

Design and
Technology
Innovators
Catch the Crest
of the Wave

The International Design Magazine
$5.95 US/$8.50 CAN NOVEMBER 1997

plastic
The Miracle
Material Reborn

BOTTLED WATER: The Emperor's New Drink
TOY ROBOTS: Japan's Techno Warriors
PARODY ADS: Selling Subversion
CAR WARS: Does Size Matter?

The International Design Magazine
$5.95 US/$8.50 CAN MARCH/APRIL 1997

Henry Dreyfuss's
American Classics

Marc Newson
Furnishes the Future

New Ceramics
from Sottsass

Raising the
Curtain on
Eiko Ishioka

Sex, Lies &
Advertising:
The Work of
Doug Lloyd

MIYAKE ATTACKS!
PUSHING THE LIMITS
OF FASHION

■ 2
Publication I.D. Magazine
Creative Directors Luke Hayman, Tony Arefin
Art Director Andrea Fella
Designer Miranda Dempster
Photographer James Wojcik
Publisher I.D. Magazine
Issues March/April 1997, May 1997,
September/October 1997
Category Overall Design

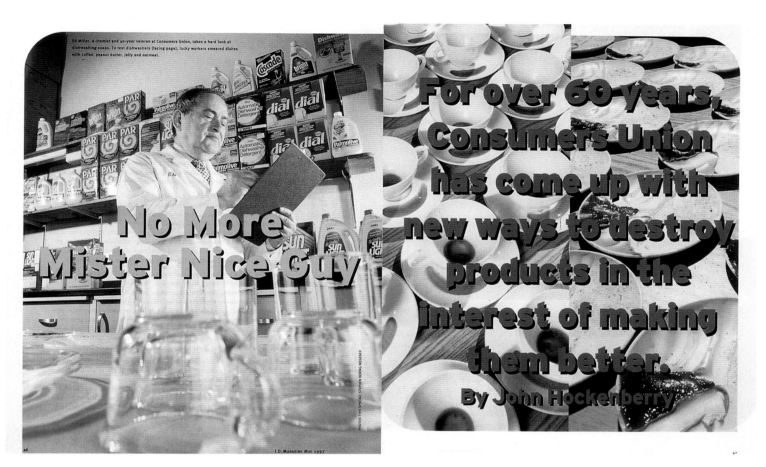

Ed Miller, a chemist and 40-year veteran at Consumers Union, takes a hard look at dishwashing soaps. To test dishwashers (facing page), lucky workers smeared dishes with coffee, peanut butter, jelly and oatmeal.

No More Mister Nice Guy

For over 60 years, Consumers Union has come up with new ways to destroy products in the interest of making them better.

By John Hockenberry

PHOTOS THIS SPREAD: STEPHEN BEGELY/REGENCY

I.D. MAGAZINE MAY 1997

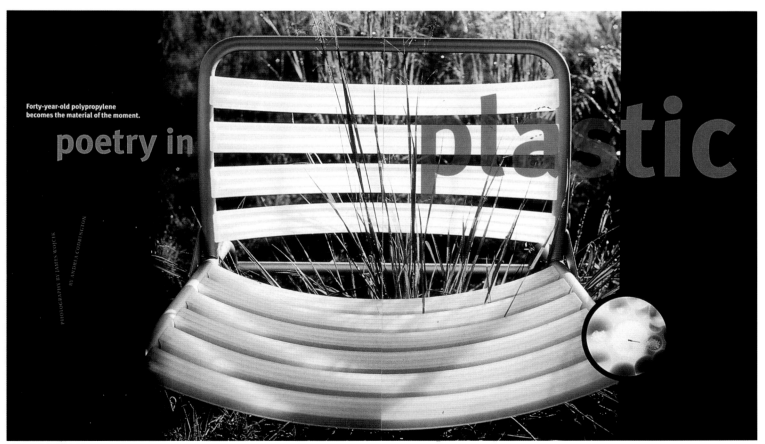

Forty-year-old polypropylene becomes the material of the moment.

poetry in plastic

PHOTOGRAPHY BY JAMES WOJCIK
BY ANDREA CODRINGTON

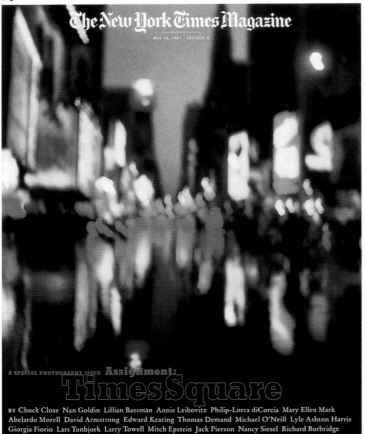

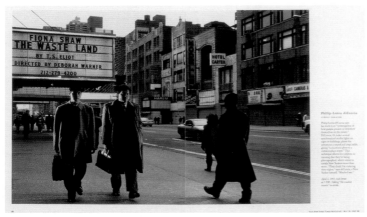

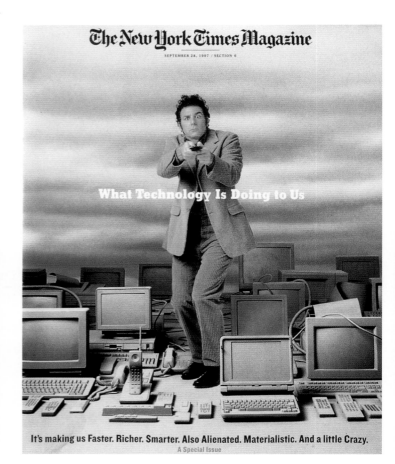

■ 3
Publication The New York Times Magazine
Art Director Janet Froelich
Designer Catherine Gilmore-Barnes
Photo Editor Kathy Ryan
Publisher The New York Times
Issues May 18, 1997, September 28, 1997, November 16, 1997
Category Overall Design

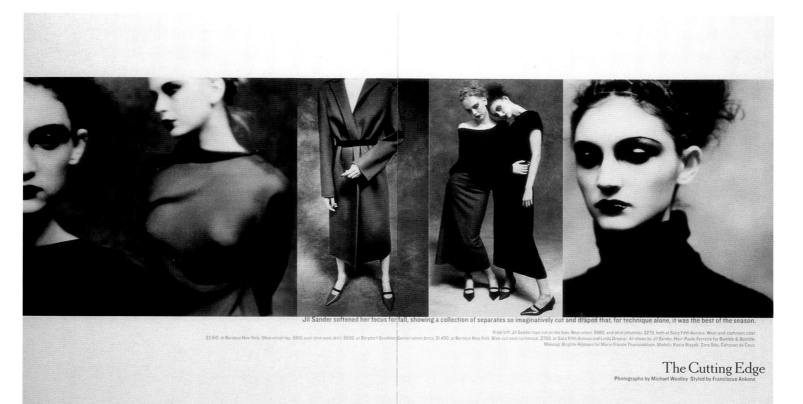

Jil Sander softened her focus for fall, showing a collection of separates so imaginatively cut and draped that, for technique alone, it was the best of the season.

From left: Jil Sander tops cut on the bias. Blue velvet, $660, and olive polyester, $270, both at Saks Fifth Avenue. Wool-and-cashmere coat, $3,510, at Barneys New York. Olive velvet top, $810, over olive-wool skirt, $600, at Bergdorf Goodman. Garnet velvet dress, $1,450, at Barneys New York. Bias-cut wool turtleneck, $700, at Saks Fifth Avenue and Linda Dresner. All shoes by Jil Sander. Hair: Paolo Ferreira for Bumble & Bumble. Makeup: Brigitte Hijmans for Marie France Thavonekham. Models: Kasia Rosyak, Zora Star, Cahusac de Caux.

The Cutting Edge
Photographs by Michael Woolley Styled by Franciscus Ankoné

42 43

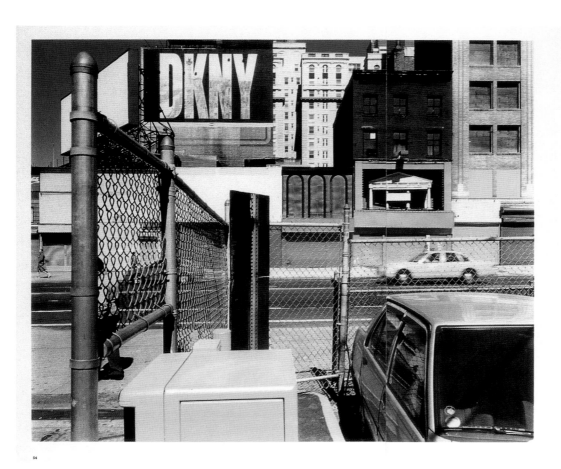

Lars Tunbjork
THE COLOR OF CHANGE

Standing in the spot where he was mugged a decade ago, Lars Tunbjork fixated on the temporary measures taken during Times Square's redevelopment, especially the shuttered former theaters and porn shops slated for demolition next month that have been painted in glossy, exuberant colors like some Brobdingnagian child's toy blocks. "It is a ghostlike place in the daylight, always empty," says the 41-year-old Swede. "Yet there was this remarkable effort to make these empty buildings look nice." Tunbjork, who is documenting office workers on three continents, is energized by the area's mix of grit, commercialism and buttoned-down corporatism. With tchotchke shops and McDonald's abutting trading floors and the Eighth Avenue sex industry, Tunbjork says he's "never been to a place where you find so many different things in such a small area."

March 23, 1997: The fleeting face of 42d Street near Eighth Avenue.

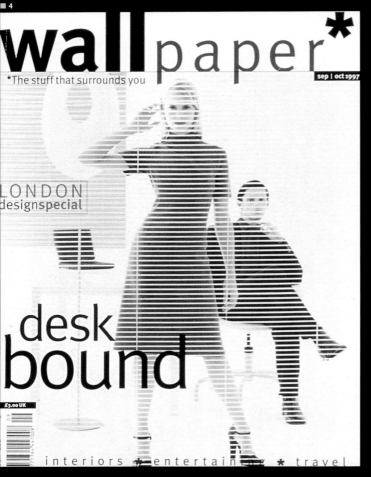

wall paper*

*The stuff that surrounds you

sep | oct 1997

LONDON
designspecial

£3.00 UK

desk
bound

interiors * entertaining * travel

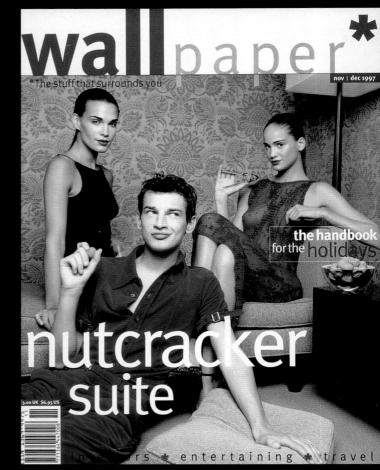

wall paper*

The stuff that surrounds you

nov | dec 1997

the handbook
for the holidays

£3.00 UK $6.95 US

nutcracker
suite

interiors * entertaining * travel

the trip

TOKYO
STOREYS

The big quake is due any day now and nothing in Tokyo has been built to last. In seconds, this dazzling, grimy maze, and some of the world's most valuable real estate, could be rubble. Yet Tokyo continues to boom. As geisha girl meets Gucci girl, the play-off between traditional and Western cultures hots up – and no one is quite sure of 'the rules'. **Alice Rawsthorn** dons her Gianni Valentino hard hat, climbs into a candy-coloured cab and hits Asia's edgiest city head on

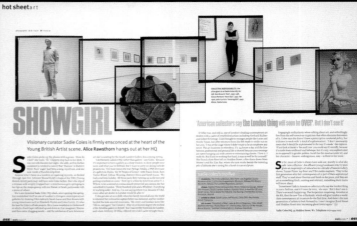

hot sheet art

SHOWGIRL

Visionary curator Sadie Coles is firmly ensconced at the heart of the Young British Artist scene. **Alice Rawsthorn** hangs out at her HQ

'American collectors say the London thing will soon be OVER. But I don't see it'

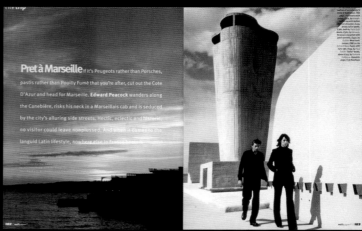

the trip

Pret à Marseille If it's Peugeots rather than Porsches, pastis rather than Pouilly Fumé that you're after, cut out the Côte D'Azur and head for Marseille. **Edward Peacock** wanders along the Canebière, risks his neck in a Marseillais cab and is seduced by the city's alluring side streets. Hectic, eclectic and historic, no visitor could leave nonplussed. And when it comes to the languid Latin lifestyle, nowhere else in France comes close

■ 4
Publication Wallpaper*
Creative Director Martin Jacobs
Art Director Herbert Winkler
Designer Jonnie Vigar
Illustrator Walter Chin
Photo Editor Ariel Childs
Publisher Time Inc.
Issues July/August 1997, September/October 1997, November/December 1997
Category Overall Design

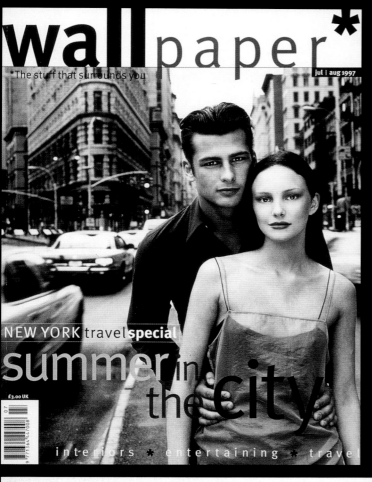

wallpaper*

*The stuff that surrounds you

jul | aug 1997

£3.00 UK

NEW YORK travel **special**

summer in the city

interiors * entertaining * travel

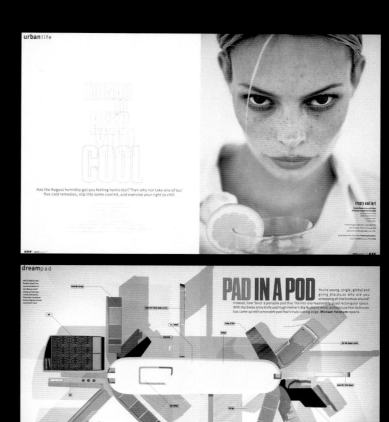

urban life

COOL

Has the August humidity got you feeling homicidal? Then why not take one of our five cold remedies, slip into some cool kit, and exercise your right to chill

frosty and tart

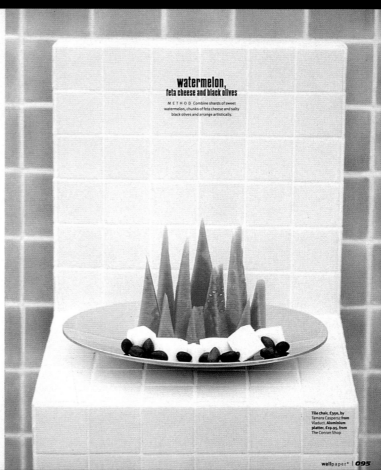

dreampad

PAD IN A POD

You're young, single, global and going places, so why are you schlepping all that furniture around? Instead, how 'bout a portable pod that fits into any reasonably sized rectangular space. With the Swiss army knife and Hugh Hefner's Big Bunny in mind, architecture firm Softroom has come up with a movable pad that's truly cutting edge. Michael Horsham reports

the **dish**

CHILL

When things get all moist and sticky and the company you're keeping becomes hot and bothered, it might be time to turn frosty to cool the mood. Master these seven simple dishes to create a menu that will help take the heat out of even the steamiest summer night

photographer **Chris Chapman**
photographer's assistant **James Bedford**
food editor **Melina Keays**
stylist **Page Marchese**
special thanks to **Andrew and Martina Waugh**

watermelon,
feta cheese and black olives

M E T H O D Combine shards of sweet watermelon, chunks of feta cheese and salty black olives and arrange artistically.

Tile chair, £350, by Tamara Caspersz from Viaduct. Aluminium platter, £59.95, from The Conran Shop

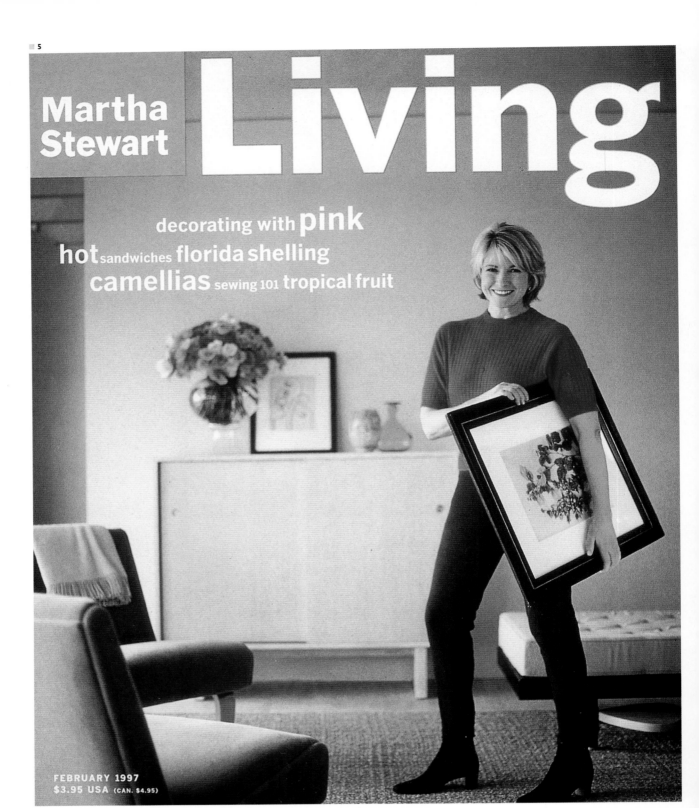

Martha Stewart Living

decorating with pink
hot sandwiches florida shelling
camellias sewing 101 tropical fruit

FEBRUARY 1997
$3.95 USA (CAN. $4.95)

■ 5
Publication Martha Stewart Living
Design Director Eric A. Pike
Art Directors James Dunlinson, Scot Schy, Claudia Bruno, Agnethe Glatved
Designer Robert Fisher
Illustrator Harry Bates
Photo Editor Heidi Posner
Photographers Antoine Bootz, Amy Neunsinger, James Merrel, Reed Davis,
Maria Robledo, Henry Bourne, Gentl + Hyers, Evan Sklar, Fernando Bengoechea
Publisher Martha Stewart Living Omnimedia
Issues February 1997, May 1997, November 1997
Category Overall Design

Martha Stewart Living

classic
layer cakes
growing euphorbias
arranging pictures
collecting linens
water gardens
sushi 101

MAY 1997
$3.95 USA (CAN. $4.95)

MARTHA STEWART Living

H.E.S.
1847

Thanksgiving
a classic american menu
all about **nuts**
collecting pewter
homemade **crackers**
sweet potatoes
deep colors
knitting 101

NOVEMBER 1997
$4.50 USA (CAN. $5.50)

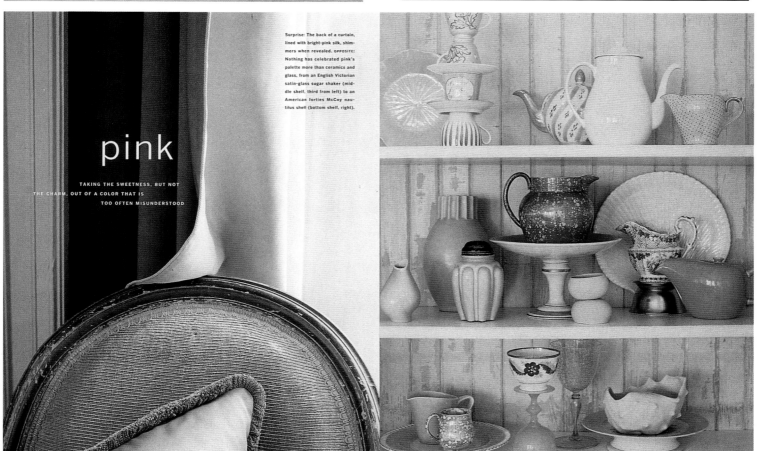

Surprise: The back of a curtain, lined with bright-pink silk, shimmers when revealed. OPPOSITE: Nothing has celebrated pink's palette more than ceramics and glass, from an English Victorian satin-glass sugar shaker (middle shelf, third from left) to an American forties McCoy nautilus shell (bottom shelf, right).

pink

TAKING THE SWEETNESS, BUT NOT
THE CHARM, OUT OF A COLOR THAT IS
TOO OFTEN MISUNDERSTOOD

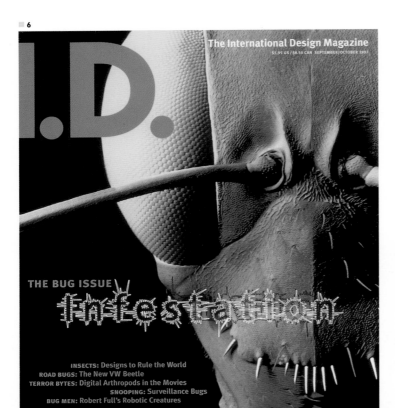

The International Design Magazine

$5.95 US / $8.50 CAN SEPTEMBER/OCTOBER 1997

I.D.

THE BUG ISSUE

INSECTS: Designs to Rule the World
ROAD BUGS: The New VW Beetle
TERROR BYTES: Digital Arthropods in the Movies
SNOOPING: Surveillance Bugs
BUG MEN: Robert Full's Robotic Creatures

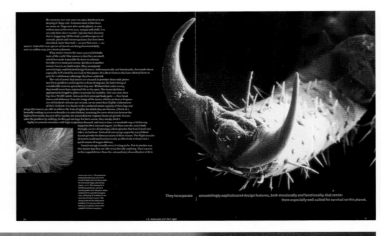

They incorporate astonishingly sophisticated design features, both structurally and functionally, that render them especially well suited for survival on this planet.

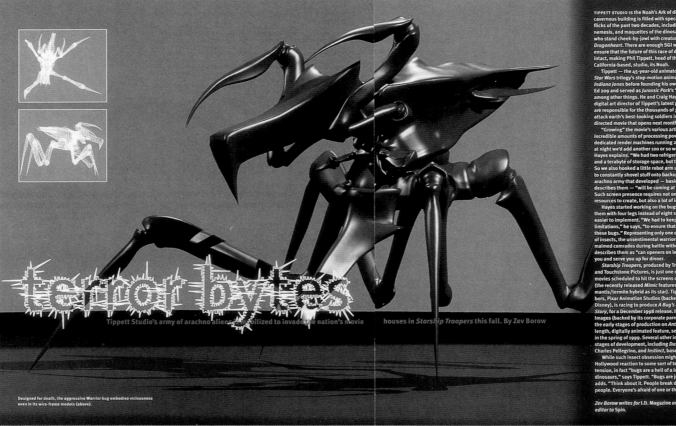

Designed for death, the aggressive Warrior bug embodies viciousness even in its wire-frame models (above).

terror bytes

Tippett Studio's army of arachno aliens is mobilized to invade the nation's movie houses in *Starship Troopers* this fall. By Zev Borow

TIPPETT STUDIO IS the Noah's Ark of digital effects. The long, cavernous building is filled with specimens from the best sci-fi flicks of the past two decades, including Ed 209, RoboCop's nemesis, and maquettes of the dinosaurs from *Jurassic Park*, who stand cheek-by-jowl with creatures from *Star Wars* and *Dragonheart*. There are enough SGI workstations here to ensure that the future of this race of digital film heroes remains intact, making Phil Tippett, head of the 100-person Berkeley, California-based, studio, its Noah.

Tippett — the 45-year-old animator who oversaw the *Star Wars* trilogy's stop-motion animation and the effects for *Indiana Jones* before founding his own studio — masterminded Ed 209 and served as *Jurassic Park*'s "dinosaur consultant," among other things. He and Craig Hayes, the 34-year-old digital art director of Tippett's latest project, *Starship Troopers*, are responsible for the thousands of 70 mm alien insects that attack earth's best-looking soldiers in the Paul Verhoeven-directed movie that opens next month.

"Growing" the movie's various arthropods demanded incredible amounts of processing power. "We had a farm of 55 dedicated render machines running 24 hours a day, and then at night we'd add another 100 or so workstations on the floor," Hayes explains. "We had two refrigerator-sized servers and a terabyte of storage space, but that still wasn't enough. So we also hooked a little robot arm up to the tape machine to constantly shovel stuff onto backup tapes." The aggressive arachno army that developed — basic ground troops, as Hayes describes them — "will be coming at you thousands at a time." Such screen presence requires not only a great deal of resources to create, but also a lot of ingenuity.

Hayes started working on the bugs in 1993, at first designing them with four legs instead of eight so that they would be easier to implement. "We had to keep in mind manufacturing limitations," he says, "to ensure that we could actually make these bugs." Representing only one of the movie's six species of insects, the unsentimental warriors roll right over their maimed comrades during battle without missing a beat. Hayes describes them as "can openers on legs," able to slice you, dice you and serve you up for dinner.

Starship Troopers, produced by TriStar, Big Bug Pictures and Touchstone Pictures, is just one of the many animated bug movies scheduled to hit the screens over the next few years (the recently released *Mimic* features a cockroach/praying mantis/termite hybrid as its star). Tippett's Bay-area neighbors, Pixar Animation Studios (backed by its corporate parent, Disney), is racing to produce *A Bug's Life*, its follow-up to *Toy Story*, for a December 1998 release. In Palo Alto, Pacific Data Images (backed by its corporate parent, Dreamworks) is in the early stages of production on *Antz*, the company's first full-length, digitally animated feature, set for release, tentatively, in the spring of 1999. Several other insect films are in earlier stages of development, including *Dust*, based on a novel by Charles Pellegrino, and *Instinct*, based on a Ron Kasdan novel.

While such insect obsession might seem like a textbook Hollywood reaction to some sort of techno-millenial societal tension, in fact "bugs are a hell of a lot easier to make than dinosaurs," says Tippett. "Bugs are just post-dinosaur," Hayes adds. "Think about it. People break down into snake or bug people. Everyone's afraid of one or the other."

Zev Borow writes for I.D. Magazine and is a contributing editor to Spin.

6
Publication I.D. Magazine
Design Director Luke Hayman
Art Director Andrea Fella
Designer Miranda Dempster
Photographer James Wojcik
Publisher I.D. Magazine
Issue September/October 1997
Category Entire Issue

Assignment: Times Square

By Michael Kimmelman

The most famous photograph of Times Square is surely Alfred Eisenstaedt's chestnut of the kissing couple, which summed up the national mood in 1945 because it combined all the right elements: the returning soldier, the woman who welcomed him back and Times Square, the crossroads that symbolized home.

Some people were upset to learn later that Eisenstaedt may have staged the kiss, as if this somehow invalidated the image. The picture had first been published in Life, which meant that it was assumed to document what happened serendipitously at the instant the shutter clicked. Of course, all photographs are contrived to the degree that the photographer chooses the image, framing what is to be in and out of it, and Eisenstaedt, to insure he'd get the effect he wanted, simply recreated for the camera what was taking place around him anyway. But, if so, he still broke the pact between photojournal and viewer, creating something that tended toward fiction or theater. In a strange way it was true at least to the spirit of Times Square, the epicenter of Broadway.

That was then. If you want to see where photography is now, take a look in this issue at Philip-Lorca diCorcia's own version of a man and woman embracing in the square. DiCorcia lights his

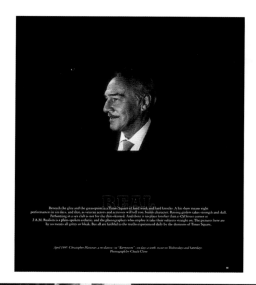

REAL

Beneath the glitz and the greasepaint is a Times Square of hard work and hard knocks. A hit show means eight performances in six days, and that, as veteran actors and actresses will tell you, builds character. Raising golden takes strength and skill. Performing in a set club is not for the thin-skinned. And there is no place lonelier than a 42d Street corner at 2 A.M. Realism is a plain-spoken esthetic, and the photographers who employ it take their subjects straight on. The pictures here are by no means all gritty or bleak. But all are faithful to the truths experienced daily by the denizens of Times Square.

April 1997. Christopher Plummer, a revelation in "Barrymore" six days a week, 15 or so Wednesdays and Saturdays.
Photograph by Chuck Close

SURREAL

Times Square has long represented New York's teeming uncertainties, the surreal crossroads of memory and desire. Here is where the lights are hallucinatory, where nostalgia and fantasy pay the rent and where any street corner might be a setting for an encounter that's they look strange standing together?
The surreal photograph makes meaning of the oddest juxtaposition, creates meaning from the barely visible and half-remembered, blurs meaning with a swipe of soft focus. The photographs here have the odd, the irrational, the fantastic Times Square as urban dreamscape.

March 1997. Members of the United States Armed Forces recruiting station, fine view.
Photograph by Lyle Ashton Harris

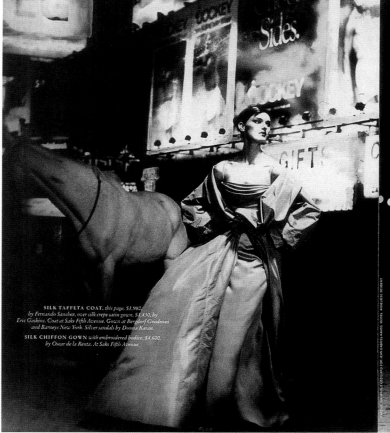

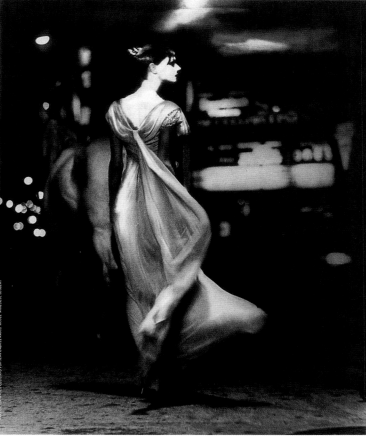

SILK TAFFETA COAT, this page, $1,980, by Fernando Sanchez, over silk crepe satin gown, $1,430, by Eric Gaskins. Coat at Saks Fifth Avenue. Gown at Bergdorf Goodman and Barneys New York. Silver sandals by Donna Karan.

SILK CHIFFON GOWN with embroidered bodice, $4,600, by Oscar de la Renta. At Saks Fifth Avenue.

■ 7
Publication The New York Times Magazine
Art Director Janet Froelich
Designer Catherine Gilmore-Barnes
Photo Editor Kathy Ryan
Publisher The New York Times
Issue May 18, 1997
Category Feature Story

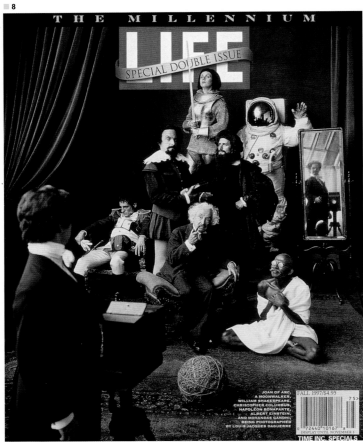

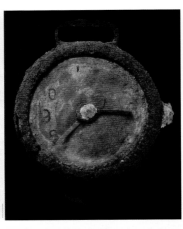

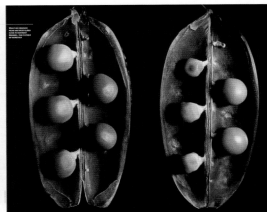

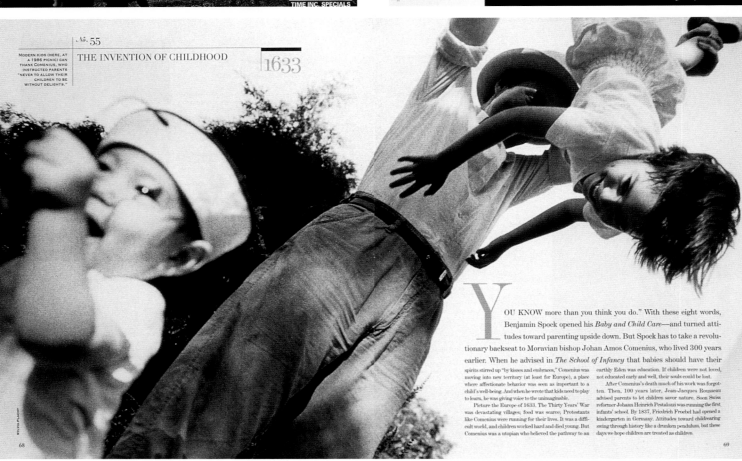

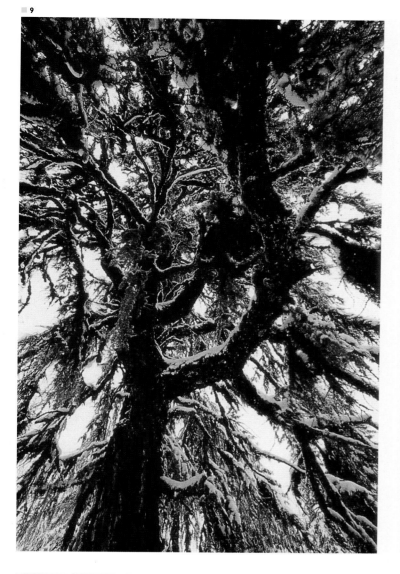

NORBERT ROSING

Natur pur

Norbert Rosing gilt derzeit als einer der besten Naturfotografen.
Ein soeben erschienener opulenter Bildband über deutsche Nationalparks
bündelt die Arbeit der vergangenen sieben Jahre.

Das Mikro ist bereits abgeschaltet. Norbert Rosing lehnt sich zurück und überlegt. Etwas, wirft er behutsam ein, hätten wir vergessen. Die Zerstörung natürlicher Lebensräume. »Man sagt heute, daß die Regenwälder in fünf bis zehn Jahren weg sind. Und in Kanada werden nach dem sogenannten ›Clearcut‹-Verfahren riesige Waldgebiete in einem irrsinnigen Tempo abgeholzt. So wird es für uns Naturfotografen immer schwieriger, Themen zu finden oder an einem Langzeitthema zu arbeiten. Und das wirklich Schockierende daran ist, daß es niemanden interessiert.« Norbert Rosing liebt die Natur. Bereits als Kind habe er abend- und nächtelang an nahen Teichen gesessen. »Und stets hatte ich eine kleine Kamera dabei.« Allerdings seien die Bilder nie etwas geworden. Es war zu dunkel. »Aber«, so Rosing, »der Reiz war schon da.« Norbert Rosing, in Grafrath bei München zu Hause, Naturfotograf mit zahlreichen Publikationen u. a. in *Life*, *Geo* und *National Geographic*, ist schon von Berufs wegen in hohem Maße sensibilisiert für die Vernichtung natürlicher Lebensräume. Und doch kommt diese Bedrohung in seinen Arbeiten nicht vor. Rosing folgt einem anderen Konzept. »Ich bin«, sagt er, »kein Reportagefotograf. Ich möchte Bilder machen, in denen das Auge ruhen kann. Ich möchte aufklären in dem Sinne, daß man sagt: Mensch, das wäre doch erhaltenswert.« Norbert Rosing liebt die Natur – und die Fotografie. In der Naturfotografie hat er sein ›Element‹ gefunden. Bis aus dem gelernten Krankenpfleger und Hobbyfotografen ein Profi wurde, war es

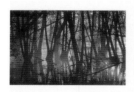

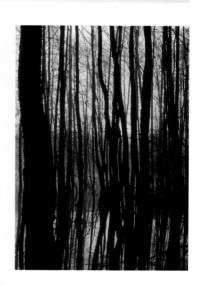

■ 8
Publication LIFE
Design Director Tom Bentkowski
Art Director Sharon Okamoto
Designers Tom Bentkowski, Sharon Okamoto,
Melanie deForest, Sam Serebin, Sarah Garcea
Photo Editors Alison Morley, Vivette Porges
Photographer Gregory Heisler, Sylvia Plachy, David Newman, Seiji Fukasawa
Publisher Time Inc.
Issue Fall 1997
Category Entire Issue

■ 9
Publication Leica World
Creative Director Horst Moser
Designers Carin Drexler, Horst Moser
Photo Editors Michael Koettzle, Horst Moser
Photographer Norbert Rosing
Studio Independent Medien Design
Publisher Leica Camera AG
Issue September 1997
Category Feature Story

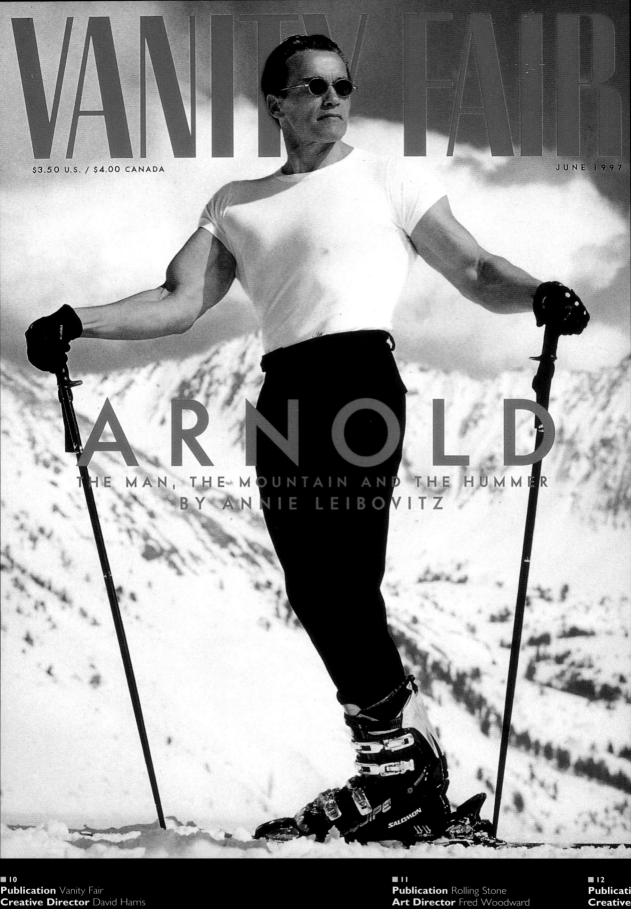

VANITY FAIR

$3.50 U.S. / $4.00 CANADA

JUNE 1997

ARNOLD
THE MAN, THE MOUNTAIN AND THE HUMMER
BY ANNIE LEIBOVITZ

■ 10
Publication Vanity Fair
Creative Director David Harris
Designers Gregory Mastrianni, David Harris
Photo Editors Susan White, Lisa Berman
Photographer Annie Leibovitz
Publisher Condé Nast Publications Inc.
Issue June 1997
Category Cover

■ 11
Publication Rolling Stone
Art Director Fred Woodward
Designers Fred Woodward,
Gail Anderson
Photo Editor Jodi Peckman
Photographer Matt Mahurin
Publisher Wenner Media
Issue January 23, 1997
Category Feature Spread

■ 12
Publicati
Creative
Designer
Illustrato
Photo E
Publisher
Issue Mar
Category

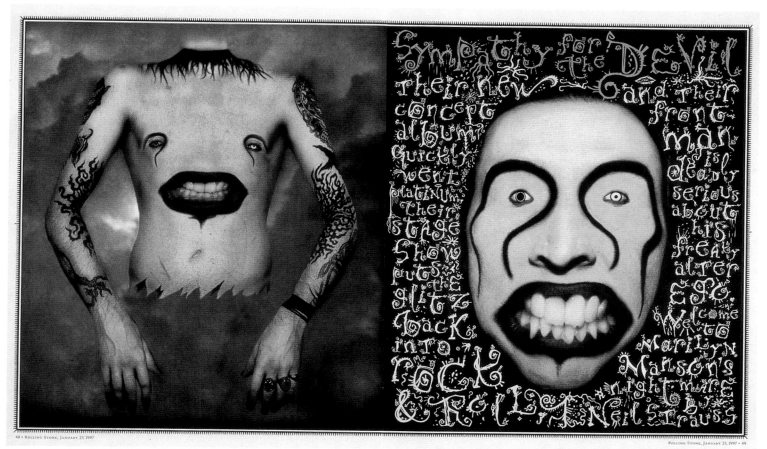

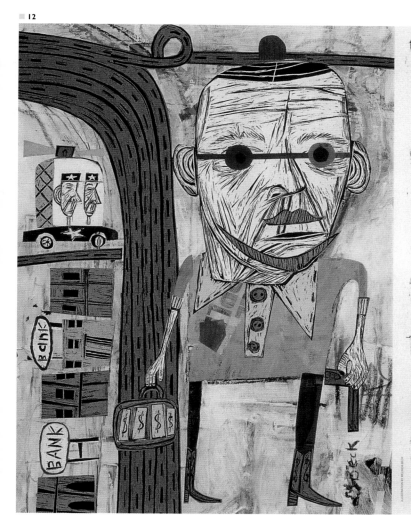

FEELS DIFFERENT, DOESN'T IT?

CADENCE 1996 ANNUAL REPORT

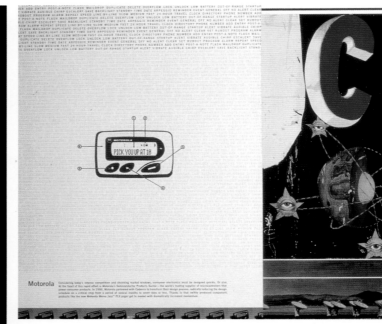

Motorola

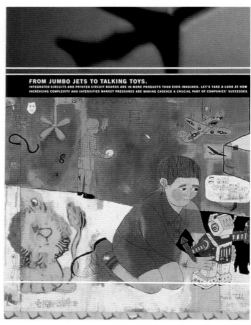

FROM JUMBO JETS TO TALKING TOYS.

INTEGRATED CIRCUITS AND PRINTED CIRCUIT BOARDS ARE IN MORE PRODUCTS THAN EVER IMAGINED. LET'S TAKE A LOOK AT HOW INCREASING COMPLEXITY AND INTENSIFIED MARKET PRESSURES ARE MAKING CADENCE A CRUCIAL PART OF COMPANIES' SUCCESSES.

■ 13
Publication Cadence 1996 Annual Report
Creative Director Bill Cahan
Designer Bill Dinetz
Illustrators Bob Dinetz, Jason Holley,
Riccardo Vecchio, Mark Todd
Photographers Amy Guip, Tony Stromberg
Studio Cahan & Associates
Client Cadence Design Systems
Issue March 1997
Category Overall

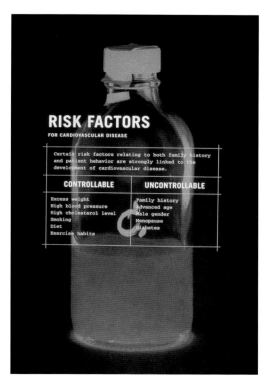

RISK FACTORS

FOR CARDIOVASCULAR DISEASE

Certain risk factors relating to both family history and patient behavior are strongly linked to the development of cardiovascular disease.

CONTROLLABLE	UNCONTROLLABLE
Excess weight	Family history
High blood pressure	Advanced age
High cholesterol level	Male gender
Smoking	Menopause
Diet	Diabetes
Exercise habits	

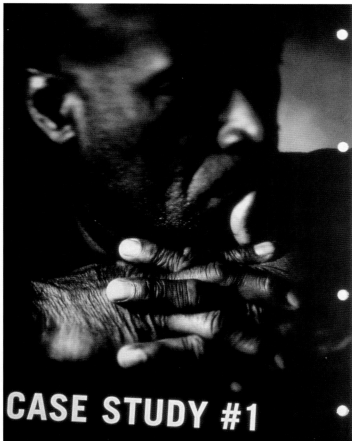

CASE STUDY #1

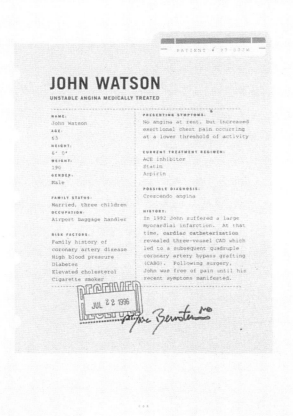

JOHN WATSON

UNSTABLE ANGINA MEDICALLY TREATED

NAME:
John Watson
AGE:
63
HEIGHT:
6' 0"
WEIGHT:
190
GENDER:
Male

FAMILY STATUS:
Married, three children
OCCUPATION:
Airport baggage handler

RISK FACTORS:
Family history of
coronary artery disease
High blood pressure
Diabetes
Elevated cholesterol
Cigarette smoker

PRESENTING SYMPTOMS:
No angina at rest, but increased exertional chest pain occurring at a lower threshold of activity

CURRENT TREATMENT REGIMEN:
ACE inhibitor
Statin
Aspirin

POSSIBLE DIAGNOSIS:
Crescendo angina

HISTORY:
In 1992 John suffered a large myocardial infarction. At that time, cardiac catheterization revealed three-vessel CAD which led to a subsequent quadruple coronary artery bypass grafting (CABG). Following surgery, John was free of pain until his recent symptoms manifested.

JUL 22 1996

■ 14
Publication COR Therapeutics 1996 Annual Report
Creative Director Bill Cahan
Art Director Bill Cahan
Designer Kevin Roberson
Illustrator Kevin Roberson
Photographers Keith Bardin, John Kolesa, Tony Stromberg
Studio Cahan & Associates
Client COR Therapeutics
Issue April 1997
Category Overall

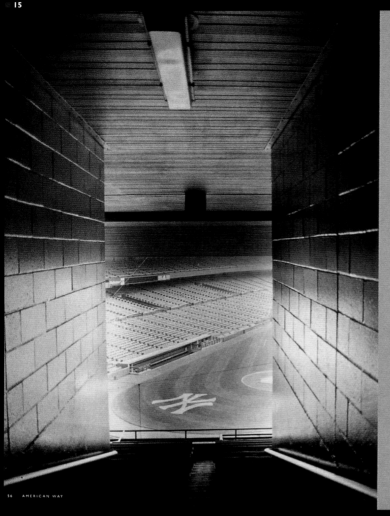

For at least one devotee, Yankee Stadium embodies everything that baseball once was.

Story by Jim Morrison. Photography by Douglas Merriam

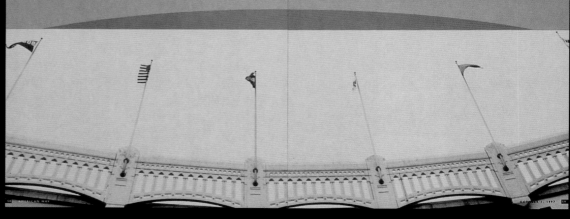

On my first visit to The Stadium, I saw Yankees legend Mickey Mantle hit a home run deep into the left-field pews off a fastball thrown by Yankees legend Whitey Ford. I groaned as Joe DiMaggio grounded out. And I chuckled when eighty-three-year-old Casey Stengel skipped across the field during introductions before settling down to manage the losing side.

It sounds like a dream. And it certainly seemed like a fantasy to me, a fifteen-year-old kid from a small town that had worshiped the Yankees, even when they finished back in the pack during the late 1960s.

But then Yankee Stadium is baseball's cathedral of dreams. So it is inconceivable that just as the Yankees are again creating October memories and winning championships, George Steinbrenner is barking about moving the team. Maybe to New Jersey of all places. Consider renovating the stadium to bring back some of the original charm? Absolutely. Leave the hallowed grounds of the Bronx? Never.

My confirmation into the faithful came on Old-Timers' Day 1973. It was the fiftieth anniversary of The House That Ruth Built and the legends from the most famous team in the world offered tribute to the most famous stadium in the world. Most of the saints were there. Joe D. The Mick. Scooter. Yogi. Moose. Elston.

The Yankees — and Mickey Mantle — were the one thing my father and I could agree on in those days. I adored Joe Namath. He favored Roman Gabriel. I worshiped Muhammad Ali. He rooted for Joe Frazier. But we both suffered with the Yankees. And, even though he was retired, I wore Mantle's number seven.

As we wound our way through the caverns inside the stadium, looking for our 14 box seats in right field, I remember strolling down a narrow catwalk, emerging into the sun, and looking out over an outfield green so expansive I couldn't imagine anyone covering it. Deep in center field were monuments honoring Babe Ruth, Lou Gehrig, and Miller Huggins. No other ballpark had monuments on the playing field. But this was The Stadium. If Reggie Jackson, who was playing for the Oakland A's that day, ripped a fastball, he might send Bobby Murcer, the Yanks' center fielder, racing around them to retrieve the ball.

Ringing the upper deck was a scalloped copper frieze, painted white. Hanging from it were the Yankees' championship banners. World Champions 1927. World Champions 1938. World Champions 1951. World Champions 1956. One after the other, a winning lineage so successful that banners covered the façade from foul pole to foul pole.

15
Publication American Way
Design Director Scott Feaster
Designer Charles Stone
Photographer Douglas Merriam
Publisher American Airlines Inflight Media
Issue October 1, 1997
Category Feature Story

1997
HOLIDAY

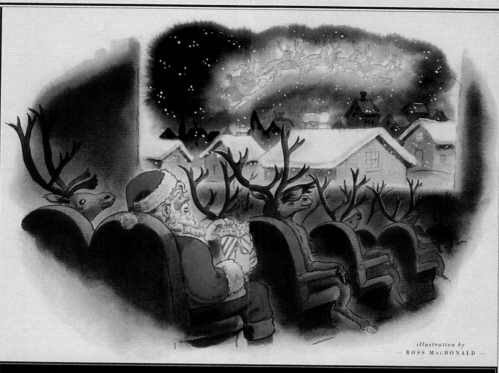

illustration by
— ROSS MacDONALD —

MOVIE PREVIEW

*A*ction! Kinetic slime! Sinking ships! And Academy Award winners?! Brace yourself for one of the most exciting—and oddball—moviegoing holiday seasons in years. Hollywood is hoping you'll be shaken by its miles-out-of-season blockbuster wannabes and sequels (the new Bond flick, FLUBBER, SCREAM 2) and stirred by its high-toned Oscar hopefuls (Clint Eastwood's MIDNIGHT IN THE GARDEN OF GOOD AND EVIL, Quentin Tarantino's JACKIE BROWN, Steven Spielberg's AMISTAD, and James Cameron's TITANIC). Herewith, your guide to more than 40 holiday releases offering tears, chills, and thrills to keep you in from the cold. ♦

■ 16
Publication Entertainment Weekly
Design Director John Korpics
Art Director Joe Kimberling
Illustrator Ross MacDonald
Photo Editors Doris Brautigan, Michael Kochman
Photographers Terry Doyle, Jeffery Newbury
Publisher Time Inc.
Issue November, 21, 1997
Category Feature Story

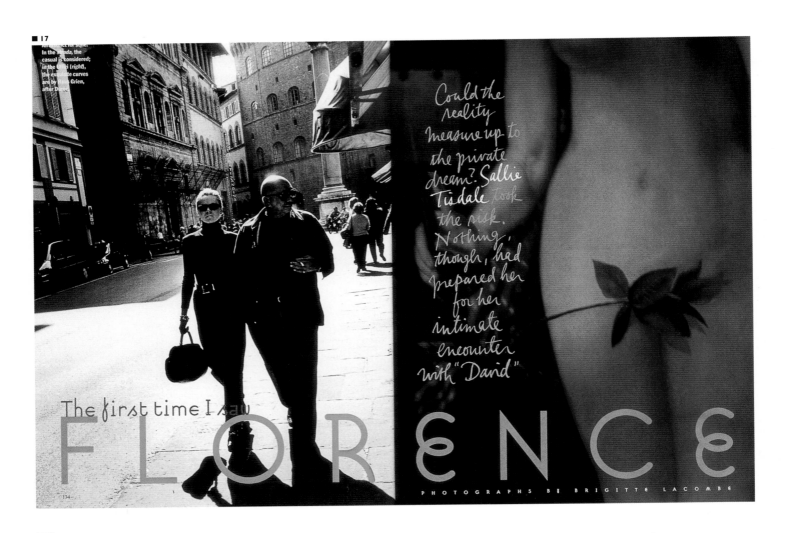

An instinct for style: In the *strada*, the casual is considered; in the Uffizi (*right*), the exquisite curves are by Hans Grien, after Dürer.

Could the reality measure up to the private dream? Sallie Tisdale took the risk. Nothing, though, had prepared her for her intimate encounter with "David"

The first time I saw
FLORENCE

PHOTOGRAPHS BY BRIGITTE LACOMBE

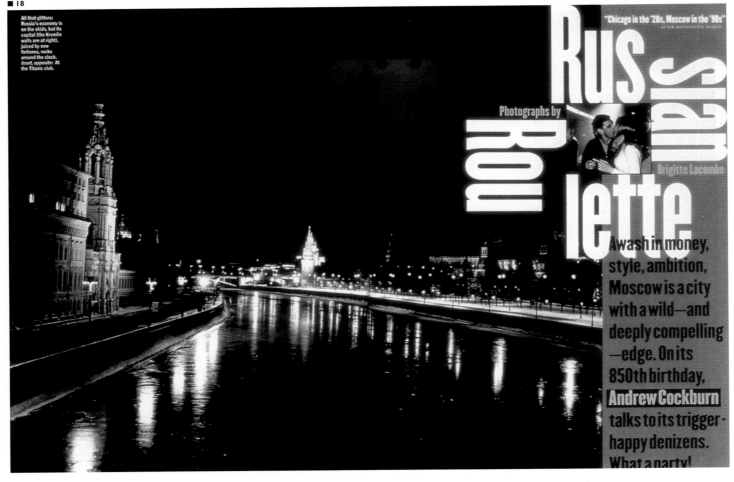

All that glitters: Russia's economy is on the skids, but its capital (the Kremlin walls are at right), juiced by new fortunes, rocks around the clock. *Inset, opposite:* At the Titanic club.

"Chicago in the '20s, Moscow in the '90s"
ACTOR KONSTANTIN RAIKIN

Russian Roulette

Photographs by Brigitte Lacombe

Awash in money, style, ambition, Moscow is a city with a wild—and deeply compelling —edge. On its 850th birthday, Andrew Cockburn talks to its trigger-happy denizens. What a party!

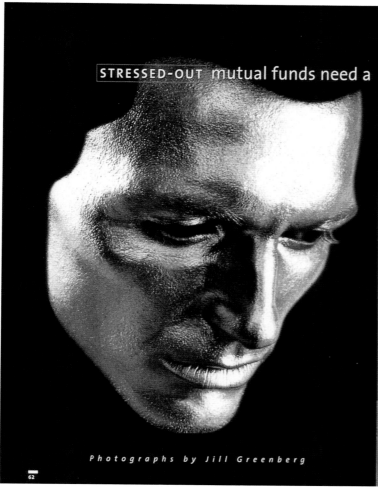

STRESSED-OUT mutual funds need a

Photographs by Jill Greenberg

62

wake-up call:

Consumers rule!

BY LYNN BRENNER

■ 17
Publication Condé Nast Traveler
Design Director Robert Best
Art Director Carla Frank
Designer Carla Frank
Photo Editor Kathleen Klech
Photographer Brigitte LaCombe
Publisher Condé Nast Publications Inc.
Issue March 1997
Category Feature Spread

■ 18
Publication Condé Nast Traveler
Design Director Robert Best
Art Director Carla Frank
Designer Robert Best
Photo Editor Kathleen Klech
Photographer Brigitte LaCombe
Publisher Condé Nast Publications Inc.
Issue June 1997
Category Feature Spread

■ 19
Publication Bloomberg Personal Finance
Art Director Carol Layton
Designer Carol Layton
Photo Editor Mary Shea
Photographer Jill Greenberg
Publisher Bloomberg L. P.
Issue December 1997
Category Feature Spread

luis
sanchis
new york
march
31

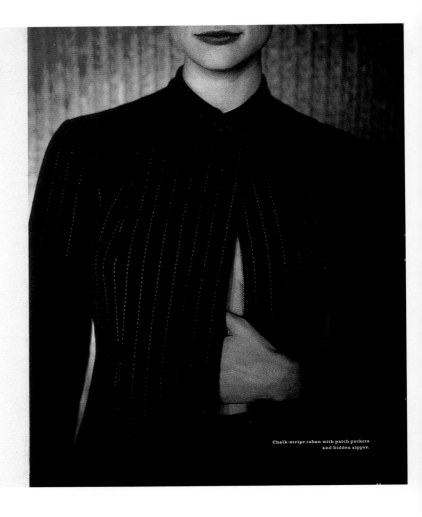

Full trousers in light iridescent velvet, with
small, very tight jacket.

Chalk-stripe caban with patch pockets
and hidden zipper.

40

■ 20
Publication EA
Art Director David Carson
Designer David Carson
Photographer Luis Sanchez
Studio David Carson Design
Client Armani
Category Feature Spread

■ 21
Publication Blue
Art Director David Carson
Designer David Carson
Photographer Laura Levine
Studio David Carson Design
Publisher Blue Media
Category Cover

blue

blue
a journal for the new traveler

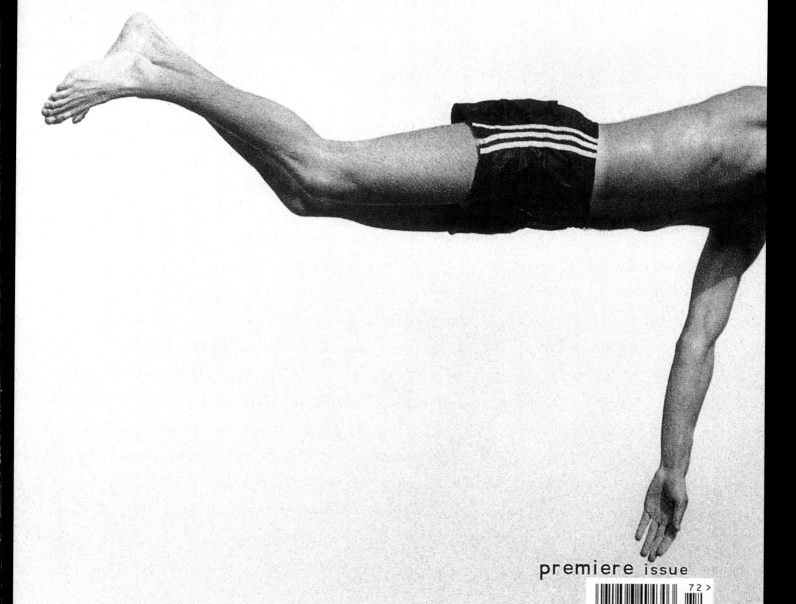

premiere issue

72 >

0 71896 49430 3

$3.95 display until october 15. 1997

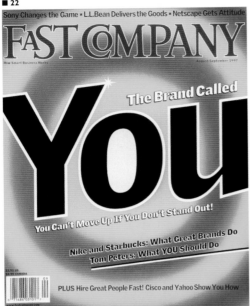

■ 22
Publication Fast Company
Art Director Patrick Mitchell
Designers Emily Crawford, Gretchen Smelter, Patrick Mitchell
Illustrator Steve Brodner
Photographers Fredrik Broden, David Zadig
Issue August/September 1997
Category Entire Issue

SPECIAL COLLECTOR'S EDITION **THE GREATEST HITS·VOLUME 1**

FAST COMPANY
NEW RULES OF BUSINESS

Sponsored by:
Coopers &Lybrand

LEAD CHANGE SUCCEED WORK CREATE

Learn
Fight
Lead

BY RICHARD PASCALE

PHOTOGRAPHS BY BRIAN SMALE

To check out the future of democratic capitalism, get in the checkout line at Whole Foods Market—where all work is teamwork, everyone sees the numbers, and people vote on who gets hired. Sound too soft? It's on track to become a billion-dollar company.

WHOLE FOODS IS ALL TEAMS

BY CHARLES FISHMAN
PHOTOGRAPHS BY CHRIS CARROLL

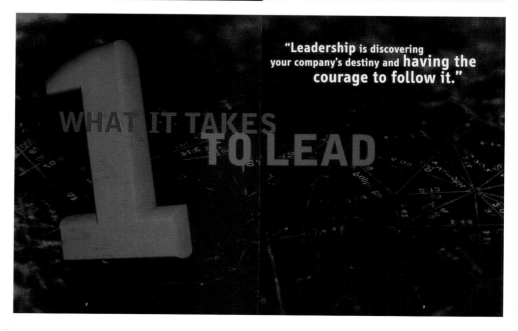

"Leadership is discovering your company's destiny and **having the courage to follow it.**"

WHAT IT TAKES TO LEAD

1

■ 23
Publication Fast Company
Design Director Patrick Mitchell
Art Director Clifford Stoltze
Designers Dina Radeka, Wing Ngan, Clifford Stoltze
Illustrator Joe Polevy
Photographers Brian Smale, Chris Carroll
Studio Stoltze Design
Issue September 1997
Category Entire Issue

CMYK

kinko's
THE FREE-AGENT HOME OFFICE

SURE, THIS FAST-GROWING COMPANY
MAKES COPIES—12 *BILLION* COPIES
IN 1997 ALONE. BUT ITS REAL MISSION
IS TO HELP THE GROWING POPULATION
OF SELF-EMPLOYED PROFESSIONALS
REMAKE HOW THEY WORK AND LIVE.
BY PAUL ROBERTS • PHOTOGRAPHY BY SCOGIN MAYO

164 DECEMBER/JANUARY 1998

kinko's
The new way to office.®

She reads the *Times*,
shops at D'Agostino, and designs
software. But in the privacy
of her home, one personality
gives way to the chaos
of many. A New Yorker's
psychological struggle.

Divided She Stands
By Laura Emily Mason

Photograph by James Porto

24

Publication Fast Company
Art Director Patrick Mitchell
Designer Patrick Mitchell
Photographer Scogin Mayo
Issue December 1997/January 1998
Category Feature Spread

25

Publication New York
Design Director Florian Bachleda
Art Director Jennifer Gilman
Designer Sue Conley
Photo Editor Margery Goldberg
Photographer James Porto
Publisher K-III Publications
Issue August 4, 1997
Category Feature Spread

FRANCE
M A G A Z I N E

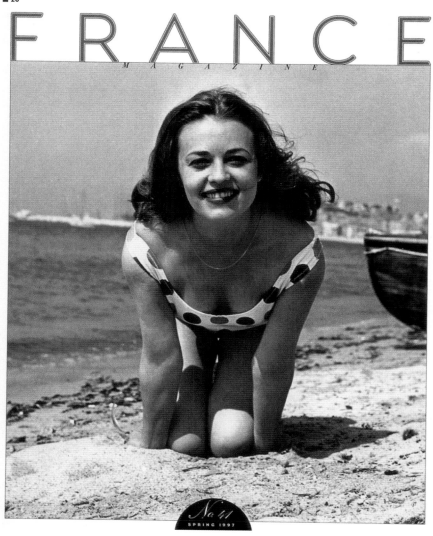

No 41
SPRING 1997

■ 26
Publication France
Creative Director Kelly Doe
Designers Miguel Buckenmeyer, Kelly Doe
Photo Editor Kelly Doe
Photographer Leo Merkine
Publisher French Embassy
Issue Spring 1997
Category Feature Story

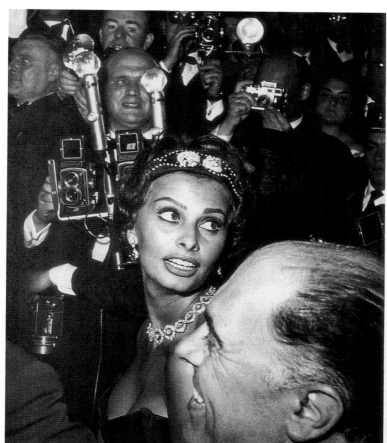

Cannes

50

A GOLDEN ANNIVERSARY FOR LA PALME D'OR By Molly Haskell

Photographs by Léo Mirkine

MONIKA ROBL

Skulpturen auf Zeit

*Blumen, Blüten, Blattwerk, Gräser: Seit Jahren verfolgt
die Fotografin Monika Robl neben ihrer professionellen Tätigkeit in
Editorial und Werbung ein eigenes und sehr privates Thema.*

Gewiß, man könnte die Bildkunst der Renaissance zitieren, darauf verweisen, daß die ‹Autonomisierung des Dinglichen› (Norbert Schneider) hier ihren Anfang genommen hat, könnte sich erinnern an die zarten Studien eines Georg Flegl (um 1630) oder die opulenten Arrangements eines Jan Davidsz de Heem, dessen bildfüllende Arrangements die späteren fotografischen Bildschöpfungen aus dem Hause Adolphe Braun (um 1880) vorwegzunehmen scheinen. Womit wir bei der Fotografie angelangt wären, die das Thema Blume, Blüte, Pflanzenstudie von Anfang an in ihren Kanon aufgenommen hat, beginnend mit Talbot und seinen ‹Photogenic drawings› über die Fotografie der Neuen Sachlichkeit mit Blossfeldt, Renger-Patzsch, Florence Henri, Aenne Biermann, Edward Weston und Paul Strand bis hin zur Postmoderne, die mit Robert Mapplethorpe, Marie-Jo Lafontaine oder Joan Fontcuberta das Thema aufgreift, variiert, ironisiert, transzendiert. Die Blume, die

Eines Tages im Botanischen Garten in München...

LEICA WORLD 1/97

53

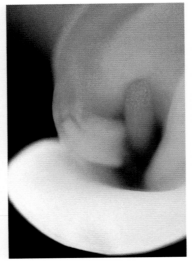

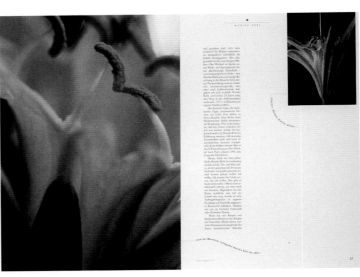

■ 27
Publication Leica World
Creative Director Horst Moser
Designers Carin Drexler, Horst Moser
Photo Editors Michael Koettzle, Horst Moser
Photographer Monika Robl
Studio Independent Medien Design
Publisher Leica Camera AG
Issue February 1997
Category Feature Story

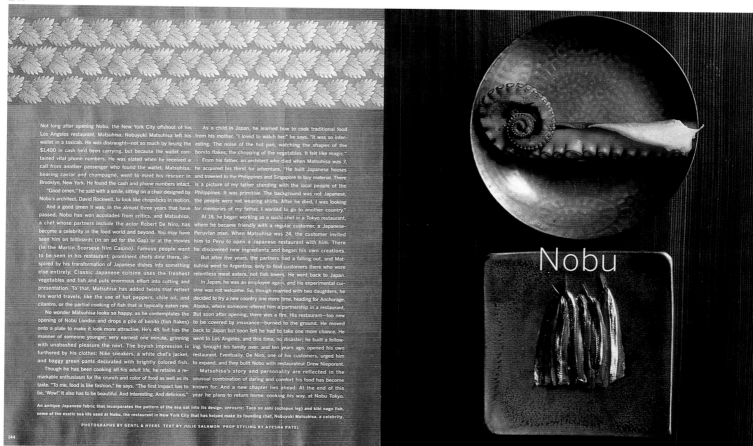

Not long after opening Nobu, the New York City offshoot of his Los Angeles restaurant, Matsuhisa, Nobuyuki Matsuhisa left his wallet in a taxicab. He was distraught—not so much by losing the $1,400 in cash he'd been carrying, but because the wallet contained vital phone numbers. He was elated when he received a call from another passenger who found the wallet. Matsuhisa, bearing caviar and champagne, went to meet his rescuer in Brooklyn, New York. He found the cash and phone numbers intact.

"Good omen," he said with a smile, sitting on a chair designed by Nobu's architect, David Rockwell, to look like chopsticks in motion.

And a good omen it was. In the almost three years that have passed, Nobu has won accolades from critics, and Matsuhisa, a chef whose partners include the actor Robert De Niro, has become a celebrity in the food world and beyond. You may have seen him on billboards (in an ad for the Gap) or at the movies (in the Martin Scorsese film *Casino*). Famous people want to be seen in his restaurant; prominent chefs dine there, inspired by his transformation of Japanese dishes into something else entirely. Classic Japanese cuisine uses the freshest vegetables and fish and puts enormous effort into cutting and presentation. To that, Matsuhisa has added twists that reflect his world travels, like the use of hot peppers, chile oil, or cilantro, or the partial cooking of fish that is typically eaten raw.

No wonder Matsuhisa looks so happy, as he contemplates the opening of Nobu London and drops a pile of bonito (fish flakes) onto a plate to make it look more attractive. He's 48, but has the manner of someone younger; very earnest one minute, grinning with unabashed pleasure the next. The boyish impression is furthered by his clothes: Nike sneakers, a white chef's jacket, and baggy green pants decorated with brightly colored fish.

Though he has been cooking all his adult life, he retains a remarkable enthusiasm for the crunch and color of food as well as its taste. "To me, food is like fashion," he says. "The first impact has to be, 'Wow!' It also has to be beautiful. And interesting. And delicious."

As a child in Japan, he learned how to cook traditional food from his mother. "I loved to watch her," he says. "It was so interesting. The noise of the hot pan, watching the shapes of the bonito flakes, the chopping of the vegetables. It felt like magic."

From his father, an architect who died when Matsuhisa was 7, he acquired his thirst for adventure. "He built Japanese houses and traveled to the Philippines and Singapore to buy material. There is a picture of my father standing with the local people of the Philippines. It was primitive. The background was not Japanese, the people were not wearing shirts. After he died, I was looking for memories of my father. I wanted to go to another country."

At 18, he began working as a sushi chef in a Tokyo restaurant, where he became friendly with a regular customer, a Japanese-Peruvian man. When Matsuhisa was 24, the customer invited him to Peru to open a Japanese restaurant with him. There he discovered new ingredients and began his own creations.

But after five years, the partners had a falling out, and Matsuhisa went to Argentina, only to find customers there who were relentless meat eaters, not fish lovers. He went back to Japan.

In Japan, he was an employee again, and his experimental cuisine was not welcome. So, though married with two daughters, he decided to try a new country one more time, heading for Anchorage, Alaska, where someone offered him a partnership in a restaurant. But soon after opening, there was a fire. His restaurant—too new to be covered by insurance—burned to the ground. He moved back to Japan but soon felt he had to take one more chance. He went to Los Angeles, and this time, no disaster; he built a following, brought his family over, and ten years ago, opened his own restaurant. Eventually, De Niro, one of his customers, urged him to expand, and they built Nobu with restaurateur Drew Nieporent.

Matsuhisa's story and personality are reflected in the unusual combination of daring and comfort his food has become known for. And a new chapter lies ahead: At the end of this year he plans to return home, cooking *his* way, at Nobu Tokyo.

An antique Japanese fabric that incorporates the pattern of the sea oat into its design. OPPOSITE: Taco no ashi (octopus leg) and kibi nago fish, some of the exotic sea life used at Nobu, the restaurant in New York City that has helped make its founding chef, Nobuyuki Matsuhisa, a celebrity.

PHOTOGRAPHS BY GENTL & HYERS TEXT BY JULIE SALAMON PROP STYLING BY AYESHA PATEL

144

Nobu

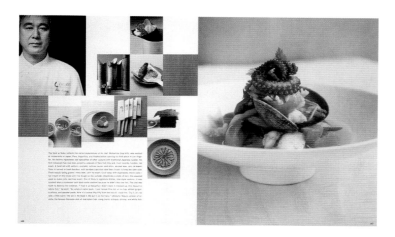

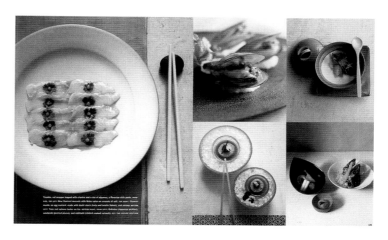

■ 28
Publication Martha Stewart Living
Design Director Eric A. Pike
Art Director Claudia Bruno
Designers Claudia Bruno, Ayesha Patel, Susan Spungen, Nobuyuki Matushisa
Photo Editor Heidi Posner
Photographer Gentl + Hyers
Publisher Martha Stewart Living Omnimedia
Issue May 1997
Category Feature Story

SPECIAL REPORT

DECEMBER 8, 1997

Sports Illustrated

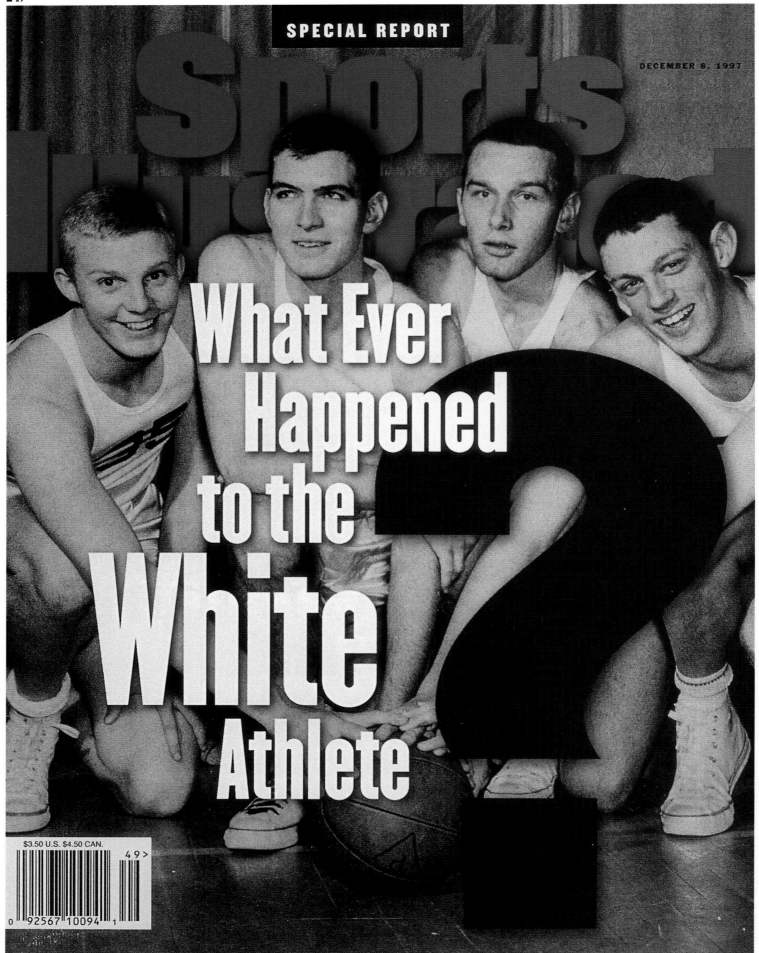

What Ever Happened to the White Athlete?

BUILDING A WINNER
A Decade of Drafting

OUR STUDY OF THE NFL DRAFT REVEALS ITS UPS AND DOWNS, AND CHOICES BOTH BRILLIANT AND BOTCHED

BY DAVID SABINO

At the conclusion of our exhaustive statistical examination of every NFL draft of the past decade, one team emerged atop the list as the best selector of collegiate talent. Guess who. The 49ers? Nope. The Cowboys? Wrong again. Try the Detroit Lions. Yes, we too were shocked. But the Lions ranked near the top in each of four categories (games played and games started by a draftee for the team that chose him, and total games played and started by a draftee), and from 1987 to '96, Detroit selected six players who went on to the Pro Bowl—Jerry Ball, Bennie Blades, Herman Moore, Dan Saleaumua, Barry Sanders and Chris Spielman. The trouble with the Lions, who are 72–87 since '87, is that though they're good at identifying talent, they're not so good at holding on to it. Ball, Blades, Saleaumua and Spielman will hang their helmets elsewhere in 1997.

The Redskins, meanwhile, have not only drafted poorly but have held on to their poor picks. Washington was below the league average in all four categories, and only Carolina, Jacksonville and Tampa Bay had fewer draftees named to the Pro Bowl. (The Panthers and Jaguars did not begin drafting players until 1995, so they were exempted from the overall ratings.)

All teams make mistakes, but when they do so in the first round, it sticks out like a sore thumb. Still, for every first-round blunder like the Raiders' Todd Marinovich or the Dolphins' Sammie Smith, there is a late-round discovery like the Broncos' Terrell Davis or Shannon Sharpe. The charts on the following pages show which teams have been the best at distinguishing Sharpes from Smiths, foretelling who will be a gem and who will be a lemon.

Ten Years of Picks: How They Stack Up

In rating the drafting prowess of each of the 30 NFL teams, we evaluated the 2,968 players selected from 1987 to 1996. Players were given credit for playing in games, starting games and appearing in the Pro Bowl. These figures were then weighted and combined to calculate an overall score, with a total of 100.0 assigned to the top team.

	Total no. of picks	Avg. no. of games played for team by draftees	Avg. no. of games played in NFL by draftees	Avg. no. of starts for team by draftees	Avg. no. of starts in NFL by draftees	Pro Bowl appearances by draftees	OVERALL SCORE
Detroit Lions	92	9.57	12.65	5.70	7.39	20	100.0
Dallas Cowboys	114	8.40	12.55	4.94	7.24	44	96.7
Pittsburgh Steelers	116	9.47	12.43	5.17	6.78	24	95.2
Philadelphia Eagles	97	9.39	12.45	5.10	6.61	20	90.5
Miami Dolphins	106	8.82	12.80	5.59	7.45	16	88.8
Buffalo Bills	111	9.63	13.16	5.30	7.13	14	73.2
Arizona Cardinals	117	7.49	11.92	4.61	6.78	16	72.1
Kansas City Chiefs	96	8.50	11.70	4.09	5.21	20	71.0
San Francisco 49ers	89	8.64	13.24	3.97	5.72	16	69.4
New England Patriots	122	9.43	12.73	5.56	7.03	13	66.5
Denver Broncos	102	8.91	12.46	4.01	5.44	16	66.3
San Diego Chargers	116	8.52	12.36	4.55	6.46	15	62.2
Green Bay Packers	116	9.56	12.77	5.29	7.28	12	60.9
Oakland Raiders	84	10.09	11.75	5.02	5.67	14	60.1
Seattle Seahawks	94	9.99	12.62	6.33	7.61	7	58.0
Baltimore Ravens*	88	8.57	13.03	4.37	7.06	12	51.9
Tennessee Oilers	112	8.61	12.58	4.34	5.70	13	48.2
Indianapolis Colts	100	9.23	12.71	4.87	6.76	11	48.0
Cincinnati Bengals	109	9.79	11.80	4.64	5.68	7	32.9
New Orleans Saints	107	9.01	12.55	4.28	5.76	7	31.2
Chicago Bears	114	10.07	12.30	4.91	5.54	6	27.0
Tampa Bay Buccaneers	117	8.37	12.83	5.37	8.23	2	24.4
Atlanta Falcons	95	7.76	11.78	3.77	5.41	9	22.8
New York Giants	108	9.31	12.63	4.68	6.27	4	22.7
New York Jets	103	8.76	12.11	4.63	6.32	4	19.4
Minnesota Vikings	95	7.94	12.24	4.38	6.54	4	17.1
St. Louis Rams	114	7.94	12.00	4.02	5.97	5	13.8
Washington Redskins	92	8.04	11.58	3.95	5.50	3	0.0
Carolina Panthers	21	11.10	11.10	5.90	5.90	0	N.A.
Jacksonville Jaguars	20	8.83	9.13	5.39	5.39	0	N.A.

*Before 1996, the Ravens were the Cleveland Browns

Marinovich (far left) and Smith (third from left) were duds for the Raiders and the Dolphins, respectively, but Davis, Denver's sixth-round pick in '95, was a steal and Moore (above) is one reason the Lions landed atop our list.

■ 29
Publication Sports Illustrated
Creative Director Steven Hoffman
Designers Steven Hoffman, Michael Picon
Publisher Time Inc.
Issue December 8, 1997
Category Cover

■ 30
Publication Sports Illustrated Presents
Art Director F. Darrin Perry
Photo Editor Jeff Weig
Publisher Time Inc.
Issue August 1997
Category Feature Spread

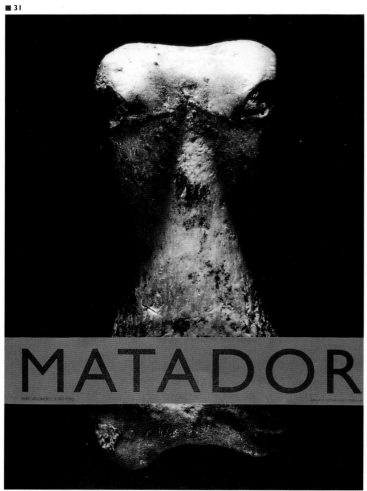

MATADOR

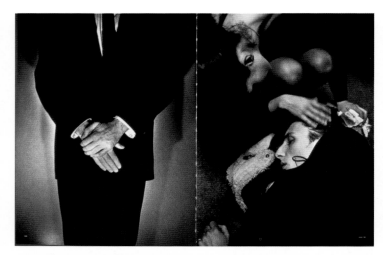

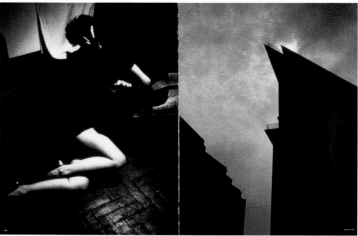

PAULO NOZOLINO

PAULO NOZOLINO, FOTÓGRAFO PORTUGUÉS INSTALADO EN PARÍS, RECORRE SU PAÍS DE LA MANO DE UNA GENERACIÓN QUE HA VIVIDO AL LÍMITE, EN EL FILO DE LA NAVAJA. SUS IMÁGENES SON UN RETRATO CARGADO DE EMOCIÓN, ANGUSTIA Y DESENCANTO. UNA HISTO-RIA DE PRÍNCIPES DESTRONADOS. **EL LARGO VIAJE**

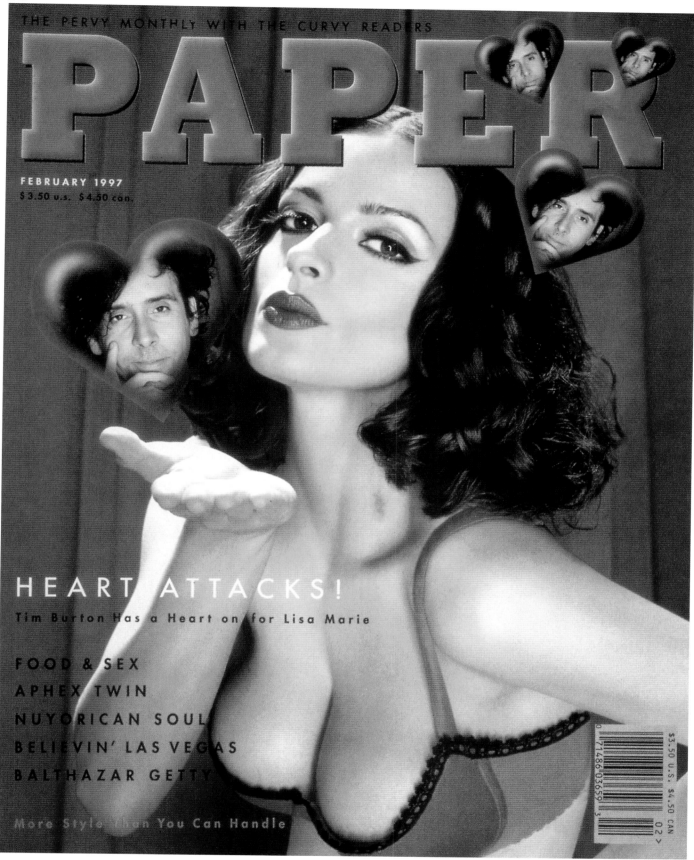

THE PERVY MONTHLY WITH THE CURVY READERS

PAPER

FEBRUARY 1997
$3.50 u.s. $4.50 cán.

HEART ATTACKS!

Tim Burton Has a Heart on for Lisa Marie

FOOD & SEX

APHEX TWIN

NUYORICAN SOUL

BELIEVIN' LAS VEGAS

BALTHAZAR GETTY

More Style Than You Can Handle

■ 31
Publication Matador
Art Director Fernando Gutiérrez
Designers María Ulecia, Xavi Roca, Emmanuel Ponty,
Pablo Martín, Fernando Gutiérrez
Photo Editor Luis de las Alas
Studio GRAFICA
Publisher La Fábrica, S.L.
Issue October 25, 1997
Category Feature Story

■ 32
Publication Paper
Art Director Bridget De Socio
Designer Ninja v. Oertzen
Photographer Dah-Len
Studio Socio X
Publisher Paper Publishing Co.
Issue February 1997
Category Cover

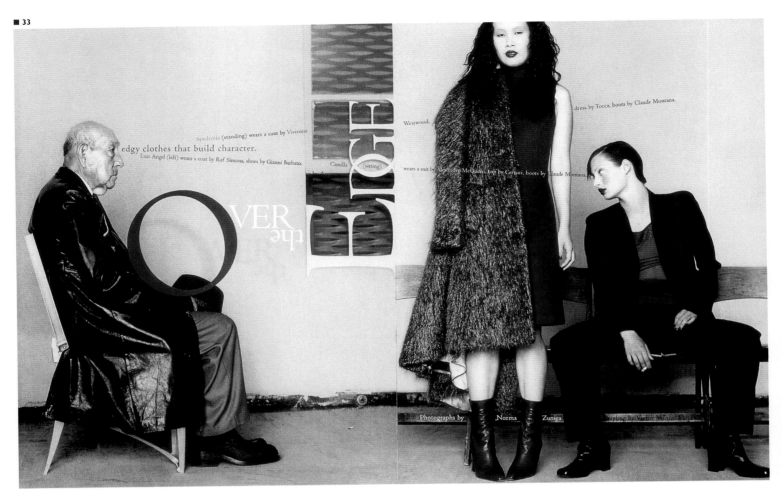

OVER the EDGE

edgy clothes that build character.

Synderela (standing) wears a coat by Vivienne Westwood,

Luis Angel (left) wears a coat by Raf Simons, shoes by Gianni Barbato.

Camilla (sitting) wears a suit by Alexander McQueen, top by Cerruti, boots by Claude Montana.

dress by Tocca, boots by Claude Montana.

Photographs by Norma Zuniga Styling by Victor Manuel

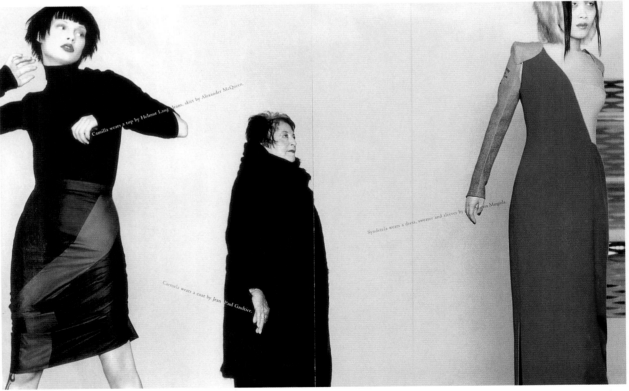

Camilla wears a top by Helmut Lang, Jeans, skirt by Alexander McQueen.

Camilla wears a coat by Jean Paul Gaultier.

Synderela wears a dress, sweater and sleeves by Martin Margiela.

■ 33
Publication Paper
Art Director Bridget De Socio
Designer Albert Lin
Photographers Jean-Pierre Khazem, Norma Zuniga
Studio Socio X
Publisher Paper Publishing Co.
Issue October 1997
Category Feature Story

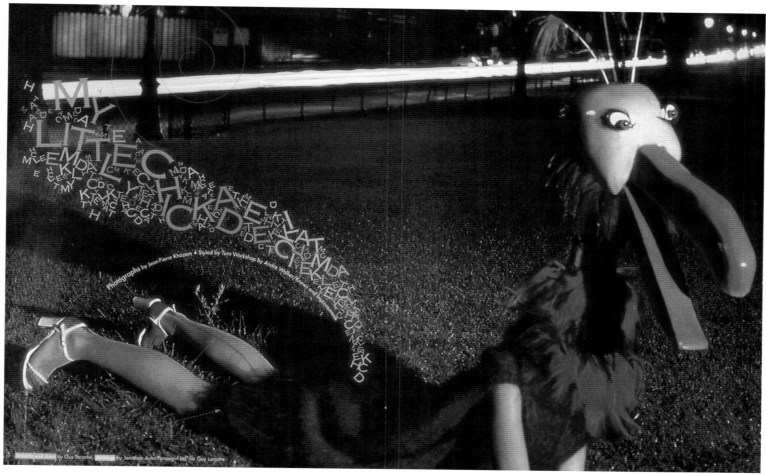

MY LITTLE CHICK

Photographs by Jean-Pierre Khazem • Styled by Turn Workshop by André Walker

Sandals and dress by Guy Laroche, Stockings by Jonathan Aston Panzegirl Ltd for Guy Laroche

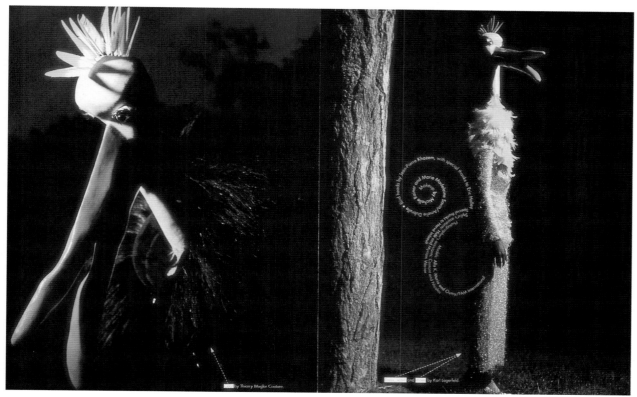

by Thierry Mugler Couture.

and by Karl Lagerfeld.

■ 34
Publication Paper
Art Director Bridget De Socio
Designer Ninja v. Oertzen
Photographer Norma Zuniga
Studio Socio X
Publisher Paper Publishing Co.
Issue November 1997
Category Feature Story

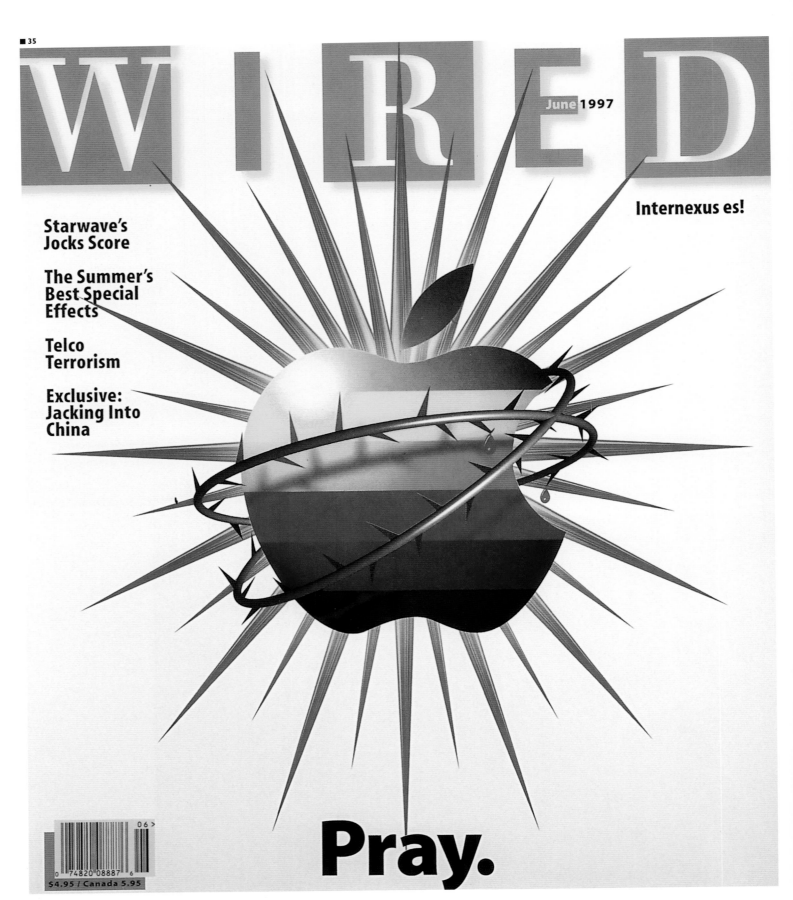

■ 35

WIRED

June 1997

Internexus es!

**Starwave's
Jocks Score**

**The Summer's
Best Special
Effects**

**Telco
Terrorism**

**Exclusive:
Jacking Into
China**

Pray.

0 74820 08887 6
$4.95 / Canada 5.95

■ 35
Publication Wired
Creative Director John Plunkett
Design Director Thomas Schneider
Designer John Plunkett
Illustrator John Klassen
Publisher Wired Ventures
Issue June 1997
Category Cover

■ 36
Publication Wired
Creative Director John Plunkett
Design Director Thomas Schneider
Designer John Plunkett
Photo Editor Erica Ackerberg
Photographers Ricki Rosen, Jay Ullal
Publisher Wired Ventures
Issue November 1997
Category Feature Story

44

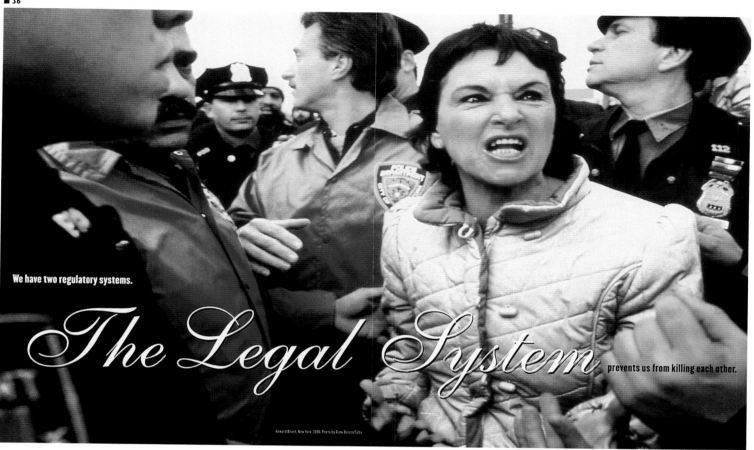

We have two regulatory systems.

The Legal System prevents us from killing each other.

Howard Beach, New York, 1986. Photo by Ricky Rosen/Saba

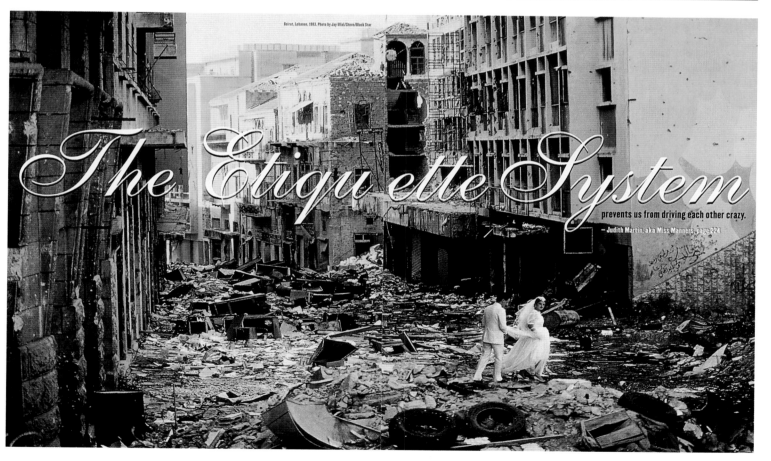

Beirut, Lebanon, 1983. Photo by Jay Ullal/Stern/Black Star

The Etiquette System prevents us from driving each other crazy.

— Judith Martin, aka Miss Manners, page 224

U&lc

Type Transformations

UPPER AND LOWER CASE

THE INTERNATIONAL JOURNAL

OF GRAPHIC DESIGN AND DIGITAL MEDIA

PUBLISHED BY INTERNATIONAL TYPEFACE CORPORATION

VOLUME 24, NUMBER 2, FALL 1997

$5.00 US, $9.90 AUD, £4.95

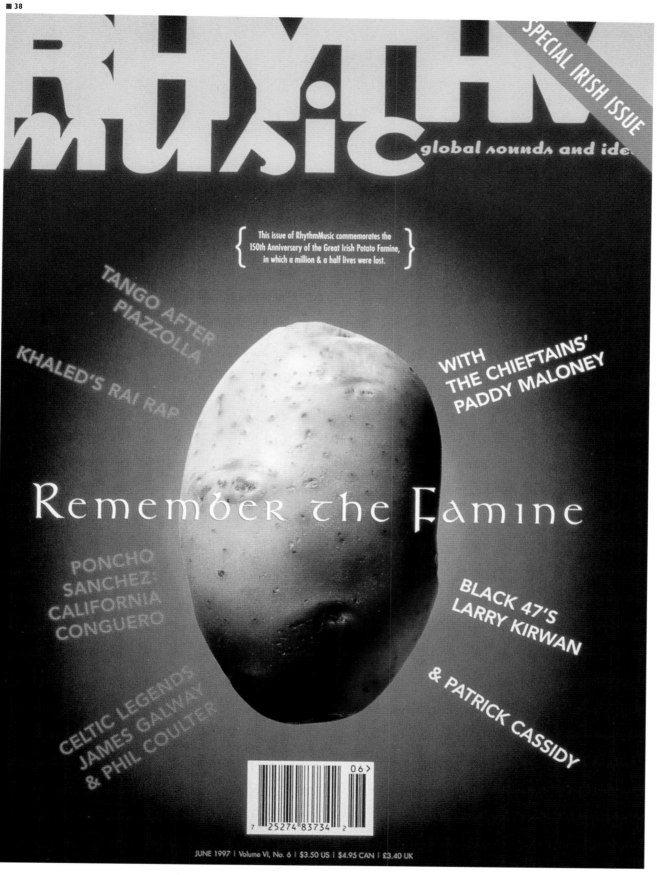

■ 38

RHYTHM MUSIC
global sounds and ide...

SPECIAL IRISH ISSUE

{ This issue of RhythmMusic commemorates the 150th Anniversary of the Great Irish Potato Famine, in which a million & a half lives were lost. }

TANGO AFTER PIAZZOLLA

KHALED'S RAI RAP

WITH THE CHIEFTAINS' PADDY MALONEY

Remember the Famine

PONCHO SANCHEZ: CALIFORNIA CONGUERO

BLACK 47'S LARRY KIRWAN

CELTIC LEGENDS JAMES GALWAY & PHIL COULTER

& PATRICK CASSIDY

7 25274 83734 2 06>

JUNE 1997 | Volume VI, No. 6 | $3.50 US | $4.95 CAN | £3.40 UK

■ 37
Publication U & lc
Creative Director Maryjane Fahey
Designers Ariel Cepeda, Maryjane Fahey
Studio Roger Black Partners
Publisher International Typeface Corp.
Issue Fall 1997
Category Cover

■ 38
Publication Rhythm Music
Creative Director Carol Bobolts
Art Director Laurie Goldman
Designer Laurie Goldman
Photographer Photodisc
Studio Red Herring Design
Client World Marketing
Issue June 1997
Category Cover

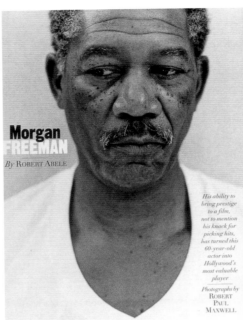

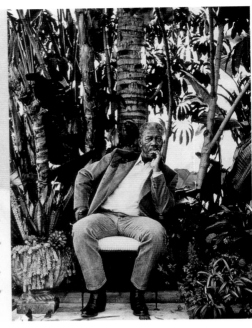

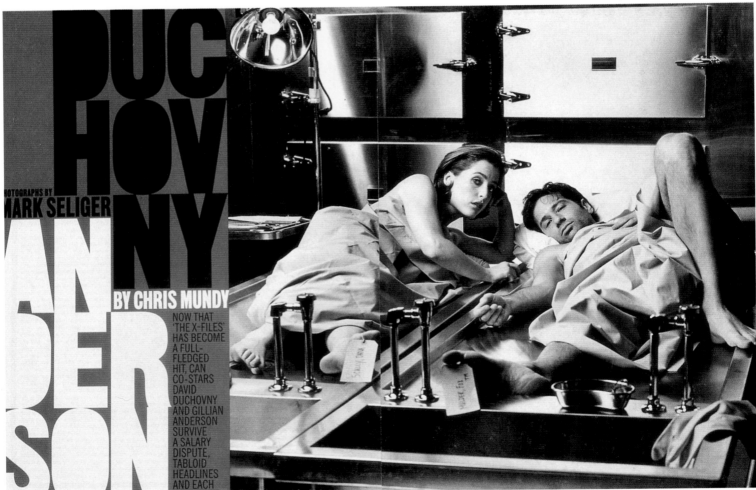

■ 39
Publication US
Art Director Richard Baker
Designers Daniel Stark, Bess Wong
Photo Editors Jennifer Crandall, Rachel Knepfer
Photographers Robert Paul Maxwell, Mark Seliger
Publisher US Magazine Co., L. P.
Issue May 1997
Category Entire Issue

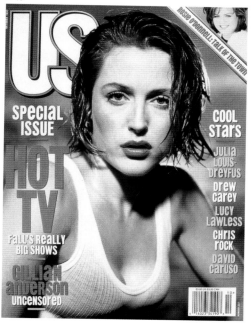

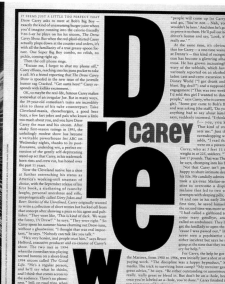

IT SEEMS JUST A LITTLE TOO PERFECT THAT Drew Carey asks to meet at Bob's Big Boy — exactly the kind of unassuming burger joint where you'd imagine running into the calorie-friendly 9-to-5-er he plays on his hit sitcom, *The Drew Carey Show*. But when the red-plaid-shirted Carey actually plops down at the counter and orders, it's with all the familiarity of a true greasy-spoon fixture. One Super Big Boy combo, no relish, no pickle, coming right up.

Then the cell phone rings.

"Excuse me, I forgot to shut my phone off," Carey offers, reaching into his jeans pocket to take a call. It's a friend reporting that *The Drew Carey Show* is spoofed in the new issue of the juvenile humor rag Cracked. "Get outta here!" Carey responds with kidlike excitement.

OK, so maybe the real-life, famous Carey makes somewhat of an irregular Joe. But in many ways, the 39-year-old comedian's tastes are incredibly akin to those of his tube counterpart. Take Cleveland-mania, cheeseburgers, a good beer buzz, a few fart jokes and pals who know a little too much about you, and you have Drew Carey the man and his sitcom. After shaky first-season ratings in 1995, the unfailingly modest show has become a veritable powerhouse for ABC on Wednesday nights, thanks to its post-*Roseanne*, underdog wit, a perfect extension of the gently self-deprecating stand-up act that Carey, in his trademark horn rims and crew cut, has honed over the past 11 years.

Now the Cleveland native has a shot at further entrenching his status as America's working-stiff smartass of choice, with the September release of his first book, a slathering of raunchy laughs, personal anecdotes and riffs, unapologetically called *Dirty Jokes and Beer: Stories of the Unrefined*. Carey originally wanted to write a collection of short stories but backed off from that concept after showing a piece to his agent and publisher. "They were like, 'This is kind of dark. We want the funny, TV Drew!'" he says. "Nobody can talk like you talk."

"He's very honest, and people trust him," says Bruce Helford, executive producer and co-creator of Carey's show. The two met in 1994 when the comedian was playing second banana on a short-lived 1994 sitcom called *The Good Life*. "He's a regular person, and he'll say what he thinks, and I think that comes across to the audience. There's no phoniness." Still, on road trips, when the pair scarf at places like Burger King, Helford reports,

"people will come up [to Carey] and go, 'You're not... Nah, you wouldn't be here.' And then he's got to prove it to them. He'll pull out his driver's license and say, 'Look, it's really me.'"

At the same time, it's obvious that for Carey — a one-time waiter at Denny's — this kind of recognition has become a glittering albatross. He has grown increasingly wary of the tabloids, which have variously reported on an alcohol-laden cast-and-crew excursion to Disney World ("I got drunk and had a blast. Big deal!") and a supposed secret engagement ("This was two weeks after I'd told this girl I wanted to date other people," says Carey, who is currently single). "Some guy came to Bob's Big Boy and was asking [the staff], 'Do you have anything bad to say about him?'" he says, suddenly incensed. "I think, well, f— you, you know? That kind of stuff upsets me." Just then an eavesdropping waitress adds, "I read that you were on a potato diet."

Carey, who at 5 feet 11 inches weighs in at 225, snickers. "Yeah, I lost 17 pounds. That was *The Star*," he says, chomping into his burger.

Not that Carey isn't perfectly happy to share intimate details of his life. He candidly admits that it took a six-year Marine-reserves stint to overcome a dispiriting malaise that led to two suicide attempts with sleeping pills, one at 18 and one in his early 30s. The first time, he saved himself, but the second time was more serious. "I had called a girlfriend to give some teary goodbye, and she called an ambulance. They had to get the landlady to open the door, 'cause I was passed out." He has never seen a psychiatrist about either incident but says he could grasp at the time that they were "a cry for help."

For Carey, the help he got from the Marines, from 1980 to 1986, was initially just a shot at steady, paying work. "The discipline was a happy by-product," he remarks. The trick to surviving boot camp? "My recruiter gave me great advice," he says. "Be either outstanding or anonymous; be really, really great or blend in. But don't be an a—hole, because once you're labeled an a—hole, you're done." Carey finished in the top 10 percent of his platoon.

Once out of the service, a rejuvenated Carey threw himself into stand-up, living out of his car on gigs and [Continued on page 134]

HE'S THE ULTIMATE EVERYGUY — AND, OH, YEAH, A TV STAR BY ROBERT ABELE

Drew CAREY

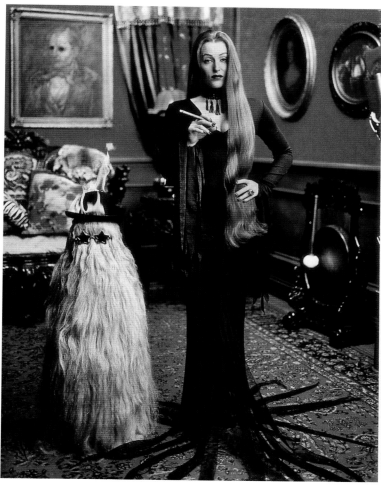

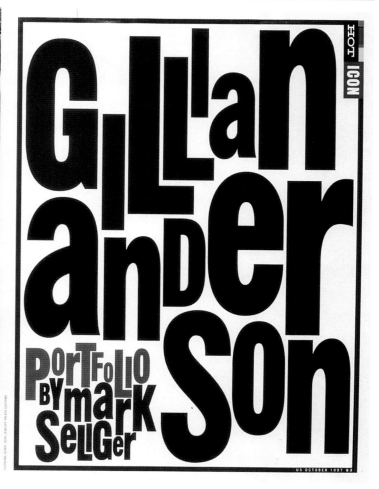

GILLIAN ANDERSON

PORTFOLIO BY mark SELIGER

US OCTOBER 1997 63

■ 40
Publication US
Art Director Richard Baker
Designers Daniel Stark, Bess Wong
Photo Editors Jennifer Crandall, Rachel Knepfer
Photographer Mark Seliger
Publisher US Magazine Co., L. P.
Issue October 1997
Category Entire Issue

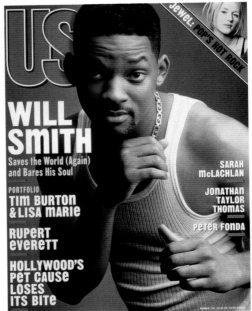

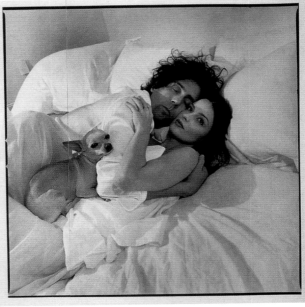

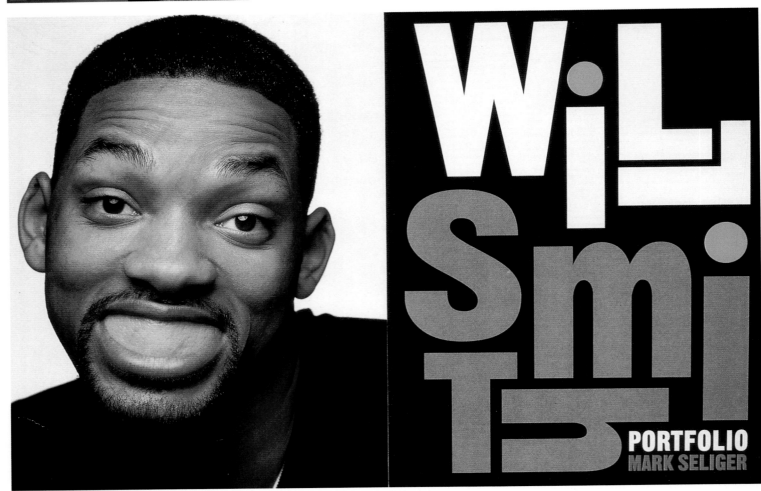

■ 41
Publication US
Art Director Richard Baker
Designer Bess Wong
Photo Editors Jennifer Crandall, Rachel Knepfer
Photographers Mary Ellen Mark, Mark Seliger
Publisher US Magazine Co., L. P.
Issue August 1997
Category Entire Issue

■ 42
Publication Worth
Art Director Philip Bratter
Designer Deanna Lowe
Photo Editor Sabine Meyer
Photographer Charles S. Anderson
Publisher Capital Publishing L. P.
Issue December 1997
Categories Entire Issue
 A Merit Spread
 B Merit Spread

■ 43
Publication Worth
Art Director Philip Bratter
Designer Deanna Lowe
Photo Editor Sabine Meyer
Photographer Charles S. Anderson
Publisher Capital Publishing L. P.
Issue December 1997
Category Feature Spread

Worth

FINANCIAL INTELLIGENCE

INVESTING OUTLOOK 1998

Strategies for the Coming Year

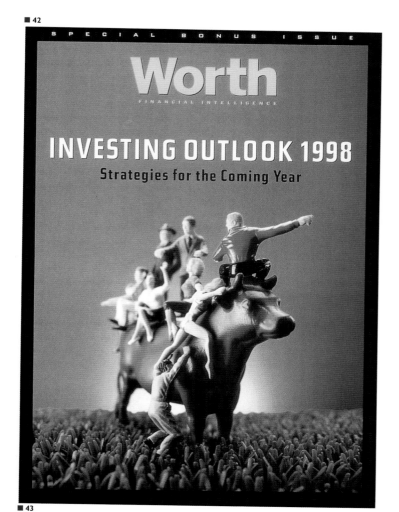

A

Official Denial

PHOTOGRAPHS BY PLASTOCK, CSA ARCHIVE

THE RECOVERY MAY GO ON RECORD as one of the most heavily discounted of the postwar period. Time and again, mainstream economists have doubted the economy's underlying strength only to be forced to recant as growth has consistently come in at the upper range of expectations. Judging from recent events, we think they'll be no more accurate in 1998. In the Blue Chip Consensus Forecast's September poll, the nation's most prestigious economists projected the U.S. gross domestic product to grow at a 2.5 percent annu-

GOVERNMENT FIGURES SAY THE U.S. ECONOMY IS SLUGGISH AND PRODUCTIVITY IS STALLED. IN THE REAL WORLD, THE PICTURE IS VERY DIFFERENT.

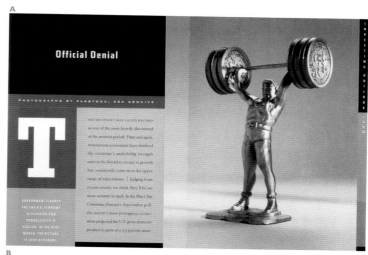

B

All Economics Is Local

THE INVESTMENT WORLD beyond the United States became a far more complicated in the second half of 1997. In the first part of the year, stock and bond investors began to believe that the emerging markets in Asia, Latin America, and Eastern Europe had actually emerged. Around midyear, Brazilian stocks were up 86 percent; the Hang Seng index in Hong Kong—defying fears of a sell-off after the territory's return to Chinese control in July—

SURE, THERE'S A GLOBAL MARKETPLACE— IT JUST HAPPENS TO CONSIST OF LOTS OF INDIVIDUAL MARKETPLACES

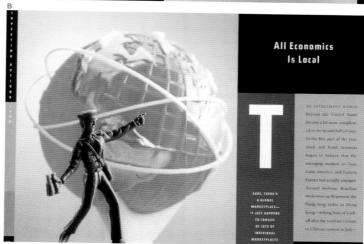

INVESTING OUTLOOK 1998

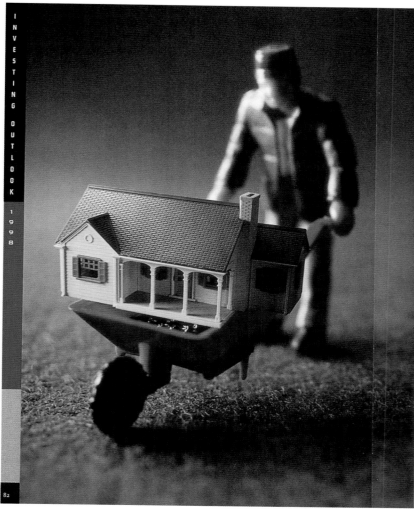

82

I

Movin' On Up

WITH SALES THROUGH THE ROOF AND MORTGAGE RATES DOWN, NOW IS THE TIME FOR REFINANCING, BUYING A BIGGER HOUSE, OR FINALLY ACQUIRING THAT WEEKEND GETAWAY

F YOU BOUGHT YOUR HOME IN THE early 1990s, you probably encountered a sluggish housing market, relatively low home prices, and mortgage rates of between 8 percent and 9 percent. My, how things change. Fueled by low unemployment, improved consumer confidence, and a boom in stocks, the housing market is now humming. In September, sales of existing homes reached their highest seasonally adjusted level since the National Association of Realtors began tracking the figure in 1968. Median home prices increased as well, jumping 6.6 percent from a year earlier to $125,600, and the average rate for a 30-year fixed mortgage slid to 7.61 percent—the lowest level in a year and a half. "Nineteen ninety-seven may prove to be the biggest year ever for the housing market." says Fred Flick, NAR's vice president of research. But this window of opportunity for home buying is not guaranteed to last far into 1998. Regional Financial Asso-

BY CLAIRE POOLE

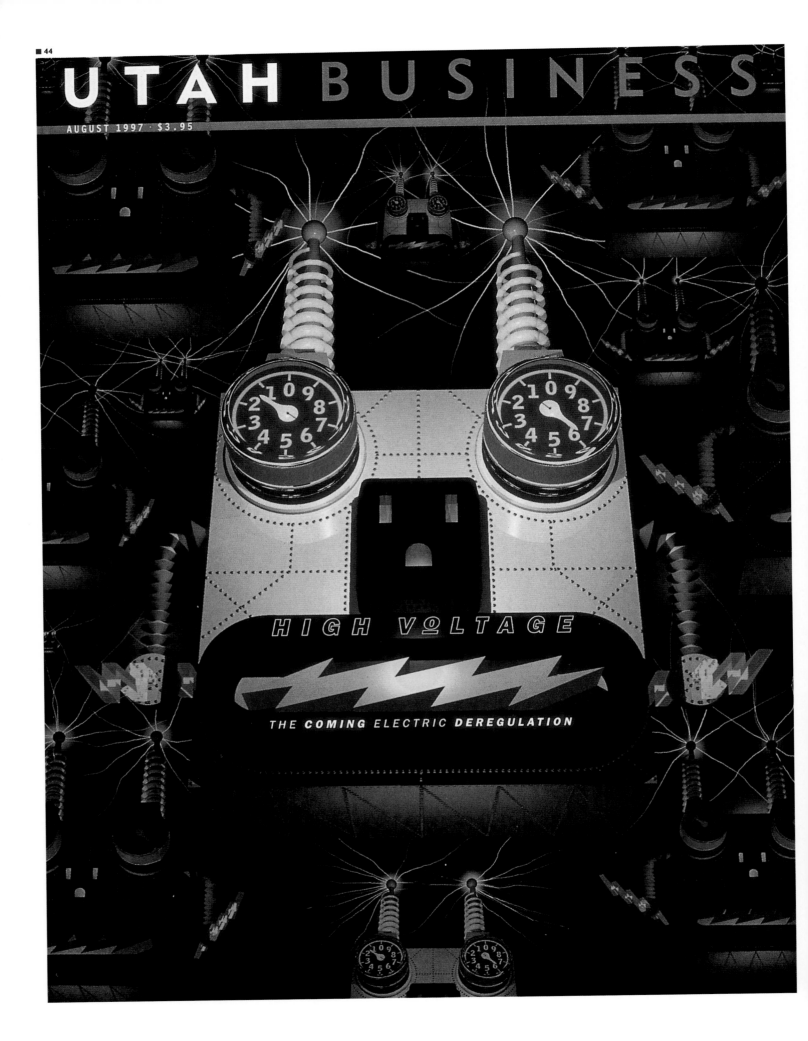

UTAH BUSINESS

AUGUST 1997 · $3.95

HIGH VOLTAGE

THE **COMING** ELECTRIC **DEREGULATION**

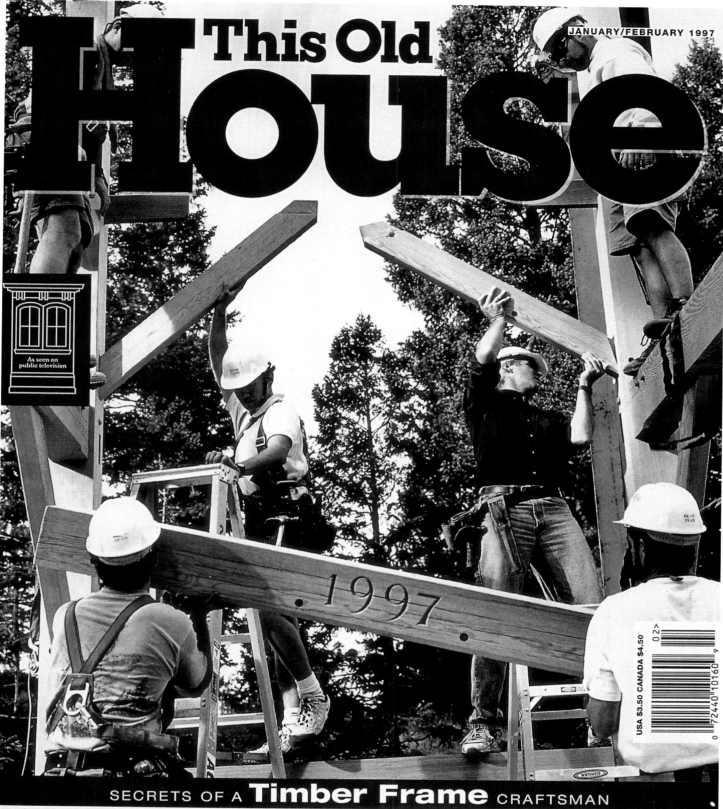

JANUARY/FEBRUARY 1997

This Old HOUSE

As seen on public television

· 1997 ·

USA $3.50 CANADA $4.50

SECRETS OF A **Timber Frame** CRAFTSMAN

FABULOUS **Nantucket** FINALE • A **Fireplace** THAT WORKS—AND DOESN'T POLLUTE

REPLACEMENT WINDOWS • **SNOWBLOWERS** • CHISELS • **GUEST BATH**

■ 44
Publication Utah Business
Art Director Ryan Mansfield
Designer Ryan Mansfield
Illustrator John Hersey
Studio The Phillips Agency
Publisher Olympus Publishers
Issue August 1997
Category Cover

■ 45
Publication This Old House
Design Director Matthew Drace
Designer Mo Flan
Photographer Aldo Rossi
Publisher Time Inc.
Issue January/February 1997
Category Cover

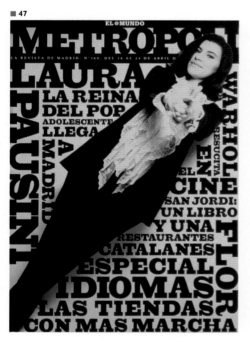

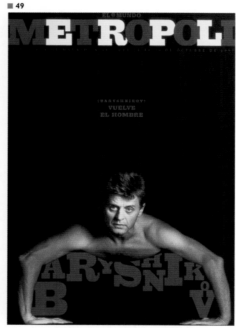

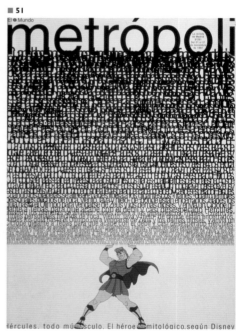

■ 46
Publication El Mundo Metropoli
Design Director Carmelo Caderot
Art Director Rodrigo Sanchez
Designer Maria González
Photo Editor Rodrigo Sanchez
Publisher Unidad Editorial S. A.
Issue April 4, 1997
Category Cover

■ 47
Publication El Mundo Metropoli
Design Director Carmelo Caderot
Art Director Rodrigo Sanchez
Designer Maria González
Photo Editor Rodrigo Sanchez
Publisher Unidad Editorial S. A.
Issue April 18, 1997
Category Cover

■ 48
Publication El Mundo Metropoli
Design Director Carmelo Caderot
Art Director Rodrigo Sanchez
Designer Maria González
Photo Editor Rodrigo Sanchez
Publisher Unidad Editorial S. A.
Issue November 14,1997
Category Cover

■ 49
Publication El Mundo Metropoli
Design Director Carmelo Caderot
Art Director Rodrigo Sanchez
Designer Maria González
Photo Editor Rodrigo Sanchez
Publisher Unidad Editorial S. A.
Issue October 24, 1997
Category Cover

■ 50
Publication El Mundo Metropoli
Design Director Carmelo Caderot
Art Director Rodrigo Sanchez
Designer Maria González
Photo Editor Rodrigo Sanchez
Publisher Unidad Editorial S. A.
Issue March 7, 1997
Category Cover

■ 51
Publication El Mundo Metropoli
Design Director Carmelo Caderot
Art Director Rodrigo Sanchez
Designer Maria González
Photo Editor Rodrigo Sanchez
Publisher Unidad Editorial S. A.
Issue November 21,1997
Category Cover

■ 52
Publication El Mundo Metropoli
Design Director Carmelo Caderot
Art Director Rodrigo Sanchez
Designer Maria González
Photo Editor Rodrigo Sanchez
Publisher Unidad Editorial S. A.
Issue September 26, 1997
Category Cover

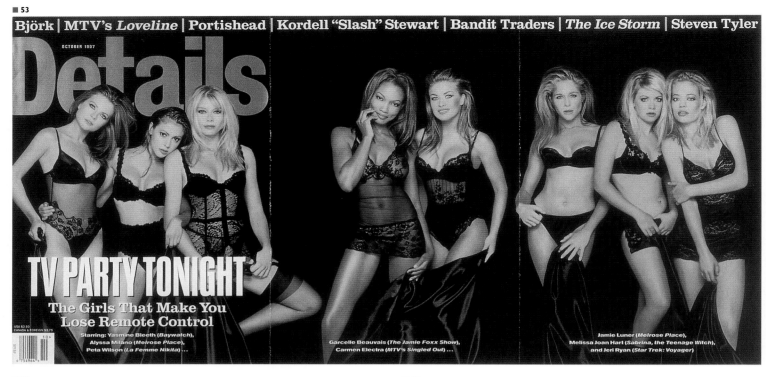

Björk | MTV's *Loveline* | Portishead | Kordell "Slash" Stewart | Bandit Traders | *The Ice Storm* | Steven Tyler

OCTOBER 1997

Details

TV PARTY TONIGHT
The Girls That Make You Lose Remote Control

USA $2.50
CANADA & FOREIGN $2.75

Starring: Yasmine Bleeth (*Baywatch*),
Alyssa Milano (*Melrose Place*),
Peta Wilson (*La Femme Nikita*) …

Garcelle Beauvais (*The Jamie Foxx Show*),
Carmen Electra (*MTV's Singled Out*) …

Jamie Luner (*Melrose Place*),
Melissa Joan Hart (*Sabrina, the Teenage Witch*),
and Jeri Ryan (*Star Trek: Voyager*)

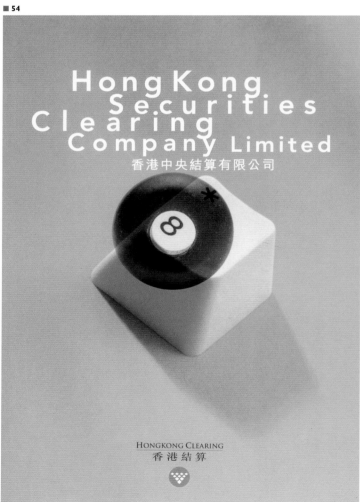

Hong Kong
Securities
Clearing
Company Limited
香港中央結算有限公司

HONGKONG CLEARING
香港結算

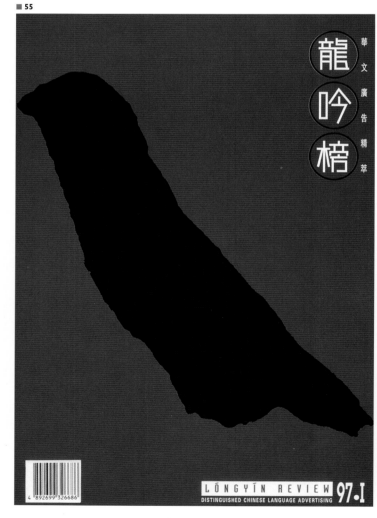

龍吟榜 華文廣告精萃

4 892699 326686

LONGYIN REVIEW 97·I
DISTINGUISHED CHINESE LANGUAGE ADVERTISING

■ 53
Publication Details
Design Director Robert Newman
Art Director Mark Michaelson
Photo Editor Greg Pond
Photographer Matthew Rolston
Fashion Editor William Mullen
Publisher Condé Nast Publications Inc.
Issue October 1997
Category Cover

■ 54
Publication Hong Kong Clearing Corporate Brochure
Creative Director Benny Cheng
Art Director Benny Lau
Designer Benny Lau
Photo Editor Falcon Lo
Photographer Ricky Chan
Studio Gallery Ltd.
Publisher Hong Kong Clearing Co. Ltd.
Issue June 1997
Category Cover

■ 55
Publication Longyin Review
Creative Director Benny Cheng
Art Director Benny Lau
Designers Kenneth Tung, Tommy Ng, Benny Lau
Illustrator Kenneth Tung
Photographers Ricky Chan, Mark Sung
Studio Gallery Ltd.
Publisher Longyin Review Ltd.
Issue January 1997
Category Cover

November 1 1997

weekend The Guardian

Plus 16 pages of Italian food & drink

Universal high?
Elizabeth Young on
the normalisation
of drugs

April 19 1997

weekend The Guardian

**How one man
murdered
the New York
club scene
By Alix Sharkey**

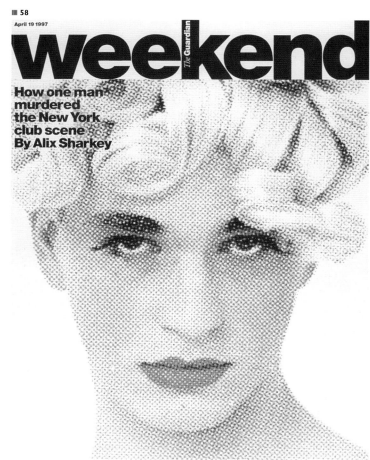

May 3 1997

weekend The Guardian

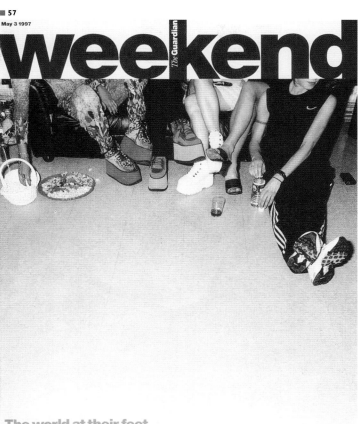

**The world at their feet
Kathy Acker
meets the Spice Girls**

November 29 1997

weekend The Guardian

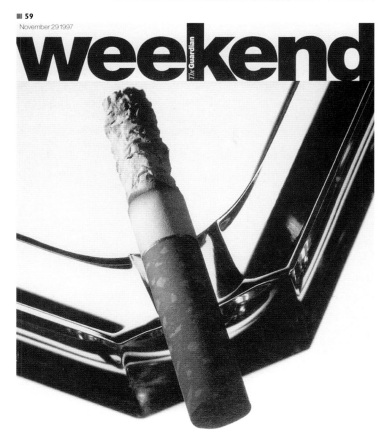

Precious bane Sally Vincent on smoking

■ 56
Publication Guardian Weekend
Art Director Mark Porter
Designer Balwant Ahira
Illustrator Robert Crumb
Photo Editor Vivien Hamley
Publisher Guardian Media Group
Issue November 1, 1997
Category Cover

■ 57
Publication Guardian Weekend
Art Director Mark Porter
Designer Balwant Ahira
Photo Editor Vivien Hamley
Photographer Nigel Shafran
Publisher Guardian Media Group
Issue May 3, 1997
Category Cover

■ 58
Publication Guardian Weekend
Art Director Mark Porter
Designer Balwant Ahira
Photo Editor Vivien Hamley
Publisher Guardian Media Group
Issue April 19, 1997
Category Cover

■ 59
Publication Guardian Weekend
Art Director Mark Porter
Designer Balwant Ahira
Photo Editor Vivien Hamley
Photographer Robin Broadbent
Publisher Guardian Media Group
Issue November 29, 1997
Category Cover

■ 60

■ 62

■ 64

■ 61

■ 63

■ 65

■ 60
Publication Metropolis
Design Directors William K. van Roden,
Carl Lehmann-Haupt
Publisher Bellerophon Publications
Issue April 1997
Category Cover

■ 62
Publication Oz
Creative Director Ted Fabella
Designer Ted Fabella
Photographer Photodisc
Studio Office of Ted Fabella
Publisher Oz Publishing
Issue July/August 1997
Category Cover

■ 64
Publication Preservation
Art Director Brian Noyes
Designer Brian Noyes
Photographer Scott Warren
Publisher National Trust for Historic Preservation
Issue September/October 1997
Category Cover

■ 61
Publication George
Creative Director Matt Berman
Designer Kristi Norgaard
Photo Editor Jennifer Miller
Photographer Stephane Sednaoui
Publisher Hachette Filipacchi Magazines, Inc.
Issue July 1997
Category Cover

■ 63
Publication New York
Design Director Florian Bachleda
Art Director Jennifer Gilman
Photo Editor Margery Goldberg
Photographer Steve Wisbauer
Publisher K-III Publications
Issue July 14, 1997
Category Cover

■ 65
Publication Stick
Design Director Scot Clum
Designer Jayson Selander
Photo Editor Kevin Zacher
Photographer Kevin Zacher
Studio Ride
Publisher Ray Gun Publishing
Issue December 1997
Category Cover

■ 66

Directory
A resource guide for the home and garden

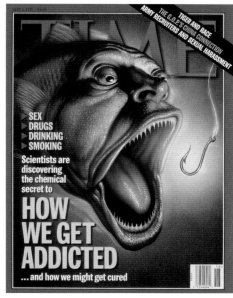

■ 68

NOTORIOUS B.I.G. 1973-1997

RollingStone

The Wasted Years

The Rolling Stone Interview

Beck
Where It's At Now
BY MARK KEMP

Life at the Nation's #1 PARTY SCHOOL

SPRING STYLE

THE WAR ON DRUGS
Cruel, Wrong & Unwinnable

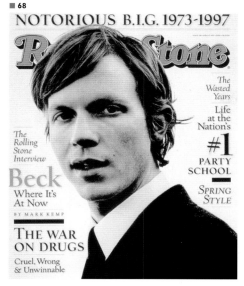

■ 70

ANNUAL MUSIC AWARDS ISSUE

RollingStone

BEST NEW ARTIST
Marilyn Manson's Beautiful Nightmare
BY NEIL STRAUSS

ALBUM OF THE YEAR
Beck's "Odelay"

ARTIST OF THE YEAR
Smashing Pumpkins

THE HOMECOMING QUEEN
MURDER
BY PETER WILKINSON

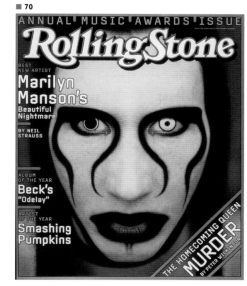

■ 67

TIME

TIGER AND RACE
THE G.O.P.'S CHINA CONNECTION
ARMY RECRUITERS AND SEXUAL HARASSMENT

▸ SEX
▸ DRUGS
▸ DRINKING
▸ SMOKING

Scientists are discovering the chemical secret to

HOW WE GET ADDICTED
...and how we might get cured

■ 69

The 1997 HOT issue

RollingStone

HOT PHENOM
PRODIGY catch FIRE

TripleXXX
HOT LIST
sex!
CRIME!
MUSIC!
BaBes
who kick BUTT!

KEITH FLINT, FIRESTARTER

Gianni versace 1946-1997

HAIR METAL comes BACK

insane CLOWN POSSE gets DUMPED

■ 66
Publication This Old House
Design Director Matthew Drace
Art Director Tim Jones
Illustrator Mark Gagnon
Publisher Time Inc.
Issue May/June 1997
Category Cover

■ 67
Publication TIME
Art Director Arthur Hochstein
Illustrator Mark Fredrickson
Publisher Time Inc.
Issue May 5, 1997
Category Cover

■ 68
Publication Rolling Stone
Art Director Fred Woodward
Designer Geraldine Hessler
Photo Editor Jodi Peckman
Photographer Anton Corbijn
Publisher Wenner Media
Issue April 17, 1997
Category Cover

■ 69
Publication Rolling Stone
Art Director Fred Woodward
Designer Geraldine Hessler
Photo Editor Jodi Peckman
Photographer Peter Robathan
Publisher Wenner Media
Issue August 21, 1997
Category Cover

■ 70
Publication Rolling Stone
Art Director Fred Woodward
Designers Fred Woodward, Gail Anderson
Photo Editor Jodi Peckman
Photographer Matt Mahurin
Typographer Eric Siry
Publisher Wenner Media
Issue November 23, 1997
Category Cover

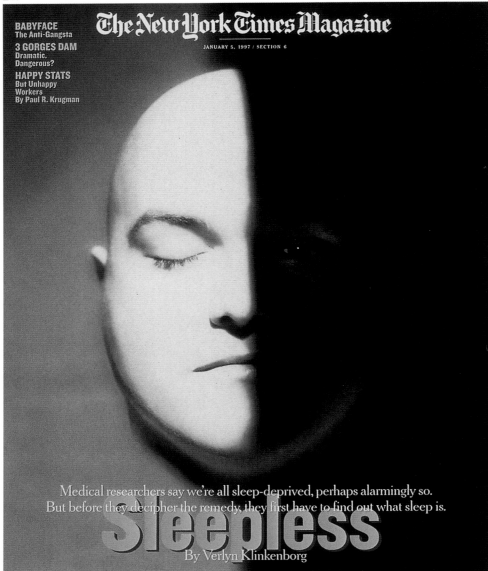

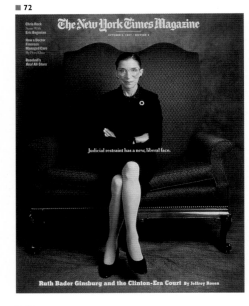

■ 71
Publication The New York Times Magazine
Art Director Janet Froelich
Designer Joel Cuyler
Photo Editor Kathy Ryan
Photographer Lisa Spindler
Publisher The New York Times
Issue January 5, 1997
Category Cover

■ 72
Publication The New York Times Magazine
Art Director Janet Froelich
Photo Editor Kathy Ryan
Photographer Timothy Greenfield-Sanders
Publisher The New York Times
Issue October 5, 1997
Category Cover

■ 73
Publication The New York Times Magazine
Design Director Catherine Gilmore-Barnes
Art Director Janet Froelich
Illustrator Barbara Nessim
Publisher The New York Times
Issue June 29, 1997
Category Cover

■ 74
Publication Texas Medicine
Designer Kevin Goodbar
Studio Fuller Dyal & Stamper
Publisher Texas Medical Association
Issue February 1997
Category Cover

■ 75
Publication Texas Medicine
Designer Kevin Goodbar
Studio Fuller Dyal & Stamper
Publisher Texas Medical Association
Issue November 1997
Category Cover

■ 76
Publication The Observer Life
Art Director Wayne Ford
Designer Wayne Ford
Photo Editor Charlotte Harrison
Photographer Rick Quest
Publisher Guardian Newspapers Limited
Issue January 26, 1997
Category Cover

■ 77
Publication The Observer Life
Art Director Wayne Ford
Designer Wayne Ford
Photo Editor Jennie Ricketts
Photographer Fleur Olby
Publisher Guardian Newspapers Limited
Issue February 9, 1997
Category Cover

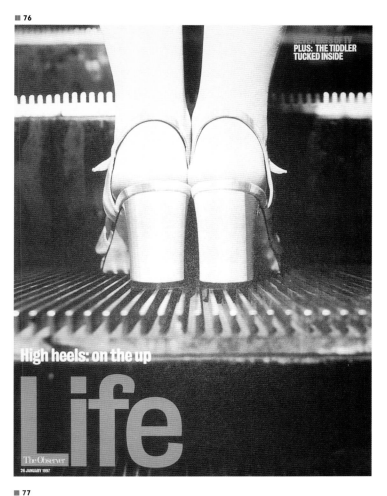

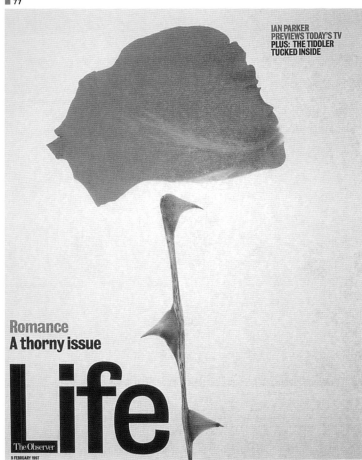

■ 78

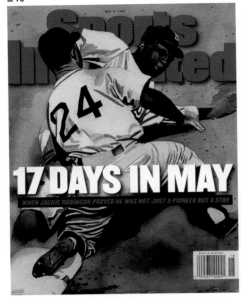

■ 80

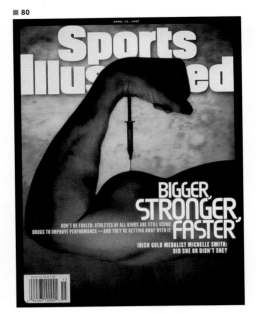

■ 82

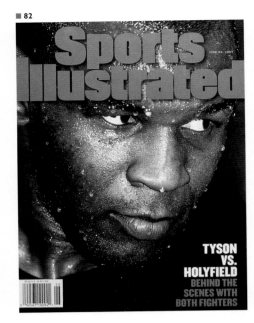

■ 79

■ 81

■ 83

■ 84
Publication US
Art Director Richard Baker
Photo Editor Jennifer Crandall
Photographer Mark Seliger
Publisher US Magazine Co., L. P.
Issue May 1997
Category Cover

■ 85
Publication US
Art Director Richard Baker
Photo Editor Jennifer Crandall
Photographer Mark Seliger
Publisher US Magazine Co., L. P.
Issue December 1997
Category Cover

■ 86
Publication US
Art Director Richard Baker
Photo Editors Jennifer Crandall,
Rachel Knepfer
Photographer Mark Seliger
Publisher US Magazine Co., L. P.
Issue August 1997
Category Cover

■ 87
Publication US
Art Director Richard Baker
Photo Editor Jennifer Crandall
Photographer Mark Seliger
Publisher US Magazine Co., L. P.
Issue November 1997
Category Cover

■ 78
Publication Sports Illustrated
Creative Director Steven Hoffman
Designer Steven Hoffman
Illustrator Julian Allen
Publisher Time Inc.
Issue May 5, 1997
Category Cover

■ 79
Publication Sports Illustrated
Creative Director Steven Hoffman
Designer Craig Gartner
Photographer John Huet
Publisher Time Inc.
Issue August 18, 1997
Category Cover

■ 80
Publication Sports Illustrated
Creative Director Steven Hoffman
Designer Craig Gartner
Photographer Matt Mahurin
Publisher Time Inc.
Issue April 14, 1997
Category Cover

■ 81
Publication Sports Illustrated
Creative Director Steven Hoffman
Designer Edward Truscio
Photographer Brian Lanker
Publisher Time Inc.
Issue December 22, 1997
Category Cover

■ 82
Publication Sports Illustrated
Creative Director Steven Hoffman
Designer Steven Hoffman
Photographer Ken Regan
Publisher Time Inc.
Issue June 30, 1997
Category Cover

■ 83
Publication LIFE
Design Director Tom Bentkowski
Designers Tom Bentkowski,
Sharon Okamoto
Photo Editors David Friend,
Barbara Baker Burrows
Photographer Mario Testino
Publisher Time Inc.
Issue November 1997
Category Cover

US

Special Report:
KELSEY GRAMMER
Tears of a Clown

JULIANNA MARGULIES: THE HEART OF 'ER'

CHRISTOPHER REEVE'S Brave New Role

X-FILES'
GILLIAN ANDERSON & DAVID DUCHOVNY
Boldly Go Where They've Never Gone Before

THE CARDIGANS
JUDY DAVIS
MORGAN FREEMAN
KIEFER SUTHERLAND

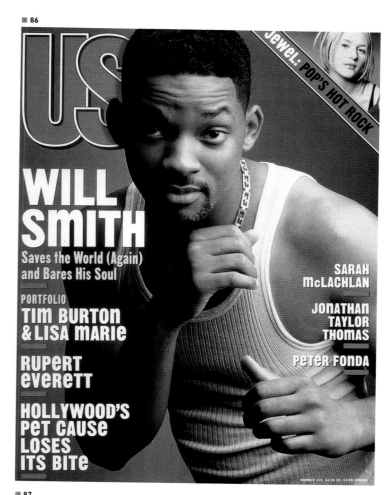

US

JEWEL: POP'S HOT ROCK

WILL SMITH
Saves the World (Again) and Bares His Soul

PORTFOLIO
TIM BURTON & LISA MARIE

RUPERT EVERETT

HOLLYWOOD'S PET CAUSE LOSES ITS BITE

SARAH McLACHLAN

JONATHAN TAYLOR THOMAS

PETER FONDA

NUMBER 235 $3.50 US $3.95 CANADA

US

RICHARD GERE: Sex and the Single Guy

SALT-N-PEPA SHAKE IT UP

MIDNIGHT IN THE GARDEN OF GOOD AND EVIL

WINONA RYDER KICKS ALIEN BUTT!

DENNIS FRANZ

HELENA BONHAM CARTER

DENIS LEARY

CRAZY SEXY COOL
SPECIAL STYLE ISSUE

US

THE NEW COURTNEY LOVE AMERICAN STYLE

75 WAYS TO LOOK HOLLYWOOD

DEMI MOORE
MICK JAGGER
TOMMY HILFIGER
MATT DILLON

DREW BARRYMORE
GWYNETH PALTROW
PARKER POSEY

$3.50 US $4.00 CAN
NUMBER 233

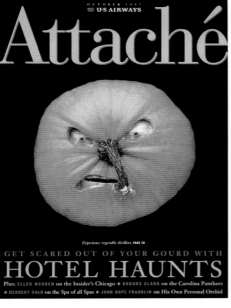

■ 88
Publication US Airways Attaché
Creative Director Michael Grossman
Art Director Paul Carstensen
Designer Paul Carstensen
Illustrator Joost Elffers
Publisher Pace Communications
Issue October 1997
Category Cover

■ 89
Publication Waters
Art Director Dimity Jones
Designer Dimity Jones
Photographer Paul Whicheloe
Publisher Waters Information Services
Issue November 1997
Category Cover

■ 90
Publication Utah Business
Art Director Ryan Mansfield
Designer Ryan Mansfield
Illustrator Robert Neubecker
Publisher Olympus Publishers
Issue April 1997
Category Cover

■ 91
Publication Utah Business
Art Director Ryan Mansfield
Designer Ryan Mansfield
Photographer Hugh Kretschmer
Studio The Phillips Agency
Publisher Olympus Publishers
Issue July 1997
Category Cover

■ 92
Publication W
Creative Director Dennis Freedman
Design Director Edward Leida
Art Director Kirby Rodriguez
Designer Marcella Bove-Huttie
Publisher Fairchild Publications
Issue January 1997
Category Cover

■ 93
Publication Who Cares
Art Director David Vogin
Designer David Vogin
Photographer Francisco Rosario
Studio Photo Effects
Client Who Cares, Inc.
Issue September/October 1997
Category Cover

■ 94
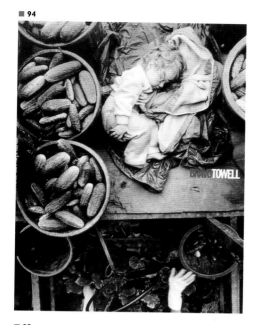

■ 96
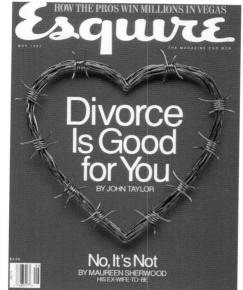

■ 98
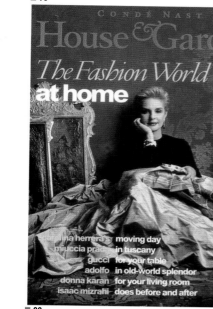

■ 95

■ 97

■ 99

■ 94
Publication BravoTowell,
Bravo Photo Masters Series
Creative Director Jurek Wajdowicz
Designers Jurek Wajdowicz, Lisa LaRochelle
Photographer Larry Towell
Studio Emerson, Wajdowicz Studios
Client E.B. Eddy Paper/Island Paper Mills Division
Issue Issue No.3
Category Cover

■ 95
Publication Entertainment Weekly
Design Director John Korpics
Designer Rina Migliaccio
Illustrator Nola Lopez
Publisher Time Inc.
Issue January 24, 1997
Category Cover

■ 96
Publication Esquire
Design Director Robert Priest
Art Director Rockwell Harwood
Designer Robert Priest
Photo Editor Danielle Place
Publisher The Hearst Corporation
Magazines Division
Issue May 1997
Category Cover

■ 97
Publication American Salon
Design Director Saralynne Lowrey
Art Director Kathy Nestor
Designer Saralynne Lowrey
Photographer Karina Taira
Publisher Advanstar Communications
Issue February 1997
Category Cover

■ 98
Publication Condé Nast House & Garden
Art Director Diana LaGuardia
Designer Diana LaGuardia
Photo Editor Dana Nelson
Photographer Claus Wickrath
Publisher Condé Nast Publications Inc.
Issue November 1997
Category Cover

■ 99
Publication Condé Nast House & Garden
Art Director Diana LaGuardia
Designer Diana LaGuardia
Photo Editor Dana Nelson
Photographer Melanie Acevedo
Publisher Condé Nast Publications Inc.
Issue September 1997
Category Cover

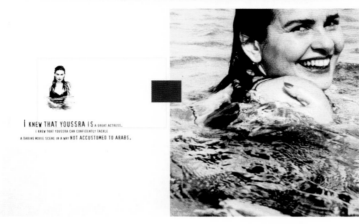

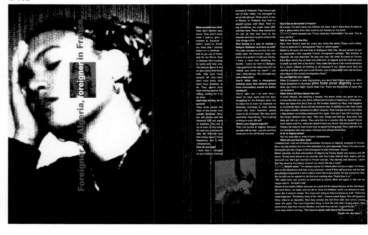

■ 100
Publication Alive
Art Director Rima Sinno
Designer Rima Sinno
Photographer Youssef Nabil
Category Feature Story

■ 101
Publication Alive
Art Director Rima Sinno
Designer Rima Sinno
Illustrator Marty Bruinsma
Photographer Hadi Salehi
Issue November 1997
Category Contents

■ 102
Publication Alive
Art Director Rima Sinno
Designer Rima Sinno
Photographer Lara Baladi
Issue November 1997
Category Department

■ 103
Publication Alive
Art Director Rima Sinno
Designer Rima Sinno
Photographer Hadi Salehi
Issue November 1997
Category Feature Spread

■ 104

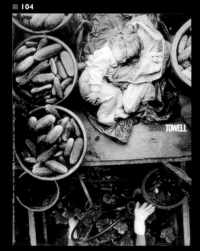

■ 105

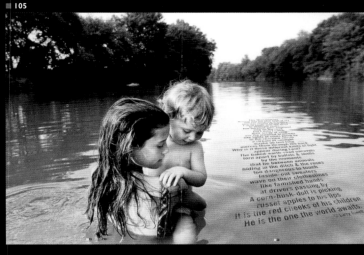

■ 106

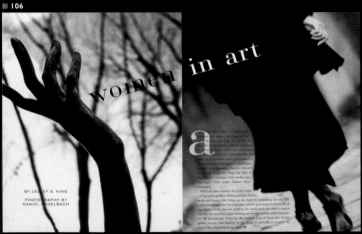

women in art

BY LESLEY S. KING

PHOTOGRAPHY BY
DANIEL NADELBACH

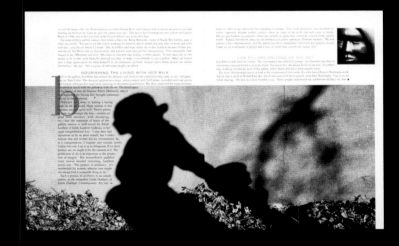

■ 104
Publication BravoTowell, Bravo
Photo Masters Series
Creative Director Jurek Wajdowicz
Designers Jurek Wajdowicz,
Lisa LaRochelle
Photographer Larry Towell
Studio Emerson, Wajdowicz Studios
Client E.B. Eddy Paper/Island Paper
Mills Division
Issue Issue No.3
Category Entire Issue

■ 105
Publication BravoTowell,
Bravo Photo Masters Series
Creative Director Jurek Wajdowicz
Designers Jurek Wajdowicz,
Lisa LaRochelle
Photographer Larry Towell
Studio Emerson, Wajdowicz Studios
Client E.B. Eddy Paper/
Island Paper Mills Division
Issue Issue No.3
Category Feature Spread

■ 106
Publication Santa Fean
Art Director Paula Eastwood
Designer Paula Eastwood
Photographer Daniel Nadelbach
Issue May 1997
Category Feature Story

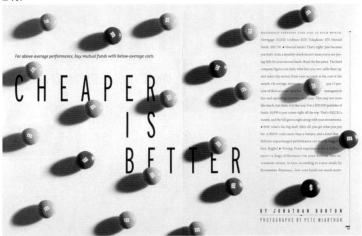

For above-average performance, buy mutual funds with below-average costs.

CHEAPER IS BETTER

BY JONATHAN BURTON
PHOTOGRAPHS BY PETE McARTHUR

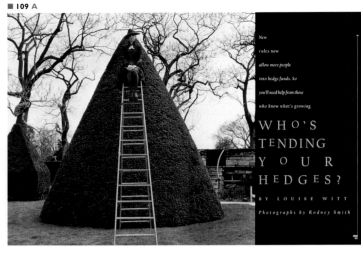

New rules now allow more people into hedge funds. So you'll need help from those who know what's growing.

WHO'S TENDING YOUR HEDGES?

BY LOUISE WITT

Photographs by Rodney Smith

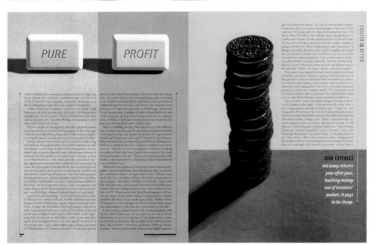

PURE PROFIT

HIGH EXPENSES
eat away returns year after year, leaching money out of investors' pockets. It pays to be cheap.

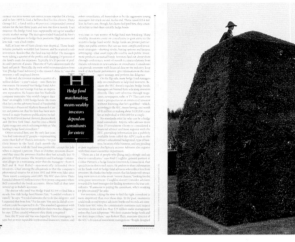

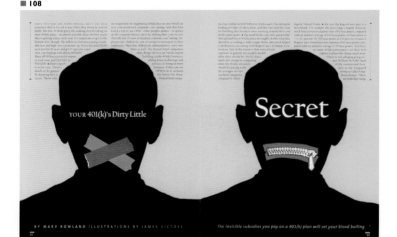

YOUR 401(k)'s Dirty Little

Secret

BY MARY ROWLAND ILLUSTRATIONS BY JAMES VICTORE

The invisible subsidies you pay on a 401(k) plan will set your blood boiling

A NEW CHANCE TO BRANCH OUT

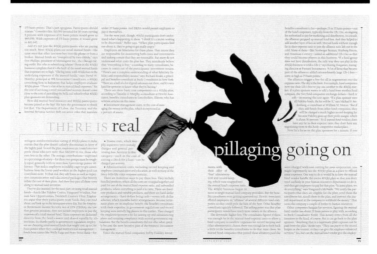

THERE IS real

pillaging going on

■ 107
Publication
Bloomberg Personal Finance
Art Director Carol Layton
Designer Carol Layton
Photo Editor Mary Shea
Photographer Pete McArthur
Publisher Bloomberg L. P.
Issue July/August 1997
Category Feature Story

■ 108
Publication
Bloomberg Personal Finance
Art Director Carol Layton
Designer Frank Tagariello
Illustrator James Victore
Publisher Bloomberg L. P.
Issue September 1997
Category Feature Story

■ 109
Publication
Bloomberg Personal Finance
Art Director Carol Layton
Designer Carol Layton
Photo Editor Mary Shea
Photographer Rodney Smith
Publisher Bloomberg L. P.
Issue July/August 1997
Categories Feature Story
 A Spread

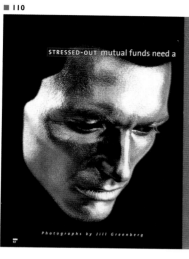

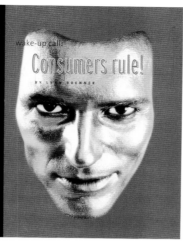

STRESSED-OUT mutual funds need a

wake-up call:

Consumers rule!

BY LYNN DOENNER

Photographs by Jill Greenberg

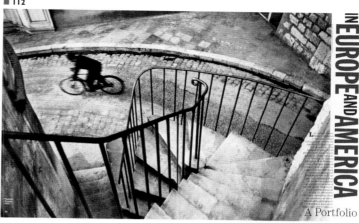

IN EUROPE AND AMERICA

A Portfolio

DESIGN MERIT ■

WHEN A FUND
is offered through
A "SUPERMARKET," ALL
of its investors pay
HIGHER COSTS

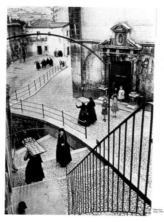

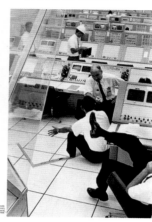

imagine:

THE DAY IS MONDAY, JANUARY 3, 2000.

2000:
A Business
Odyssey

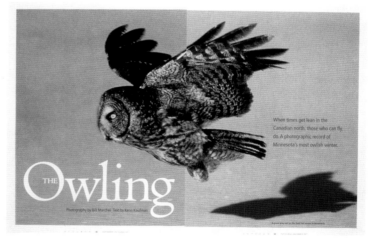

When times get lean in the
Canadian north, those who can fly,
do. A photographic record of
Minnesota's most owlish winter.

THE Owling

Photography by Bill Marchel · Text by Kenn Kaufman

■ 110
Publication
Bloomberg Personal Finance
Art Director Carol Layton
Designers Carol Layton,
Frank Tagariello
Photo Editor Mary Shea
Photographer Jill Greenberg
Publisher Bloomberg L. P.
Issue December 1997
Category Feature Story

■ 111
Publication Context
Creative Director Mitch Shostak
Designer Viviana Bromberg
Illustrator Craig Frazier
Studio Shostak Studios Inc.
Publisher
American Express Publishing
Issue May/June 1997
Category Feature Spread

■ 112
Publication American Photo
Art Director Deborah Mauro
Designer Pamela Hastings
Photographer
Henri Cartier-Bresson
Publisher Hachette Filipacchi
Magazines, Inc.
Issue September/October 1997
Category Feature Story

■ 113
Publication Audubon
Art Director Suzanne Morin
Designers Johnathan B. Foster,
Suzanne Morin
Photo Editor Peter Howe
Photographer Bill Marchel
Publisher National Audubon Society
Issue November/December 1997
Category Feature Spread

69

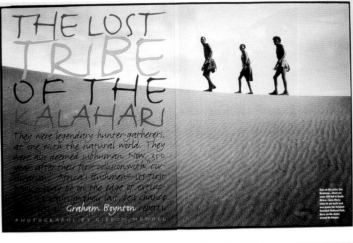

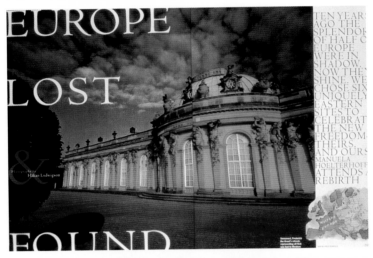

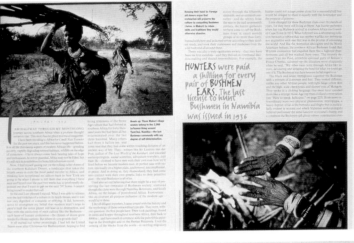

■ 114
Publication Condé Nast Traveler
Design Director Robert Best
Art Director Carla Frank
Designers Linda Root,
Devin Pedzwater
Photo Editor Kathleen Klech
Publisher
Condé Nast Publications Inc.
Issue May 1997
Category Entire Issue

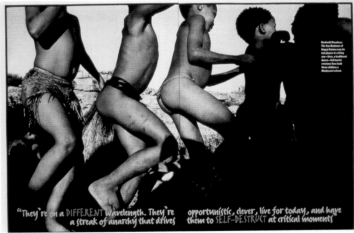

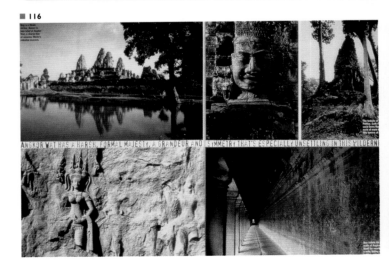

■ 115
Publication Condé Nast Traveler
Design Director Robert Best
Art Director Carla Frank
Designer Carla Frank
Photo Editor Kathleen Klech
Photographer Gideon Mendel
Publisher
Condé Nast Publications Inc.
Issue May 1997
Category Feature Story

■ 116
Publication Condé Nast Traveler
Design Director Robert Best
Art Director Carla Frank
Designer Robert Best
Photo Editor Kathleen Klech
Photographer Kenro Izu
Publisher
Condé Nast Publications Inc.
Issue January 1997
Category Feature Spread

■ 117

Fire Down Below

A Photo Portfolio

Flying over Iceland, Yann Arthus-Bertrand captures a hauntingly beautiful landscape. Beneath the surface it's another matter

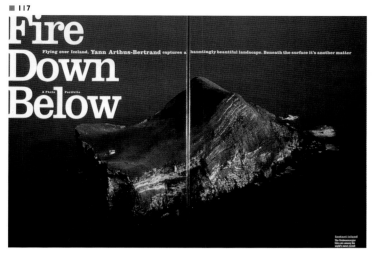

Iceland's Heimaey

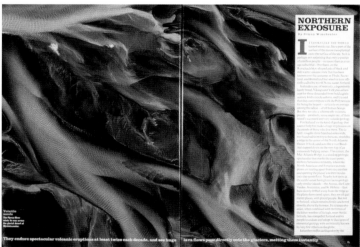

NORTHERN EXPOSURE
By Simon Winchester

They endure spectacular volcanic eruptions at least twice each decade, and see huge lava flows pour directly onto the glaciers, melting them instantly

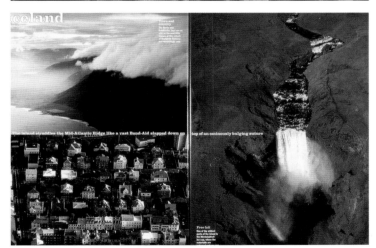

The island straddles the Mid-Atlantic Ridge like a vast Band-Aid slapped down on top of an ominously bulging suture

■ 118

tracking the source

With plans to be the first to descend Africa's Niger River, MARK JENKINS treks the highland jungles of Guinea with his best friend Mike, two hometown buddies, and four kayaks—going all out in search of extraordinary adventure

ILLUSTRATIONS BY
Robert Andrew Parker

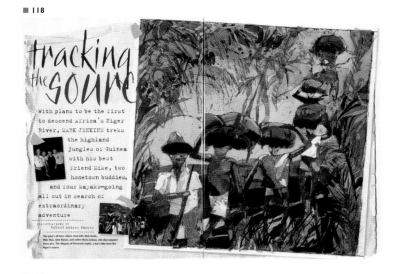

■ 119

TRESPASSING ON eternity

PHOTOGRAPHS BY

Bob Payne knew that every step he took, every crumb he let drop, would freeze in place—which was exactly what he was there to fix. He had joined the first expedition sent to erase human impact

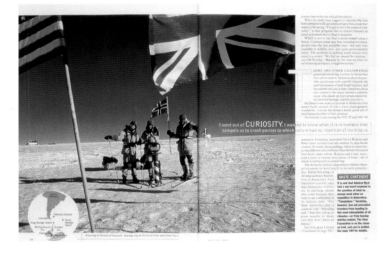

I went out of CURIOSITY. I wanted to know what it is in humans that compels us to crash parties to which nature had no intention of inviting us

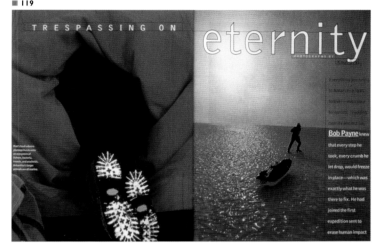

■ 117
Publication Condé Nast Traveler
Design Director Robert Best
Art Director Carla Frank
Designer Robert Best
Photo Editor Kathleen Klech
Photographer Yann Arthus-Bertram
Publisher
Condé Nast Publications Inc.
Issue August 1997
Category Feature Story

■ 118
Publication Condé Nast Traveler
Design Director Robert Best
Art Director Carla Frank
Designer Carla Frank
Illustrator Robert Andrew Parker
Publisher
Condé Nast Publications Inc.
Issue August 1997
Category Feature Spread

■ 119
Publication Condé Nast Traveler
Design Director Robert Best
Art Director Carla Frank
Designer Carla Frank
Photo Editor Kathleen Klech
Photographer Knut Bry
Publisher
Condé Nast Publications Inc.
Issue January 1997
Category Feature Story, Spread

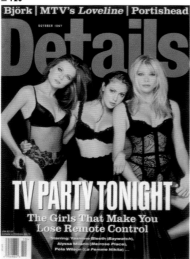

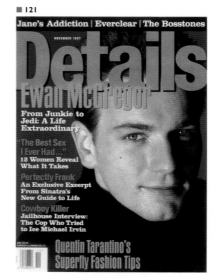

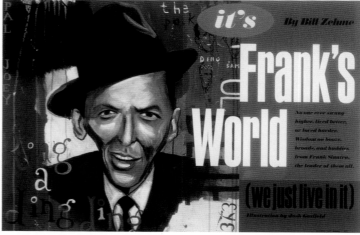

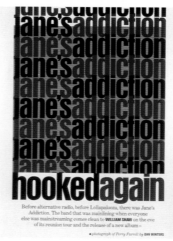

■ 120
Publication Details
Design Director Robert Newman
Art Director Mark Michaelson
Designers Ronda Thompson, Marlene Sezni, Zoe Miller,
Alden Wallace, John Giordani
Photo Editor Greg Pond
Photographers Brian Smale,
Albert Watson, Matthew Rolston
Fashion Editor William Mullen
Fashion Editor Derick Procope
Publisher Condé Nast Publications Inc.
Issue October 1997
Category Entire Issue

■ 121
Publication Details
Design Director Robert Newman
Art Director Mark Michaelson
Designers Ronda Thompson, Marlene Sezni,
Zoe Miller, Alden Wallace, John Giordani
Illustrator Josh Gosfield
Photo Editor Greg Pond
Photographers Herb Ritts, Dan Winters
Fashion Editor William Mullen
Fashion Editor Derick Procope
Publisher Condé Nast Publications Inc.
Issue October 1997
Category Entire Issue

■ 122

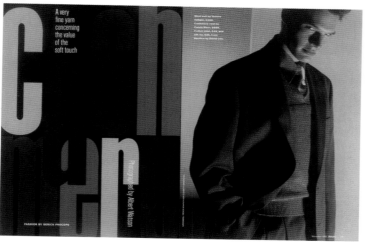

A very fine yarn concerning the value of the soft touch

Photographed by Albert Watson

■ 124

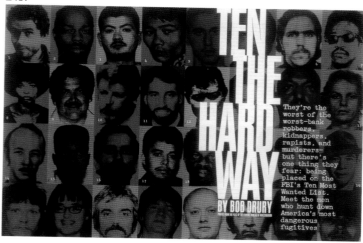

TEN THE HARD WAY

BY BOB DRURY

They're the worst of the worst—bank robbers, kidnappers, rapists, and murderers—but there's one thing they fear: being placed on the FBI's Ten Most Wanted List. Meet the men who hunt down America's most dangerous fugitives

■ 123 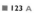 A

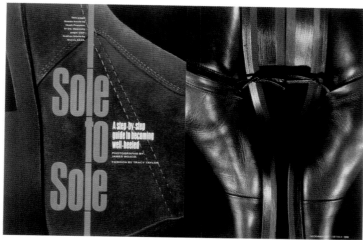

Sole to Sole

A step-by-step guide to becoming well-heeled

PHOTOGRAPHED BY JAMES WOJCIK

FASHION BY TRACY TAYLOR

■ 125

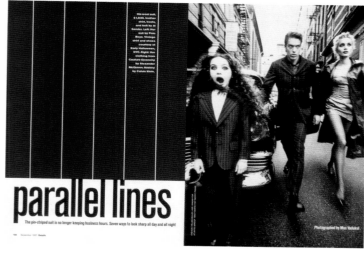

parallel lines

The pin-striped suit is no longer keeping business hours. Seven ways to look sharp all day and all night

Photographed by Max Vadukul

■ 126

AHEAD OF THE CLASS

Confused by the new rules in college planning? For advisors who take the time to learn the ropes, there's opportunity aplenty to help clients.

BY ROBERT N. VERES

ILLUSTRATION BY JOSEPH DANIEL FIEDLER

■ 122
Publication Details
Design Director
Robert Newman
Designer Alden Wallace
Photo Editor Greg Pond
Photographer Albert Watson
Fashion Editor
Derick Procope
Publisher
Condé Nast Publications Inc.
Issue November 1997
Category Feature Spread

■ 123
Publication Details
Design Director
Robert Newman
Designer Alden Wallace
Photo Editor Greg Pond
Photographer James Wojcik
Fashion Editor Tracy Taylor
Publisher
Condé Nast Publications Inc.
Issue December 1997
Categories Feature Story
　　　　　　A Spread

■ 124
Publication Details
Design Director
Robert Newman
Designer Helene Silverman
Photo Editor Greg Pond
Photographer FBI
Publisher
Condé Nast Publications Inc.
Issue December 1997
Category Feature Spread

■ 125
Publication Details
Design Directors Robert
Newman, Mark Michaelson
Designer Mark Michaelson
Photo Editor Greg Pond
Photographer Max Vadukul
Fashion Editor
William Mullen
Publisher
Condé Nast Publications Inc.
Issue September 1997
Category Feature Spread

■ 126
Publication Dow Jones
Investment Advisor
Creative Director
Dorothy O'Connor-Jones
Designer
Dorothy O'Connor-Jones
Illustrator
Joseph Daniel Fiedler
Publisher Dow Jones Financial
Publishing Corp.
Issue August 1997
Category Feature Spread

RINGLING BROS' NEWLY ADDED AVIARY & AQUARIUM

LADIES' ORCHESTRAL SYMPHONY CLUB

TREMENDOUS STRANGE & CURIOUS AMPHIBIOUS MARVELS OF RIVER & OCEAN EXHIBITED IN HUGE PORTABLE FOUNTAIN-PLAYING TANKS. BEAUTIFUL INTERESTING BIRD DISPLAY CONTAINING THE FEATHERED SONGSTERS & GAYLY PLUMAGED BIRDS OF EVERY LAND AND CLIME. ALL NOW ADDED TO THE WORLD'S GREATEST MENAGERIE AND FORMING THE LARGEST ZOOLOGICAL EXHIBIT ON EARTH.

STEP RIGHT UP

Eye-popping posters announce that the circus is coming to town, bringing death-defying stunts, reality turned upside-down and thrills and fantasy under the Big Top ● By Katherine Dunn

JOSEP PLA

UN DÍA COMO AYER, HACE UN SIGLO, VENÍA A ESTE MUNDO EL GRAN ESCRITOR DE LAS LETRAS CATALANAS. HOMENAJES, CONFERENCIAS, EXPOSICIONES, RUTAS TURÍSTICAS Y GASTRONÓMICAS, TEATRO Y OTRAS 'COLLONADES', COMO DIRÍA ÉL, CONFIGURAN LOS ACTOS DEL AÑO PLA. VARIAS PERSONAS QUE LE CONOCIERON HABLAN DEL AUTOR DE UNA INGENTE 'OBRA COMPLETA' DE LA QUE DESTACAN 'EL QUADERN GRIS' O 'EL CARRER ESTRET'.

TEXTO: LUIS MIGUEL MARCO
FOTOS: EUGENI FORCANO

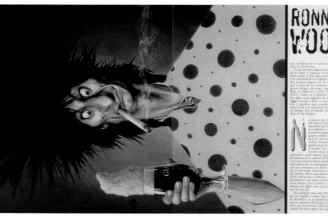

THE ROLLING STONES

NI LAS CANAS, NI LAS ARRU-GAS, NI LOS ACHAQUES DE LA EDAD HAN LOGRADO APARTAR A ESTOS CINCUENTONES DE LOS ESCENARIOS. LOS ABUE-LOS DEL ROCK SE HAN EM-BARCADO EN UNA NUEVA GI-RA MUNDIAL PARA PRESEN-TAR SU ÚLTIMO DISCO "BRIDGES TO BABYLON". ESTÁN DISPUESTOS A SEGUIR DANDO GUERRA, Y ASÍ LO HARÁN A PARTIR DEL PRÓXIMO MARTES. POR LO MENOS MIEN-TRAS EL CUERPO AGUANTE.

TEXTO: ALBERT GUASCH
ILUSTRACIONES: SEBASTIAN KRUGER

RONNIE WOOD

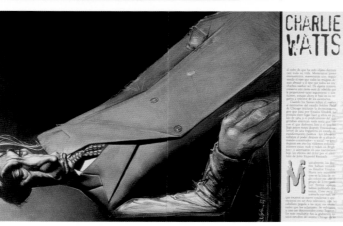

CHARLIE WATTS

MONTA UK LITE

Vicente Wolf's retreat on the tip of Long Island is an oasis of calm

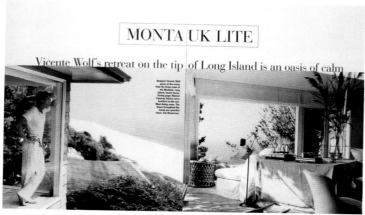

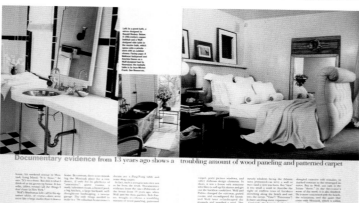

Documentary evidence from 13 years ago shows a troubling amount of wood paneling and patterned carpet

"In Montauk, you really can be anonymous"

T

DALLAS 2000

A Texas couple builds a house to bring their family into the next millennium

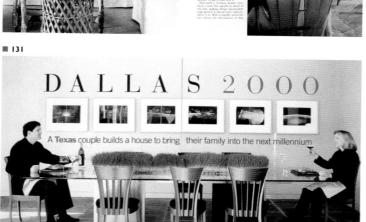

small wonders

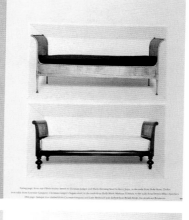

When you're short on space, go for good-looking and practical

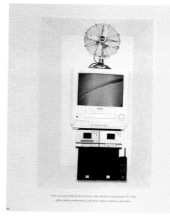

■ 130
Publication Elle Decor
Art Director Nora Sheehan
Designer Nora Sheehan
Photo Editor Quintana Dunne
Photographer Minh & Wass
Publisher Hachette Filipacchi
Magazines, Inc.
Issue March 1997

■ 131
Publication Elle Decor
Art Director Nora Sheehan
Designer Nora Sheehan
Photo Editor Quintana Dunne
Photographer Fernando Bengoechea
Publisher Hachette Filipacchi
Magazines, Inc.
Issue September 1997
Category Feature Spread

■ 132
Publication Elle Decor
Art Director Nora Sheehan
Designer Nora Sheehan
Photo Editor Quintana Dunne
Photographer Carlton Davis
Publisher Hachette Filipacchi
Magazines, Inc.
Issue September 1997
Category Feature Story

133

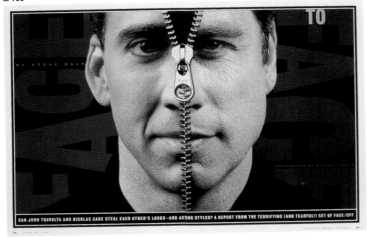

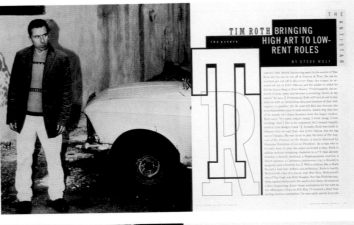136

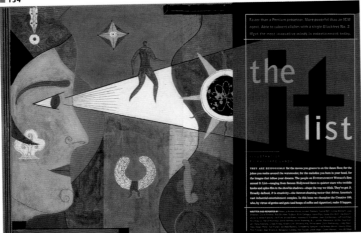134

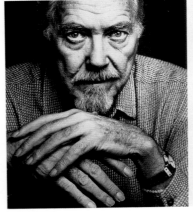

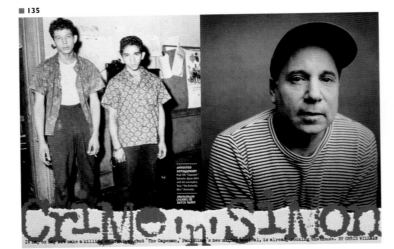135

■ 133
Publication Entertainment Weekly
Design Director John Korpics
Art Director Joe Kimberling
Photo Editor Sarah Rozen
Photographer Michael O'Neill
Publisher Time Inc.
Issue June 20, 1997
Category Feature Spread

■ 134
Publication Entertainment Weekly
Design Director John Korpics
Art Director Rina Migliaccio
Illustrator Philippe Lardy
Publisher Time Inc.
Issue July 4, 1997
Category Feature Spread

■ 135
Publication Entertainment Weekly
Design Director John Korpics
Art Director John Walker
Illustrator David Barry
Photo Editors Mary Dunn,
Michelle Romero
Publisher Time Inc.
Issue December 12, 1997
Category Feature Spread

■ 136
Publication Entertainment Weekly
Design Director John Korpics
Art Director Lisa Wagner
Illustrator Amy Guip
Photographers Anton Corbijn,
Andrew Southam, Michael Haber,
Michael O'Neill, Matthew Welch
Publisher Time Inc.
Issue November/December 1997
Category Feature Story

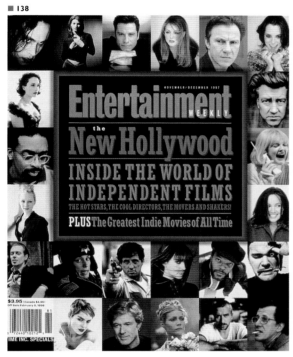

■ 138

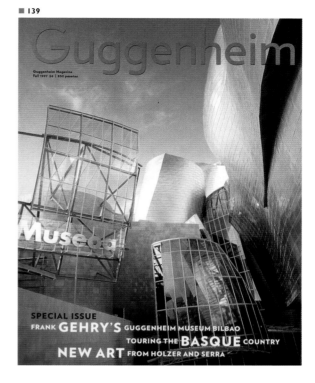

It's been a long, strange cinematic trip
this underground journey, from 1926's
Metropolis to 1960's *La Dolce Vita* to
1994's *Pulp Fiction*. Of the hundreds of
indie films lensed over the decades,
which have been the most crucial? Hard
to say. The trouble with ranking them is
that these genre-busting, envelope-
pushing flicks are, by definition, unique.
It's like comparing apples and oranges
that are bent on redefining what it
means to be an apple or an orange. But

THE MOVIES we've tried. On
these pages, you'll find our list of the
most unforgettable independent movies
of the last two decades—along with the
50-year history that led to this new
golden age and a peek at some upcoming
films. Plus, a look back at one of the
most successful indie flicks ever.
(What is it? The answer's a scream.)

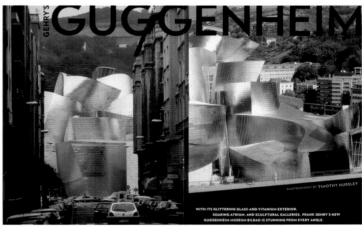

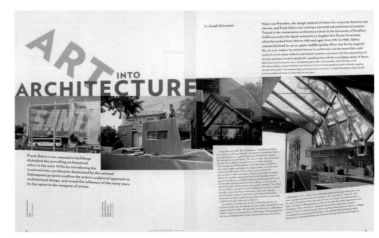

■ 137
Publication Entertainment Weekly
Design Director John Korpics
Art Director Lisa Wagner
Photo Editor Sarah Rozen
Photographer Jeffrey Thurnher
Publisher Time Inc.
Issue November/December 1997
Category Contents or Department

■ 138
Publication Entertainment Weekly
Design Director John Korpics
Art Director Lisa Wagner
Designers Katherine Mann,
Dirk Barnett
Photo Editor Sarah Rozen
Publisher Time Inc.
Issue December 1997
Category Entire Issue

■ 139
Publication Guggenheim Magazine
Art Director Paul Carlos
Photo Editor Maria Millán
Photographer Timothy Hursley
Studio Design/Writing/Research, NY
Issue October 1997
Category Entire Issue

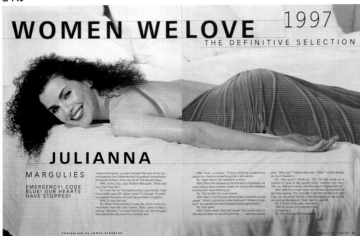

WOMEN WE LOVE 1997
THE DEFINITIVE SELECTION

JULIANNA
MARGULIES
EMERGENCY! CODE
BLUE! OUR HEARTS
HAVE STOPPED!

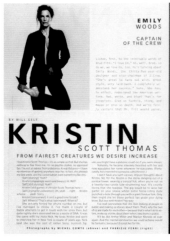

EMILY
WOODS
CAPTAIN
OF THE CREW

KRISTIN
SCOTT THOMAS
FROM FAIREST CREATURES WE DESIRE INCREASE

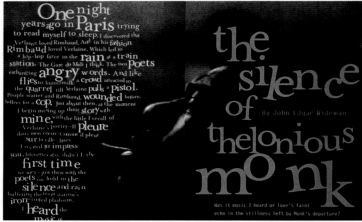

One night years ago in Paris trying to read myself to sleep, I discovered that Verlaine loved Rimbaud. And in his fashion Rimbaud loved Verlaine.

the silence of thelonious monk

By John Edgar Wideman

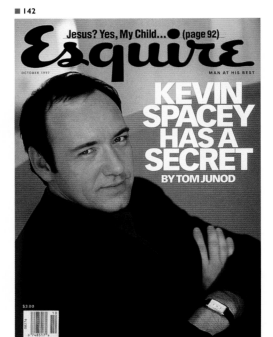

Jesus? Yes, My Child... (page 92)
Esquire
OCTOBER 1997
MAN AT HIS BEST

KEVIN
SPACEY
HAS A
SECRET
BY TOM JUNOD

$3.00

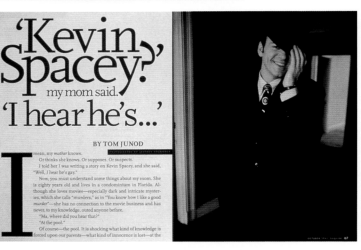

'Kevin Spacey?' my mom said. 'I hear he's...'
BY TOM JUNOD

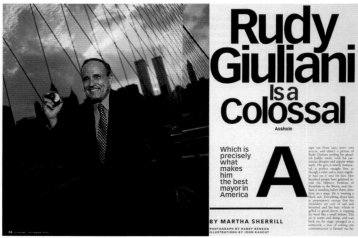

Rudy
Giuliani
Is a
Colossal
Asshole

Which is precisely what makes him the best mayor in America

BY MARTHA SHERRILL
PHOTOGRAPH BY HARRY BENSON
ILLUSTRATIONS BY JOHN KASCHT

■ 140
Publication Esquire
Design Director Robert Priest
Art Director Rockwell Harwood
Designer Rockwell Harwood
Photo Editor Danielle Place
Photographers Lance Staedler, Naomi Kaltman, Michael O'Neill, Fabrizio Ferri, Michel Comte, George Holz, Antoine Verglas, Stewart Shining, John Ragel, Mark Hanauer
Publisher The Hearst Corporation-Magazines Division
Issue August 1997
Category Feature Story

■ 141
Publication Esquire
Design Director Robert Priest
Art Director Rockwell Harwood
Designer Joshua Liberson
Photo Editor Danielle Place
Photographer W. Eugene Smith
Publisher The Hearst Corporation-Magazines Division
Issue November 1997
Category Feature Spread

■ 142
Publication Esquire
Design Director Robert Priest
Art Director Rockwell Harwood
Designers Dina White, Rockwell Harwood, Robert Priest
Photo Editor Danielle Place
Publisher The Hearst Corporation-Magazines Division
Issue October 1997
Category Entire Issue

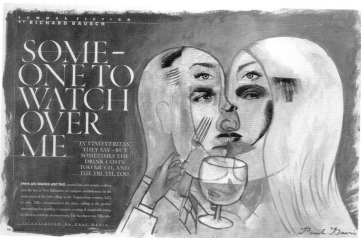

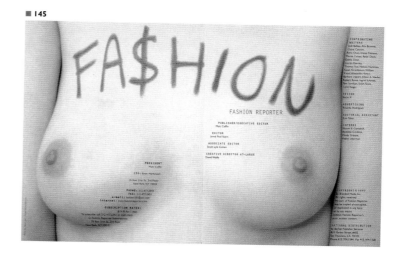

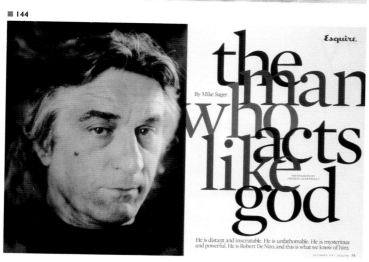

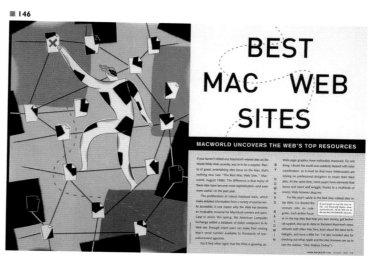

■ 143
Publication Esquire
Design Director Robert Priest
Art Director Rockwell Harwood
Designer Rockwell Harwood
Illustrator Paul Davis
Photo Editor Danielle Place
Publisher The Hearst Corporation-
Magazines Division
Issue July 1997
Category Feature Spread

■ 144
Publication Esquire
Design Director Robert Priest
Art Director Rockwell Harwood
Designer Joshua Liberson
Photo Editor Danielle Place
Photographer
Frank W. Ockenfels 3
Publisher The Hearst
Corporation-Magazines Division
Issue December 1997
Category Feature Spread

■ 145
Publication Fashion Reporter
Art Director Bridget De Socio
Designer Ninja v. Oertzen
Photographer Mark Lyon
Studio Socio X
Publisher Bigtop Publisher Services
Issue April/May 1997
Category Contents or Department

■ 146
Publication Macworld
Design Director Leslie Barton
Art Director Joanne Hoffman
Designer Tim Johnson
Illustrator Jeff Neumann
Issue October 1997
Category Feature Spread

■ 147

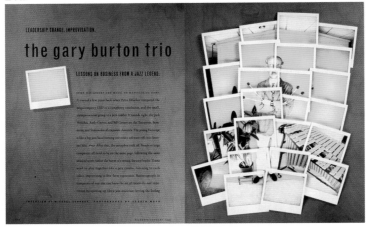

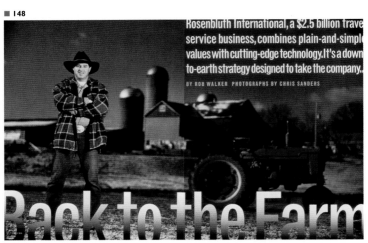

■ 148

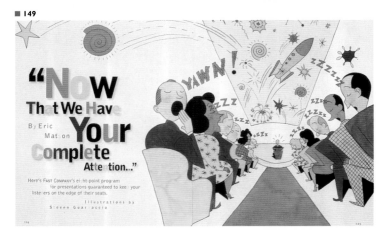

■ 149

■ 150 A

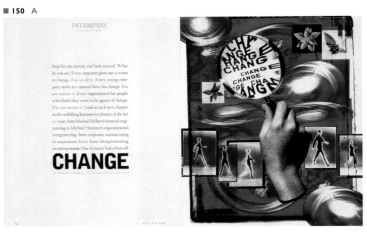

■ 147
Publication Fast Company
Art Director Patrick Mitchell
Designer Patrick Mitchell
Photographer Scogin Mayo
Issue December/January 1997
Category Feature Spread

■ 148
Publication Fast Company
Art Director Patrick Mitchell
Designer Patrick Mitchell
Photographer Chris Sanders
Issue February/March 1997
Category Feature Spread

■ 149
Publication Fast Company
Art Director Patrick Mitchell
Designer Patrick Mitchell
Illustrator Steven Guarnaccia
Issue February/March 1997
Category Feature Spread

■ 150
Publication Fast Company
Art Director Patrick Mitchell
Designer Patrick Mitchell
Illustrator Amy Guip
Issue April/May 1997
Categories Feature Story
　　　　　　A Spread

■ 151

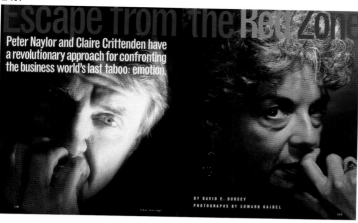

Escape From The Red Zone

Peter Naylor and Claire Crittenden have a revolutionary approach for confronting the business world's last taboo: emotion.

BY DAVID E. DORSEY
PHOTOGRAPHS BY EDWARD GAJDEL

■ 152

FAST COMPANY
AUGUST/SEPTEMBER 1997

THE BRAND CALLED YOU™

By Tom Peters

Illustrations by Alison Seiffer

FAST COMPANY 83

■ 153

"WELCOME TO **NEW HOPE**. YOU ARE THE **ELITES** HERE. YOU HAVE A GREAT RESPONSIBILITY. I'VE COMPILED SOME ADVICE TO HELP YOU: **DON'T** LET YOURSELF GET COMFORTABLE. DON'T MAKE FRIENDS. DO COMMIT UNNATURAL ACTS. DO TALK TO THE DEVIL...."

BY ELIZABETH WEIL

POWER CAMP

Illustrations by David Cowles

Out on the edge of the continent, on the site of a former evangelical retreat, there's a camp where businesspeople confront issues of power and authority, mull negotiation horror-stories fundamental to the world of work. Upon arrival, participants forfeit their corporate identities. Upon departure, they say work, tough calls, leave jobs. Here the rules of engagement are different, the mental and physical demands extreme. People who attend say it's the weirdest place they've ever been. They say it's just like their company.

■ 154

MAKE SMARTER MISTAKES

Nobody's perfect. Here are six reality-tested strategies for fixing, preventing, and learning from the bad things that can happen to good businesspeople.

BY PAMELA KRUGER · ILLUSTRATIONS BY MARC ROSENTHAL

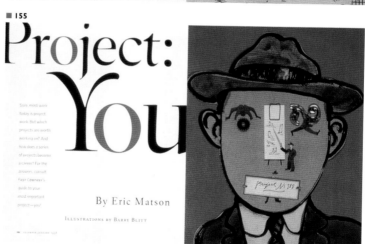

■ 155

Project: You

Sure, most work today is project work. But which projects are worth working on? And how does a series of projects become a career? For the answers, consult Fast Company's guide to your most important project—you!

By Eric Matson

ILLUSTRATIONS BY BARRY BLITT

■ 151
Publication Fast Company
Art Director Patrick Mitchell
Designer Patrick Mitchell
Photographer Edward Gajdel
Issue April/May 1997
Category Feature Spread

■ 152
Publication Fast Company
Art Director Patrick Mitchell
Designer Patrick Mitchell
Illustrator Alison Seiffer
Issue August/September 1997
Category Feature Spread

■ 153
Publication Fast Company
Art Director Patrick Mitchell
Designer Patrick Mitchell
Illustrator David Cowles
Issue August/September 1997
Category Feature Single Page

■ 154
Publication Fast Company
Art Director Patrick Mitchell
Designer Patrick Mitchell
Illustrator Marc Rosenthal
Issue October/November 1997
Category Feature Spread

■ 155
Publication Fast Company
Art Director Patrick Mitchell
Designer Patrick Mitchell
Illustrator Barry Blitt
Issue December/January 1998
Category Feature Spread

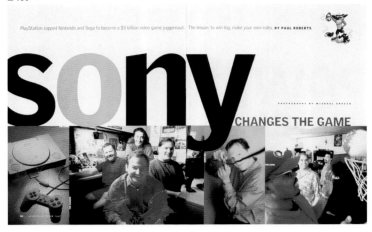

sony

CHANGES THE GAME

PlayStation zapped Nintendo and Sega to become a $5 billion video game juggernaut. The lesson: to win big, make your own rules. BY PAUL ROBERTS

PHOTOGRAPHY BY MICHAEL GRECCO

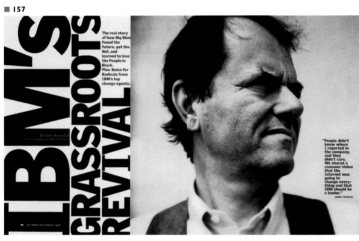

IBM'S GRASSROOTS REVIVAL

The real story of how Big Blue found the future, get the Net, and learned to love the People in Black. Plus: Rules for Radicals from IBM's top change agents.

By Erin Reynolds
Photography by William Huber

"People didn't know where I reported in the company, and they didn't care. We shared a common vision that the Internet was going to change everything and that IBM should be a leader." JOHN PATRICK

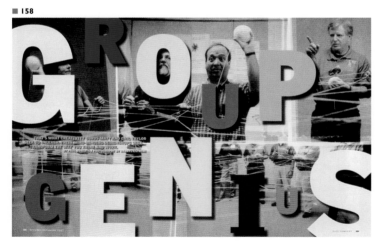

GROUP GENIUS

ARTIST SHOWCASE

After Japanese photographer Masao Yamamoto has printed one of his serene, Zen-like images, he frays its edges. Bent, torn, and stained, the photos—most are no more than 4 x 6 inches—become more than their subject: They remind us of postcards, or of snapshots, records of intimate, wordless moments

MASAO YAMAMOTO

that are at once fleeting and eternal. True to his unembellished aesthetic, Yamamoto often exhibits his photographs simply taped to the wall or invites viewers to browse through stacks of pictures placed in an old leather satchel. Like pebbles, they sink through the clear water of our perception; like ocean waves, they ruffle our horizons. The teachings of Zen tell us that "form is only emptiness; emptiness is only form." Yamamoto's haunting emptiness is dense with our own memories and dreams.

■ 156
Publication Fast Company
Art Director Patrick Mitchell
Designer Patrick Mitchell
Photographer Michael Grecco
Issue August/September 1997
Category Feature Spread

■ 157
Publication Fast Company
Art Director Patrick Mitchell
Designer Patrick Mitchell
Photographer William Huber
Issue October/November 1997
Category Feature Spread

■ 158
Publication Fast Company
Art Director Patrick Mitchell
Designer Patrick Mitchell
Photographer Darryl Estrine
Issue October/November 1997
Category Feature Spread

■ 159
Publication Hemispheres
Art Director Jaimey Easler
Designer Jaimey Easler
Photographer Maseo Yamamoto
Publisher Pace Communications
Client United Airlines
Issue January 1997
Category Feature Story

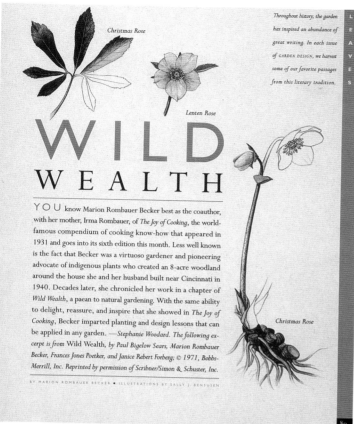

Christmas Rose

Lenten Rose

WILD
WEALTH

Throughout history, the garden has inspired an abundance of great writing. In each issue of GARDEN DESIGN, we harvest some of our favorite passages from this literary tradition.

YOU know Marion Rombauer Becker best as the coauthor, with her mother, Irma Rombauer, of *The Joy of Cooking*, the world-famous compendium of cooking know-how that appeared in 1931 and goes into its sixth edition this month. Less well known is the fact that Becker was a virtuoso gardener and pioneering advocate of indigenous plants who created an 8-acre woodland around the house she and her husband built near Cincinnati in 1940. Decades later, she chronicled her work in a chapter of *Wild Wealth*, a paean to natural gardening. With the same ability to delight, reassure, and inspire that she showed in *The Joy of Cooking*, Becker imparted planting and design lessons that can be applied in any garden. —Stephanie Woodard. *The following excerpt is from Wild Wealth, by Paul Bigelow Sears, Marion Rombauer Becker, Frances Jones Poetker, and Janice Rebert Forberg; © 1971, Bobbs-Merrill, Inc. Reprinted by permission of Scribner/Simon & Schuster, Inc.*

BY MARION ROMBAUER BECKER • ILLUSTRATIONS BY SALLY J. BENSUSEN

Christmas Rose

89

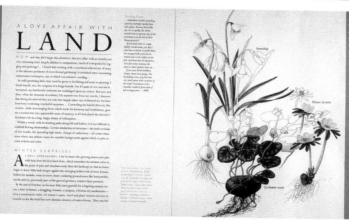

A LOVE AFFAIR WITH
LAND

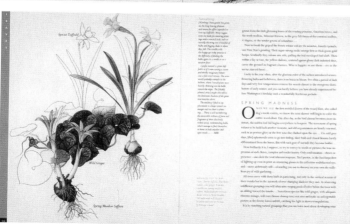

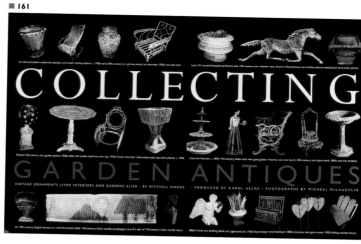

COLLECTING
GARDEN ANTIQUES

VINTAGE ORNAMENTS LIVEN INTERIORS AND GARDENS ALIKE • BY MITCHELL OWENS • PRODUCED BY CAROL HELMS • PHOTOGRAPHS BY MICHEAL McLAUGHLIN

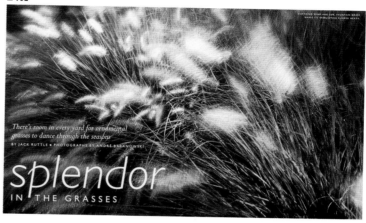

There's room in every yard for ornamental grasses to dance through the seasons
BY JACK RUTTLE • PHOTOGRAPHS BY ANDRÉ BARANOWSKI

splendor
IN THE GRASSES

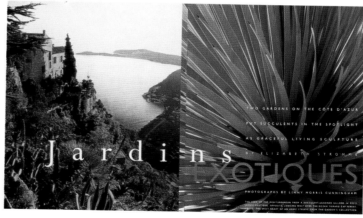

Jardins
EXOTIQUES

TWO GARDENS ON THE CÔTE D'AZUR
PUT SUCCULENTS IN THE SPOTLIGHT
AS GRACEFUL LIVING SCULPTURE

PHOTOGRAPHS BY LINNY MORRIS CUNNINGHAM

■ 160
Publication Garden Design
Creative Director
Michael Grossman
Art Director Christin Gangi
Designer Neal Boulton
Illustrator Sally Bensusen
Publisher Meigher Communications
Issue November 1997
Category Feature Story

■ 161
Publication Garden Design
Creative Director
Michael Grossman
Art Director Christin Gangi
Designer Christin Gangi
Photo Editor Lauren Hicks
Publisher Meigher Communications
Issue November 1997
Category Feature Spread

■ 162
Publication Garden Design
Creative Director
Michael Grossman
Art Director Christin Gangi
Designer Stacie Reistetter
Photo Editor Lauren Hicks
Photographer André Baranowski
Publisher Meigher Communications
Issue December 1997/January 1998
Category Feature Spread

■ 163
Publication Garden Design
Creative Director
Michael Grossman
Art Director Christin Gangi
Designer Neal Boulton
Photo Editor Lauren Hicks
Photographer
Linny Morris Cunningham
Publisher Meigher Communications
Issue May 1997
Category Feature Spread

По
утрам

надев
часы,
не забудьте
про...
пальто

Этой зимой пальто — в центре
внимания. Длинное, узкое, часто
без подкладки, оно завернет
тебя, женет и отдет решающую
роль в модных списуда. Если уже
всё-же — выразительная деталь
на стенка модных.
Стража, плотное кашмировое
пальто; черное шерстяное боди
из тонком шерсти и чёрный
брюки из шерстяной креп. Donna
Karan Signature, Calvin Klein.
Стилист Тоне Goodman
Фотограф Patrick
Demarchelier

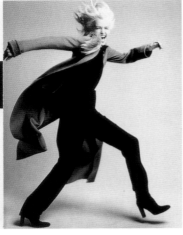

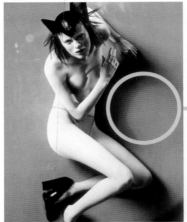

Кутюр

О тблеск

Элемент кутюр — эксклюзив-
ная штучка. Бретелии,
прозрачная ткань, отделка
скрещивающимися страмики —
выражают изысканность,
утонченность, декаданство
наг грамене приходящего сезона.
На странице справа —
прозрачные трусики. Calvin
Klein Underwear; чёрная
шляпка. Philip Treacy; туфли. Prada.
Стилист Melanie Ward
Фотограф Craig McDean

great
greens

Stir-fried, steamed, or sautéed, they're delicious—

and they can help keep cancer at bay. BY WENDY MARSTON

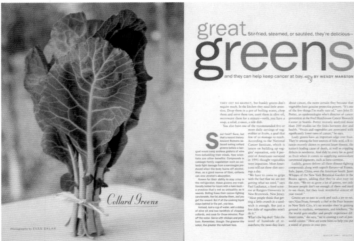

Collard Greens

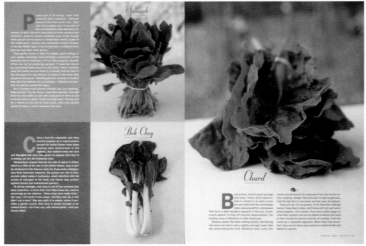

Spinach

Bok Choy

Chard

■ 164

Publication Harper's Bazaar
Russian Edition
Art Director Isabelle Salvadori
Photographer Patrick Demarchelier
Publisher Hearst Independent Media
Publishing
Issue January/February 1997
Category Feature Spread

■ 165

Publication Harper's Bazaar
Russian Edition
Art Director Isabelle Salvadori
Designer Tatiana Muradova
Photographer Craig McDean
Publisher Hearst Independent
Media Publishing
Issue November 1997
Category Feature Spread

■ 166

Publication Health
Art Director Jane Palecek
Designer Dorothy Marschall
Photographer Evan Sklar
Publisher Time Inc.
Issue March 1997
Category Feature Story

■ 167

Publication House Beautiful
Art Director Andrzej Janerka
Designer Jennifer Carling
Photographer Christopher Irion
Publisher The Hearst Corporation-
Magazines Division
Issue October 1997
Category Feature Story

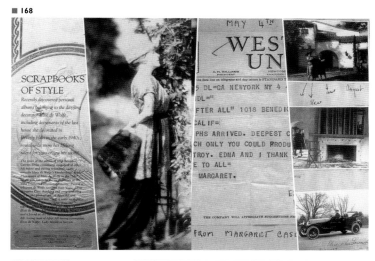

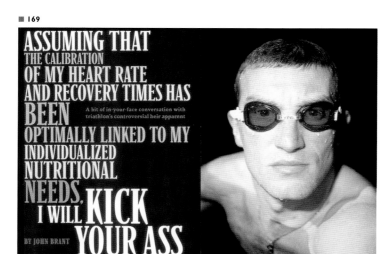

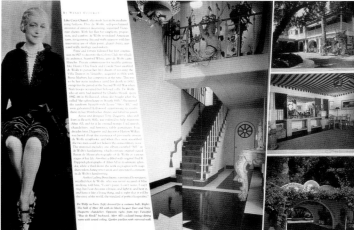

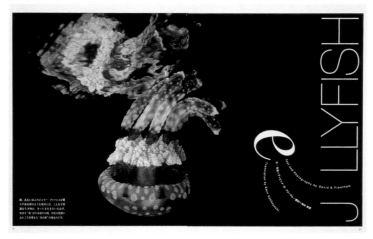

■ 168
Publication House Beautiful
Art Director Andrzej Janerka
Publisher The Hearst Corporation-
Magazines Division
Issue May 1997
Category Feature Story

■ 169
Publication Outside
Creative Director Susan Casey
Designer Susan Casey
Photo Editor Susan B. Smith
Publisher Mariah Media, Inc.
Issue November 1997
Category Feature Spread

■ 170
Publication Pacifica
Design Director Kunio Hayashi
Designer Nori Sato
Photographer David B. Fleetham
Studio Communication Design Corp.
Publisher Pacifica
Issue August 1997
Category Feature Spread

■ 171
Publication Pacifica
Design Director Kunio Hayashi
Designer Nori Sato
Illustrator Alfredo Lista Garma
Photographer Dana Edmunds
Studio Communication Design Corp.
Publisher Pacifica
Issue October 1997
Category Feature Spread

Out with
quantity, in with
quality: Our
secrets to the new
minimalism

what's hot now?

SIMPLE STYLE

SPECIAL COLLECTOR'S ISSUE

InStyle
Celebrity · Lifestyle · Beauty

Audrey Hepburn, Classic Chic

The 10 Best Dressed
Michelle Pfeiffer
Anjelica Huston
Elizabeth Hurley
Nicole Kidman
Sharon Stone
Will Smith
...and more

The 5 Greatest Looks Ever And How to Get Them!

Legendary Glamour
Marilyn Monroe
Katharine Hepburn
Grace Kelly

50 Years of Hollywood Fashion

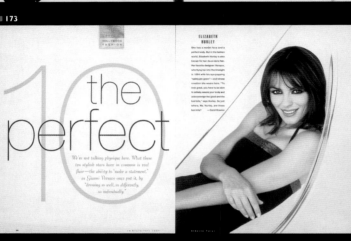

HOLLYWOOD FASHION

10 the perfect

We're not talking physique here. What these ten stylish stars have in common is real flair—the ability to "make a statement," as Gianni Versace once put it, by "dressing as well, as differently, so individually."

ELIZABETH HURLEY

the rebel

Get out of their way. These are the stars who love to break the rules.

ANN-MARGRET

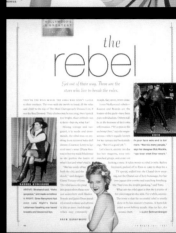
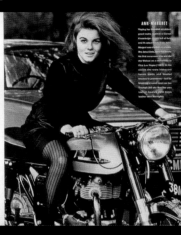

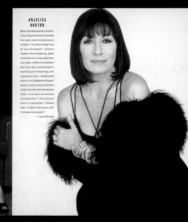

NICOLE KIDMAN

ANJELICA HUSTON

sole survivors

Six shoes to buy, wear and buy away ... but never lose one.

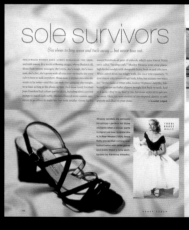

THE IN STYLE SHOPPER

wisebuys

Going for a
sharp-looking table?
Choose from
classic patterns or
fashion-forward

flatware designs,
sensible stainless
or sumptuous
sterling

cutting edge

■ 172

Publication InStyle
Art Director Paul Roelofs
Designer Paul Roelofs
Photo Editor Maureen Griffin
Publisher Time Inc.
Issue January 1997
Category Feature Spread

■ 173

Publication InStyle
Art Director Don Morris
Designers Josh Klenert,
Jennifer Starr, Cay Tolson
Photo Editors Julie Mihaly,
Kristina Snyder
Publisher Time Inc.
Issue Fall 1997
Category Feature Story

■ 174

Publication InStyle
Art Director Paul Roelofs
Designer Siobhan Hardy
Photo Editor Maureen Griffin
Photographer Devon Jarvis
Publisher Time Inc.
Issue July 1997
Category Department

■ 175

Publication InStyle
Art Director Don Morris
Designers Josh Klenert,
Jennifer Starr, Cay Tolson
Photo Editors Julie Mihaly,
Kristina Snyder
Publisher Time Inc.
Issue Fall 1997
Category Entire Issue

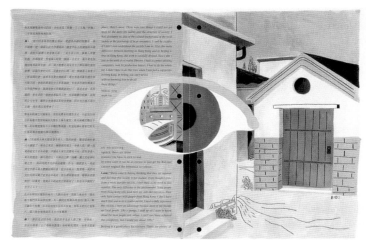

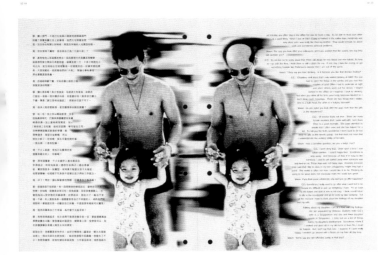

■ 176
Publication Longyin Review
Creative Director Benny Cheng
Art Director Benny Lau
Designers Kenneth Tung, Benny Lau, Raymond Fu
Illustrator Kenneth Tung
Photo Editor Kenneth Tung
Photographer Mark Sung
Studio Gallery Ltd.
Publisher Longyin Review Ltd.
Issue October 1997
Category Entire Issue

■ 177
Publication Longyin Review
Creative Director Benny Cheng
Art Director Benny Lau
Designers Kenneth Tung, Benny Lau
Illustrator Bernard Chow
Photographer Mark Sung
Studio Gallery Ltd.
Publisher Longyin Review Ltd.
Issue July 1997
Category Entire Issue

■ 178
Publication Men's Fitness
Art Director Dean Abatemarco
Designer Dean Abatemarco
Publisher Weider Publications Inc.
Issue June 1997
Category Feature Spread

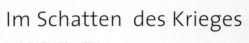

Im Schatten des Krieges

Fünf Jahre lang verfolgte der junge französische Bildjournalist Emmanuel Ortiz mit seiner Leica den Krieg im ehemaligen Jugoslawien.

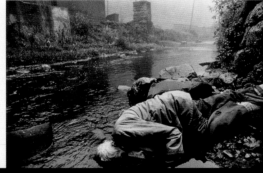

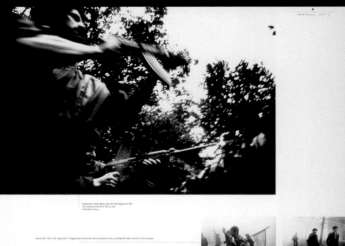

EIN GESPRÄCH MIT HENRY WOLF

»Ich hatte ziemlich freie Hand«

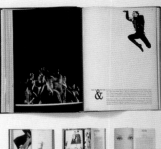

179
Publication Leica World
Creative Director Horst Moser
Designer Julia Kessler
Photo Editors Michael Koettzle, Horst Moser
Photographer Emmanuel Ortiz
Studio Independent Medien Design
Publisher Leica Camera AG
Issue February 1997
Category Feature Story

180
Publication Leica World
Creative Director Horst Moser
Designer Horst Moser
Photo Editors Michael Koettzle, Horst Moser
Studio Independent Medien Design
Publisher Leica Camera AG
Issue February 1997
Category Feature Story

Der Weg ist das Ziel

Er hat Nena entdeckt. »Die Ärzte« gemanagt. Nina Hagen zum Erfolg geführt. Aus dem Musikgeschäft hat sich Jim Rakete zurückgezogen. Nicht allen aus der Fotografie: Nach drei Jahrzehnten zählt der Wahl-Hamburger zu Deutschlands gefragtesten Fotografen.

Roma am Ende der Welt

Anfang der neunziger Jahre entdeckte Yves Leresche das Leben der rumänischen Zigeuner, seitdem hat das Thema des jungen Leica-Fotografen nicht mehr losgelassen.

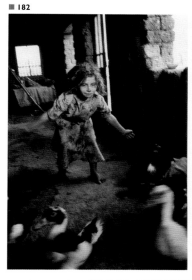

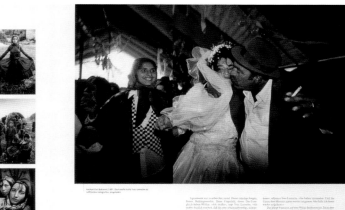

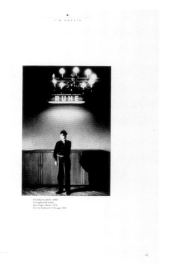

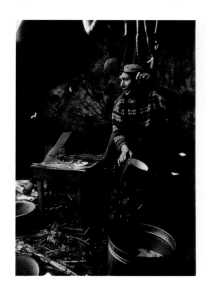

■ 181
Publication Leica World
Creative Director Horst Moser
Designers Horst Moser, Julia Kessler
Photo Editors Michael Koettzle, Horst Moser
Photographer Jim Rakete
Studio Independent Medien Design
Publisher Leica Camera AG
Issue September 1997
Category Feature Story

■ 182
Publication Leica World
Creative Director Horst Moser
Designer Horst Moser
Photo Editors Michael Koettzle, Horst Moser
Photographer Yves Leresche
Studio Independent Medien Design
Publisher Leica Camera AG
Issue September 1997
Category Feature Story

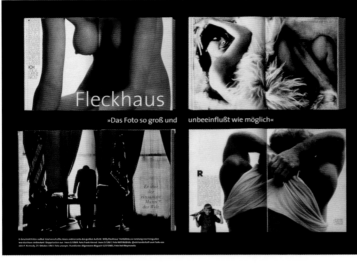

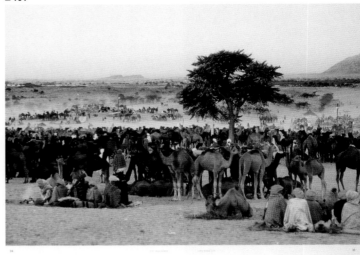

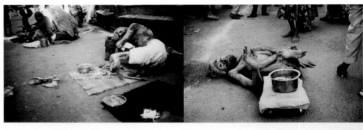

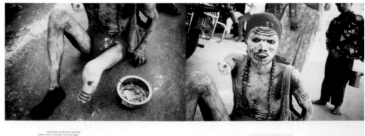

■ 183
Publication Leica World
Creative Director Horst Moser
Designer Horst Moser
Photo Editors Michael Koettzle, Horst Moser
Studio Independent Medien Design
Publisher Leica Camera AG
Issue September 1997
Category Feature Story

■ 184
Publication Leica World
Creative Director Horst Moser
Designer Julia Kessler
Photo Editors Michael Koettzle, Horst Moser
Photographer Roberto Dotti
Studio Independent Medien Design
Publisher Leica Camera AG
Issue February 1997
Category Feature Story

The
Visible
Man

The execution and
electronic after-life
of Joseph Paul Jernigan

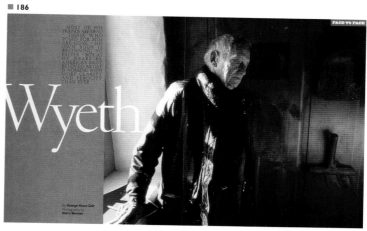

FACE TO FACE

MOST OF HIS
FRIENDS ARE DEAD.
THOSE WHO
POND FOR HIM
ARE GONE. THIS
IS ANDY'S
BEGINNING TO
REFLECT, BUT AS
THE YEARS GO
AMERICA'S MOST
ACUTE ARTIST
IS WORKING WITH
MORE CLARITY
AND FEROCITY
THAN EVER.

Wyeth

By George Howe Colt
Photographed by
Harry Benson

The matter that makes up the mind is 85 percent
water. Out of the skull, it slumps like a blob of jel-O.
Aristotle thought the brain function was that of a
radiator to cool the blood. It does receive 20 per-
cent of the body's blood supply, but the brain can
cool the blood solely through rational thought.

The Brain

FACE TO FACE

Kindergarten class photo, Buffalo, Minn. 1957

OPRAH WINFREY A LIFE IN BOOKS

"No one ever told
me I was loved.
Ever, ever, ever.
Reading and being
able to be a *smart
girl* was my only
sense of value, and
it was the only
time I felt loved."

—Oprah Winfrey, in an interview with LIFE 1997

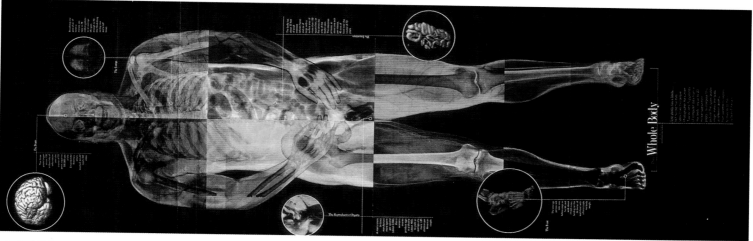

Whole Body

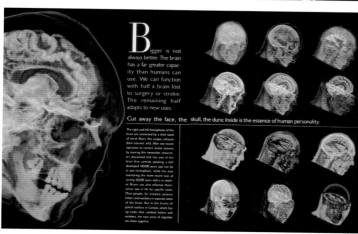

B
igger is not
always better: The brain
has a far greater capac-
ity than humans can
use. We can function
with half a brain lost
to surgery or stroke:
The remaining half
adapts to new uses.

Cut away the face, the skull, the dura: Inside is the essence of human personality.

The right and left hemispheres of the
brain are connected by a thick band
of nerve fibers, the corpus callosum
(blue crescent, left). After one recent
operation to correct severe seizures
by severing the connection, research-
ers discovered that the area of the
brain that controls speaking, a skill
developed 100,000 years ago, can be
in one hemisphere, while the area
monitoring the more recent task of
writing (10,000 years old) is in anoth-
er. Brains can also reformat them-
selves late in life for specific tasks.
Most people, for instance, process
letters and numbers in separate areas
of the brain. But in the brains of
postal workers in Canada, which has
zip codes that combine letters and
numbers, the two areas of cognition
are closer together.

■ 185
Publication LIFE
Design Director Tom Bentkowski
Art Director Sharon Okamoto
Designers Sam Serebin,
Melanie deForest
Illustrator Steve Walkowiak
Photo Editor David Friend
Publisher Time Inc.
Issue February 1997
Category Entire Issue

■ 186
Publication LIFE
Design Director Tom Bentkowski
Designer Tom Bentkowski
Photo Editor David Friend
Photographer Harry Benson
Publisher Time Inc.
Issue March 1997
Category Feature Spread

■ 187
Publication LIFE
Design Director Tom Bentkowski
Designer Sam Serebin
Photo Editors David Friend,
Dubravka Bondulic
Photographer Art Wolfe
Publisher Time Inc.
Issue September 1997
Category Feature Spread

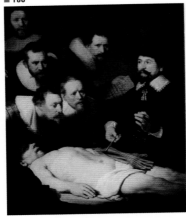

Through the Ages, Artists and Doctors Have Confounded the

Mysteries of Anatomy

The body illuminated, from ancient woodcuts to modern CAT scans

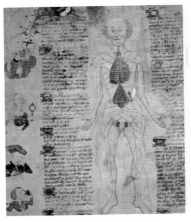

1493

1412

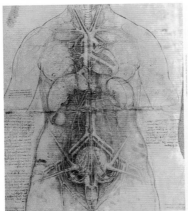

1543

1509

1896

1773

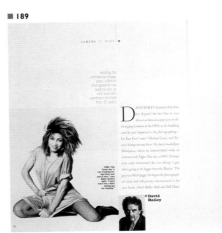

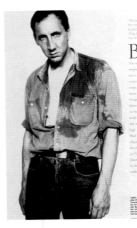

David Bailey

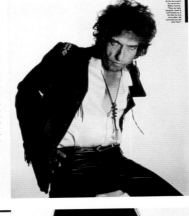

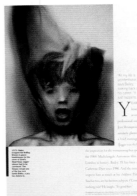

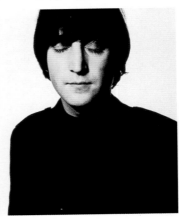

■ 188
Publication LIFE
Design Director Tom Bentkowski
Designers Tom Bentkowski, Sam Serebin
Photo Editors David Friend, Melanie deForest
Publisher Time Inc.
Issue February 1997
Category Feature Story

■ 189
Publication LIFE
Design Director Tom Bentkowski
Designer James Elsis
Photo Editors David Friend, Vivette Porges
Photographer David Bailey
Publisher Time Inc.
Issue April 1997
Category Feature Story

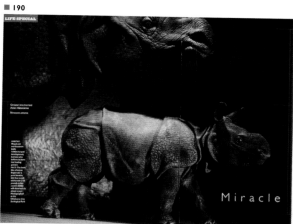

LIFE SPECIAL

Miracle Babies

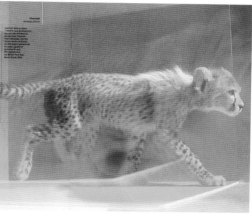

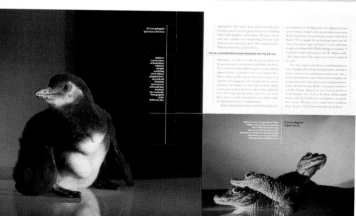

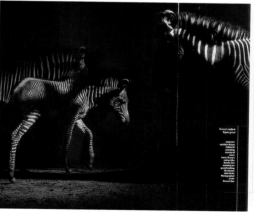

CAMERA AT WORK

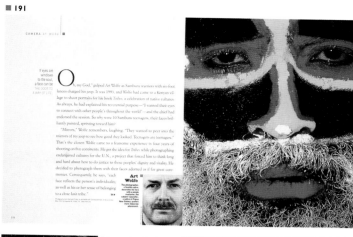

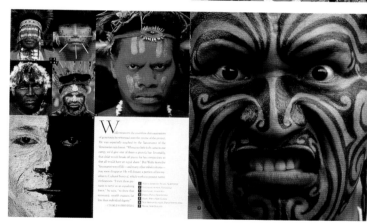

Art Wolfe

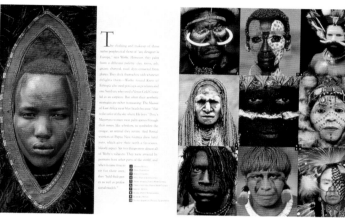

■ 190
Publication LIFE
Design Director Tom Bentkowski
Designer Tom Bentkowski
Photo Editors David Friend, Melanie deForest
Photographer James Balog
Publisher Time Inc.
Issue March 1997
Category Feature Story

■ 191
Publication LIFE
Design Director Tom Bentkowski
Designer James Elsis
Photo Editors David Friend, Vivette Porges
Photographer Art Wolfe
Publisher Time Inc.
Issue May 1997
Category Feature Story

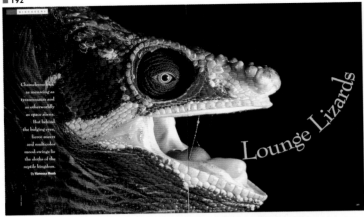

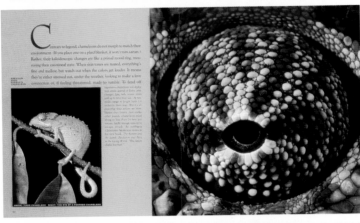

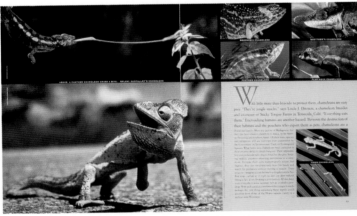

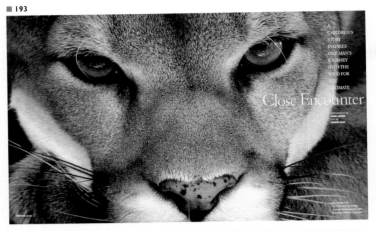

Close Encounter

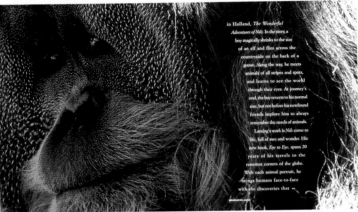

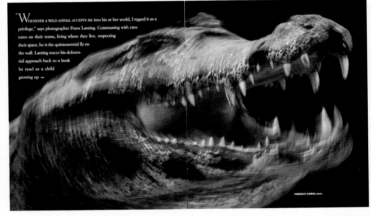

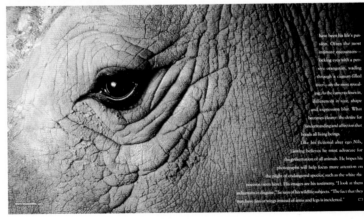

■ 192
Publication LIFE
Design Director Tom Bentkowski
Designer Sharon Okamoto
Photo Editors David Friend,
Azurea Lee Dudley
Publisher Time Inc.
Issue September 1997
Category Feature Story

■ 193
Publication LIFE
Design Director Tom Bentkowski
Designer Sam Serebin
Photo Editors David Friend, Marie Schumann
Photographer Frans Lanting
Publisher Time Inc.
Issue October 1997
Category Feature Story

JOHN F. KENNEDY

JOHN F. KENNEDY and CAROLINE, WASHINGTON, D.C., 1996

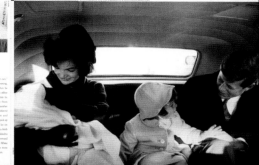

JACQUELINE KENNEDY SCHOOLING HER SON, JOHN JR., CAROLINE AND THE PRESIDENT, WASHINGTON, D.C., 1963

EUNICE SHRIVER

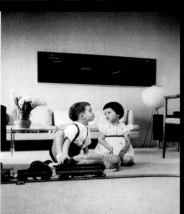

BOBBY, MARIA, TIMMY, SARGENT, MARK, EUNICE AND ANTHONY, TIMBERLAWN, 1966

BOBBY AND MARIA SHRIVER, CHICAGO, 1958

PATRICIA LAWFORD

PAT AND PETER LAWFORD WITH SYDNEY AND CHRISTOPHER, SANTA MONICA, 1956

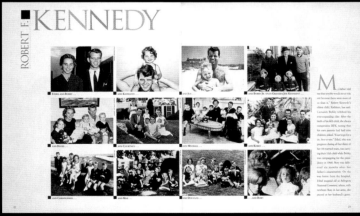

PAT LAWFORD WITH KIDS (FROM TOP) SYDNEY, CHRISTOPHER, ROBIN AND VICTORIA, SANTA MONICA, 1962

ROBERT F. KENNEDY

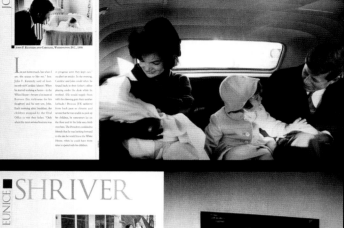

Extravagant Spirits

A NEW POEM
BY MAYA ANGELOU

Without their fierce devotion
We are fragile and forlorn,
Stumbling briefly, among the stars.

We and our futures belong to them
Exquisitely, our beliefs and our
Breaths are made tangible in their love.

By their extravagant spirits, they draw us
From the safe borders
And into the center of the center ring
There they urge dance upon our
Leaden feet
And to our sullen hearts.
Bright laughter.

Not the crowd's roar nor the gasped
Breath of the timorous can stay their mission.

There is no moderation in their nature.
They spit upon their fingers
To test the wind of history;
Then, slip into their bonds and steal us
Away from the slavery of cowardice.

They skin back their thin lips over fanged teeth and
Rocks in hand, in our presence
Face down our Goliath.

These mothers, fathers, pastors and priests,
These Rabbis, Imams and gurus,
Teach us by their valor and mold us with their courage.

Without their fierce devotion
We are only forlorn and only fragile
Stumbling briefly, among the stars.

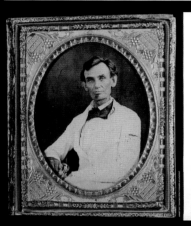

HALL OF HEROES

Just who are the all-American heroes?
They are men or women, privileged or poor, patriots or rebels. They are different from the rest of us, and yet the same. They are our inspiration and therefore essential. From the melting pot the greatest rise, elevating us all.

13. ABRAHAM LINCOLN

SKILL

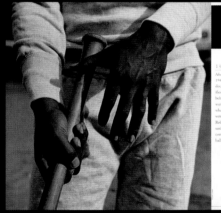

14. JACKIE ROBINSON

15. ROBERT E. LEE

15. JOHN MARSHALL

16. JANE ADDAMS

17. CESAR CHAVEZ

A Child Who Chose Life

Standing beside what they believed would be a deathbed, Tony and Jacque Holding asked their five-year-old daughter if she was ready to be with Jesus. From behind a tangle of tubes and bottles, tiny Blaike defiantly shook her head no.

Photographs by Rick Collins Text by Allison Adato

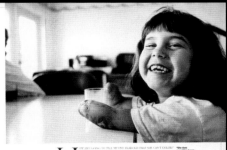

■ 194
Publication LIFE
Design Director Tom Bentkowski
Art Director Mimi Park
Designer Mimi Park
Photo Editors David Friend, Barbara Baker Burrows
Publisher Time Inc.
Issue Summer 1997
Category Feature Story

■ 195
Publication LIFE
Design Director Tom Bentkowski
Art Director Sharon Okamoto
Designer Sharon Okamoto
Photo Editor Marie Schumann
Publisher Time Inc.
Issue Spring 1997
Category Entire Issue

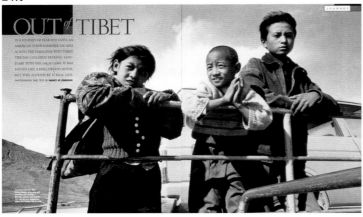

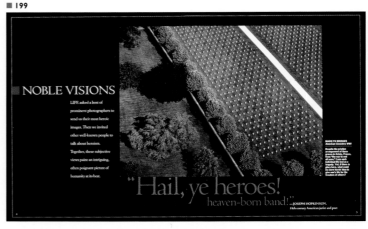

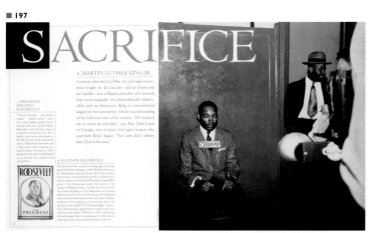

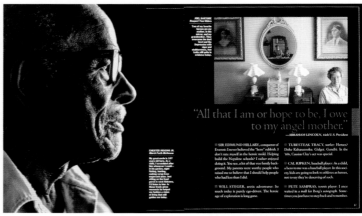

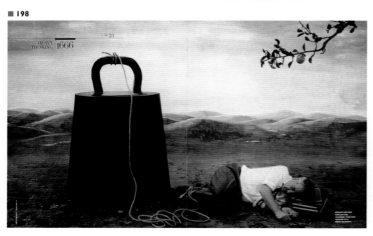

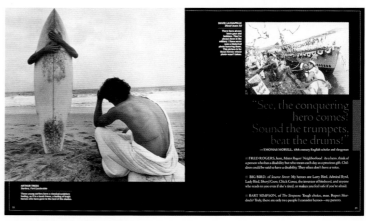

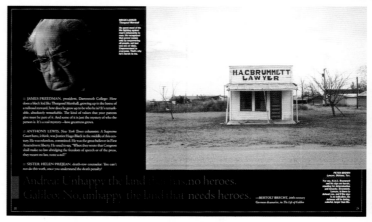

■ 196
Publication LIFE
Design Director Tom Bentkowski
Designer Sharon Okamoto
Photo Editors David Friend, Barbara Baker Burrows
Photographer Nancy Jo Johnson
Publisher Time Inc.
Issue December 1997
Category Feature Spread

■ 197
Publication LIFE
Design Director Tom Bentkowski
Art Director Sharon Okamoto
Designer Sharon Okamoto
Photo Editor Marie Schumann
Photographer Paul Robertson
Publisher Time Inc.
Issue Spring 1997
Category Feature Spread

■ 198
Publication LIFE
Design Director Tom Bentkowski
Art Director Sharon Okamoto
Designers Sharon Okamoto, Tom Bentkowski
Photo Editor Alison Morley
Photographer Teun Hocks
Publisher Time Inc.
Issue Fall 1997
Category Feature Spread

■ 199
Publication LIFE
Design Director Tom Bentkowski
Art Director Sharon Okamoto
Designer Sharon Okamoto
Photo Editor Marie Schumann
Publisher Time Inc.
Issue Spring 1997
Category Feature Story

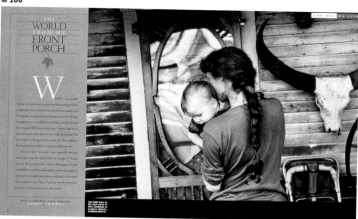

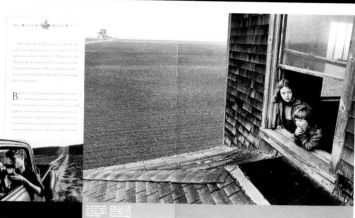

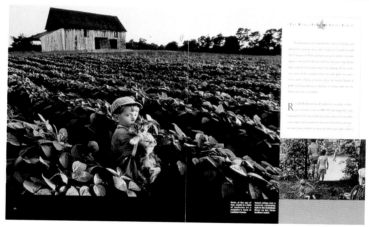

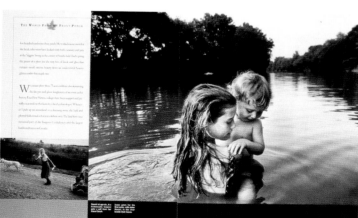

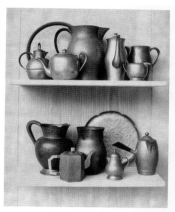

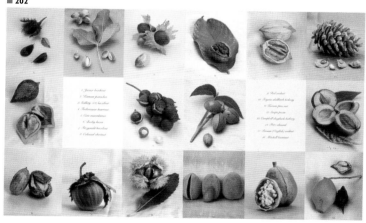

■ 200
Publication LIFE
Design Director Tom Bentkowski
Designer Tom Bentkowski
Photo Editor David Friend
Photographer Larry Towell
Publisher Time Inc.
Issue September 1997
Category Feature Story

■ 201
Publication Martha Stewart Living
Design Director Eric A. Pike
Designers Fritz Karch, Eric A. Pike
Photo Editor Heidi Posner
Photographer José Picayo
Publisher
Martha Stewart Living Omnimedia
Issue November 1997
Categories Feature Story
 A Spread

■ 202
Publication Martha Stewart Living
Design Director Eric A. Pike
Art Director Claudia Bruno
Designers Claudia Bruno,
Susan Sugarman
Photo Editor Heidi Posner
Photographer Victor Schrager
Publisher
Martha Stewart Living Omnimedia
Issue November 1997
Category Feature Spread

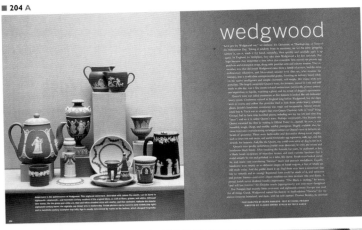

wedgwood

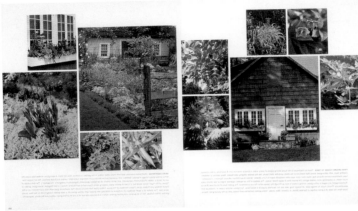

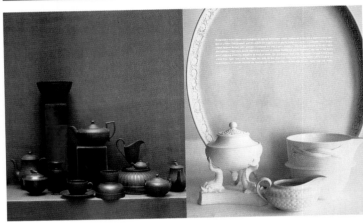

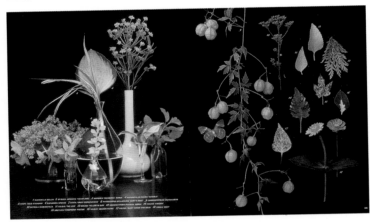

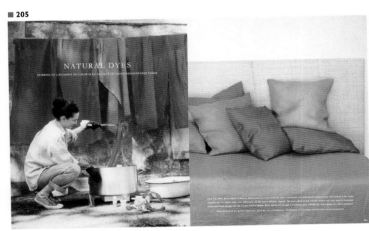

NATURAL DYES

■ 203
Publication Martha Stewart Living
Design Director Eric A. Pike
Designers Ayesha Patel, Eric A. Pike
Photo Editor Heidi Posner
Photographer Christopher Baker
Publisher
Martha Stewart Living Omnimedia
Issue March 1997
Categories Feature Story
 A Spread

■ 204
Publication Martha Stewart Living
Design Director Eric A. Pike
Art Director Claudia Bruno
Designers Fritz Karch, Claudia Bruno
Photo Editor Heidi Posner
Photographer Maria Robledo
Publisher
Martha Stewart Living Omnimedia
Issue April 1997
Categories Feature Story
 A Spread

■ 205
Publication Martha Stewart Living
Design Director Eric A. Pike
Art Director Claudia Bruno
Designers Hannah Milman,
Claudia Bruno
Photo Editor Heidi Posner
Photographer Maria Robledo
Publisher
Martha Stewart Living Omnimedia
Issue September 1997
Category Feature Story

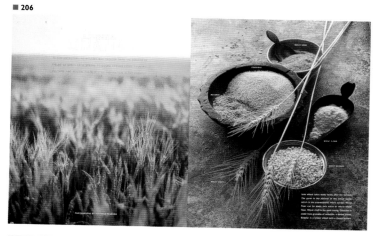

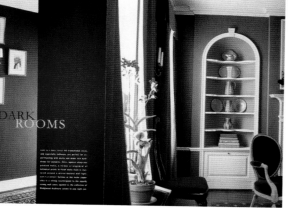

DARK ROOMS

WHO'S AFRAID OF DARK ROOMS?

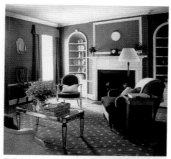

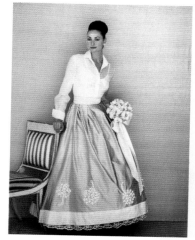

FLORAL DRESSES

CUTTINGS

■ 206
Publication Martha Stewart Living
Design Director Eric A. Pike
Art Director Scot Schy
Designers Ayesha Patel, Scot Schy
Photo Editor Heidi Posner
Photographer Victoria Pearson
Publisher
Martha Stewart Living Omnimedia
Issue October 1997
Category Feature Story

■ 207
Publication Martha Stewart Living
Design Director Eric A. Pike
Art Director Esther Bridavsky
Designers Kevin Sharkey, Stephen
Earle, Esther Bridavsky
Photo Editor Heidi Posner
Photographer William Abranowicz
Publisher
Martha Stewart Living Omnimedia
Issue November 1997
Category Feature Story

■ 208
Publication Martha Stewart Living
Design Director Eric A. Pike
Designers Rebecca Thuss, Darcy
Miller, Eric A. Pike
Photo Editor Heidi Posner
Photographer Carlton Davis
Publisher
Martha Stewart Living Omnimedia
Issue Winter 1997/Spirng 1998
Category Feature Story

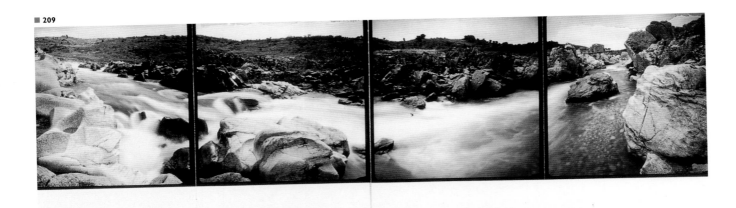

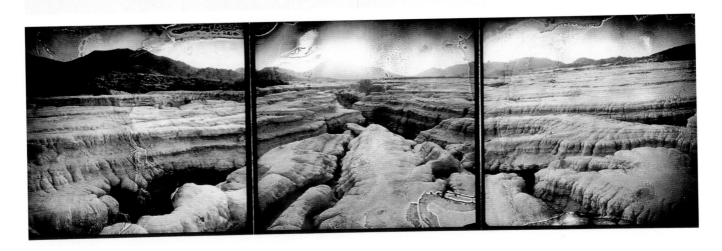

Juan Manuel Castro Prieto Paisaje de agua

La fuerza hace bailar las geo. En el agua que fluye. Encerrado en su delicadeza, Juan Manuel Castro Prieto ha creado un paisaje fantástico. Sus imágenes de la realidad, multiplicadas, dan origen a nuevos mundos. Estos paisajes de agua son el resultado de un sueño. Se llaman Fotística.

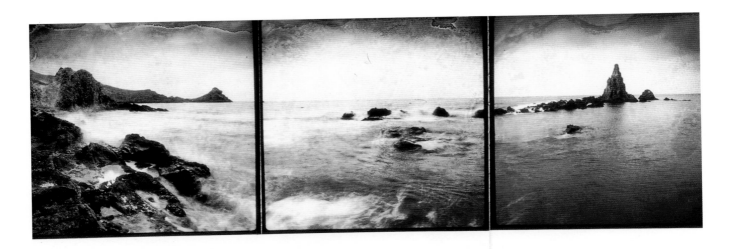

■ 209
Publication Matador
Art Director Fernando Gutiérrez
Designers María Ulecia, Xavi Roca, Emmanuel Ponty,
Pablo Martín, Fernando Gutiérrez
Photo Editor Luis de las Alas
Photographer Juan Manuel Castro Prieto
Studio GRAFICA
Publisher La Fábrica, S.L.
Issue October 25, 1997
Category Feature Story

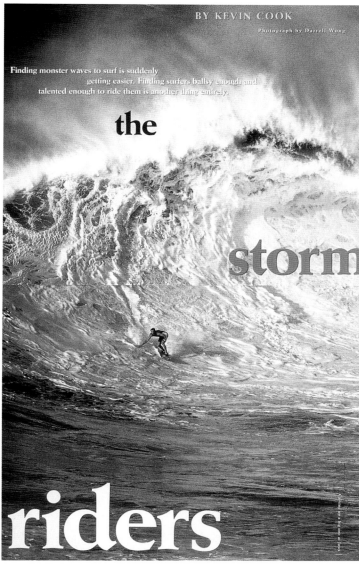

BY KEVIN COOK

Photograph by Darrell Wong

Finding monster waves to surf is suddenly
getting easier. Finding surfers ballsy enough and
talented enough to ride them is another thing entirely.

the

storm

riders

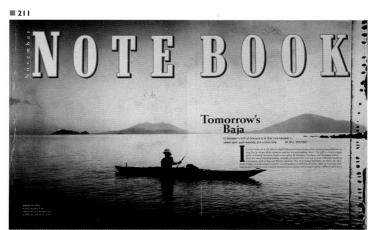

November

NOTE BOOK

Tomorrow's Baja

El Salvador's Gulf of Fonseca is in that rare kayaker's
sweet spot: post-warring, pre-cruise-ship. BY BILL GRAVES

SPECIAL SECTION

Tech

Winter
guide 98

It was 1970 when, in *Future Shock*, Alvin Toffler wrote: "Technology feeds on itself. Technology makes more technology possible."
Almost 30 years later that's still true — and our living rooms will never be the same. Home-theater systems are more compact and
affordable than ever. Personal computers aren't merely office tools anymore; they're home-entertainment centers, packed with dig-
ital video-disc players, along with high-fidelity monitors and speakers. Remember when it was revolutionary to load 5 or 10 discs
at a time into your CD player and customize the order in which you listened to them? Now CD jukeboxes can hold up to 200 discs.
Who's supposed to keep track of all these innovations? We are. You just worry about freeing up some space in your living room.

Home Theater **Multimedia PCs** **CD Jukeboxes**

143

MEN'S JOURNAL, DECEMBER 1997/JANUARY 1998

AN ALL-AMERICAN STORY OF SPORTS
AND SEX AND FAME AND SLEAZE

THE SCREWING OF
Frank
Gifford

Gifford in 1957: perfect

HE WAS SCREWED EVEN
before he got to the hotel
room — when he walked out
of Le Cirque 2000 with
Kathie Lee on the afternoon
of May 1 and a flash went off.
The picture caught him smil-
ing almost smugly, his arm snaked
around his wife, a perfect brown hand-
kerchief rising from the breast pocket of
his tan blazer, and — most unfortunate —
his tongue licking his lips as he grinned.

It was a small piece of the
melodrama about to erupt,
and it was a beaut: Frank
Gifford has lunch *with his wife*,
then goes to the Regency
Hotel to bang a former stew-
ardess with humongous
breasts. ¶ The picture ended up even in
tasteful publications — the last shot of
the Giffords as ideal couple. As Frank
kissed his wife goodbye, Suzen John-
son was waiting for him in Room 521. ▶

BY LISA DEPAULO

103

MEN'S JOURNAL, DECEMBER 1997/JANUARY 1998

■ 210
Publication Men's Journal
Art Director David Armario
Designer David Armario
Photo Editor Denise Sfraga
Photographer Darrell Wong
Publisher Straight Arrow
Issue April 1997
Category Feature Single Page

■ 211
Publication Men's Journal
Art Director Michael Lawton
Designer Michael Lawton
Photo Editor Casey Tierney
Photographer Russell Kaye
Publisher Straight Arrow
Issue November 1997
Category Feature Spread

■ 212
Publication Men's Journal
Art Director Michael Lawton
Designer Arem Duplessis
Publisher Straight Arrow
Issue December 1997/January 1998
Category Department

■ 213
Publication Men's Journal
Art Director Michael Lawton
Designer Michael Lawton
Publisher Straight Arrow
Issue December 1997/January 1998
Category Feature Single Page

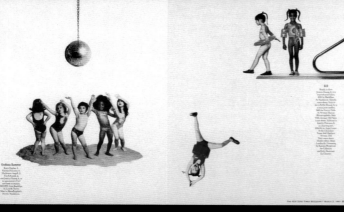

■ 214
Publication
The New York Times Magazine
Art Director Janet Froelich
Designer Nancy Harris
Photographer Robert Trachtenberg
Stylist Elizabeth Stewart
Publisher The New York Times
Issue March 2, 1997
Category Feature Story

■ 215
Publication
The New York Times Magazine
Art Director Janet Froelich
Designers Lisa Naftolin, Joel Cuyler
Photo Editor Kathy Ryan
Publisher The New York Times
Issue March 9, 1997
Category Feature Story

The Witnesses
Day after day, the Truth and Reconciliation Commission in South Africa listens to the pain of apartheid's victims and offers amnesty to its villains. But the jury is still out on whether truth is the same as justice.

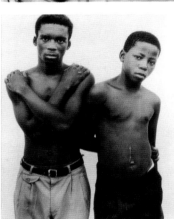

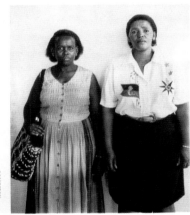

Atomic Guinea Pigs
For decades, those who claimed to be victims of clandestine radiation experiments conducted by the United States Government were dismissed as paranoid. At the Department of Energy, which oversees America's nuclear-weapons research, these people were referred to collectively as "the Crazies." But the opening of cold-war archives has brought the Crazies in from the fringe.

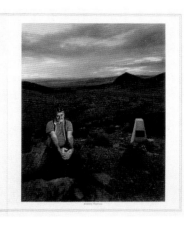

BY MICHAEL D'ANTONIO Photographs by DAN WINTERS

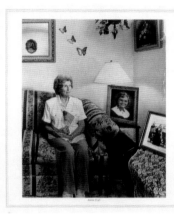

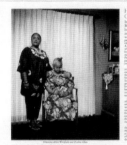

■ 216
Publication The New York Times Magazine
Art Director Janet Froelich
Designer Catherine Gilmore-Barnes
Photo Editor Kathy Ryan
Photographer Jillian Edelstein
Publisher The New York Times
Issue June 22, 1997
Category Feature Story

■ 217
Publication The New York Times Magazine
Art Director Janet Froelich
Designer Catherine Gilmore-Barnes
Photo Editor Kathy Ryan
Photographer Dan Winters
Publisher The New York Times
Issue August 131,997
Category Feature Story

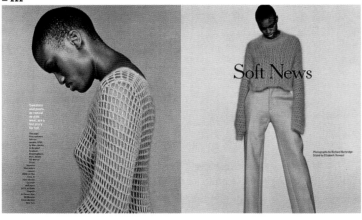

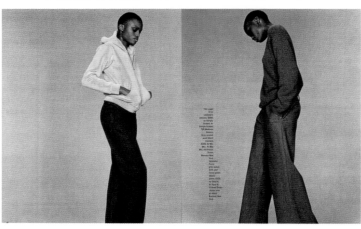

Soft News

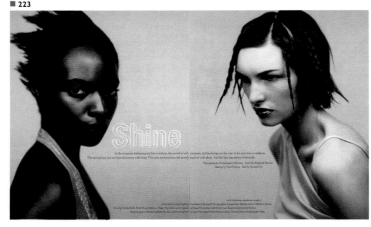

Shine

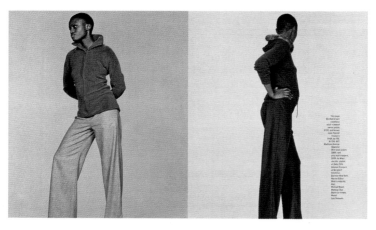

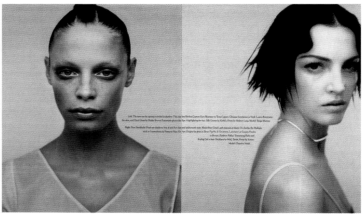

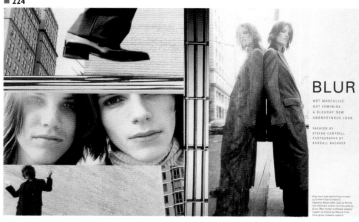

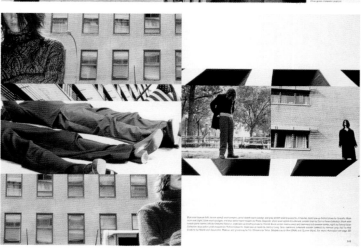

BLUR

NOT MASCULINE.
NOT FEMININE.
A SLOUCHY NEW
ANDROGYNOUS LOOK.

FASHION BY
STEFAN CAMPBELL
PHOTOGRAPHS BY
RANDALL BACHNER

Publication
The New York Times Magazine
Art Director Janet Froelich
Designer Lisa Naftolin
Photographer Richard Burbridge
Stylist Elizabeth Stewart
Publisher The New York Times
Category Feature Story

■ 223
Publication
The New York Times Magazine
Art Director Janet Froelich
Designer Lisa Naftolin
Photographer
Michelangelo di Battista
Stylist Elizabeth Stewart
Publisher The New York Times
Category Feature Story

■ 224
Publication Out
Art Director George Karabotsos
Designers George Karabotsos,
Stefan Campbell
Photo Editor Stefan Campbell
Photographer Randall Bachner
Publisher Out Publishing
Issue September 1997
Category Feature Story

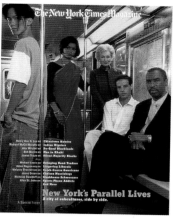

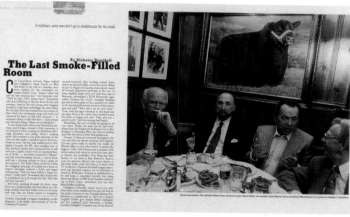

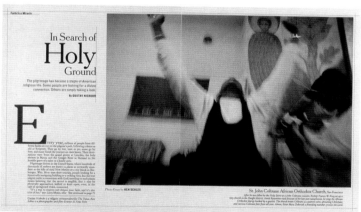

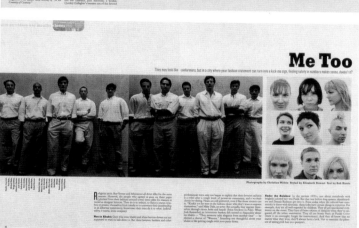

Publication The New York Times Magazine
Art Director Janet Froelich
Designers Lisa Naftolin, Joel Cuyler
Photo Editor Kathy Ryan
Photographers Michael O'Neill, Gilles Peress, Christian Witkin
Publisher The New York Times
Issue October 19,997
Category Feature Story

Publication The New York Times Magazine
Art Director Janet Froelich
Illustrator Nancy Harris
Photo Editor Sarah Harbutt
Publisher The New York Times
Issue December 7, 1997
Category Feature Story

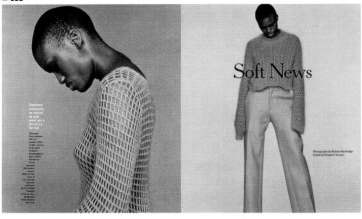

Soft News

Photographs by Richard Burbridge
Styled by Elizabeth Stewart

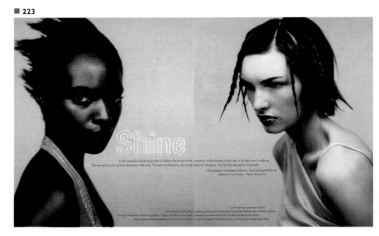

Shine

Photographs by Michelangelo di Battista · Styled by Elizabeth Stewart
Makeup by Tom Pecheux · Hair by Vincente D'o

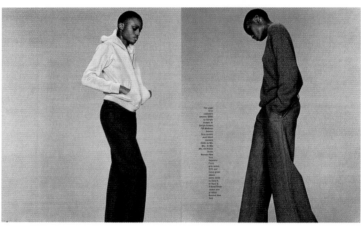

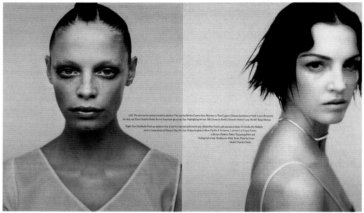

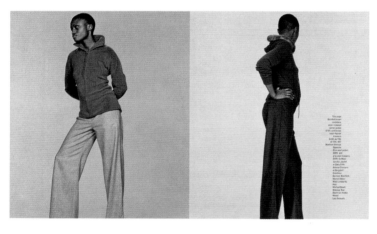

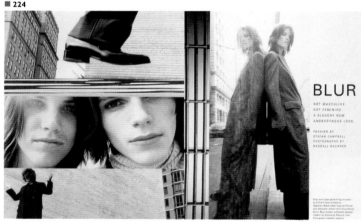

BLUR

NOT MASCULINE
NOT FEMININE
A SLOUCHY NEW
ANDROGYNOUS LOOK.

FASHION BY
STEFAN CAMPBELL
PHOTOGRAPHS BY
RANDALL BACHNER

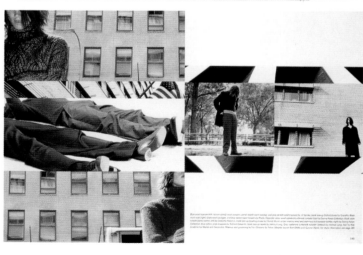

■ 222
Publication
The New York Times Magazine
Art Director Janet Froelich
Designer Lisa Naftolin
Photographer Richard Burbridge
Stylist Elizabeth Stewart
Publisher The New York Times
Category Feature Story

■ 223
Publication
The New York Times Magazine
Art Director Janet Froelich
Designer Lisa Naftolin
Photographer
Michelangelo di Battista
Stylist Elizabeth Stewart
Publisher The New York Times
Category Feature Story

■ 224
Publication Out
Art Director George Karabotsos
Designers George Karabotsos,
Stefan Campbell
Photo Editor Stefan Campbell
Photographer Randall Bachner
Publisher Out Publishing
Issue September 1997
Category Feature Story

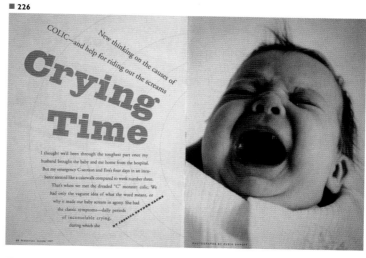

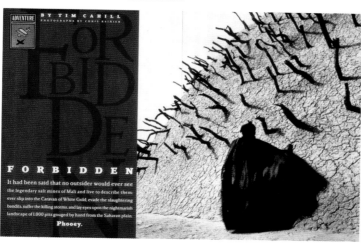

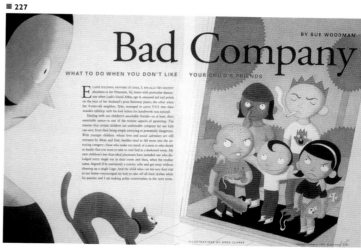

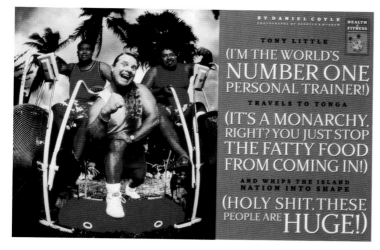

■ 225
Publication Outside
Creative Director Susan Casey
Art Directors Dave Allen, Mike Bain, Sarah Horwitz
Photo Editor Susan B. Smith
Publisher Mariah Media, Inc.
Issue October 1997
Category Entire Issue

■ 226
Publication Parenting
Art Director Susan Dazzo
Designer James Lung
Photo Editor Kate Sullivan
Photographer Zubin Shroff
Publisher Time Inc.
Issue October 1997
Category Feature Spread

■ 227
Publication Parenting
Art Director Susan Dazzo
Designer Susan Dazzo
Illustrator Greg Clarke
Photo Editor Kate Sullivan
Publisher Time Inc.
Issue December 1997/January 1998
Category Feature Spread

■ 228
Publication Philadelphia Magazine
Art Directors Betsy Brecht, Frank Baseman
Designer Betsy Brecht
Photographer David Fields
Publisher Metrocorp
Issue February 1997
Category Feature Spread

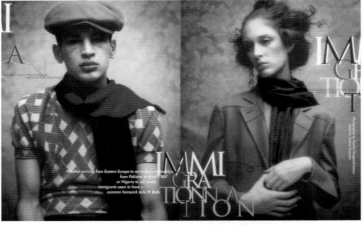

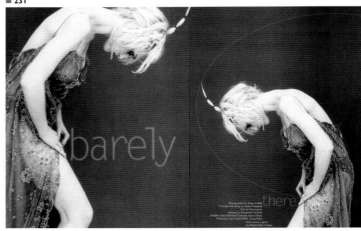

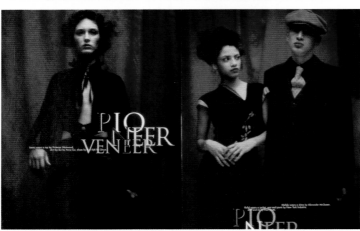

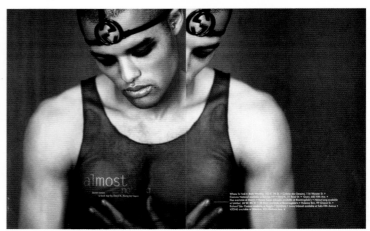

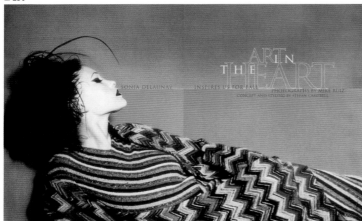

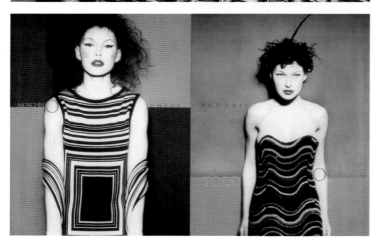

■ 229
Publication Paper
Art Director Bridget De Socio
Designer Albert Lin
Photographer
Martha Hoogland Ivanow
Studio Socio X
Publisher Paper Publishing Co.
Issue September 1997
Category Feature Story

■ 230
Publication Paper
Art Director Bridget De Socio
Designer Lara Harris
Photographer Mike Ruiz
Studio Socio X
Publisher Paper Publishing Co.
Issue September 1997
Category Feature Story

■ 231
Publication Paper
Art Director Bridget De Socio
Designer Albert Lin
Photographer Diego Uchitel
Studio Socio X
Publisher Paper Publishing Co.
Issue July 1997
Category Feature Story

■ 232
Publication Retail I.T.
Art Director Sarika Olenyik
Designer Sarika Olenyik
Studio Ernst & Young
Creative Services
Issue October 1997
Category Contents

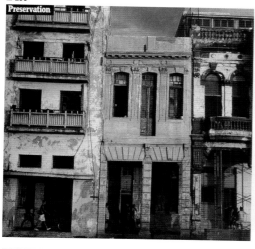

Preservation

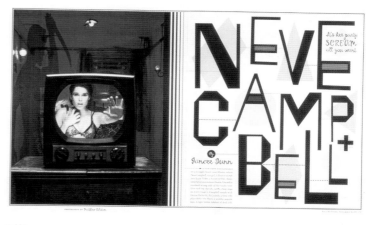

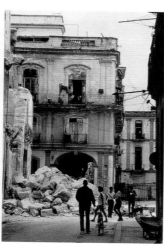

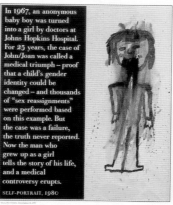

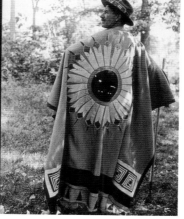

■ 233
Publication Preservation
Art Director Brian Noyes
Designer Brian Noyes
Photographer Scott Warren
Publisher National Trust
for Historic Preservation
Issue September/October 1997
Category Feature Story

■ 234
Publication Smithsonian
Design Director Don Morris
Designers Josh Klenert, Jennifer Starr
Photo Editor Edgar Rich
Photographer Brown Brothers
Issue July 1997
Category Feature Spread

■ 235
Publication Rolling Stone
Art Director Fred Woodward
Designers Fred Woodward,
Geraldine Hessler
Photo Editor Jodi Peckman
Photographer Mark Seliger
Publisher Wenner Media
Issue September 4, 1997
Category Feature Spread

■ 236
Publication Rolling Stone
Art Director Fred Woodward
Designer Geraldine Hessler
Photo Editor Jodi Peckman
Photographer Matthew Rolston
Publisher Wenner Media
Issue September 18, 1997
Category Feature Spread

■ 237
Publication Rolling Stone
Art Director Fred Woodward
Designers Fred Woodward,
Gail Anderson
Illustrator John/Joan
Publisher Wenner Media
Issue December 11, 1997
Category Feature Spread

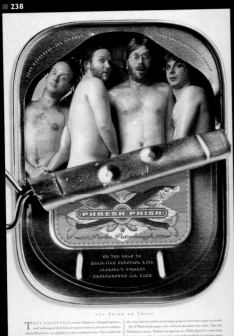

THE X-RATED REDEMPTION OF MARK WAHLBERG

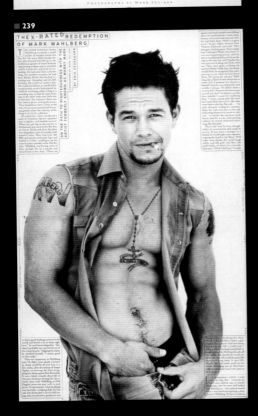

SEXUAL HEALING

RS 775

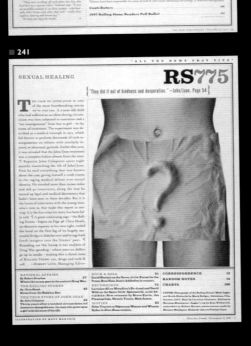

■ 238
Publication Rolling Stone
Art Director Fred Woodward
Designers Fred Woodward,
Geraldine Hessler
Photo Editor Jodi Peckman
Photographer Mark Seliger
Publisher Wenner Media
Issue February 20, 1997
Category Feature Spread

■ 239
Publication Rolling Stone
Art Director Fred Woodward
Designer Eric Siry
Photo Editor Jodi Peckman
Photographer Mark Seliger
Publisher Wenner Media
Issue October 30, 1997
Category Feature Spread

■ 240
Publication Rolling Stone
Art Director Fred Woodward
Designers Fred Woodward,
Gail Anderson
Photo Editor Jodi Peckman
Photographer Jerry
Schatzberg
Publisher Wenner Media
Issue November 13, 1997
Category Contents

■ 241
Publication Rolling Stone
Art Director
Fred Woodward
Illustrator Matt Mahurin
Publisher Wenner Media
Issue December 11, 1997
Category Contents

■ 242
Publication Rolling Stone
Art Director Fred Woodward
Designers Fred Woodward,
Geraldine Hessler
Photo Editor Fiona McDonagh
Photographer Hunter S. Thompson
Publisher Wenner Media
Issue June 12, 1997
Categories Feature Story
 A Spread

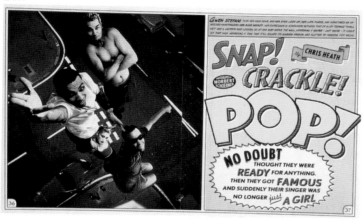

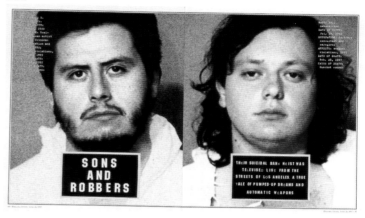

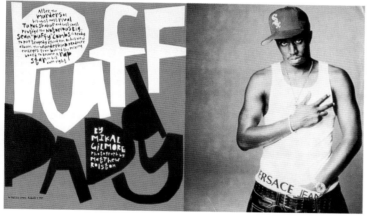

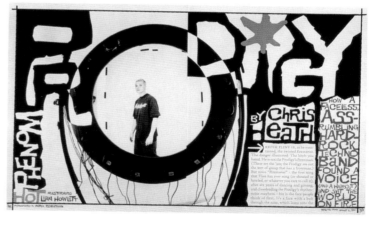

■ 243
Publication Rolling Stone
Art Director Fred Woodward
Designers Fred Woodward,
Lee Bearson
Photo Editor Jodi Peckman
Photographer Dan Winters
Publisher Wenner Media
Issue March 6, 1997
Category Feature Spread

■ 244
Publication Rolling Stone
Art Director Fred Woodward
Designers Fred Woodward,
Gail Anderson
Photo Editor Jodi Peckman
Photographer Norbert Schoerner
Typographer Eric Siry
Publisher Wenner Media
Issue May 1, 1997
Category Feature Spread

■ 245
Publication Rolling Stone
Art Director Fred Woodward
Designer Gail Anderson
Photo Editor Jodi Peckman
Photographer Matthew Rolston
Publisher Wenner Media
Issue August 7, 1997
Category Feature Spread

■ 246
Publication Rolling Stone
Art Director Fred Woodward
Designer Geraldine Hessler
Photo Editor Jodi Peckman
Photographer Anton Corbijn
Publisher Wenner Media
Issue April 17, 1997
Category Feature Spread

■ 247
Publication Rolling Stone
Art Director Fred Woodward
Designers Fred Woodward,
Gail Anderson
Photo Editor Jodi Peckman
Publisher Wenner Media
Issue June 26, 1997
Category Feature Spread

■ 248
Publication Rolling Stone
Art Director Fred Woodward
Designer Geraldine Hessler
Photo Editor Jodi Peckman
Photographer Peter Robathan
Publisher Wenner Media
Issue August 21, 1997
Category Feature Spread

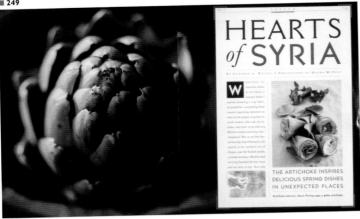

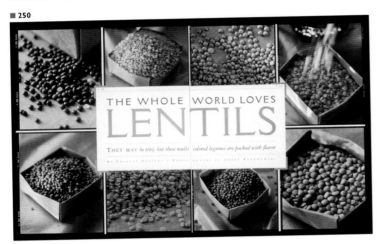

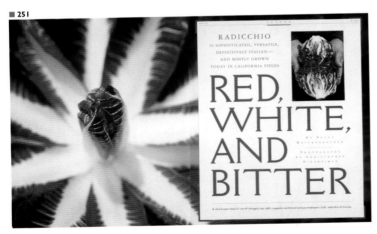

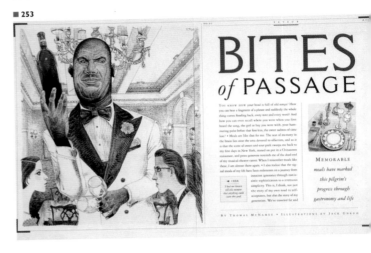

■ 249
Publication Saveur
Creative Director
Michael Grossman
Art Director Jill Armus
Designer Toby Fox
Photo Editor Maura McEvoy
Photographer Maria Millán
Publisher Meigher Communications
Issue March 1997
Category Feature Spread

■ 250
Publication Saveur
Creative Director
Michael Grossman
Art Director Jill Armus
Designer Jill Armus
Photo Editor Maria Millán
Photographer André Baranowski
Publisher Meigher Communications
Issue April 1997
Category Feature Spread

■ 251
Publication Saveur
Creative Director Michael Grossman
Art Director Jill Armus
Designer Jill Armus
Photo Editor Maria Millán
Photographer Christopher Hirsheimer
Publisher Meigher Communications
Issue December 1997
Category Feature Spread

■ 252
Publication Saveur
Creative Director
Michael Grossman
Art Director Jill Armus
Designer Toby Fox
Photo Editor Maria Millán
Photographer Per Breiehagen
Publisher Meigher Communications
Issue May/June 1997
Category Feature Spread

■ d295
Publication Saveur
Creative Director
Michael Grossman
Art Director Jill Armus
Designer Jill Armus
Illustrator Jack Unruh
Photo Editor Maria Millán
Publisher Meigher Communication
Issue July/August 1997
Category Feature Spread

Tailoring Master Trusts to CBO/CLO Structures

New Names Energize Lease Market

Demand Drives 'BB' Auto Deals

HELBS Prepayments Defy Convention

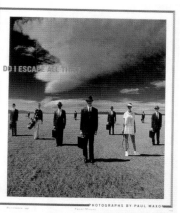

YOU KNOW YOU THINK ABOUT IT. LIKE ON THOSE DAYS WHEN YOUR BOSS HAS BEEN WORKING YOUR NERVES ONE TOO MANY TIMES AND YOU'RE READY TO BELT HIM. LIKE THOSE TIMES WHEN YOU READ YET ANOTHER ARTICLE IN *FORTUNE* MAGAZINE ABOUT THOSE SILICON VALLEY MILLIONAIRES AND YOU SAY TO YOURSELF, 'I'M A LOSER.' LIKE WHEN YOU HEAR A STORY ABOUT A 45-YEAR-OLD CORPORATE OVERACHIEVER WHO DROPPED DEAD OF A HEART ATTACK WHILE WORKING AT HIS DESK IN THE MIDDLE OF THE NIGHT. HERE'S WHAT YOU THINK: HOW DO I ESCAPE ALL THIS?

NET ASSETS

New Issuers Lift Equipment Finance Market To New Heights

All Signs Point To Health And Happiness In The New Year

■ 254

Publication SmartMoney
Art Director Amy Rosenfeld
Designers Amy Rosenfeld, Donna Agajanian, Anna Kula, Julie Lazarus
Illustrator Nick Dewar, Stuart Bradford
Photo Editors Jane Clark, Betsy Keating
Photographers Lizzie Himmel, Paul Maxon, Ken Shung, Brian Smale, Angela Cappetta
Publisher Dow Jones & Hearst Corp.
Issue November 1997
Category Entire Issue

■ 255

Publication Structured Finance
Design Director Sara Burris
Art Director Beth Russo
Designers Steve Mclure, Daniela Di Ono
Publisher Standard & Poor's/McGraw-Hill
Issue December 1997
Category Redesign

S T A N F O R D
M E D I C I N E

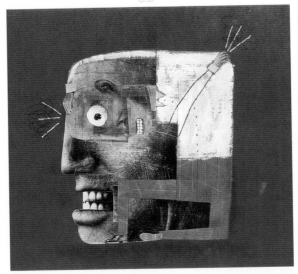

Yes, it hurts. But why?

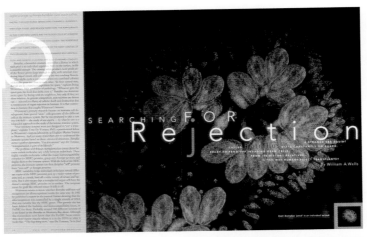

SEARCHING FOR
Rejection

lights, camera, biology in action

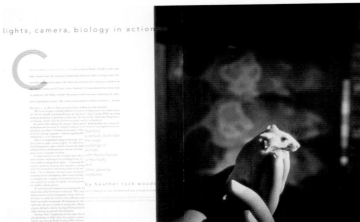

by heather rock woods

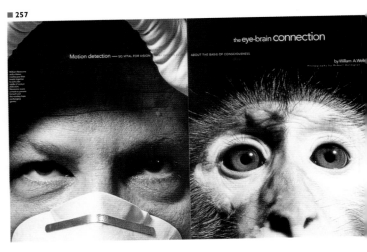

Motion detection — SO VITAL FOR VISION

the eye-brain connection

by William A. Wells

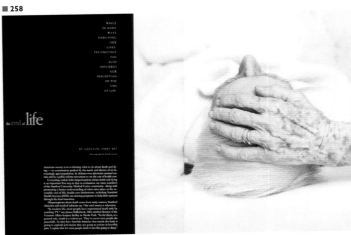

the end . life

BY HASSAUN JONES SEY

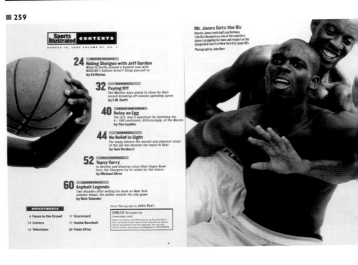

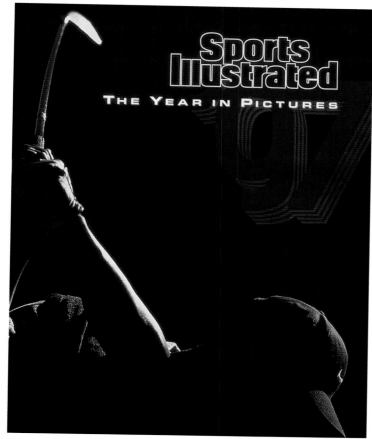

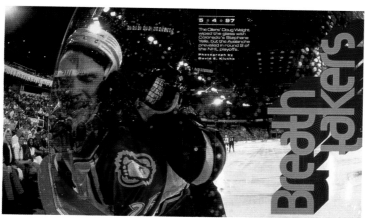

This summer's local number portability trial in Chicago proved that LNP works. It also proved that technology alone can't ensure local competition **By Rachael King** After more than a year of trading complaints, insults, and lawsuits, local service providers needed a little bit of happy news. So when word got out that this

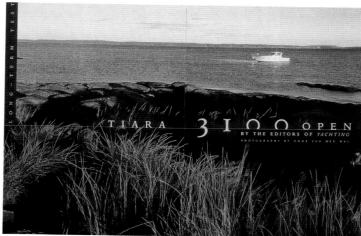

Burn, baby, burn. Texas physicians led fight to pass tough tobacco-control laws for minors
By Teri Moran, Associate editor
For years, Texas antitobacco activists have repeatedly banged their heads against a legislative brick wall. Big Tobacco soundly and adroitly pummeled any legislative efforts to restrict minors' access to tobacco. And session after session,

earnest activists would serve up fresh bills for the tobacco industry to snuff out. It was a sad, seemingly endless cycle.

Until the 1997 session, that is.

260
Publication Sports Illustrated Presents
Art Director Craig Gartner
Designer Michael Schinnerer
Photo Editor Jeff Weig
Publisher Time Inc.
Issue 1997
Category Entire Issue

261
Publication tele.com
Design Director Dennis Ahlgrim
Designer Dennis Ahlgrim
Photographer Robert Vizzini
Publisher McGraw-Hill
Issue December 1997
Category Feature Spread

262
Publication Yachting
Art Director David Pollard
Designer David Pollard
Photographer Onne van der Wal
Publisher Times Mirror Magazines
Issue December 1997
Category Feature Spread

263
Publication Texas Medicine
Designer Kevin Goodbar
Studio Fuller Dyal & Stamper
Publisher Texas Medical Association
Issue August 1997
Category Feature Spread

■ 264

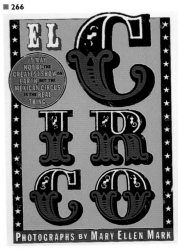

■ 265

Brenham's Paradise Lost

by Mimi Swartz

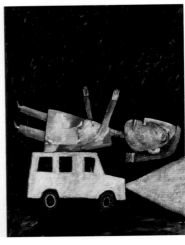

■ 266

EL CIRCO

IT MAY NOT BE THE GREATEST SHOW ON EARTH BUT THE MEXICAN CIRCUS IS THE REAL THING

PHOTOGRAPHS BY MARY ELLEN MARK

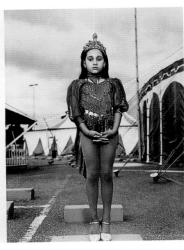

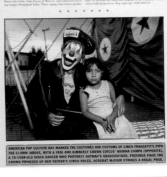

AMERICAN POP CULTURE HAS MARKED THE COSTUMES AND CUSTOMS OF CIRCO FRANZATTI'S PIPO THE CLOWN (ABOVE, WITH A FAN) AND KIMBERLY CROWN CIRCUS' MARINA CAMPA (OPPOSITE), A 79-YEAR-OLD DISCO DANCER WHO PORTRAYS BATMAN'S GRANDMOTHER; PREVIOUS PAGE, THE CROWN PRINCESS OF HER FATHER'S CIRCO ROLEX, ACROBAT MeRIAH STRIKES A REGAL POSE.

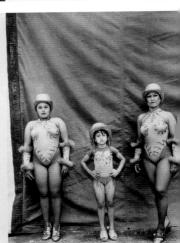

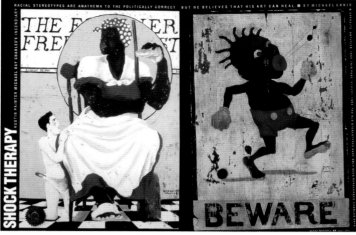

RACIAL STEREOTYPES ARE ANATHEMA TO THE POLITICALLY CORRECT ■ BUT HE BELIEVES THAT HIS ART CAN HEAL ■ BY MICHAEL ENNIS

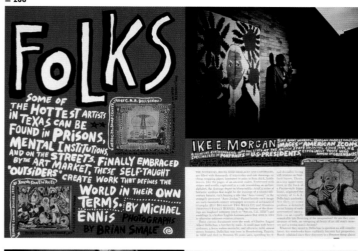

FOLKS

SOME OF THE HOTTEST ARTISTS IN TEXAS CAN BE FOUND IN PRISONS, MENTAL INSTITUTIONS, AND ON THE STREETS. FINALLY EMBRACED BY THE ART MARKET, THESE SELF-TAUGHT "OUTSIDERS" CREATE WORK THAT DEFINES THE WORLD IN THEIR OWN TERMS. BY MICHAEL ENNIS PHOTOGRAPHS BY BRIAN SMALE

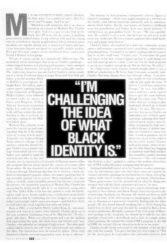

"I'M CHALLENGING THE IDEA OF WHAT BLACK IDENTITY IS."

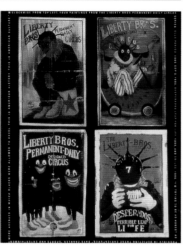

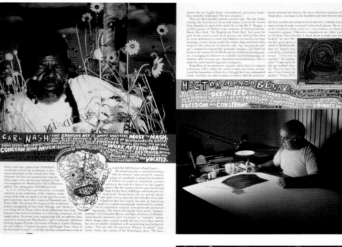

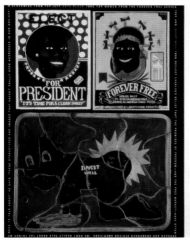

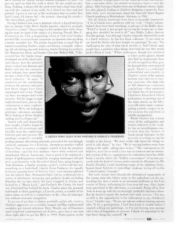

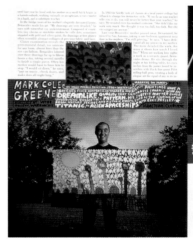

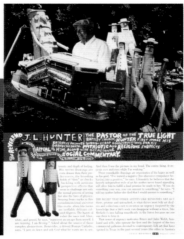

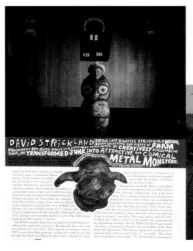

■ 267
Publication Texas Monthly
Creative Director D. J. Stout
Designer D. J. Stout
Illustrator Michael Ray Charles
Publisher Texas Monthly
Issue June 1997
Category Feature Story

■ 268
Publication Texas Monthly
Creative Director D. J. Stout
Designer D. J. Stout
Photo Editor D. J. Stout
Photographer Brian Smale
Publisher Texas Monthly
Issue June 1997
Category Feature Story

■ 269

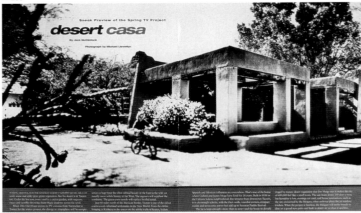

■ 270

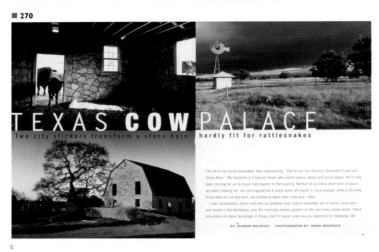

■ 271

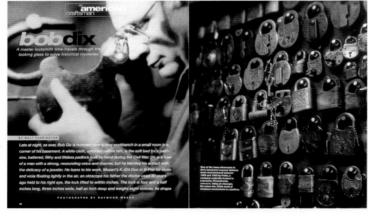

■ 272

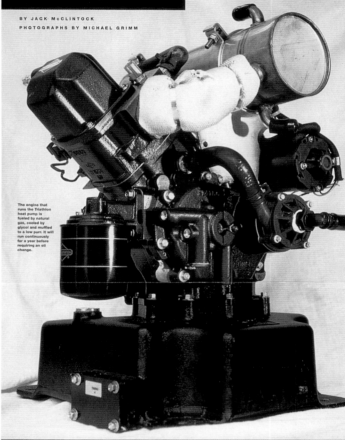

■ 273

■ 269
Publication This Old House
Design Director Matthew Drace
Designer Mo Flan
Photographer Michael Llewellyn
Publisher Time Inc.
Issue January/February 1997
Category Feature Spread

■ 270
Publication This Old House
Design Director Matthew Drace
Art Director Tim Jones
Photographer Robb Kendrick
Publisher Time Inc.
Issue January/February 1997
Category Feature Spread

■ 271
Publication This Old House
Design Director Matthew Drace
Designer Mo Flan
Photographer Raymond Meeks
Publisher Time Inc.
Issue March/April 1997
Category Feature Spread

■ 272
Publication This Old House
Design Director Matthew Drace
Designer Mo Flan
Photographer Tom Wolff
Publisher Time Inc.
Issue July/August 1997
Category Feature Spread

■ 273
Publication This Old House
Design Director Matthew Drace
Designer Mo Flan
Photographer Michael Grimm
Publisher Time Inc.
Issue July/August 1997
Category Feature Spread

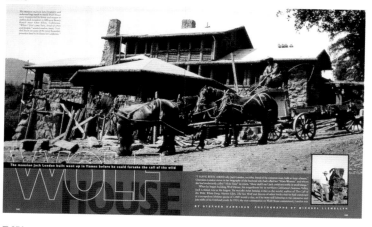

BARN AGAIN

AN AGING VERMONT COWSHED BECOMES THE
SPIRITUAL HEART OF A NEW YORK COUNTRY HOME

WOLF HOUSE

The mansion Jack London built went up in flames before he could forsake the call of the wild

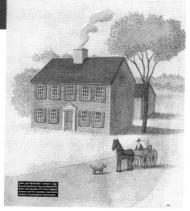

MILTON, MASS.

BUILT BEFORE THE AMERICAN REVOLUTION,
OUR DREAM HOUSE IN MILTON HAS
BEEN HOME TO PURITANS, PATRIOTS,
ABOLITIONISTS AND EVEN A FEW GENTLEFOLK

CRIME SPECIAL REPORT

HOW COPS GO BAD

Brutality, racism, cover-ups, lies:
a guilty police officer tells how the process works

By MICHAEL KRAMER PHILADELPHIA

Blondie intimidated an entire neighborhood of bad characters. He could do you in even if you had done no wrong

"It's all about numbers, like the body count in Vietnam. Others decide whether we get the right guy or not." —BLONDIE

A common joke had it that Philadelphia was a place where children could play cops and robbers at the same time

■ 274
Publication This Old House
Design Director Matthew Drace
Art Director Tim Jones
Photographer David Barry
Publisher Time Inc.
Issue September/October 1997
Category Feature Spread

■ 275
Publication This Old House
Design Director Matthew Drace
Designer Mo Flan
Photographer Michael LLewellyn
Publisher Time Inc.
Issue September/October 1997
Category Feature Spread

■ 276
Publication This Old House
Design Director Matthew Drace
Art Director Tim Jones
Designer Mo Flan
Illustrator Pierre Le Tan
Photographer Pierre Le Tan
Publisher Time Inc.
Issue November/December 1997
Category Feature Spread

■ 277
Publication TIME
Art Directors Susan Langholz,
Arthur Hochstein
Illustrator Amy Guip
Photo Editor Hillary Raskin
Publisher Time Inc.
Issue December 15, 1997
Category Feature Story

ROBERT REDFORD'S SUNDANCE RESORT

TRAVEL & LEISURE
secrets of Provence

Double Happiness in Shanghai
Mexico's Ultimate Seaside Village
Geneva: The Best Places to Stay, Eat, Shop

UNOFFICIAL **NASHVILLE**
SKIP THE RHINESTONE COWBOY CORN PONE AND DIG DOWN TO THE REAL ROOTS OF AMERICA'S MUSIC CITY

By Jesse Kornbluth

Photographed by Norman Jean Roy

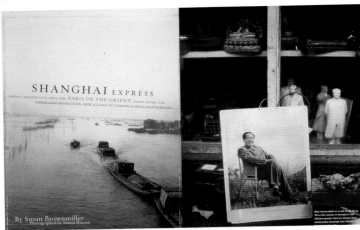

SHANGHAI EXPRESS

CHINA'S BIGGEST CITY, ONCE THE PARIS OF THE ORIENT, FADED AFTER THE COMMUNIST REVOLUTION. NOW, AT LAST, IT'S TAKING A GREAT LEAP FORWARD.

By Susan Brownmiller
Photographed by Simon Watson

NASHVILLE'S BEST LIVE MUSIC

HAS **NOTHING** IN COMMON WITH THE STUFF THAT **AFFLICTS** YOU ON COMMERCIAL COUNTRY RADIO

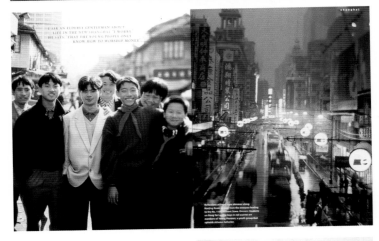

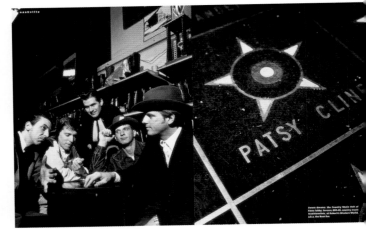

The Marquis de Sade's corner of Provence has changed little since he left it centuries ago. Yet the haunting ruins of Sade's once-imposing château—and the legends of excess that still outrage many of his countrymen—give this bucolic landscape an edge of wildness that time hasn't tamed. By Francine du Plessix Gray Photographed by Stewart Shining

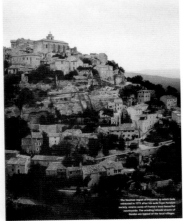

The Vaucluse region of Provence, to which Sade retreated in 1771 after his exile from Parisian society, retains some of France's most beautiful countryside. The winding hillside streets of Gordes are typical of the local villages.

■ 278
Publication Travel & Leisure
Design Director Pamela Berry
Designers Dina White, Valerie Fong, Dan Josephs, Pamela Berry
Photo Editors Jim Franco, Fran Gealer
Publisher American Express Publishing
Issue March 1997
Category Entire Issue

■ 279
Publication Travel & Leisure
Design Director Pamela Berry
Designer Dina White
Photo Editor Jim Franco
Photographers Norman, Jean Roy
Publisher American Express Publishing
Issue April 1997
Category Feature Story

earthly delights
in the quiet countryside
just beyond paris, the journées
des plantes is putting a
decidedly french twist on
flower shows

By Mac Griswold Photographed by Alexandre Bailhache

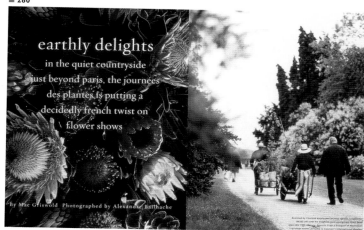

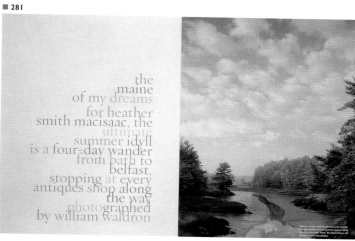

the
of my dreams
maine
for heather
smith macisaac, the
ultimate
summer idyll
is a four-day wander
from path to
belfast,
stopping at every
antiques shop along
the way
photographed
by william waldron

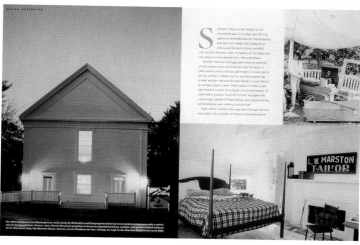

maine antiquing

Rosa Bonheur's studio remains
just as it was in 1899 — complete with a set of
fringed buckskins donated by Buffalo Bill,
who once dropped in

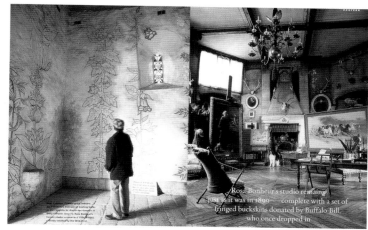

maine antiquing

Lofty, bright,
and quiet, the
chapel at
the Robinhood Free
Meetinghouse is as
uplifting
as a stand of pines,
appealingly plain
as an icebox cake

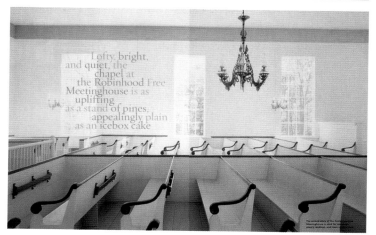

■ 280
Publication Travel & Leisure
Design Director Pamela Berry
Designer Pamela Berry
Photo Editor Jim Franco
Photographer Alexandre Bailhache
Publisher
American Express Publishing
Issue May 1997
Category Feature Story

■ 281
Publication Travel & Leisure
Design Director Pamela Berry
Designer Dan Josephs
Photo Editor Jim Franco
Photographer William Waldron
Publisher
American Express Publishing
Issue July 1997
Category Feature Story

when
Each September, as if by magic, Paris

paris
transforms itself into ■ something suddenly and

comes
entirely new. In his words and drawings.

home
artist Donald Sultan prepares for the fall season

Mizrahi's
could-do
should-do
must-do
list from
A to Tea
by Heather
Smith
MacIsaac
photographed
by Stewart
Shining

isaac does
LONDON

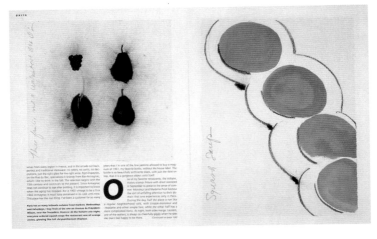

In the heart of
Morocco lies a onetime
fortress city that still
has an air of secrecy—in
its maze of alleyways,
its quiet cloisters, its
windowless houses,
Susanna Moore
investigates

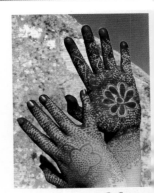

the mysteries of fez

PHOTOGRAPHED BY RUVEN AFANADOR

■ 282
Publication Travel & Leisure
Design Director Pamela Berry
Designer Dan Josephs
Illustrator Donald Sultan
Publisher
American Express Publishing
Issue August 1997
Category Feature Story

■ 283
Publication Travel & Leisure
Design Director Pamela Berry
Designers Valerie Fong,
Dan Josephs, Pamela Berry
Photo Editors
Jim Franco, Fran Gealer
Photographer Ruven Afanador
Publisher
American Express Publishing
Issue October 1997
Category Entire Issue

A Guide to New York's Most Romantic Places

TRAVEL
& LEISURE

thanksgiving in the
Caribbean

The Fabulous Lodges
of New Zealand

Indochina's
Best-Kept Secret

DON'T
LOOK
BACK
BY ANTHONY DeCURTIS

island
pilgrims
photographed by
melanie acevedo

slip on a swimsuit
and pass the turkey.
michael gross
indulges in
a thanksgiving
on st. bart's

SITE
Seeing

A collective and selective
surfing of World Wide Web
sites of typographic interest,
travel tips and literary merit.

The Word Made Pixel
by Matthew Butterick

BECAUSE I AM A TYPE DESIGNER-turned-Internet entrepreneur, colleagues sometimes ask me whether the advent of the Internet spells doom for traditional typography. If the coarse screen resolution and crude font specifications don't annoy you enough, the work of plebeian designers will. There are people designing Web sites who couldn't tell you the difference between Electra and Elektrix if their mouse-clicking finger depended on it. Kerning, leading and tracking have been replaced by their hideous Bizarro-world counterparts: drop shadow, bevel and 3-D rotation.

Do my colleagues have valid concerns or are their opinions mere snobbery? I don't speculate, but rather observe that typography on the Internet may not be great yet, but it exists. Indeed it must exist because text is at the core of the Internet experience, and, I believe, always will be. Typography will always be key.

'I should be
chopping celery
for stuffing'

island habitués
know it's as easy to
avoid the scene as
to make the scene
on chic st. bart's

■ 284
Publication Travel & Leisure
Design Director Pamela Berry
Designers Valerie Fong,
Dan Josephs, Pamela Berry
Photo Editors Jim Franco,
Fran Gealer
Photographer Melanie Aceveo
Publisher
American Express Publishing
Issue November 1997
Category Entire Issue

■ 285
Publication Unlimited
Creative Director Robb Allen
Art Director Eugene Wang
Designer Brian Kelly
Photo Editor Andrea Jackson
Photographer Beth Herzhaft
Publisher
Hachette Filipacchi Magazines, Inc.
Client Philip Morris
Issue August 1997
Category Feature Spread

■ 286
Publication U & lc
Creative Director Maryjane Fahey
Designer Ariel Cepeda
Studio Roger Black Partners
Publisher
International Typeface Corp.
Issue Fall 1997
Category Feature Spread

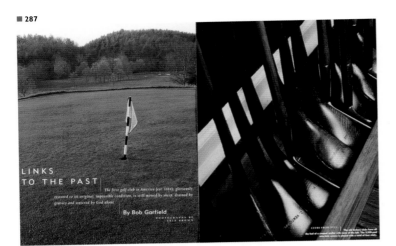

LINKS
TO THE PAST

The first golf club in America (est. 1888), gloriously restored to its original, impossible condition, is still mowed by sheep, drained by gravity and watered by God alone.

By Bob Garfield

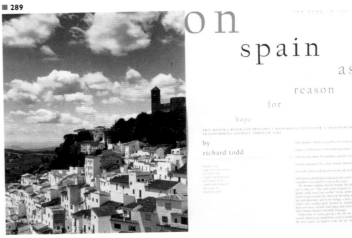

on spain

as

reason

for

hope

by
richard todd

M E N
IN
H A T S

First, for the brave, came knickers. Now, for après golf, comes weather recherche du temps perdu . . . a time when most men wore hats.

PRODUCED BY CAROLINE CONWAY
PHOTOGRAPHS BY RODNEY SMITH

The light
Every
traveler
to Andalusia is transfixed by it.
The intense light and dry heat . . . the
brightness an absolution of the spirit.

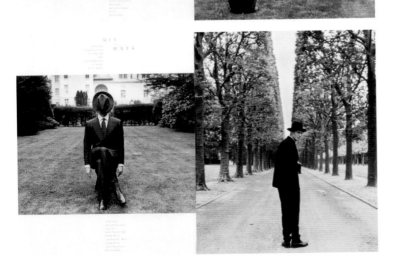

■ 287
Publication Travel & Leisure Golf
Design Director Tom Brown
Designer Tom Brown
Photo Editor Leora Kahn
Photographer Skip Brown
Publisher
American Express Publishing
Category Feature Spread

■ 288
Publication Travel & Leisure Golf
Design Director Tom Brown
Designer Tom Brown
Photo Editor Leora Kahn
Photographer Rodney Smith
Publisher
American Express Publishing
Category Feature Story

■ 289
Publication Travel & Leisure Golf
Design Director Tom Brown
Designer Tom Brown
Photo Editor Leora Kahn
Photographer John Huba
Publisher
American Express Publishing
Category Feature Story

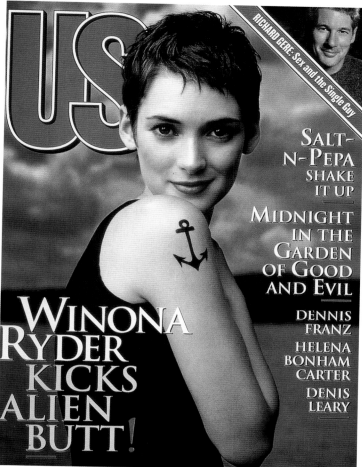

WOODY ALLEN

AMERICA'S MOST FAMOUS AUTEUR MAKES A MUSICAL, BUT HE ISN'T SINGING THE BLUES ABOUT THE SCANDAL THAT ROCKED HIS WORLD

BY JOHANNA SCHNELLER

PHOTOGRAPH BY MICHAEL O'NEILL

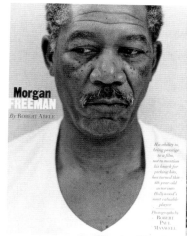

Morgan FREEMAN
By ROBERT ABELE

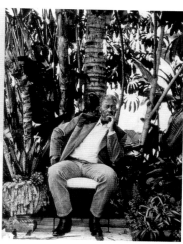

RENAISSANCE MAN: The actor and activist gets real about politics, movies and marriage

Richard Gere

Interview BY JOHANNA SCHNELLER Photograph BY MARY ELLEN MARK

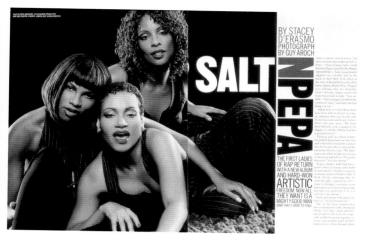

BY STACEY D'ERASMO

PHOTOGRAPH BY GUY AROCH

SALT N PEPA

THE FIRST LADIES OF RAP RETURN WITH A NEW ALBUM AND HARD-WON ARTISTIC FREEDOM. NOW ALL THEY WANT IS A MIGHTY GOOD MAN (AND THAT'S HARD TO FIND)

■ 290

Publication US
Art Director Richard Baker
Designers Bess Wong, Rina Migliaccio
Photo Editor Jennifer Crandall
Photographer Guy Aroch
Publisher US Magazine Co., L. P.
Issue December 1997
Category Entire Issue

■ 291

Publication US
Art Director Richard Baker
Designer Daniel Stark
Photo Editor Jennifer Crandall
Photographer Michael O'Neill
Publisher US Magazine Co., L. P.
Issue February 1997
Category Feature Spread

■ 292

Publication US
Art Director Richard Baker
Photo Editors Jennifer Crandall, Rachel Knepfer
Photographer Robert Maxwell
Publisher US Magazine Co., L. P.
Issue May 1997
Category Feature Spread

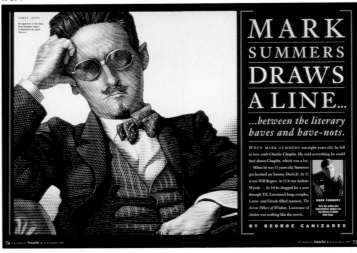

■ 293
Publication US Airways Attaché
Creative Director Michael Grossman
Art Director Paul Carstensen
Designers Paul Carstensen, Michael Grossman
Illustrators Geoff Hunt, Jamie Hogan, Lou Beach, Jon Tomanio,
Mark Matcho, David Cowles, Coco Masuda, Steven Stankiewicz
Photographers Cindy Lewis, Carl Fischer, Mary Ellen Bartley,
Joel Meyerowitz, Ken Druse, Christopher Harting, William Stites
Publisher Pace Communications
Issue July 1997
Category Redesign

■ 294
Publication US Airways Attaché
Creative Director
Michael Grossman
Art Director Paul Carstensen
Designer Paul Carstensen
Illustrator Mark Summers
Publisher Pace Communications
Issue September 1997
Category Feature Spread

■ 295
Publication US Airways Attaché
Creative Director
Michael Grossman
Art Director Paul Carstensen
Designer Paul Carstensen
Photographer Robert Holmgren
Publisher Pace Communications
Issue October 1997
Category Feature Spread

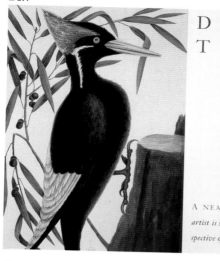

DAPPLED THINGS

A NEARLY FORGOTTEN *naturalist* and *artist* is snatched from obscurity with a new retrospective of his work. *by* MICHAEL CANNELL

AN ASSORTMENT of *creatures—snakes, squirrels, crabs, turtles, corals, lizards, frogs, and beetles—*PARADE ACROSS HIS PAGES.

CATESBY PERSONALLY *translated his watercolors into 220 hand-colored etchings and published them in* A TWO-VOLUME SET.

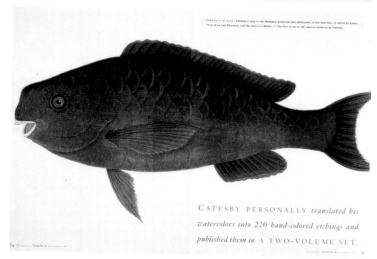

NOW & THEN: THE ANNIVERSARY ISSUE

Birthday Suit

The 25 Most Beautiful Years in Fashion
Plus: Hollywood Heat, Robin Wright Penn, Washington's Social Minefield, the Man Who Created Jenny McCarthy, Andrea Mitchell, Lord...
Best Spas, Daryl K, Bruce Chatwin, Suzy & the Spiciest Girls in Fashion

NOW

TWENTY-FIVE YEARS OF STYLE

& THEN

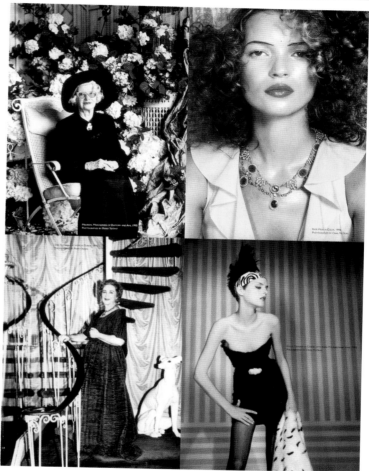

■ 296
Publication US Airways Attaché
Creative Director
Michael Grossman
Art Director Paul Carstensen
Designer Paul Carstensen
Photographer Voldi Tanner
Publisher Pace Communications
Issue December 1997
Category Feature Spread

■ 297
Publication US Airways Attaché
Creative Director
Michael Grossman
Art Director Paul Carstensen
Designer Paul Carstensen
Illustrator Mark Catesby
Publisher Pace Communications
Issue November 1997
Category Feature Story

■ 298
Publication W
Creative Director Dennis Freedman
Design Director Edward Leida
Art Director Kirby Rodriguez
Designers Marcella Bove-Huttie,
Kirby Rodriguez, Edward Leida
Publisher Fairchild Publications
Issue August 1997
Category Entire Issue

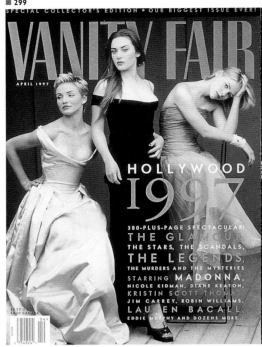
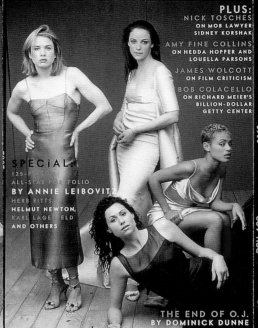
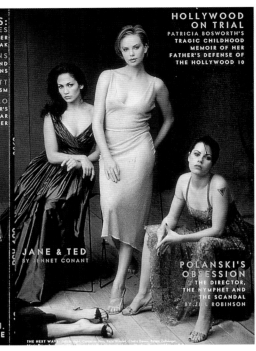

VANITY FAIR

APRIL 1997

SPECIAL COLLECTOR'S EDITION • OUR BIGGEST ISSUE EVER!

PLUS:
NICK TOSCHES
ON MOB LAWYER
SIDNEY KORSHAK

AMY FINE COLLINS
ON HEDDA HOPPER AND
LOUELLA PARSONS

JAMES WOLCOTT
ON FILM CRITICISM

BOB COLACELLO
ON RICHARD MEIER'S
BILLION-DOLLAR
GETTY CENTER

**HOLLYWOOD
ON TRIAL**
PATRICIA BOSWORTH'S
TRAGIC CHILDHOOD
MEMOIR OF HER
FATHER'S DEFENSE OF
THE HOLLYWOOD 10

HOLLYWOOD
1997

380-PLUS-PAGE SPECTACULAR!
THE GLAMOUR,
THE STARS, THE SCANDALS,
THE LEGENDS,
THE MURDERS AND THE MYSTERIES
STARRING **MADONNA,**
NICOLE KIDMAN, DIANE KEATON,
KRISTIN SCOTT THOMAS,
JIM CARREY, ROBIN WILLIAMS,
LAUREN BACALL,
EDDIE MURPHY AND DOZENS MORE...

SPECIAL
125-PAGE
ALL-STAR POP FOLIO
BY ANNIE LEIBOVITZ
HERB RITTS,
HELMUT NEWTON,
KARL LAGERFELD
AND OTHERS

JANE & TED
BY JENNET CONANT

**POLANSKI'S
OBSESSION**
THE DIRECTOR,
THE NYMPHET AND
THE SCANDAL
BY JILL ROBINSON

THE END OF O.J.
BY DOMINICK DUNNE

"There's a sense
that projects of this scale
are important
in defining what L.A.
is becoming."

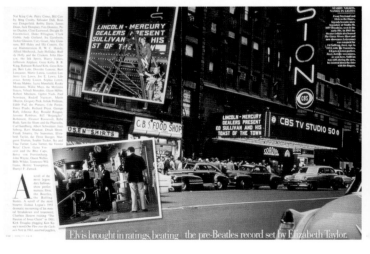

Mr. Sunday Night

Stiff, prudish, and wildly uncharismatic, Ed Sullivan ruled the TV airwaves Sunday night after Sunday night through the 50s and 60s, introducing America to everybody from the Beatles and Elvis Presley to the Moscow Circus, Myron Cohen, and Topo Gigio. Nearly 50 years after the premiere of television's longest-running variety show, NICK TOSCHES reveals why its powerful, enigmatic host was the perfect man for the job

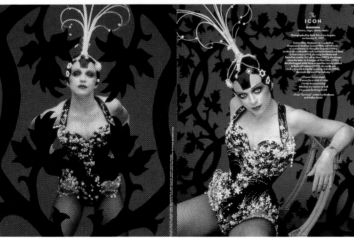

Elvis brought in ratings, beating the pre-Beatles record set by Elizabeth Taylor.

■ **299**
Publication Vanity Fair
Creative Director David Harris
Art Directors Gregory Mastrianni, David Harris, Julie Weiss, Mimi Dutta
Designer John Dixon
Photo Editors Susan White, Lisa Berman, Synhee Grinnell
Photographer Annie Leibovitz
Publisher Condé Nast Publications Inc.
Issue April 1997
Category Entire Issue

■ **300**
Publication Vanity Fair
Creative Director David Harris
Designer Gregory Mastrianni
Photo Editors Susan White, Jeannie Rhodes, Betsy Horan
Publisher Condé Nast Publications Inc.
Issue July 1997
Category Feature Story

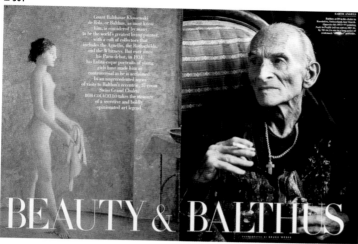

TheWarrenStandard

Volume Four
No. Two
1997

CORPORATE COMMUNICATIONS

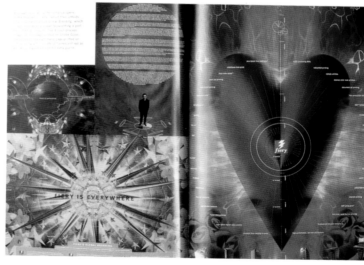

FIERY IS EVERYWHERE

■ 301

Publication Vanity Fair
Creative Director David Harris
Designers Gregory Mastrianni, David Harris
Photo Editors Susan White, Jeannie Rhodes
Photographer Bruce Weber
Publisher Condé Nast Publications Inc.
Issue December 1997
Category Feature Story

■ 302

Publication Warren Standard
Creative Director Cheryl Heller
Design Director Carole Freehauf
Art Director Veronica Oh
Client S.D. Warren
Issue December 1997
Category Entire Issue

■ 303

The Washington Post Magazine

What Should Teachers Know?

And What Should Students Read?

Amy Virshup on teacher standards Michael Dirda on multiculturalism
Plus: Jay Mathews on smart strategies for adults headed back to school

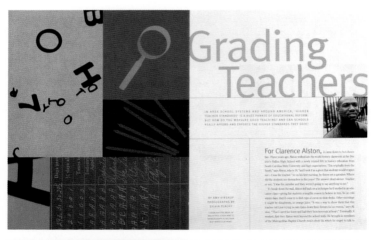

Grading Teachers

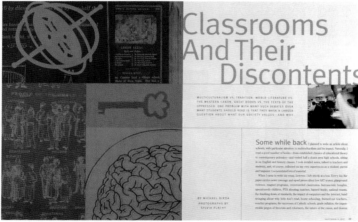

Classrooms And Their Discontents

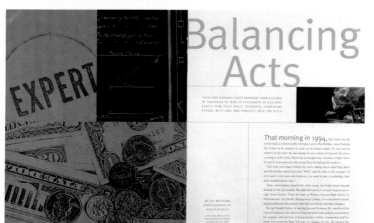

Balancing Acts

■ 304

THE RED CROSS WENT INTO CHECHNYA TO HELP WAR
VICTIMS. THEN SIX OF ITS OWN WORKERS WERE MURDERED—
SHAKING THE ORGANIZATION TO ITS CORE AND CHALLENGING ITS
BELIEFS ABOUT THE NEUTRAL DELIVERY OF HUMANITARIAN AID

'HOW DID WE DESERVE THIS?'

BY LEE HOCKSTADER

■ 305

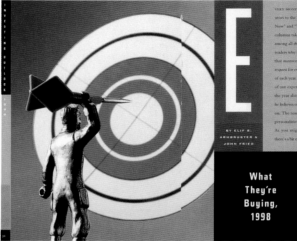

What They're Buying, 1998

■ 306

KEEPING IT

PROTECTING PAPER PROFITS

■ 303
Publication
The Washington Post Magazine
Art Director Kelly Doe
Designers Kelly Doe, Lisa Schreiber
Photo Editor Karen Tanaka
Photographer Sylvia Plachy
Publisher The Washington Post Co.
Issue November 9, 1997
Category Entire Issue

■ 304
Publication
The Washington Post Magazine
Art Director Kelly Doe
Designer Lisa Schreiber
Photo Editor Crary Pullen
Publisher The Washington Post Co.
Issue August 17, 1997
Category Feature Spread

■ 305
Publication Worth
Art Director Philip Bratter
Designer Deanna Lowe
Photo Editor Sabine Meyer
Photographer Charles S. Anderson
Publisher Capital Publishing L. P.
Issue December 1997
Category Feature Spread

■ 306
Publication Worth
Art Director Philip Bratter
Designer Deanna Lowe
Photo Editor Sabine Meyer
Photographer Charles S. Anderson
Publisher Capital Publishing L. P.
Issue December 1997
Category Feature Spread

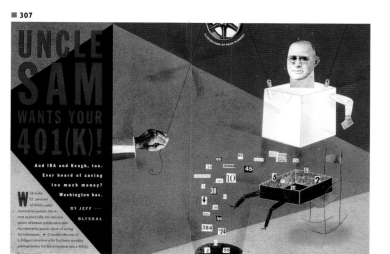

■ 308

■ 311

■ 309

■ 307
Publication Worth
Art Director Philip Bratter
Designers Philip Bratter,
Cynthia Eddy
Illustrator David Plunkert
Publisher Capital Publishing L. P.
Issue April 1997
Category Feature Spread

■ 308
Publication Worth
Art Director Philip Bratter
Designer Lynette Cortez
Illustrator Janet Woolley
Publisher Capital Publishing L. P.
Issue May 1997
Category Feature Spread

■ 309
Publication Worth
Art Director Philip Bratter
Designer Deanna Lowe
Illustrator Paul Davis
Publisher Capital Publishing L. P.
Issue September 1997
Category Feature Spread

■ 310
Publication Worth
Art Director Philip Bratter
Designer Cynthia Eddy
Illustrator John Weber
Publisher Capital Publishing L. P.
Issue October 1997
Category Feature Spread

■ 311
Publication Worth
Art Director Philip Bratter
Designer Deanna Lowe
Publisher Capital Publishing L. P.
Issue November 1997
Category Department

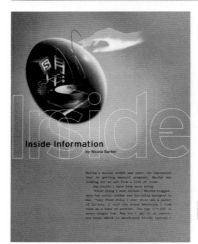

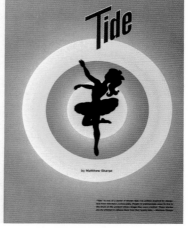

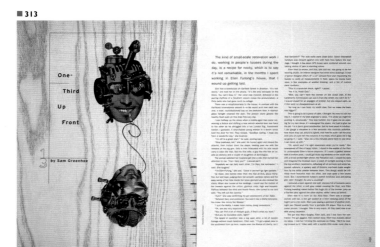

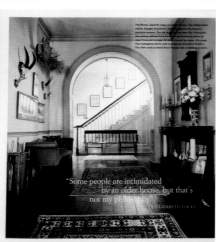

■ 312
Publication Zoetrope Short Stories
Creative Directors Tamar Cohen, David Slatoff
Designers David Slatoff, Tamar Cohen
Illustrator Tamar Cohen
Photographers David Slatoff, Geoff Spear
Studio Slatoff + Cohen Partners Inc.
Publisher AZX Publications
Issue Vol. 1, No. 1
Category Entire Issue

■ 313
Publication Zoetrope Short Stories
Creative Directors Tamar Cohen, David Slatoff
Designers David Slatoff, Tamar Cohen
Illustrator David Plunkert
Studio Slatoff + Cohen Partners Inc.
Publisher AZX Publications
Issue Vol. 1, No. 1
Category Feature Spread

■ 314
Publication
Condé Nast House & Garden
Art Director Diana LaGuardia
Deputy Art Director Nancy Brooke S
Photo Editor Dana Nelson
Photographer William Abranowicz
Publisher Condé Nast Publications Inc.
Issue October 1997
Category Feature Story

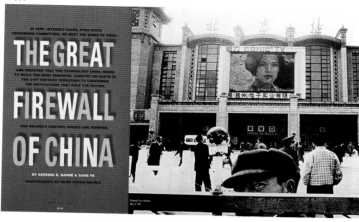

THE GREAT FIREWALL OF CHINA

AT XI'PE, INTERNET CAFÉS, EVEN STATE CENSORSHIP COMMITTEES, WE MEET THE WIRED OF CHINA

AND DISCOVER THAT THE TECHNOLOGY CHINA NEEDS TO BUILD THE MOST POWERFUL COUNTRY ON EARTH IN THE 21ST CENTURY THREATENS TO UNDERMINE THE INSTITUTIONS THAT RULE THE NATION.

AND BEIJING'S CONTROL FREAKS ARE WORRIED

BY GEREMIE R. BARMÉ & SANG YE

PHOTOGRAPHY BY MARK LEONG/MATRIX

THEME & VARIATIONS

Conductor William Christie, who has breathed new life into 17th-century music, does the same for a long-neglected 18th-century house in the west of France.

WRITTEN BY KATRINE AMES
PHOTOGRAPHED BY FRANÇOIS HALARD PRODUCED BY CAROLINA IRVING

■ 316

dress rehearsal

The dramatic restraint of Dominique Sirop's designs is mirrored in a Paris apartment with a theatrical past.

WRITTEN BY WILLIAM NORWICH PHOTOGRAPHED BY GUY HERVAIS
PRODUCED BY CAROLINA IRVING

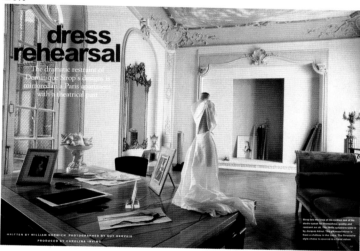

"INFORMATION INDUSTRIES OF CHINA UNITE!"

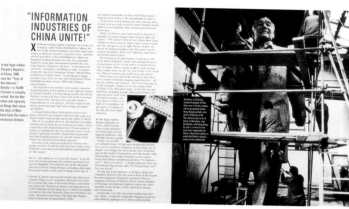

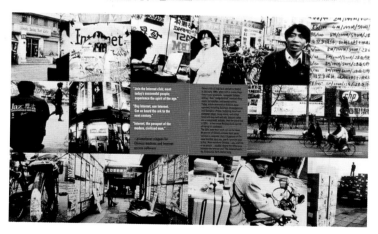

■ 315

Publication
Condé Nast House & Garden
Art Director Diana LaGuardia
Designer Audrey Razgaitis
Photo Editors Deborah Needleman, Dana Nelson
Photographer François Halard
Publisher Condé Nast Publications Inc.
Issue October 1997
Category Feature Spread

■ 316

Publication
Condé Nast House & Garden
Art Director Diana LaGuardia
Deputy Art Director
Nancy Brooke Smith
Photo Editor Dana Nelson
Photographer Guy Hervais
Publisher Condé Nast Publications Inc.
Issue November 1997
Category Feature Spread

■ 317

Publication Wired
Creative Director John Plunkett
Design Director Thomas Schneider
Designer John Plunkett
Photo Editor Erica Ackerberg
Photographer Mark Leong
Publisher Wired Ventures
Issue June 1997
Category Feature Story

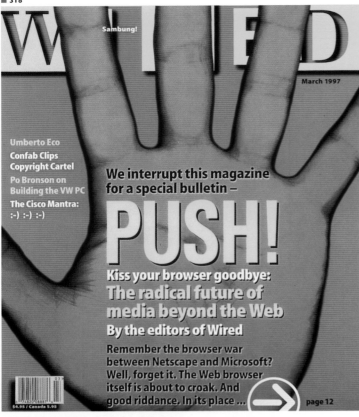

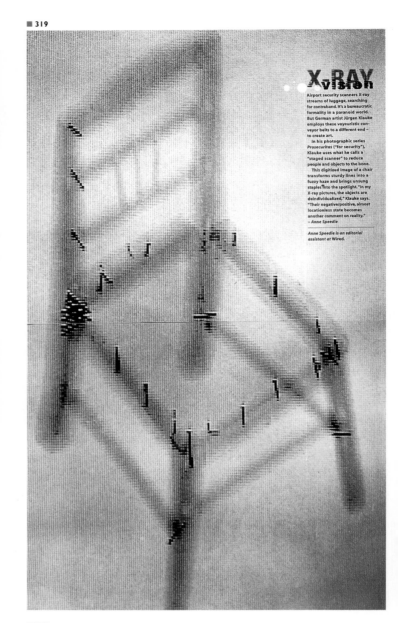

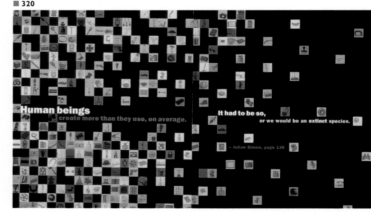

■ 318
Publication Wired
Creative Director John Plunkett
Design Director Thomas Schneider
Designers Eric Courtemanche,
Thomas Schneider, Erik Adigard
Publisher Wired Ventures
Issue March 1997
Category Feature Story

■ 319
Publication Wired
Creative Director John Plunkett
Design Director Thomas Schneider
Designer Eric Courtemanche
Photographer Jürgen Klauke
Publisher Wired Ventures
Issue May 1997
Category Feature Spread

■ 320
Publication Wired
Creative Director John Plunkett
Design Director Thomas Schneider
Designers John Plunkett, Eric
Courtemanche
Illustrator Eric Courtemanche
Publisher Wired Ventures
Issue February 1997
Category Feature Spread

■ 323

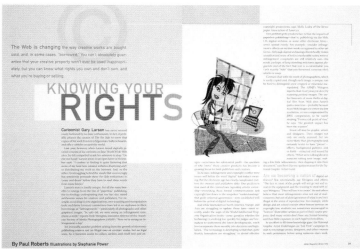

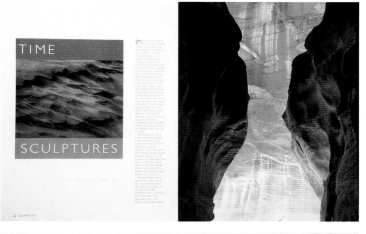

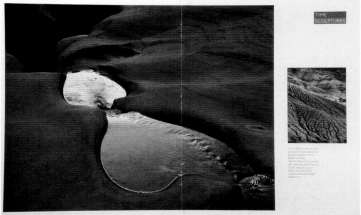

■ 321
Publication Adobe
Art Directors Jenna Ashley, Kathleen Koeneman
Designers Jenna Ashley, Kathleen Koeneman
Illustrators Joyce Hesselberth,
Stephanie Power, Brian Raszka, John Ueland,
Chip Wass, Robert Zimmerman
Photographer Karen Moskowitz, Michael Johnson
Publisher Adobe Systems Inc.
Issue Winter 1998
Category Redesign

■ 322
Publication American Health for Women
Art Director Syndi C. Becker
Designer Syndi C. Becker
Illustrator Anders Wenngren
Photo Editor Phyllis Levine
Publisher R.D. Publications, Inc.
Issue April 1997
Category Feature Spread

■ 323
Publication Arizona Highways
Art Directors Barbara Denney,
Mary Winkelman Velgos
Designer Barbara Denney
Photo Editors Richard Maack, Peter Ensenberger
Photographer Gary Ladd
Publisher Arizona Highways
Issue September 1997
Category Feature Story

■ 324

■ 325

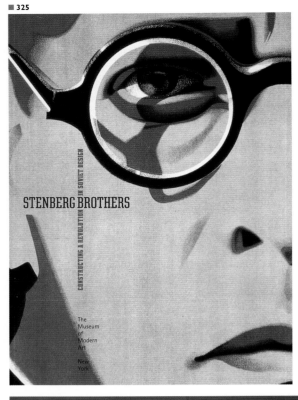

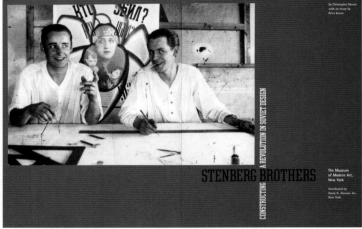

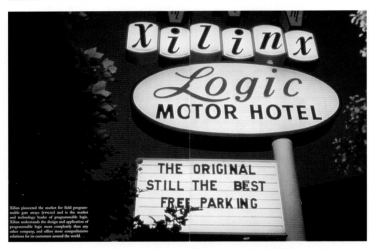

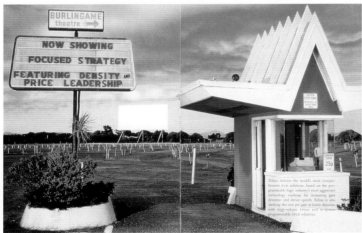

■ 324
Publication Xilinx 1996 Annual Report
Creative Director Bill Cahan
Art Director Bill Cahan
Designer Kevin Roberson
Photographer William McLeod
Studio Cahan & Associates
Issue June 1997
Category Entire Issue

■ 325
Publication Stenberg Brothers
Art Director Michael Bierut
Designers Michael Bierut, Sara Frisk
Studio Pentagram Design
Publisher Department of Publications, Museum of Modern Art, New York
Client Museum of Modern Art, New York
Issue June 1997
Category Entire Issue

DESIGN MERIT ■

The medal of the AIGA, the most distinguished in the field, is awarded to individuals in recognition of their exceptional achievements, services, or other contributions to the field of graphic design and visual communication. The contribution may be in the practice of graphic design, teaching, writing, or leadership of the profession. The awards may honor designers posthumously.

¶ Medals are awarded to those individuals who have set standards of excellence over a lifetime of work or have made individual contributions to innovation within the practice of design.

¶ Individuals who are honored may work in any country, but the contribution for which they are honored should have had a significant impact on the practice of graphic design in the United States.

¶ The Design Leadership Award, also, recognizes the role of perceptive and forward-thinking organizations that have been instrumental in the advancement of design by applying the highest standards, as a matter of policy.

■ 326
Publication AIGA Journal of Graphic Design
Creative Director Sean Adams
Designers Sean Adams, Anna Dolan
Studio Adams Morioka
Publisher American Institute of Graphic Arts
Issue 1997
Category Entire Issue

■ 327
Publication Black Mountain College Dossiers No.4
Creative Director Jon Jicha
Designer Jon Jicha
Studio Jon Jicha Design
Publisher Black Mountain College Museum & Art Center
Issue May 1997
Category Entire Issue

GERON 96
ANNUAL REPORT

WHAT DOES GETTING OLD MEAN TO YOU?

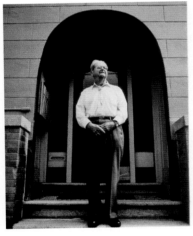

When you bend down
you don't get up as fast.

Take one day
at a time sweetie,

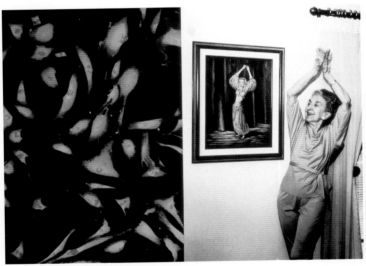

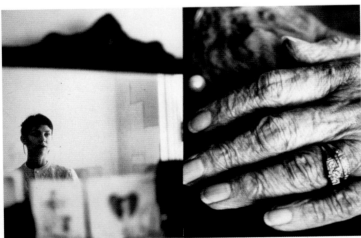

■ 328
Publication Geron 1996 Annual Report
Creative Director Bill Cahan
Art Director Bill Cahan
Designer Bob Dinetz
Photographer William McLeod
Studio Cahan & Associates
Client Geron Corporation
Issue March 1997
Category Entire Issue

■ 329
Publication Geron 1996 Annual Report
Creative Director Bill Cahan
Art Director Bill Cahan
Designer Bob Dinetz
Illustrator Lorraine Maschler, Bob Dinetz
Photographers William McLeod, Etta Clark, Geron Corporation
Studio Cahan & Associates
Client Geron Corporation
Issue March 1997
Category Entire Issue

SOLUTIONS
AREN'T
BOUGHT

THEY'RE CREATED.

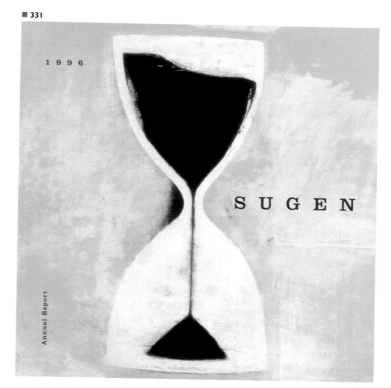

1996

S U G E N

Annual Report

P U L S E

Considering that Klein has made its reputation over the last 22 years as being constantly detailed, precise, and ultimately excessive, the use of the word "value" with a Klein has not been a common adjective. Gary Klein just doesn't like to make anything but the best. Enter the Pulse series: dollar for dollar, ounce for ounce, feature for feature, the best mountain bike value of all time. At featherweight 3.4 lbs., every Pulse is built with Klein Gradient Tube, a relatively new Klein development which varies tube wall thickness by varying wall thicknesses only internally, as opposed to the time consuming process of also tapering externally. While the Attitude is slightly lighter than the Pulse, the weight is relative. Compared to any other manufacturer's top of the line aluminum frame you'll likely find the Pulse a better climber and better handling, because even though it provides great value, it's still a Klein.

■ 330
Publication Klein Catalog
Creative Director Bill Cahan
Art Director Bill Cahan
Designer Bob Dinetz
Illustrator Bob Dinetz
Photographer Robert Schlatter
Studio Cahan & Associates
Client Trek Bicycle Corporation
Issue September 1997
Category Entire Issue

■ 331
Publication Sugen 1996 Annual Report
Creative Director Bill Cahan
Art Director Bill Cahan
Designer Sharrie Brooks
Illustrator Jeffrey Decoster
Photographer Tony Stromberg
Studio Cahan & Associates
Issue March 1997
Category Entire Issue

Publication The Boston Globe
Art Director Rena Anderson Sokolow
Designer Rena Anderson Sokolow
Publisher The Boston Globe
Issue April 20, 1997
Category Feature Single Page

Publication The Boston Globe
Art Director Jacqueline Berthet
Designer Jacqueline Berthet
Publisher The Boston Globe
Issue June 25, 1997
Category Feature Single Page

Publication Dallas Business Journal
Art Director Quincy Preston
Designer Quincy Preston
Illustrator Russ Fordyee, Michael Samples
Photographers Ted Munger, Gus Gustovich
Publisher American City Business Journals
Issue September 12, 1997
Category Contents

Publication Eastsideweek
Art Director Barbara Dow
Designer Barbara Dow
Illustrator Alli Arnold
Publisher Seattle Weekly
Issue September 3, 1997
Category Feature Single Page

Publication Internetweek
Art Director Kip Taylor
Designer Cheryl Gormandy
Publisher CMP Publications Inc.
Issue September 15, 1997
Category Contents

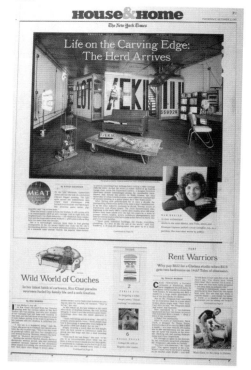

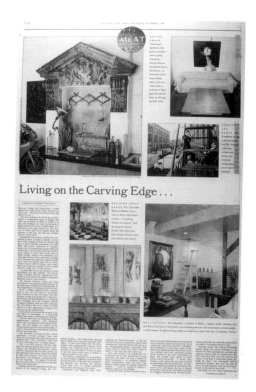

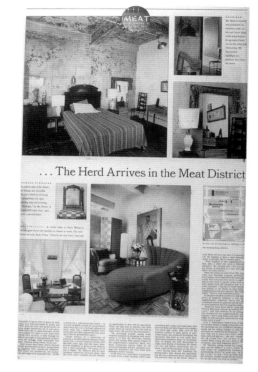

■ 337
Publication The New York Times
Art Director Nancy Kent
Photo Editor Cecilia Bohan
Photographer Fred R. Conrad
Publisher The New York Times
Issue October 2, 1997
Category Feature Story

■ 338
Publication The New York Times
Creative Directors The New York Times Staff
Publisher The New York Times
Issue December 2, 1997
Category Redesign

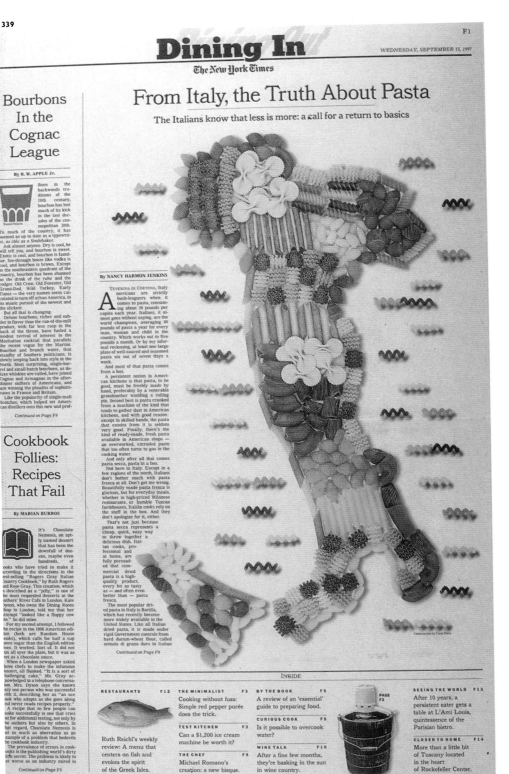

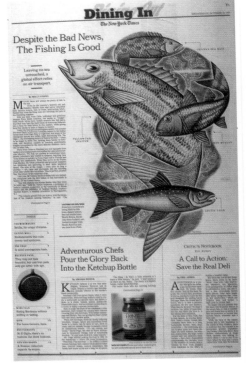

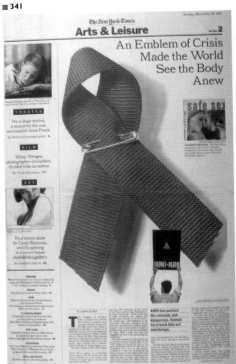

■ 342
Publication The New York Times
Art Director Richard Aloisio
Illustrator Carol Dietz
Publisher The New York Times
Issue September 17, 1997
Category Front Page

■ 340
Publication The New York Times
Art Director Richard Aloisio
Illustrator Paul Hoffman
Publisher The New York Times
Issue October 22, 1997
Category Front Page

■ 341
Publication The New York Times
Art Director Michael Kolomatsky
Photo Editor Edna Suarez
Photographer Naum Kazhdan
Publisher The New York Times
Issue November 30, 1997
Category Front Page

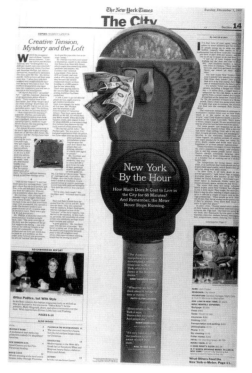

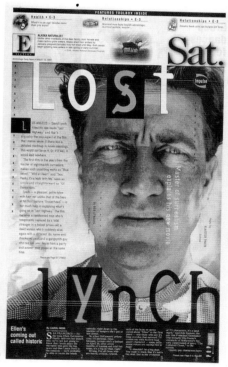

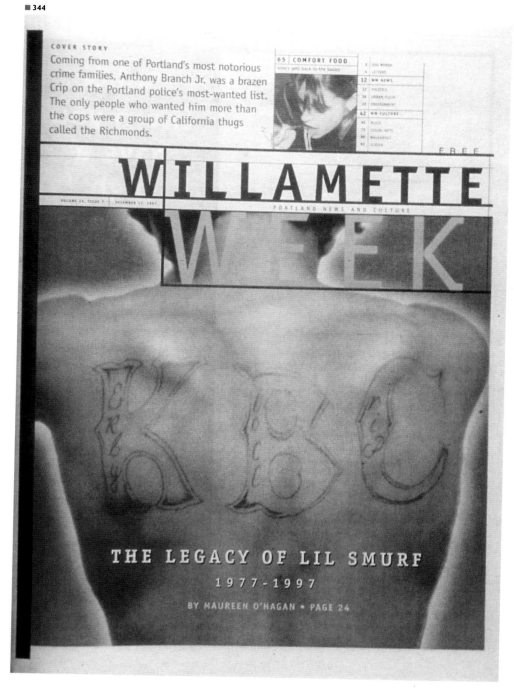

■ 339
Publication The New York Times
Art Director Ken McFarlin
Photographer Thomas Dallal
Publisher The New York Times
Issue December 7, 1997
Category Front Page

■ 343
Publication Anchorage Daily News
Creative Director Lance Lekander
Designer Lance Lekander
Photographer Alaister Thain
Publisher Anchorage Daily News
Issue March 15, 1997
Category Front Page

■ 344
Publication Willamette Week
Art Director Katherine M. Topaz
Designer Katherine M. Topaz
Issue December 17, 1997
Category Front Page

■ 345

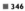

■ 346

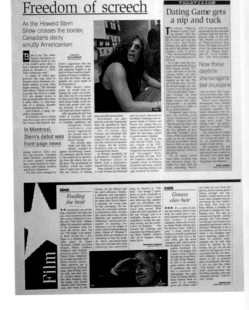

■ 345
Publication The American
Art Director Joseph E. Baron
Designers Joanna K. Dounelis, Tara E. Pastina
Issue March 23, 1997
Category Department

■ 346
Publication The American
Art Director Joseph E. Baron
Designers Joanna K. Dounelis, Tara E. Pastina
Issue October 8, 1997
Category Department

online interactive

CLEMENT MOK

is chairman and founder of the San Francisco-based multidisciplinary and media-agnostic firm Studio Archetype. Mok, whose current clients include Nintendo, QVC, UPS, American Express, NationsBank, Caterpillar and Netscape, has been involved in the design of everything from cyberspace theme parks to expert publishing systems to corporate identity programs. Mok is also the founder of two software product companies: CMCD, publisher of the award-winning *Visual Symbols Library*, and NetObjects, an internet software company whose product, *NetObjects Fusion*, has been cited by *C/net* and *Publish* magazine as the QuarkXPress of Web site authoring software. Prior to forming his own agency, Mok spent five years as a creative director at Apple Computer.

■ 347
Publication I.D. Magazine Online
Creative Director Tony Arefin
Art Director Peter Girardi
Designer Andrea Fella
Photographer James Wojcik
Studio Funny Garbage
Publisher I.D. Magazine
Issues March/April 1997, May 1997, September/October 1997
Category Overall Design

■ 348
Publication HotWired Japan
Creative Director Takeru Esaka
Design Director Hikaru Mochizuki
Art Director Hideaki Maita
Designers Saori C. Suzuki, Nobuharu Yoshida, Mayumi Notake
Publisher HotWired Japan Committee
Online Address www.hotwired.co.jp
Issue September 22, 1997
Category Home Page

■ 349
Publication Mr. Showbiz
Creative Director Kate Thompson
Art Director Cena Pohl
Designers John Smallman, Paul Burgess
Photo Editor Tiffany Middleton
Studio Starwave Corp.
Publisher ABC Internet Ventures
Online Address www.wallofsound.com
Category Entire Issue

AIR JORDAN TRAINER

A performance-enhancement training shoe for the hardest working basketball player on earth.

Original Air Jordans were banned by the NBA because of their color scheme.

FEW ARE CHOSEN

eddie jones

The Los Angeles Lakers star shooting guard takes his title literally. He shoots. He guards. And he finishes with flair that borders on...well, Jordanesque.

■ 350
Publication Jumpman
Creative Directors Aaron Sugarman, Andrew Leitch, Deanne Draeger
Art Director PJ Loughran
Designers Sabine Roehl, Vanessa Pineda, PJ Loughran
Studio AGENCY.COM
Client Nike
Online Address www.jumpman.com
Category Feature Story

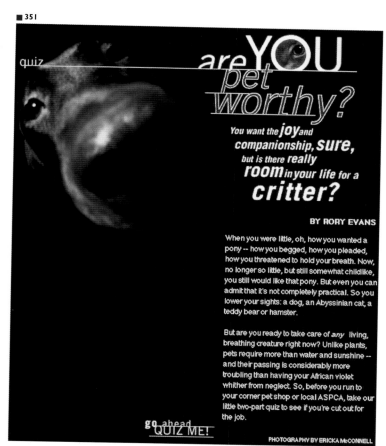

quiz

are YOU pet worthy?

You want the *joy* and companionship, **sure**, but is there really **room** *in your life for a* *critter?*

BY RORY EVANS

When you were little, oh, how you wanted a pony -- how you begged, how you pleaded, how you threatened to hold your breath. Now, no longer so little, but still somewhat childlike, you still would like that pony. But even you can admit that it's not completely practical. So you lower your sights: a dog, an Abyssinian cat, a teddy bear or hamster.

But are you ready to take care of *any* living, breathing creature right now? Unlike plants, pets require more than water and sunshine -- and their passing is considerably more troubling than having your African violet whither from neglect. So, before you run to your corner pet shop or local ASPCA, take our little two-part quiz to see if you're cut out for the job.

go ahead
QUIZ ME!

PHOTOGRAPHY BY ERICKA McCONNELL

Part 1 do you have what it takes?

1. **Your car is often:**
○ washed and/or vacuumed.
○ ticketed and/or towed.

2. **Your potted plants:**
○ are your closest confidants. Who knew bonsai trees were such good listeners?
○ make handy ashtrays.

3. **You have a very good sense of:**
○ where you'll be in 10 years.
○ smell.

4. **You've worn dirty underwear:**
○ just once, when you went on a long road/camping/Outward Bound trip.
○ on a fairly regular basis since you were a kid. In fact, you wonder, does wearing the same undies for four consecutive days qualify them as "dirty"?

5. **Your time:**
○ is scheduled down to the last nanosecond.
○ is your own. For instance, you like to blow out of town for the weekend on a nanosecond's notice.

6. **You believe:**
○ in spaying or neutering cats and dogs -- controlling their population makes life better for the ones who are alive.
○ that cats really do have nine lives.

7. **If you had to choose, you would rather be**
○ needed.
○ loved.

8. **You want a pet:**
○ because you have a lot to offer in the way of loving attention, but not in the cheesy, relationship sort of way.
○ that will complement your personal style in

a dog's life...

Myth: Canines always outlive felines. Fact: Cats generally survive many years more than dogs -- and that isn't even counting their nine lives. Felines usually go on for 14 to 18 years, while most dogs make it only 10 to 15, max (small pooches, by the way, tend to outlast large ones). The record-setters in each species: An Australian cattle dog named Bluey defied death for 29 years, 5 months; while Puss, a tabby cat from England, died the day after his 36th birthday.

ONLINE SILVER

Part 2 what pet suits you best?

1. **Your apartment:**
◉ is a testament to the powers of your very close friends, Mr. Clean, the Scrubbing Bubbles and Spic & Span.
◉ is large enough to accommodate another creature, great or small, wise and wonderful.

2. **When you get home after a long day, you want nothing more than:**
◉ to be left alone while you do stuff like open your mail, watch a little TV and/or get ready to go to the gym.
◉ to have your arrival acknowledged and appreciated.

3. **Everything should have its proper and designated little place: the dishes, your keys, your checkbook, your animal companion.**
◉ True
◉ False

4. **A dirty diaper:**
◉ is among the foulest things known to humankind.
◉ should be changed ASAP. (And then disposed of in a garbage bin, not just left between cars in the Wal-Mart parking lot.)

5. **A friend calls in dire need of help. It is a *really* bad time for you. You:**
◉ tell her your situation and offer to call her back in a few hours -- or by tomorrow, at the latest.
◉ realize she needs your help, listen to her and try to help as best you can.

6. **Puppies and kittens:**
◉ are so damned cute.
◉ can grow up to be dogs and cats that are hard of hearing, incontinent, mangy and shedding -- but so what? They're still so damned cute.

7. **Happiness is a warm puppy.**

pets to the *rescue!*

Move over Benji and Lassie -- here are five true tales of animal heroism

Agnes Chesney of Sunbright, Tenn., credits her dog, Molly, with saving her life. The 69-year-old widow, who is partially disabled and nearly deaf, woke at 2 a.m. when Molly pulled back the bedcovers, then licked and tugged at her. Thinking the dog wanted to go outside, Chesney put on her shoes and headed for the door. When she got to the living room, she saw that her front porch was on fire. Both dog and owner escaped unharmed.

Her eyes blistered shut and her paws singed, a stray cat saved her five kittens from a fire that destroyed an abandoned building in Brooklyn. An animal-shelter worker named her Scarlett for her reddish coat and scrappy attitude, and her story drew thousands of adoption offers.

a 10-year-old boy with Down's syndrome, who'd wandered away and gotten lost in a gully near his home. Even with the sheriff's department and 350 volunteers searching, it was three days before Josh was found. He'd survived in freezing temperatures only because the dogs slept on top of him and brought him food they had stolen from the provisions of rescue workers.

Two-year-old Gene Reeves was playing outside his house in Mesa, Ariz., when a rattlesnake appeared. The family cat, Mary Poppins, managed to hold off the rattler until rescue workers arrived.

■ 351
Publication Swoon
Art Director Lesley Marker
Designer Lesley Marker
Photographer Erick McConnell
Publisher CondéNet
Online Address www.swoon.com/quiz/04_pet/intro.html
Issue August 9, 1997
Category Photo Illustration/Story

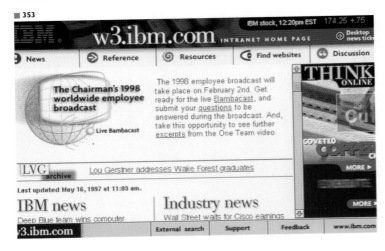

WOUNDED KNEE

ON THE MORNING OF DECEMBER 29, 1890, ON THE BANKS OF WOUNDED KNEE CREEK IN SOUTH DAKOTA, THE U.S. ARMY ATTEMPTED TO DISARM A GROUP OF LAKOTA (SIOUX) INDIANS.

On that day, in an atmosphere of mutual distrust it took only the firing of one gun to begin the

■ 352

Publication Think Online
Creative Directors John Schmitz, Theo Fels
Art Director Theo Fels
Photographer Glen Gyssler
Studio Interactive Bureau
Client IBM
Issue Spring 1997
Categories Entire Issue
 A Home Page

■ 353

Publication IBM
Creative Director Theo Fels
Designer James Caldwell
Studio Interactive Bureau
Client IBM
Issue April 1997
Category Home Page

■ 354

Publication Corbis Images
Creative Director James Wilcher
Design Director Duane Clare
Studio Wilcher Design Inc.
Client Corbis Corporation
Online Address
corbisimages.com/"speaking in visuals"catalogue pages
Issue October 20, 1997
Category Home Page

■ 355

Publication MSNBC Interactive
Creative Director John Lyle Sanford
Art Director Lisa Powers
Designers Scott Irwin, Lisa Powers
Publisher MSNBC
Online Address
www.msnbc.com/onair/msnbc/timeAndAgain/archive/sknee/splash.asp
Category Home Page

■ 356

■ 358

■ 359

■ 360

■ 357

■ **356**
Publication MSNBC Interactive
Creative Director John Lyle Sanford
Art Directors Greg Harris, Lisa Powers, Denise Trabona, Galie Jean-Louis
Designers: Sofia Vecchio, Paul Segner, Kim Carney, Chris Cox, Clay Frost, Jeremy Salyer, Bobby Stevens, Roger Black, Theo Fels, John Schmitz
Photographer Brian Storm
Publisher MSNBC
Online Address www.msnbc.com
Issue August 18, 1997
Category Overall

■ **357**
Publication MSNBC Interactive
Creative Director John Lyle Sanford
Art Director Lisa Powers
Designers Scott Irwin, Lisa Powers
Publisher MSNBC
Online Address www.msnbc.com/onair/msnbc/bwilliams/actup/splash.asp
Category Home Page

■ **358**
Publication MSNBC Interactive
Creative Director John Lyle Sanford
Art Director Galie Jean-Louis
Designer Sofia Vecchio
Photo Editor Brian Storm
Photographer Paul Souders
Publisher MSNBC
Online Address www.msnbc.com/modules/Alaska/default.asp
Category Home Page

■ **359**
Publication MSNBC Interactive
Creative Director John Lyle Sanford
Art Directors Greg Harris, Denise Trabona, Galie Jean-Louis
Designers Andy Beers, Lori Smith, David Guilbault, Dean Wright, Jim Seida, Brian Storm, Larry Dailey, Brian Frick, Clay Frost, Christine Cox, Greg Harris
Publisher MSNBC
Online Address www.msnbc.com/news/Diana_Front.asp
www.msnbc.com/modules/funeralss/funeralss.asp
Category Redesign

■ **360**
Publication MSNBC Interactive
Creative Director John Lyle Sanford
Art Director Galie Jean-Louis
Designer Sofia Vecchio
Photo Editors Brian Storm, Robert Hood
Publisher MSNBC
Online Address www.msnbc.com/modules/inFertility/default.asp
Category Home Page

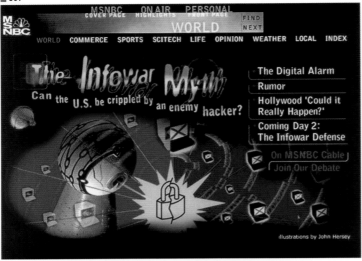

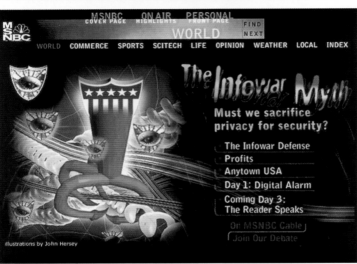

■ 361
Publication MSNBC Interactive
Creative Director John Lyle Sanford
Art Directors Denise Trabona, Galie Jean-Louis
Designer Paul Segner
Illustrator John Hersey
Photo Editor Brian Storm
Publisher MSNBC
Online Address www.msnbc.com/Specials/Infowar/day1/d1splash.asp
Category Home Page

■ 362
Publication MSNBC Interactive
Creative Director John Lyle Sanford
Art Director Galie Jean-Louis
Designer Sofia Vecchio
Illustrator Sofia Vecchio
Publisher MSNBC
Online Address www.msnbc.com
Category Contents or Department

■ 363
Publication MSNBC Interactive
Creative Director John Lyle Sanford
Art Director Galie Jean-Louis
Designer Sofia Vecchio
Illustrator Sofia Vecchio
Publisher MSNBC
Online Address www.msnbc.com
Category Contents or Department

■ 364
Publication MSNBC Interactive
Creative Director John Lyle Sanford
Art Director Galie Jean-Louis
Designer Sofia Vecchio
Photo Editor Brian Storm
Publisher MSNBC
Online Address www.msnbc.com
Category Contents or Department

■ 365
Publication MSNBC Interactive
Creative Director John Lyle Sanford
Art Director Galie Jean-Louis
Designer Sofia Vecchio
Photo Editor Brian Storm
Publisher MSNBC
Online Address www.msnbc.com
Category Contents or Department

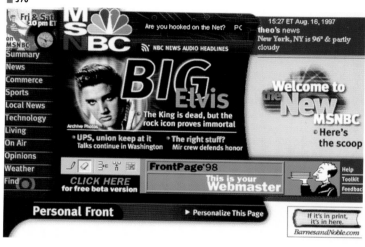

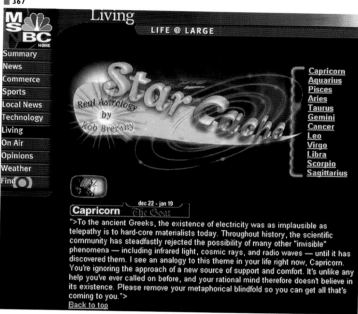

■ 366
Publication MSNBC Interactive
Creative Director John Lyle Sanford
Art Director Galie Jean-Louis
Designer Jeremy Salyer
Illustrator Jeremy Salyer
Publisher MSNBC
Online Address www.msnbc.com
Category Contents or Department

■ 367
Publication MSNBC Interactive
Creative Director John Lyle Sanford
Art Director Galie Jean-Louis
Designers Amy Franceschini, Sofia Vecchio
Illustrator Amy Franceschini
Publisher MSNBC
Online Address
www.msnbc.com/modules/starcache/default.asp
Category Home Page

■ 368
Publication MSNBC Interactive
Creative Director John Lyle Sanford
Art Director Galie Jean-Louis
Designer Jeremy Salyer
Illustrator Jeremy Salyer
Publisher MSNBC
Online Address
www.msnbc.com/modules/stylewatch/week3.asp
Category Home Page

■ 369
Publication MSNBC Interactive
Creative Director John Lyle Sanford
Art Director Greg Harris
Designers Kim Carney, Clay Frost
Publisher MSNBC
Online Address
www.msnbc.com/modules/SEVWX/default.asp
Category Home Page

■ 370
Publication MSNBC Interactive
Creative Director Roger Black
Art Director John Lyle Sanford
Designers John Schmitz, Theo Fels
Studio Interactive Bureau
Publisher MSNBC
Client IBM
Online Address
www.msnbc.com/modules/SEVWX/default.asp
Issue September 1997
Category Home Page

■ 371
Publication National Geographic Online
Creative Director Timothy C. Greenleaf
Art Director Matt Owens
Designers Alan Mazzan, Chris Garvin, Max Wilker
Photographer Timothy C. Greenleaf
Studio methodfive and volumeone
Publisher National Geographic Interactive
Online Address www.nationalgeographic.com/features/97/salem
Issue October 1997
Category Feature Story

■ 372
Publication Salon
Design Director Mignon Khargie
Designer Mignon Khargie
Publisher Salon Magazine
Online Address www.salonmagazine.com/may97/columnists/courtney970528.html
Issue May 28, 1997
Category Spread

■ 373
Publication Swoon
Art Director Warren Corbitt
Designer Barry Deck
Illustrator Claudia Newell
Publisher CondéNet
Online Address www.swoon.com/horoscopes
Issue July 1, 1997
Category Contents or Department

■ 374

■ 375

■ 376

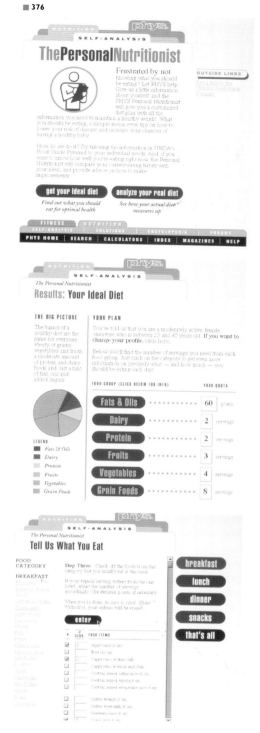

■ 377

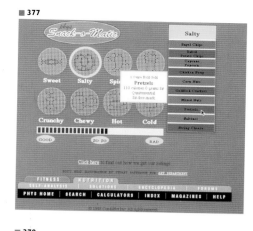

■ 378

■ 374
Publication Swoon
Art Director Lesley Marker
Designer Lesley Marker
Photographer Photodisc
Publisher CondéNet
Online Address
www.swoon.com/features/19_naughty/page2
Issue December 19, 1997
Category Home Page

■ 375
Publication Swoon
Art Director Lesley Marker
Designer Lesley Marker
Illustrator Lesley Marker
Publisher CondéNet
Online Address
www.swoon.com/homepage/970725/index
Issue July 25, 1997
Category Home Page

■ 376
Publication PHYS
Design Director Mark Michaelson
Art Director Flavia Schepmans
Publisher Condé Net
Online Address www.phys.com/b_nutrition/
01self_analysis/06pyramid/pyramid.html
Issue August 14, 1997
Category Feature Story

■ 377
Publication PHYS
Design Director Stephen Orr
Art Director Flavia Schepmans
Illustrator Teri Reub, Stuart Patterson
Publisher Condé Net
Online Address www.phys.com/b_nutrition/
02solutions/04snacko/snacko_detect.htm
Issue August 14, 1997
Category Feature Single Page or Spread

■ 378
Publication PHYS
Art Director Flavia Schepmans
Illustrator John Pirman
Publisher Condé Net
Online Address www.phys.com/a_home/10_28_97
portion/home.htm
Issue October 28, 1997
Category Home Page

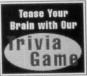

■ 379
Publication Red Rocket
Creative Director John Schmitz
Design Director Laura Eisman
Studio Interactive Bureau
Client Simon & Schuster Learning Technology Group
Online Address www.redrocket.com
Issue November 1997
Categories Entire Issue
　　　　A Home Page

■ 380
Publication Epicurious
Art Director Lizanne Deliz
Designer Lizanne Deliz
Publisher Condé Net
Online Address travel.epicurious.com/travel.epicurios.com
Category Home Page

■ 381
Publication Epicurious
Art Director Lizanne Deliz
Designer Lizanne Deliz
Illustrator John Pirman
Publisher Condé Net
Online Address food.epicurious.com/travel.epicurios.com
Category Home Page

photography

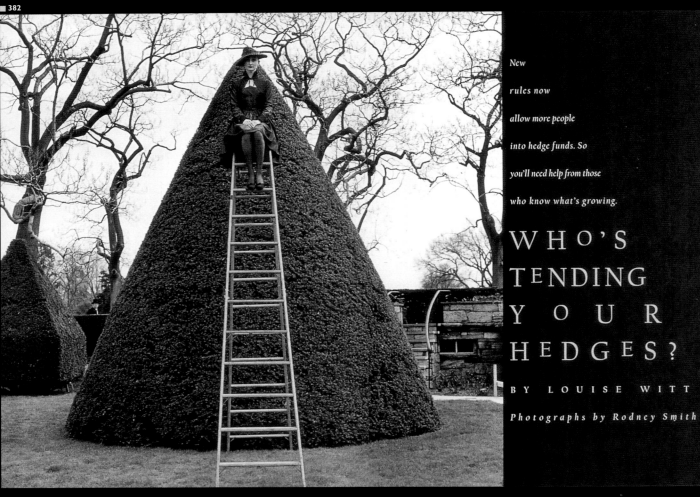

New

rules now

allow more people

into hedge funds. So

you'll need help from those

who know what's growing.

WHO'S TENDING YOUR HEDGES?

BY LOUISE WITT

Photographs by Rodney Smith

89

Hedge fund matchmaking means wealthy investors depend on consultants for entrée

W When investors are too hasty, they abdicate responsibility for their own due diligence.

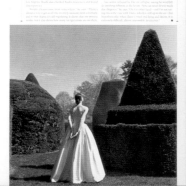

■ 382
Publication Bloomberg Personal Finance
Art Director Carol Layton
Designer Carol Layton
Photo Editor Mary Shea
Photographer Rodney Smith
Publisher Bloomberg L. P.
Issue July/August 1997
Category Photo Illustration/Story

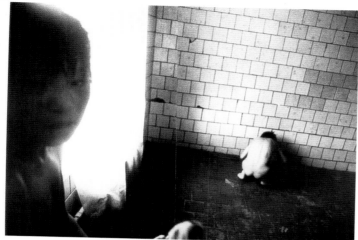

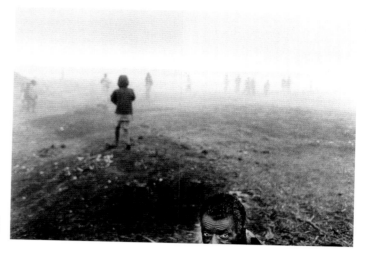

Afghanistan 1987

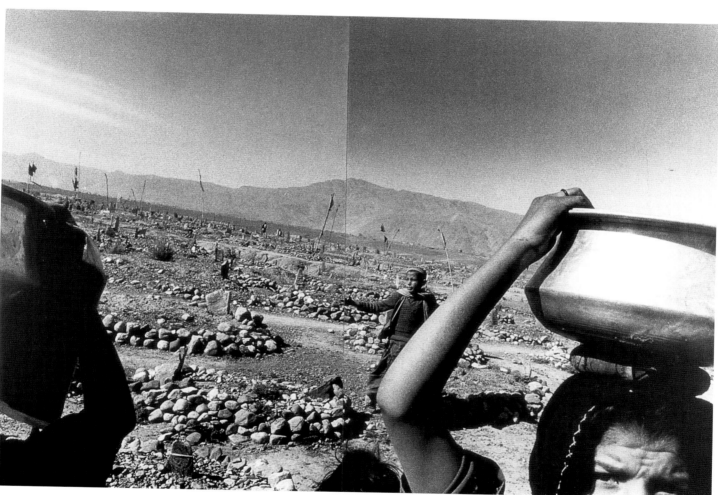

383
Publication Mizerie
Designer Jan Zacharias
Photo Editor Galerie Pecka
Photographer Antonin Kratochvil
Studio Atelier Puda
Publisher Galerie Pecka
Issue April 1997
Category Reportage & Travel/Story

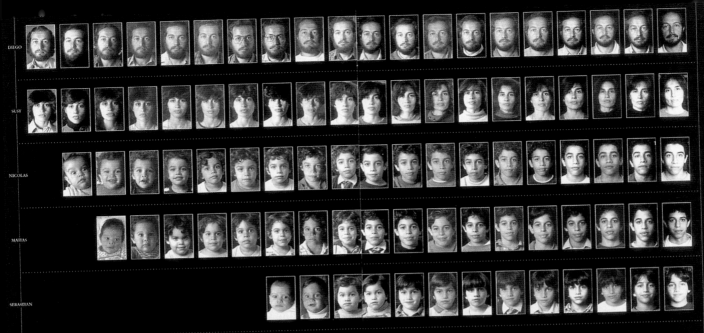

The Arrow of Time

How do we grow? A photographer gives order to the family snapshot album. **BY DIEGO GOLDBERG**

Every year, on June 17, the Argentine photographer Diego Goldberg assembles the members of his family and takes their pictures, one by one. "It started a year after I went to live together with my future wife, Susy," says Goldberg of the ritual he inaugurated 20 years ago. "Her mother said, 'I would like to have a portrait of you.' A year later, I saw the picture hanging in her bedroom, and I said to my wife, 'Why don't we do it again?' The next time I thought, 'We'll include our son.'" In the years since, Goldberg has made the family photo sessions an annual event, adding children as they arrived: Nicolas and Matias were born in Paris when he was working for the photo agency Sygma, and Sebastian after the family relocated to New York. "It's always a little ceremony," says Goldberg, now the photo editor at Clarín, a newspaper in Buenos Aires. "The problem is that I can't stop. It has a life of its own. I've got to feed the monster." Goldberg's photographs are a kind of human time-lapse photography: they catch his subjects in the act of change. And they put a frame around the often haphazard experience of growing up—a bid, as Goldberg puts it, "to stop for a fleeting moment the arrow of time as it passes by." ■

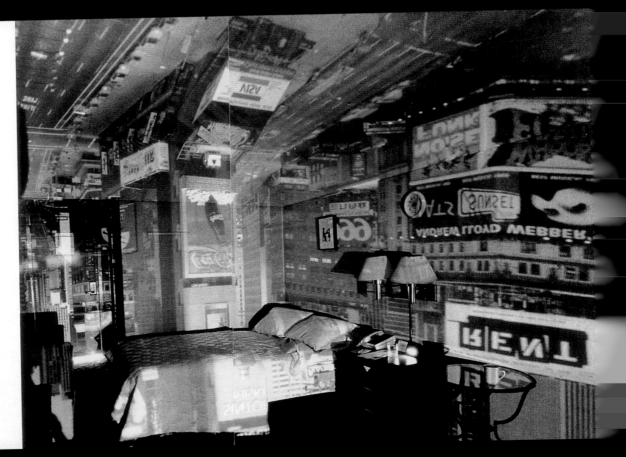

Abelardo Morell
A SIMULATION OF SIGNS

"I want a sort of historical record of what a room sees," says Abelardo Morell, a 48-year-old Cuban immigrant who lives in Brookline, Mass. Thus his penchant for the ancient technique of the camera obscura, in this case constructed by using the room itself as a camera, blacking out all but a half-inch circle of a window — the aperture — in Room 1123 at the Marriott in Times Square. Morell then set a camera on a tripod near the aperture, directing it into the room to record the optical phenomenon. Making a single exposure over two days, he captured a scene of meditative calm — the room — superimposed with the anarchy of Broadway. "Think about how many people go through this site in two days — millions — and no one stood still long enough to get seen," he says. "It's so empty, almost a perverse picture."

March 20-21, 1997: Broadway all at once from a room at the Marriott.

385

Publication The New York Times Magazine
Art Director Janet Froelich
Designer Catherine Gilmore-Barnes
Photo Editor Kathy Ryan
Photographer Abelardo Morell
Publisher The New York Times
Category Reportage & Travel/ Spread

384

Publication The New York Times Magazine
Art Director Janet Froelich
Photo Editor Kathy Ryan
Photographer Diego Goldberg
Publisher The New York Times
Issue February 2, 1997
Category Portrait/Spread

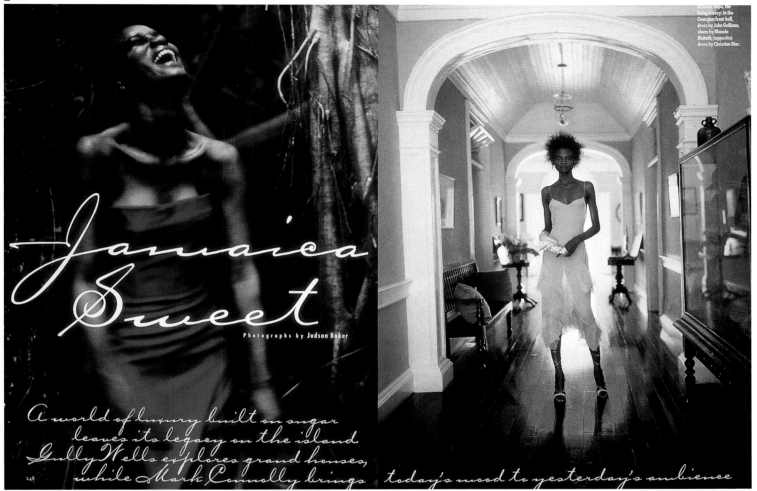

Jamaica Sweet

Photographs by Judson Baker

A world of luxury built on sugar leaves its legacy on the island. Gully Wells explores grand houses, while Mark Connolly brings today's mood to yesterday's ambience

PHOTOGRAPHY SILVER ■

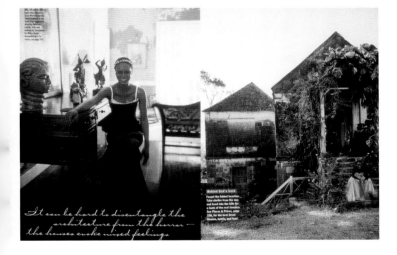

It can be hard to disentangle the architecture from the horror — the houses evoke mixed feelings

I looked down and saw huge vats of liquid fire. It was a scene out of Dante, illustrated by Piranesi

■ 386
Publication Condé Nast Traveler
Design Director Robert Best
Art Director Carla Frank
Photo Editors Mark Connolly, Kathleen Klech
Photographer Judson Baker
Publisher Condé Nast Publications Inc.
Issue September 1997
Category Reportage & Travel/Story

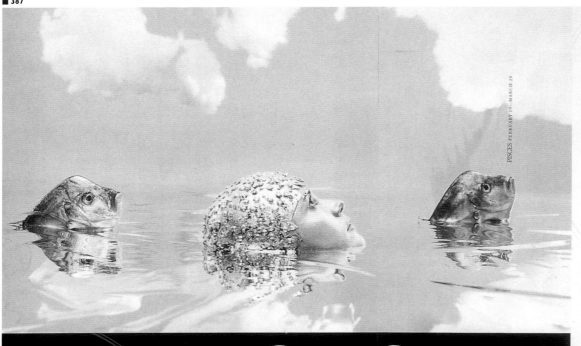

PISCES FEBRUARY 19–MARCH 20

ASTROLOGY IS HOTTER THAN IT'S
BEEN IN FOUR CENTURIES. TO
FIND OUT WHY, OUR WRITER
TRAVELS ACROSS AMERICA, TAKES
A TOUR OF SATURN, VISITS A
SOOTHSAYERS' CONVENTION AND
HAS HIS CHART READ SIX TIMES.

I never thought much about astrology until my first wife fell in love with a German named Nils. As our ailing marriage went terminal, I took to buying armloads of fashion magazines—not for the pretty pictures, which made me only more miserable, but for the horoscopes. I didn't consider myself a believer; still, the stargazers seemed to speak to me personally. They explained that as a Pisces I was sensitive, poetic and spaced-out, while my wife, a Scorpio, was passionate, secretive and vengeful. They promised that the planets would realign—that my pain would be a prelude to rebirth.

That summer I landed in a bachelor studio in Brooklyn, and soon I met a woman I liked too much. I'd planned to sow acres of wild oats before risking my lacerated heart, but on our first date we blabbed until sunrise. The next day, I called to invite her for a walk in the park. Then I paced the apartment in my boxers, too full of terror to decide what else to wear. At last, inspiration struck: Joyce Jillson's horoscope line. "Hello, Pisces," chirped the recording. "Today's lucky color is tangerine." By chance (or perhaps fate), a shirt of that hue lay in my dresser drawer. The walk was very pleasant. Three years later, in that same park, Julie and I were married.

STAR STRUCK
A JOURNEY TO THE NEW FRONTIERS OF THE ZODIAC

By **Kenneth Miller**
Photography by **Hugh Hales-Tooke**

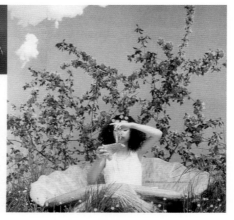

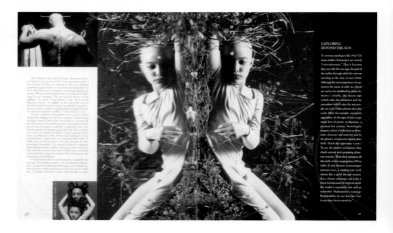

■ 387
Publication LIFE
Design Director Tom Bentkowski
Designer Sam Serebin
Photo Editor David Friend
Photographer Hugh Hales Tooke
Publisher Time Inc.
Issue July 1997
Category Photo Illustration/Story

■ 388
Publication Out
Art Director George Karabotsos
Designers George Karabotsos, Stefan Campbell
Photo Editor Stefan Campbell
Photographer Terry Richardson
Publisher Out Publishing
Issue September 1997
Category Fashion & Beauty/Story

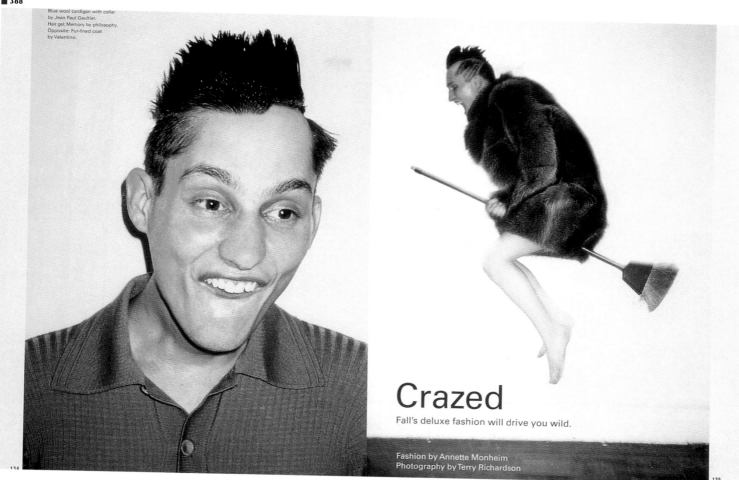

Blue wool cardigan with collar
by Jean Paul Gaultier.
Hair gel: Memory by philosophy.
Opposite: Fur-lined coat
by Valentino.

Crazed

Fall's deluxe fashion will drive you wild.

Fashion by Annette Monheim
Photography by Terry Richardson

134

135

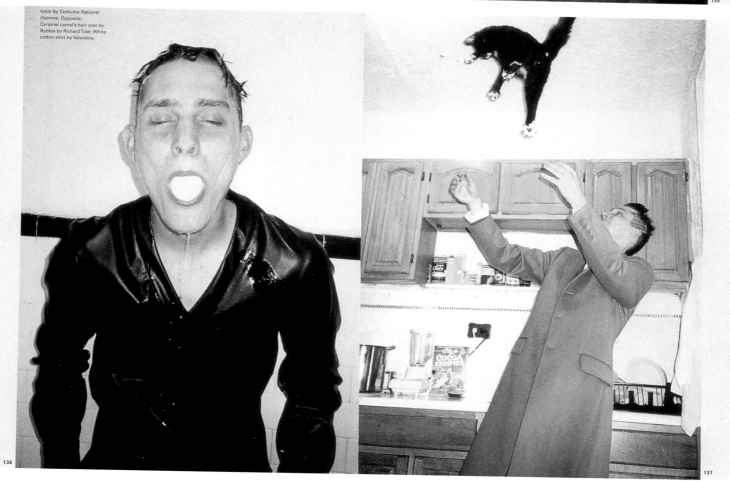

tunic by Costume National
Homme. Opposite:
Caramel camel's hair coat by
Byblos by Richard Tyler. White
cotton shirt by Valentino.

136

137

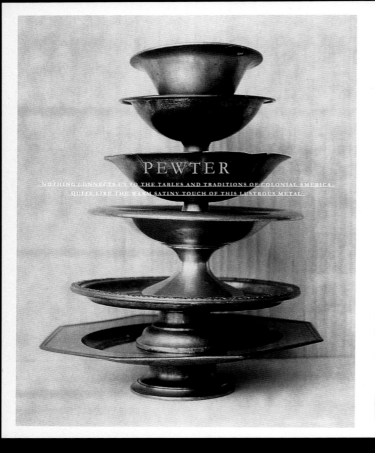

PEWTER

NOTHING CONNECTS US TO THE TABLES AND TRADITIONS OF COLONIAL AMERICA
QUITE LIKE THE WARM SATINY TOUCH OF THIS LUSTROUS METAL.

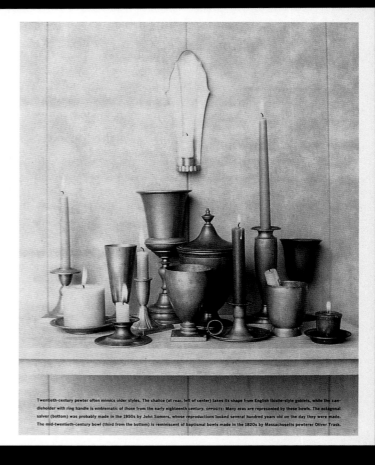

Twentieth-century pewter often mimics older styles. The chalice (at rear, left of center) takes its shape from English thistle-style goblets, while the candleholder with ring handle is emblematic of those from the early eighteenth century. OPPOSITE: Many eras are represented by these bowls. The octagonal salver (bottom) was probably made in the 1950s by John Somers, whose reproductions looked several hundred years old on the day they were made. The mid-twentieth-century bowl (third from the bottom) is reminiscent of baptismal bowls made in the 1820s by Massachusetts pewterer Oliver Trask.

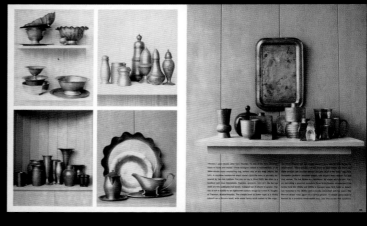

389
Publication Martha Stewart Living
Design Director Eric A. Pike
Designers Fritz Karch, Eric A. Pike
Photo Editor Heidi Posner
Photographer José Picayo
Publisher Martha Stewart Living Omnimedia

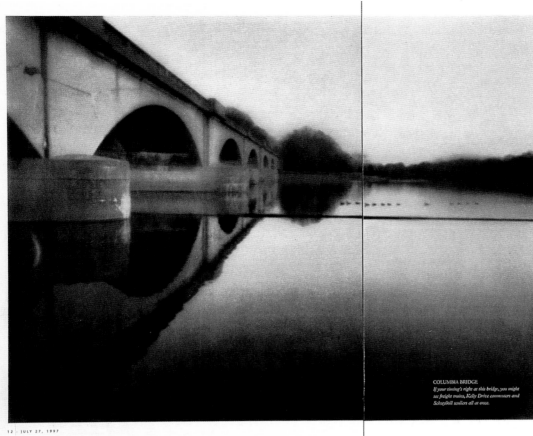

COLUMBIA BRIDGE
If your timing's right at this bridge, you might see freight trains, Kelly Drive commuters and Schuylkill scullers all at once.

12 · JULY 27, 1997

CROSSINGS

PHOTOGRAPHY BY RON TARVER

Wood, concrete, steel or stone: It almost matters less what a bridge is made of than that it is made at all.

Even in their humblest forms, bridges have the power to transform, allowing forays into new lands and joining peoples otherwise estranged. When the Brooklyn Bridge, an engineering marvel in its day, was finished in 1883, a reporter named Montgomery Schuyler wrote in Harper's Weekly, "It so happens that the work which is likely to be our most durable monument, and to convey some knowledge of us to the most remote posterity, is a work of bare utility; not a shrine, not a fortress, not a palace, but a bridge."

Schuyler's words ring truest today in this city sprawled along two rivers and tickled all over by their tributaries. For over Pennypack Creek, in

continued on next page

RON TARVER *is an Inquirer staff photographer.*

STRAWBERRY MANSION BRIDGE
A century old, this Fairmount Park bridge (top) has been called "Philadelphia's Eiffel Tower" for its graceful iron work.

TACONY-PALMYRA BRIDGE
The link between Philadelphia and Burlington County, built in 1929 to replace ferry service, was finished in just 18 months.

INQUIRER MAGAZINE · 13

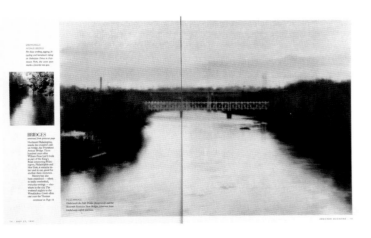

BRIDGES

PHOTOGRAPHY SILVER ■

■ 390
Publication Philadelphia Inquirer Magazine
Art Director Christine Dunleavy
Designers Susan Symick, Christine Dunleavy
Photographer Ron Tarver
Publisher Philadelphia Inquirer
Issue July 27, 1997
Category Reportage & Travel/Story

Larry Towell
THE FELT PRESENCE OF AN ABSENCE

Larry Towell, who lives
on a farm in Ontario, went to
the Port Authority Bus Terminal
expecting to see "squalidness
and a sense of menace." Finding
the building sanitized of open
crime and homelessness, he
gained the confidence of the
building's detective squad and
was ushered into its detention
cell. "This place radiated the
sense of hidden detective work,"
Towell recalls. "As one officer
told me, 'Our job is to hide
things.' " Towell says that the
challenge of a documentary
photographer is to "work with
what you have, with subjects
who are not willing." As the
detainees at the police holding
center were decidedly unwilling,
he instead captured the ghostly
silhouettes of grease and grime
left behind by countless accused
felons who had been manacled
to a bench there over the years.

*March 28, 1997: A grim detour
at the Port Authority.*

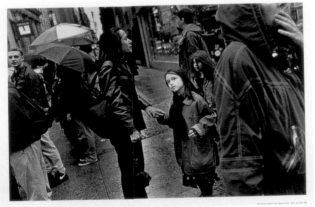

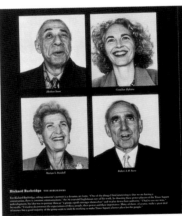

■ **400**
Publication The New York Times Magazine
Art Director Janet Froelich
Designer Catherine Gilmore-Barnes
Photo Editor Kathy Ryan
Publisher The New York Times
Issue May 18, 1997
Category Reportage & Travel/Story

■ **401**
Publication The New York Times Magazine
Art Director Janet Froelich
Photo Editor Kathy Ryan
Photographer Dan Winters
Publisher The New York Times
Issue February 23, 1997
Category Portrait/Spread

■ **402**
Publication New York
Design Director Mark Michaelson
Art Director Florian Bachleda
Photo Editors Margery Goldberg, Maisie Todd
Photographer David Barry
Publisher K-III Publications
Issue October 6, 1997
Category Portrait/Spread

Beck's Fugue

The folk-rap star's success shows the importance of being earnest and ironic for a new generation.

By Gerald Marzorati

FOR A CERTAIN KIND OF COLLEGE KID RIGHT NOW, BECK IS what Bob Dylan was ages ago, whenever, 1969: he's the singer-songwriter you could do a term paper on. You could write that Beck's approach to music evinces a comprehension of bricolage and the impossibility of esthetic originality in a post-modern moment of information overload; you could write how his grandfather was active in the neo-Dadaist art group Fluxus and how his mother hung around Warhol's Factory for a while; you could even write that the most intriguing vocal on Beck's big slow-funk hit of last summer, "Where It's At" — the part where this low, disembodied voice asks, "What about those who swing both ways, A.C./D.C.'s?" — is nothing less than an embrace of gender confusion, though that may bother Beck's girlfriend.

What you might not be comfortable writing, even though it's sort of what you feel, is how Beck gives you this whole *take* on the world. He's figured out that it's O.K. to be sincere *and* ironic about something worth caring about, which for him is the music, because irony doesn't *have* to be corrosive and because making fun of something a little protects it, makes it (and you) less vulnerable. Which is to say that Beck embodies a new way to be cool, which is a little warmer than cool is for, say, the Butthole Surfers or Wu-Tang Clan. And if you're at that point in life when you're writing term papers about the music you're listening to, this may be about as important a thing as there is.

Beck's "Odelay" was named album of the year for 1996 by Rolling Stone, two Times critics and a lot of others, all of which is carefully chronicled by this guy who calls himself Truck and has a really great Beck Web site going. What everybody likes about the songs on "Odelay" isn't the words, which can be a little hard to understand, like the stuff that friend of yours used to write when he was tripping and then read to you over the phone. What matters about Beck is his *sound*. Beck can go from the Donovan psychedelic-folk thing to the Beastie Boys hip-hop thing to the Keith Richards honky-tonk thing like *that*, which is funny but not *only*, and not in a cynical way. It's as if he's holding a channel changer and then just going *zzzzzzzzop* when he feels it's time. Which is not the point but the *starting* point. It's just the way things connect now.

Beck plays all kinds of instruments on the album — acoustic and electric guitars, old analog synthesizers and what might be a telephone answering machine — and sings, depending on the song, like a tough-guy rapper, a road-weary cowpoke or a coffeehouse folky. Beck also takes all these great bits from other people's records, which is called sampling, so on "Odelay," if you listen real hard, you'll hear a little of James Brown's "Out of Sight" as it was done more than 30 years ago by the British-invasion group Them, a pas-

sage of Schubert for strings and some vintage Jobim as performed by Laurindo Almeida and the Bossa Nova All Stars. And you would have heard a sample somewhere on "Odelay" from Barbie Flip Phone — "Come to my house Tues-day for piz-za!" — but the people who make that Barbie were not very cool about it, not that Beck's complaining or anything.

BECK DIDN'T MAKE THE NAME BECK UP; IT'S HIS REAL FIRST NAME. His real last name is Hansen, which *is* his mom's last name but not the last name on his birth certificate — it's a little complicated, the way it is for a lot of people who are 26. Beck's dad played bluegrass on the street, and maybe that's what gave Beck the idea to get a guitar and start playing on buses in L.A. after he dropped out of school, in ninth grade. He did the street-musician thing for a couple of years while he worked in a video store and stuff like that. He likes to say that what he learned playing back then is that people really like "Hey Jude."

Eventually Beck started doing these short sets at clubs in L.A. that a lot of big-time record-company guys really wish they'd paid more attention to. A tiny record company called Bong Load Custom Records signed him up and released a single called "Loser," and when it became a local hit, DGC, a subsidiary of Geffen Records, signed him up and put out a Beck album called "Mellow Gold," which he recorded for $500, mostly at his friend Karl's house, and had "Loser" on it. And if you haven't heard "Loser" by now, or seen the video on MTV, or heard something about it ... O.K. "Loser" was like the "Hey Jude" of 1994.

If you go to a database and call up all the stories about Beck and "Loser," you'll find the word "prophet" used a lot, as in *Beck is the prophet of 90's slackers*, and then, a year or so later, the phrase "one-hit wonder" used a lot, as in ... well, you get it. Beck sort of ran away from "Loser." He started showing up at concerts and refusing to sing it. He didn't want people thinking his songs were just about the *words*. And, anyway, when you still look like someone most bartenders would think about carding, you just don't want people calling you a prophet.

Beck has been nominated for three Grammy Awards, including best album, and he's supposed to do a song on the Grammy Awards TV extravaganza Wednesday night — which is great, because when Beck is playing, it's easy to see what makes Beck Beck. In the way, say, he goes (like *that*!) from the pensive-gaze thing to dancing around like that cousin of yours who made the most of every family wedding, he conveys as clearly as such things can be conveyed that it's best to try to be un-self-conscious, playful and even exuberant about being self-conscious, serious and almost weirdly reticent, all of which Beck is. Whatever. It's a very cool way to be cool, at least for right now. ■

Gerald Marzorati is the articles editor of the Magazine.

Photograph by Dan Winters

32

02

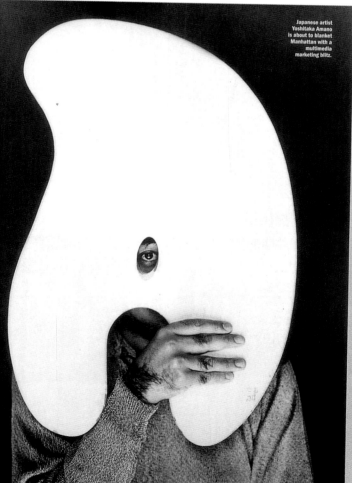

Japanese artist Yoshitaka Amano is about to blanket Manhattan with a multimedia marketing blitz.

Is Amano the Best. Artist You've Never Heard Of?

(Or just the latest Barnum of SoHo?)

JEAN-MICHEL BASQUIAT FOISTED POSTCARDS ON ANDY Warhol in a crowded SoHo restaurant. The late German artist Joseph Beuys lived in the René Block Gallery with a coyote for three weeks. Julian Schnabel published a book he claimed was written in honor of his wife's pudenda. Jeff Koons installed a 40-foot-tall puppy made of flowers at the entrance of a major European art show. The Japanese artist Jiro Yoshihara filled a

By Lang Phipps

gallery with water and rowed around it in a dinghy. Thrusting oneself into the art world never was easy, and a talent for self-promotion, no matter how vulgar or carnivalesque, certainly didn't hurt any of these guys. But very soon their antics will seem like small change when New Yorkers find out just how far some artists will go for recognition. Over the next two and a half months, much of the city will be barraged

PHOTOGRAPH BY DAVID BARRY

45

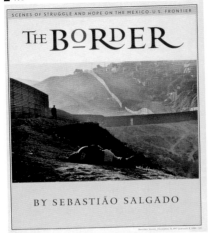

SCENES OF STRUGGLE AND HOPE ON THE MEXICO–U.S. FRONTIER

The BORDER

BY SEBASTIÃO SALGADO

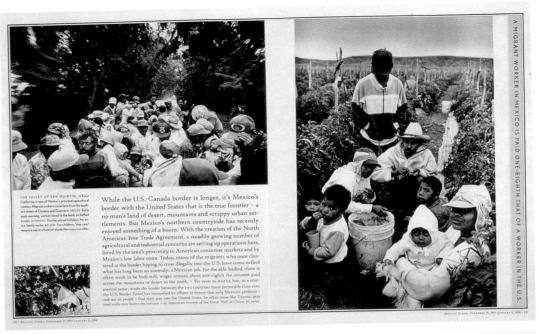

A MIGRANT WORKER IN MEXICO IS PAID ONE-EIGHTH THAT OF A WORKER IN THE U.S.

While the U.S.-Canada border is longer, it's Mexico's border with the United States that is the true frontier – a no man's land of desert, mountains and scrappy urban settlements. But Mexico's northern countryside has recently enjoyed something of a boom. With the creation of the North American Free Trade Agreement, a steadily growing number of agricultural and industrial concerns are setting up operations here, lured by the area's proximity to American consumer markets and by Mexico's low labor costs. Today, many of the migrants who once clustered at the border hoping to cross illegally into the U.S. have come to find what has long been an anomaly: a Mexican job. For the able-bodied, there is often work to be had; still, wages remain about one-eighth the amount paid across the mountains or desert to the north. ● Yet even as NAFTA has, in a commercial sense, made the border between the two countries more permeable than ever, the U.S. Border Patrol has intensified its efforts to ensure that only Mexico's products – and not its people – find their way into the United States. In urban areas like Tijuana, gray steel walls now bisect the horizon – an American version of the Great Wall of China. In more

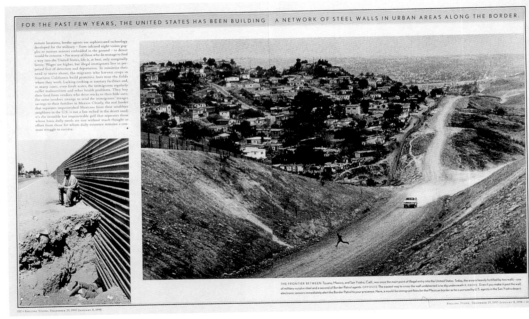

FOR THE PAST FEW YEARS, THE UNITED STATES HAS BEEN BUILDING A NETWORK OF STEEL WALLS IN URBAN AREAS ALONG THE BORDER.

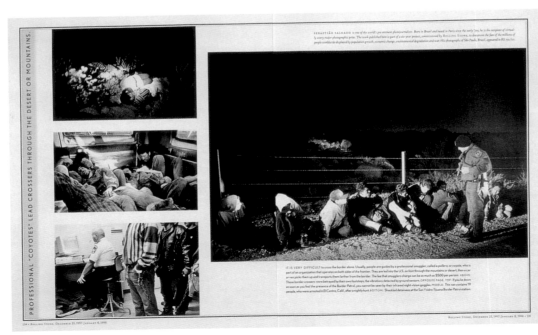

PROFESSIONAL "COYOTES" LEAD CROSSERS THROUGH THE DESERT OR MOUNTAINS.

■403
Publication Rolling Stone
Art Director Fred Woodward
Designers Fred Woodward, Gail Anderson
Photo Editor Jodi Peckman
Photographer Sebastião Salgado
Publisher Wenner Media
Issue December 25, 1997
Category Reportage & Travel/Story

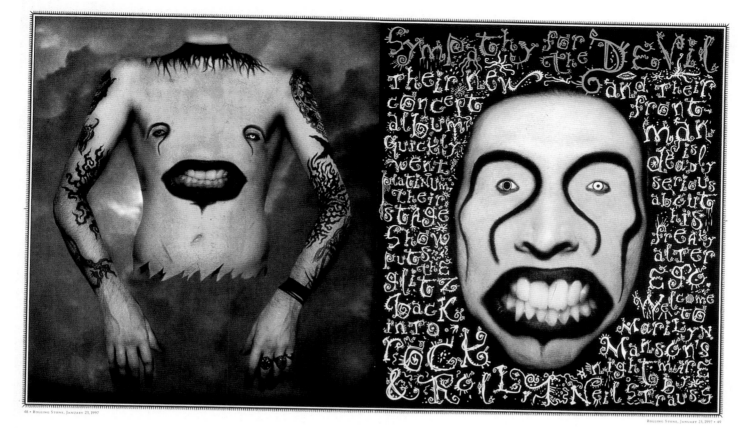

48 • ROLLING STONE, JANUARY 23, 1997 — Rolling Stone, January 23, 1997 • 49

BE CAREFUL WHEN YOU GOSSIP; A LITTLE rumor can go a long way. Especially when the subject is Marilyn Manson. ❡ "For a solid year, there was a rumor that I was going to commit suicide on Halloween," says Manson. He is sitting in a hot tub (yes, a hot tub!) in his hometown of Fort Lauderdale, Fla. "I started to think, 'Maybe I have to kill myself, maybe that's what I was supposed to do.' Then, when we were performing on Halloween, there was a bomb threat. I guess someone thought they would take care of the situation for me. It was one of those moments where chaos had control." He pauses, raises his tattoo-covered arm from the water and stares nervously through a pair of black wraparound sunglasses at the spa door. It opens a crack, then closes. No one enters. "Sometimes I wonder if I'm a character being written, or if I'm writing myself," Manson continues. "It's confusing."

Never has there been a rock star quite as complex as Marilyn Manson, frontman of the band of the same name. In the current landscape of reluctant rock stars, Manson is a complete anomaly. He craves spectacle, success and attention. And when it comes to the traditional rock-star lifestyle, he can outdo most of his contemporaries. Manson and his similarly pseudonymed band mates – bassist Twiggy Ramirez, drummer Ginger Fish, keyboardist Madonna Wayne Gacy and guitarist Zim Zum – have shat in Evan Dando's bathtub and, just last night, they coaxed Billy Corgan into snorting sea monkeys. When it comes to getting serious about his work, Manson is among the most eloquent and artful musicians. And among the most misunderstood. The rumor-hungry fans who see him as a living demon who's removed his own ribs and testicles know just as little about Manson as the detractors who dismiss him as a Halloween-costumed shock rocker riding on Trent Reznor's coattails.

The people who work with Manson on tour aren't any more privy to his personality. They have to follow the rules – no smoking, no talking about sports, no disturbing Manson in the three hours before a show – and clean up after his occasional temper tantrums that have left dressing rooms destroyed and a drummer hospitalized. In past articles on his band, Manson has deliberately toyed with the truth and with his interviewers.

"It's part of the shell that I've always built up around myself," Manson says. "And it's only because what is inside is so vulnerable that the shell has to be so hard. That is the only reason."

In the week we spend together in Florida, Manson is determined to come clean on everything, to lay all the pieces of his life and his band's new album,

Antichrist Superstar, on the table and see whether we can figure out how they fit together. He's doing a good job of revealing himself so far, because he's in a Jacuzzi at the local Holiday Inn. It was difficult for him to be here: He tried once and backed out because someone was already in the tub. He tried a second time and changed his mind because one of the garter-clad fans scouring the hotel for him had just walked by. Only when no one else was around did he finally strip down to his swim trunks and get into the tub. Though after about ten minutes, he begins to feel sick. Maybe he doesn't really belong here.

"This is going to be an important piece of press," Manson says as we get started on the first of many conversations. "It's going to be a piece of history that I want people to look at when I'm gone, and maybe it'll help them understand what I was thinking at the time when I did this record. There's been so much press and so many people feeding this sensationalism – and that's all part of Marilyn Manson. But at the same time, I want people to know that I tried to explain it to them when they had a chance to listen."

It's not going to be an easy task, he insists: "I pity anybody who has to spend a day with me."

Manson uses a number of different metaphors to describe himself: a snake,

an angel, an alien, the child snatcher from *Chitty Chitty Bang Bang*. One of the most vivid ones is a Hydra, the nine-headed serpent of Greek mythology. This image is at the heart of *Antichrist Superstar*, which entered the *Billboard* album charts at No. 3, just below two beacons of the status quo, Celine Dion and Kenny G. *Antichrist Superstar* explores a transformation and metamorphosis – of a worm to an angel to a world-destroying demon; of a boy named Brian Warner to the performer Marilyn Manson to the icon Antichrist Superstar. The album begins with a brief glimpse of the end. And that is where we will begin.

**PART 1.
ANTICHRIST SUPERSTAR**

A DREAM: *A few years ago, I started having dreams and visions of the world being destroyed, and me being the only one left. It was like an ultimate retribution for all of the things that have happened to me growing up. One dream took place sometime in the future – it may even have been in Fort Lauderdale. Entertainment had gone to such an extreme that they had taken people and made them into zombies almost just for entertainment's sake. And I had this strange vision of these women who were completely brain dead – they were just dancing in cages, and their jaws were wired shut so that they wouldn't bite off the dicks of all these guys that were around them masturbating. It was a complete Sodom and Gomorrah. And then somehow I was there and I was like either presenting the whole event or performing in it or something. That was probably the first appearance of what will be Antichrist Superstar rearing its head.*

MANSON THINKS that maybe on some level Marilyn Manson really did die. Maybe he became Antichrist Superstar. It's a strange thing to say, but Manson takes his name very, very seriously.

"When people sometimes misconceive us as being like Kiss or like Alice Cooper, or being a persona, I don't think they understand how deeply Marilyn Manson goes into my existence," he says. Manson is now sitting in a Mexican restaurant in a mall, a cheesy mariachi

band wanders from table to table. Wearing a black T-shirt and choke collar, he gazes intently straight ahead, one eye brown, the other sky blue and his hair jet black. He talks about time travel, about his ability to hurt others just by thinking about it, about destroying with his music what people see as their world. Each of his comments is greeted with skepticism, though he elaborates until you can almost see the sense in it. For instance, his Antichrist is not a seven-headed beast slaying saints left and right – he's a pop icon who encourages people to question the existence of God and believe in themselves.

In the middle of one of his explanations, Manson heaves a deep sigh. "I go through such drastic mood swings," he says, twirling a fork in his burrito. "Last night I was lying in bed, and I just wanted to kill myself. I was totally depressed. I don't know why, I just felt like I was alone. I'm in my hometown, and I've got nothing to show for it. No one to share anything with. Today I'm in a good mood. I can never figure it out."

A year ago, no one could have imagined that Marilyn Manson would be on the cover of ROLLING STONE. When his band released its first album, *Portrait of an American Family*, on Trent Reznor's Nothing label, it was just a dinky industrial act that the Nine Inch Nails mastermind had stumbled across in Florida. After a second release, *Smells Like Children*, Marilyn Manson became a popular-industrial band, thanks to a demonic version of the Eurythmics' "Sweet Dreams (Are Made of This)." But it was still a joke band, a horror movie that kids could like because it scared their parents. *Antichrist Superstar*, recorded during eight months with Reznor in New Orleans, is an incredible leap of prowess, a technically, musically and lyrically sophisticated album. Dark, complex and beautiful, the album has established Marilyn Manson as a pop force to be reckoned with. *Antichrist Superstar* was almost the band's last blast, recorded under great duress as a result of masochistic experiments with sleep deprivation, drug abuse and dreams that Manson believed foresaw his future.

The dream that Manson describes above, in fact, became one of *Antichrist Superstar*'s key songs, "Little Horn." Over death-metal riffing, Manson screams the words: "Someone better get the dog to kick/Jaws wired shut to save the dick/Out of the bottomless pit comes the Little Horn/Little Horn is born.... Everyone will suffer now." Little Horn, Manson explains, is the Antichrist.

"If you thought about it long enough," he says, "you could pose the question: Did Antichrist Superstar create Marilyn Manson as a vehicle for its rise to power? I really feel like where I'm at now is

Photographs by Matt Mahurin

50 • ROLLING STONE, JANUARY 23, 1997

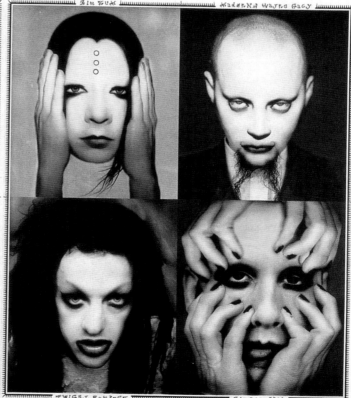

■ **404**
Publication Rolling Stone
Art Director Fred Woodward
Designers Fred Woodward, Gail Anderson
Photo Editor Jodi Peckman
Photographer Matt Mahurin
Publisher Wenner Media
Issue January 23, 1997
Categories Photo Illustration/Story
 A Photo Illustration/Spread

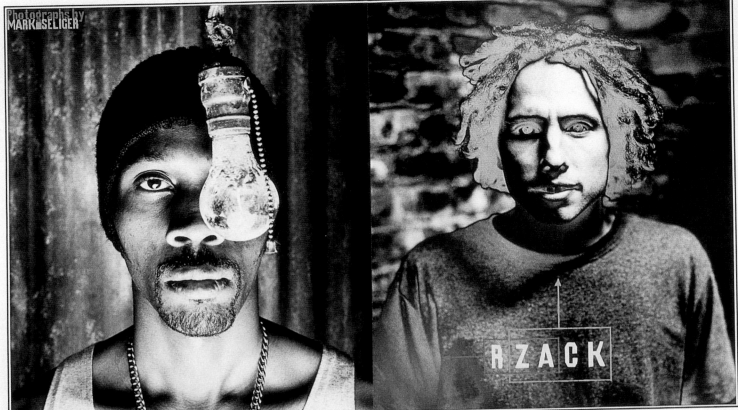

Photographs by MARK SELIGER

RZACK

Etta James

PHOTOGRAPH BY Mary Ellen Mark

"I've had people say to me, 'Can't you be more feminine?' I would go, 'Feminine? Why do I have to be feminine?' Does that mean I have to put a little apron on and bake some cookies or something?"

Somebody's stomped on your heart and you're crying mad: That's the torn-asunder sound of soul queen Etta James. Born Jamesetta Hawkins in 1938, James was raised in South Central Los Angeles and San Francisco. While still a teenager, she was discovered by the legendary R&B bandleader Johnny Otis, with whom she wrote her first single, "The Wallflower" (a.k.a "Roll With Me, Henry"), a before-its-time "answer" record (think pre-Roxanne Shanté). After touring with Otis' revue in the '50s, James went on to have numerous Top 10 R&B singles for Chess Records in the '60s – both plaintive, string-laden ballads and up-tempo scorchers, most notably the gruff but compassionate 1968 hit "Tell Mama." Hard living, including a long battle with heroin addiction, slowed James' career, but she resurfaced in 1988 with the impressively funky "Seven Year Itch." Since then, James has continued to record and tour – her bold, butt-togging live shows (with her two sons playing in her backup band) are the stuff of legend. Her 1994 album, "Mystery Lady: Songs of Billie Holiday," won James her first Grammy, and she moved toward a country sound with this year's "Love's Been Rough on Me."

So which has been rougher on you, love or life?

I think life has. Life's been tough, but life's been good. If I had to go back and do it all over again, I would live it the exact same way.

Your early vocals are so ballsy. Has anyone ever told you to be more ladylike?

I've had people say to me, "Can't you be more feminine?" And I would go, "Feminine? Why do I have to be feminine?" Does that mean I have to put a bonnet on my head and a little apron on and bake some cookies or something? People think that tough thing I do is an act. No, that's the way I am and the way I like to be.

Were your early influences more male or female?

When I first started singing in church as a kid, I liked the way the men sang. They were real powerful, the way they would make a statement and hit the podium and walk away, you know? And people would just scream. In junior high, I sang with the glee club, and I started getting kinda wimpy-poo. Then I got on the road with Johnny "Guitar" Watson, and I loved the way he sang. I don't think I really had an identity then, just a voice. Johnny and Ray Charles, too – they influenced me.

I've got to ask about the cover for 1963's "Rocks the House." You've got this white sequined dress on and your cats and makeup, and then you've got an Ace bandage around your wrist.

That picture was taken when I was a junkie, and I would put the Ace bandage on to cover up my tracks.

I thought you'd popped somebody.

I was about mean enough at that time!

Did you get forced to dress or look a certain way back then?

I sang for a while with two women. We called ourselves the Peaches, and one of us was the woman women, one was the girly girl, and I was the tomboy. We'd wear those gowns with the fish-tail things and try to be all "ooh wap doe." This was even before the Supremes.

What women in music do you like nowadays?

I like the ones that are strong. For instance, if I was to pick between Mary J. Blige and Toni Braxton, I'd pick Mary J. Blige, not just because she's a better singer, but Toni Braxton is too [makes phony, cooing noises]. Maybe I'm just jealous of her figure, I don't know.

You used to run around with drag queens early on, right?

Yup, yup. When I was about 17 or 18, my dressmaker and my hairdresser were both gay. We'd all sleep together in the same bed when we were on the road. I remember we got busted one time in Indianapolis, because you weren't allowed to room with the opposite sex if you weren't married. There we were, doing our nails and stuff, and the police came bursting in. My boys went, "Oh, Miss James, we knew we was gonna end up goin' to jail with you sooner or later, darlin'."

You still grind away up there onstage. Does anyone ever give you a hard time about it?

My youngest son hates it. He's always saying, "Ma, you look like La Wanda!" You know, the one that used to be on Sanford and Son with Redd Foxx? And one time this girl comes up to me in San Francisco – she was very bourgeois – and she says, "You know, Etta, you really have a great voice, but you need to stop doing that stuff you do onstage." It shocked me so. Basically, I do it for three reasons. One is, I'm like a clown coming out of the closet, and when I get out, I'm gonna be bad. I'm gonna be a bad little girl. Then, I'm being funny. And, finally, I'm being sexy. Maybe people think I'm obnoxious and I should just calm down now that I'm almost 60. But I'm showing you that I'm a big woman and I can do what the hell I want to do.

You've said you were a feminist before you knew what the word meant.

Yeah. When I found out about the feminists, the women that were for women, I felt real connected to that. Women in this business have to take care of themselves, make their own living and be their own boss. I'm just happy that women are where they are today, where they can say, "No, man, that ain't what I want."

Did you have much say in how things went early on?

Oh, no. I didn't even get to hire my own musicians until the '70s. Before that I was getting the guys that were left over from James Brown's band, and they were so browbeaten you weren't going to tell them nothing. When I got out of rehab, I started working with a bunch of white musicians. They were hippies, and they all knew who I was and respected me. They more or less helped me learn how to be independent.

Do you get to call the shots in your career now?

Well . . . I'd been dying to make a country record. I love the women in country – Patsy Cline, Loretta Lynn, Kitty Wells – and I wanted to be the first black woman to do the Grand Ole Opry, if just to say it's the same fucking thing as rhythm & blues! So I did Love's Been Rough on Me with Barry Beckett [James' longtime producer], and when it was done, the label heard it and said, "You gotta pizazz this up or it won't get played. [Growls] Needs some of that ass-kicking shit." Uh, OK. So they put all these horns on it and remixed it. Even the cover photo – they wouldn't use the one I wanted. That record has nothing to do with me – looking like some old woman with a leopard scarf around my neck, getting ready to go make some spaghetti!

But I wasn't gonna fight it, 'cause I wasn't gonna win. Nowadays, when you get past 35, it seems like you can't get a record going. I never hear my stuff played on the air, unless it's an oldies station and somebody goes [mock DJ voice], "Now we're gonna go waaaay back." But I'll make that country record yet. I'll be on the cover standing by an old wagon wheel, with my foot propped up on a cactus or something, with a cowboy hat on and one of those shingle leather jackets. Etta Goes Country!

You sound pretty determined.

If you want something bad enough, and you strain to get it, it'll come. Might not come right when you want it to, but it'll come. >>>>> **Katherine Dieckmann**

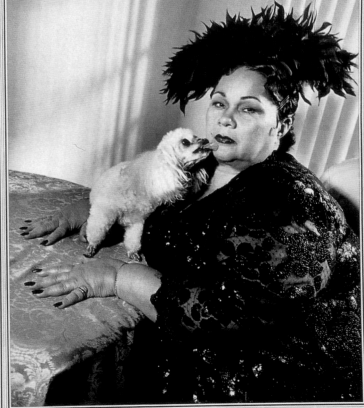

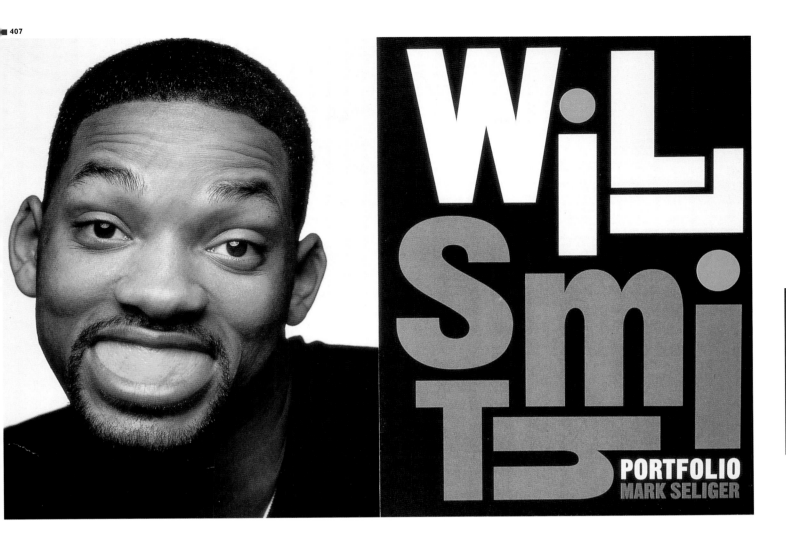

WiL Smi TH

PORTFOLIO
MARK SELIGER

■ 405
Publication Rolling Stone
Art Director Fred Woodward
Designers Fred Woodward, Geraldine Hessler
Photo Editor Jodi Peckman
Photographer Mark Seliger
Publisher Wenner Media
Issue September 4, 1997
Category Portrait/Spread

■ 406
Publication Rolling Stone
Art Director Fred Woodward
Designers Fred Woodward, Gail Anderson
Photo Editor Jodi Peckman
Photographer Mary Ellen Mark
Publisher Wenner Media
Issue November 13, 1997
Category Portrait/Spread

■ 407
Publication US
Art Director Richard Baker
Designer Bess Wong
Photo Editors Jennifer Crandall, Rachel Knepfer
Photographer Mark Seliger
Publisher US Magazine Co., L. P.
Issue August 1997
Category Portrait/Spread

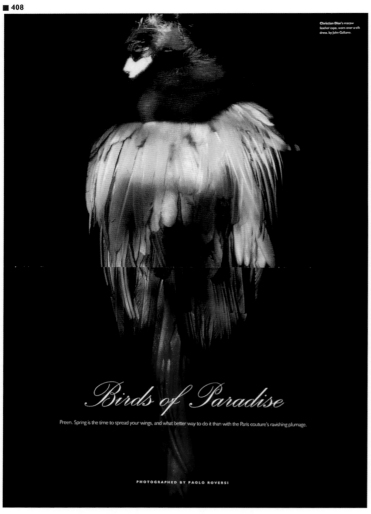

Christian Dior's macaw feather cape, worn over a silk dress, by John Galliano.

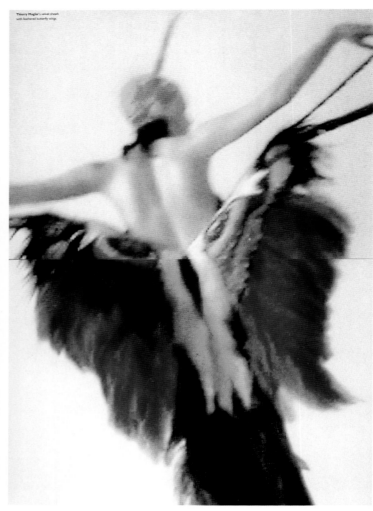

Thierry Mugler's velvet sheath with feathered butterfly wings.

Birds of Paradise

Preen. Spring is the time to spread your wings, and what better way to do it than with the Paris couture's ravishing plumage.

PHOTOGRAPHED BY PAOLO ROVERSI

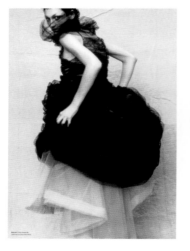

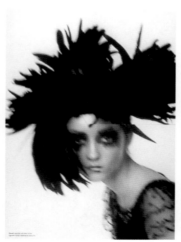

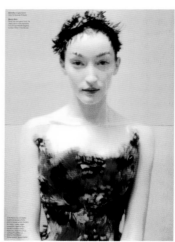

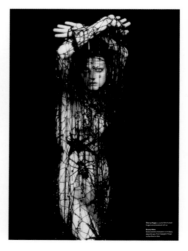

■ 408
Publication W
Creative Director Dennis Freedman
Design Director Edward Leida
Art Director Kirby Rodriguez
Designer Marcella Bove-Huttie
Photographer Paolo Roversi
Publisher Fairchild Publications
Category Fashion & Beauty/Story

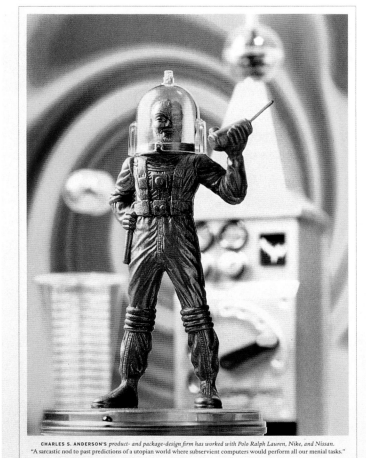

CHARLES S. ANDERSON'S *product- and package-design firm has worked with Polo Ralph Lauren, Nike, and Nissan.* "A sarcastic nod to past predictions of a utopian world where subservient computers would perform all our menial tasks."
‹ 54 ›

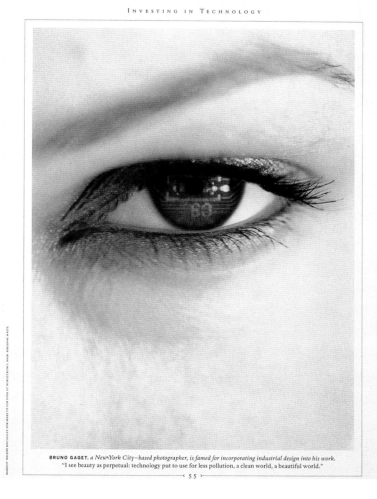

BRUNO GAGET, *a New-York City–based photographer, is famed for incorporating industrial design into his work.* "I see beauty as perpetual: technology put to use for less pollution, a clean world, a beautiful world."
‹ 55 ›

PHOTOGRAPHY SILVER ■

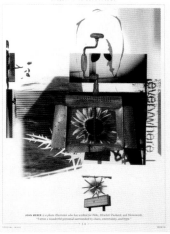

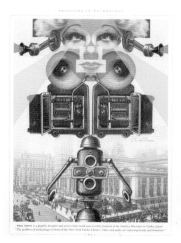

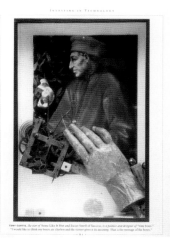

■ 409
Publication Worth
Art Director Philip Bratter
Designer Deanna Lowe
Illustrators Tony Curtis, Paul Davis, John Weber, Jean-Paul Gaultier, Paula Scher, Chip Kidd, Bruno Gaget, Charles S. Anderson
Photo Editor Jennifer Graylock
Publisher Capital Publishing L. P.
Issue August 1997
Category Photo Illustration/Story

Machine Dreams

As an illustrator, William Heath Robinson rivaled his turn-of-the-century contemporaries Aubrey Beardsley and Arthur Rackham. MAX VADUKUL revives the fanciful, elaborate contraptions that made Robinson a beloved British symbol of modern-day absurdity, while CHRISTOPHER HITCHENS examines his lunatic genius

"SELF-PROPELLED SKATING GADGET"
MIKE MYERS sheds his groovy Austin Powers gear for an equally preposterous Heath Robinson contraption, which might prove useful in his native Canada. In this, as in photographer Max Vadukul's other updates of Heath Robinson gee-wizardry on the following pages, the props and settings are handmade rather than computer-generated.

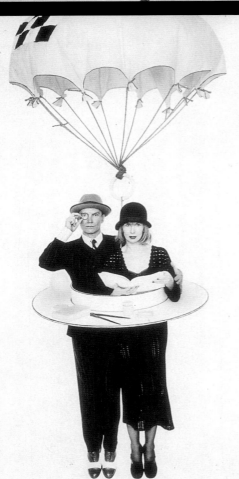

"PRACTICAL AERONAUTICS FOR MARRIED PEOPLE"
STING and his wife, TRUDIE STYLER, take a trip in a "Pair-o-Chute," one of Heath Robinson's many flying machines. "With the help of a 'Pair-o-Chute' husband and wife can make enjoyable descents from the stratosphere on Saturday afternoons without interrupting their conversation, tea, or game of picquet."

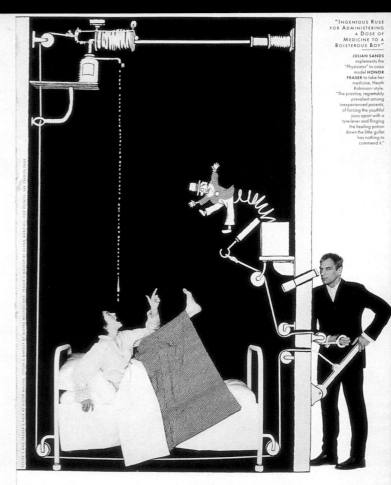

"INGENIOUS RUSE FOR ADMINISTERING A DOSE OF MEDICINE TO A BOISTEROUS BOY"
JULIAN SANDS implements the "Physicator" to coax model HONOR FRASER to take her medicine, Heath Robinson–style. "The practice, regrettably prevalent among inexperienced parents, of forcing the youthful jaws apart with a tyre-lever and flinging the healing potion down the little gullet has nothing to commend it.

In an elaborate and disarming fashion, Heath Robinson's fanciful

jalopies and widgets made the coming of technology less terrifying

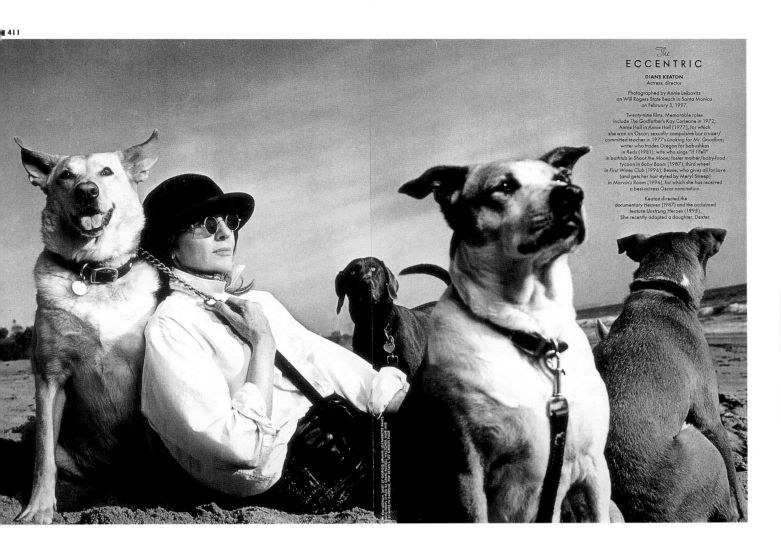

The
ECCENTRIC

DIANE KEATON
Actress, director

Photographed by Annie Leibovitz
on Will Rogers State Beach in Santa Monica
on February 3, 1997.

Twenty-nine films. Memorable roles
include *The Godfather's* Kay Corleone in 1972;
Annie Hall in *Annie Hall* (1977), for which
she won an Oscar; sexually compulsive bar cruiser/
committed teacher in 1977's *Looking for Mr. Goodbar;*
writer who trades Oregon for babushkas
in *Reds* (1981); wife who sings "If I Fell"
in bathtub in *Shoot the Moon;* foster mother/baby-food
tycoon in *Baby Boom* (1987); third wheel
in *First Wives Club* (1996); Bessie, who gives all for love
(and gets her hair styled by Meryl Streep)
in *Marvin's Room* (1996), for which she has received
a best-actress Oscar nomination.

Keaton directed the
documentary *Heaven* (1987) and the acclaimed
feature *Unstrung Heroes* (1995).
She recently adopted a daughter, Dexter.

PHOTOGRAPHY SILVER ■

■ 410
Publication Vanity Fair
Design Director David Harris
Designers David Harris, Mimi Dutta
Photo Editors Susan White, Lisa Berman
Photographer Max Vadukul
Publisher Condé Nast Publications Inc.
Issue July 1997
Category Photo Illustration/Story

■ 411
Publication Vanity Fair
Design Director David Harris
Photo Editors Susan White, Lisa Berman
Photographer Annie Leibovitz
Publisher Condé Nast Publications Inc.
Issue April 1997
Category Portrait/Spread

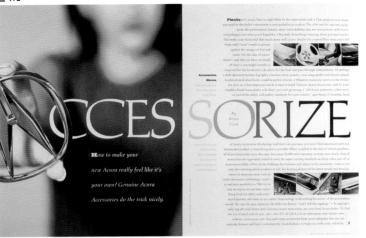

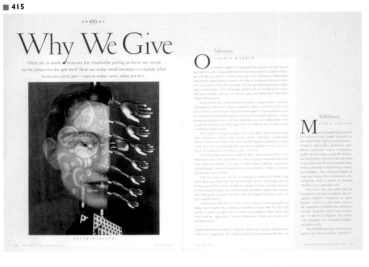

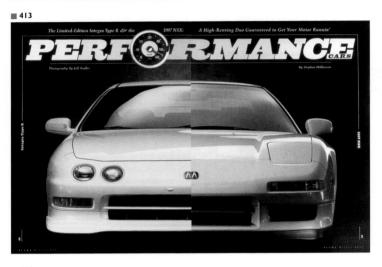

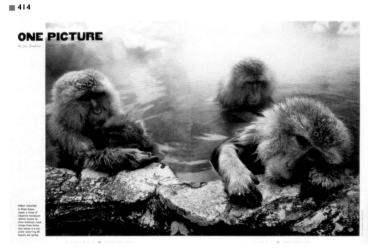

FEATURES

Through the
Viewfinder

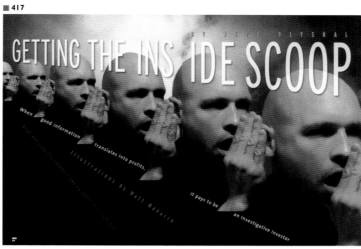

GETTING THE INS IDE SCOOP

When good information translates into profits,

Illustrations by Matt Mahurin

it pays to be

an investigative investor

PHOTOGRAPHY MERIT ■

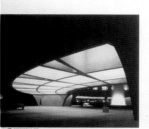

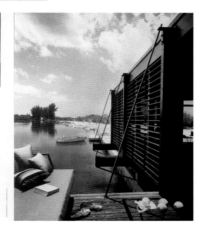

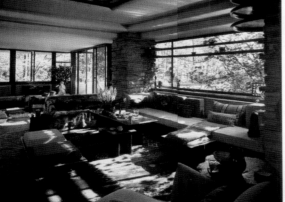

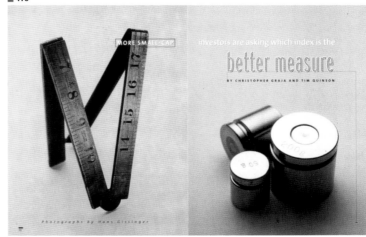

MORE SMALL-CAP

investors are asking which index is the

better measure

BY CHRISTOPHER GRAJA AND TIM QUINSON

Photographs by Hans Gissinger

■ 416
Publication Architectural Record
Design Director Anna Egger-Schlesinger
Photographer Ezra Stoller-Esto
Publisher McGraw-Hill
Issue May 1997
Category Reportage & Travel/Story

■ 417
Publication
Bloomberg Personal Finance
Art Director Carol Layton
Designer Carol Layton
Photo Editor Mary Shea
Photographer Matt Mahurin
Publisher Bloomberg L. P.
Issue May/June 1997
Category Photo Illustration/Story

■ 418
Publication
Bloomberg Personal Finance
Art Director Carol Layton
Designers Carol Layton, Evelyn Good
Photo Editor Mary Shea
Photographer Hans Gissinger
Publisher Bloomberg L. P.
Issue December 1997
Category Still Life & Interiors/Spread

■ 419

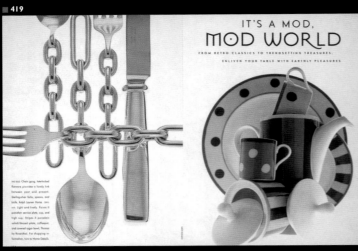

IT'S A MOD, MOD WORLD
FROM RETRO CLASSICS TO TRENDSETTING TREASURES,
ENLIVEN YOUR TABLE WITH EARTHLY PLEASURES

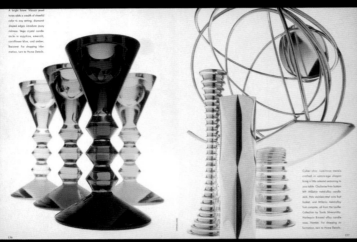

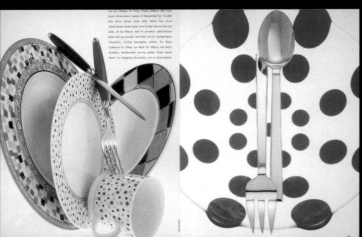

■ 420

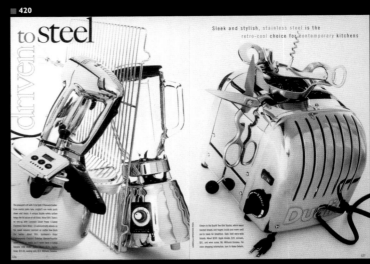

driven to **steel**

Sleek and stylish, stainless steel is the
retro-cool choice for contemporary kitchens

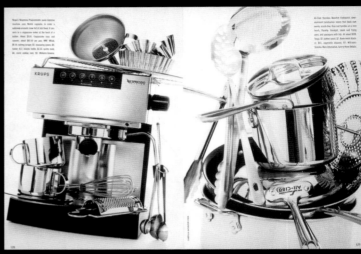

■ 421

good values

the
power
of
L♥VE

BY COLIN GREER

*Your love for your child might feel like a completely
natural emotion. But surprisingly, there are conscious ways
to demonstrate that love—and give your child
a solid sense of security. Here's how.*

■ 419
Publication Bride's
Design Director Phyllis R. Cox
Designer Clare deVilliers
Photographer Stephen Lewis
Publisher Condé Nast Publications Inc.
Issue December /January 1997
Category Still Life & Interiors/Story

■ 420
Publication Bride's
Design Director Phyllis R. Cox
Designer Clare deVilliers
Photographer Gabriella Imperatori-Penn
Publisher Condé Nast Publications Inc.
Issue April/May 1997
Category Still Life & Interiors/Story

■ 421
Publication Child
Art Director Sheri Geller
Designer Izabella Jaskierny
Photo Editor Ellen Goldberg
Photographer John Dolan
Publisher Gruner & Jahr USA Publishing
Issue December /January 1997
Category Photo Illustration/Spread

CHOICES

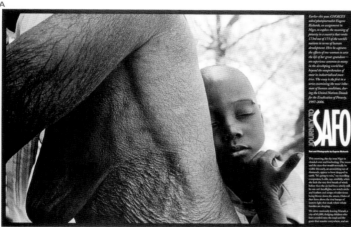

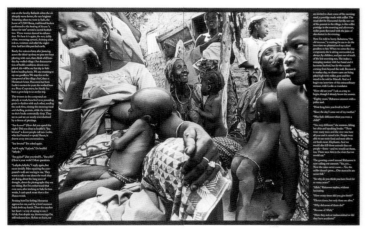

A

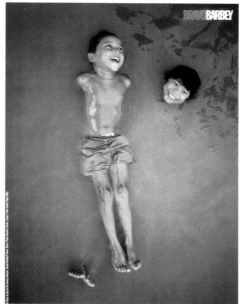

A Port Authority
Portfolio

photographs by Larry Towell

PHOTOGRAPHY MERIT

■ **422**
Publication Choices
Art Director Jurek Wajdowicz
Designers Jurek Wajdowicz,
Lisa LaRochelle
Photographer Eugene Richards
Studio Emerson, Wajdowicz Studios
Client United Nations
Development Programme
Issue October 1997
Category Reportage & Travel/Story
 A Reportage & Travel/ Spread

■ **423**
Publication BravoBarbey,
Bravo Photo Masters Series
Creative Director Jurek Wajdowicz
Designers Jurek Wajdowicz,
Lisa LaRochelle
Photographer Bruno Barbey
Studio Emerson, Wajdowicz Studios
Client E.B. Eddy Paper/
Island Paper Mills Division
Issue No. 2
Category Reportage & Travel/Single Page

■ **424**
Publication City Journal
Art Director Sandra Di Pasqua
Photo Editor Susan Rubin
Photographer Larry Towell
Client The Manhattan Institute
Issue Autumn 1997
Category Portrait/Story

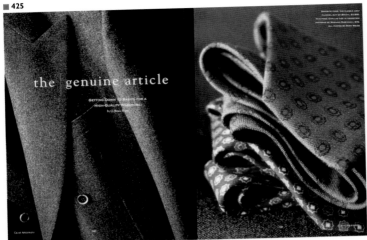

the genuine article

GETTING DOWN TO BASICS FOR A
HIGH-QUALITY WARDROBE

the dress shirt

the slip-on shoe

VISIONQUEST

Photographs by
HAKAN LUDWIGSON

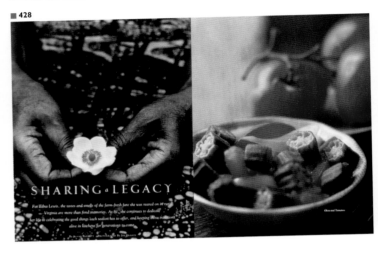

merica's open spaces have always
echoed our ambitions: of unlimited
freedom, inexhaustible resources,
and infinite variety. Whatever your
passion, there's a setting that's in
sync. Seeking the isolation of a
mountain retreat? We've sussed out
three peak experiences. A contem-
plative roost near **river's edge**? Bank
on it. **Seaside** scenery so sublime that
the world recedes with the tide? Read
on. Plus, a troika of **lakeshore** hotels
that will have you as riveted as
Narcissus, and three **desert** oases
that are pure *English Patient*. Nature
doesn't get more nurturing than this

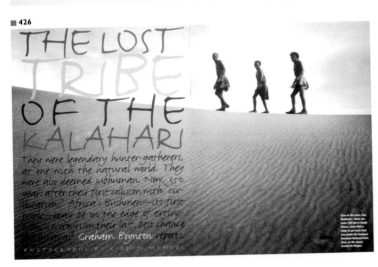

SHARING a LEGACY

THE LOST
TRIBE
OF THE
KALAHARI

They were legendary hunter-gatherers,
at one with the natural world. They
were also deemed subhuman. Now, 350
years after their first collision with civ-
ilization, Africa's Bushmen—its first
people—may be on the edge of extinc-
tion. Tourism their last, best chance
for survival? Graham Boynton reports.

PHOTOGRAPHS BY GIDEON MENDEL

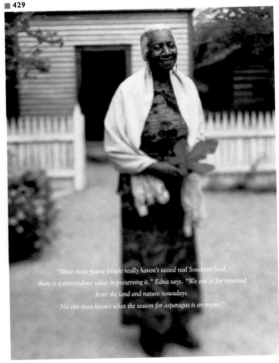

"Since most young people really haven't tasted real Southern food,
there is a tremendous value in preserving it," Edna says. "We are so far removed
from the land and nature nowadays.
No one even knows what the season for asparagus is anymore."

425
Publication Cigar Aficionado
Creative Director Martin Leeds
Art Director Lori Ende
Designer Lori Ende
Photo Editor Shawn Vale
Photographer Mark Weiss
Publisher
M. Shanken Communications
Issue May/June 1997
Category Fashion & Beauty/Story

426
Publication Condé Nast Traveler
Design Director Robert Best
Art Director Carla Frank
Photo Editor Kathleen Klech
Photographer Gideon Mendel
Publisher Condé Nast Publications Inc.
Issue May 1997
Category Reportage & Travel/ Spread

427
Publication Condé Nast Traveler
Design Director Robert Best
Art Director Carla Frank
Photo Editor Kathleen Klech
Photographer
Hakan Ludwigson
Publisher Condé Nast Publications Inc.
Issue December 1997
Category Reportage & Travel/ Spread

428
Publication Country Home
Art Director Paul Zimmerman
Designer Shelley Caldwell Christy
Photographer Jim Krantz
Publisher Meredith Corp.
Issue July/August 1997
Category Reportage & Travel/ Spread

429
Publication Country Home
Art Director Paul Zimmerman
Designer Shelley Caldwell Christy
Photographer Jim Krantz
Publisher Meredith Corp.
Issue July/August 1997
Category Portrait/Single Page

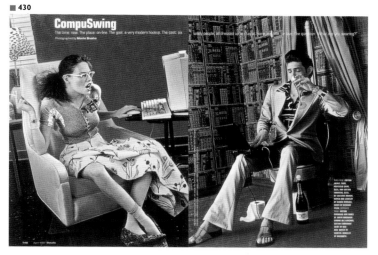

CompuSwing
That time: now. The place: on-line. The goal: a very modern hookup. The cast: six lonely people addressed to be charged with glamour and intellect. The question: what are we wearing?

Photographed by Moshe Brakha

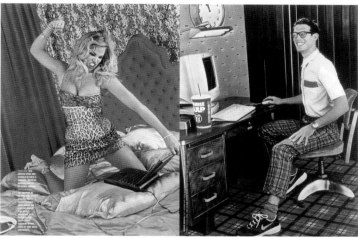

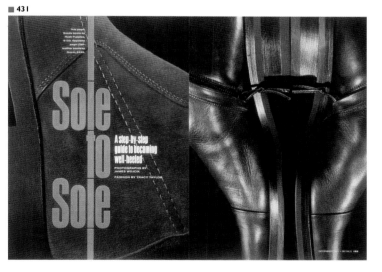

Sole to Sole
A step-by-step guide to becoming well-heeled

PHOTOGRAPHS BY JAMES WOJCIK
FASHION BY TRACY TAYLOR

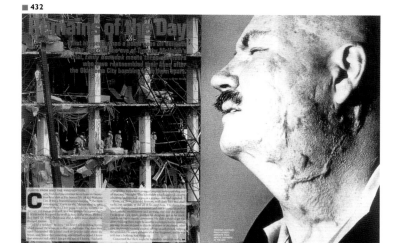

Remains of the Day

FIONA APPLE
"Mom yelled, 'Sweetie, Marilyn Manson's on the phone!'"

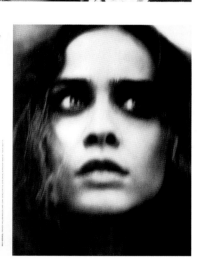

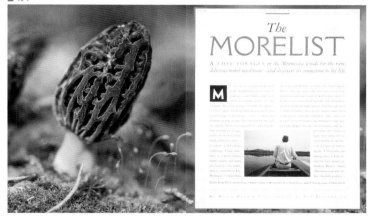

The MORELIST
A CHEF FORAGES in the Minnesota woods for the rare, delicious morel mushroom—and discovers its connection to his life

■ 432
Publication Details
Art Director Sam Chick
Designer John Giordani
Photo Editor Greg Pond
Photographer Brian Smale
Publisher Condé Nast Publications Inc.
Issue March 1997
Category Reportage & Travel/ Spread

■ 434
Publication Saveur
Creative Director Michael Grossman
Art Director Jill Armus
Designer Toby Fox
Photo Editor Maria Millán
Photographer Per Breiehagen
Publisher Meigher Communications
Issue May/June 1997
Category Reportage & Travel/ Spread

■ 430
Publication Details
Creative Director William Mullen
Art Director Sam Chick
Designer John Giordani
Photo Editor Greg Pond
Photographer Moshe Brakha
Publisher Condé Nast Publications Inc.
Issue April 1997
Category Fashion & Beauty/ Story

■ 431
Publication Details
Design Director Robert Newman
Designer Alden Wallace
Photo Editor Greg Pond
Photographer James Wojcik
Fashion Editor Tracy Taylor
Publisher Condé Nast Publications Inc.
Issue December 1997
Category Portrait/Spread

■ 433
Publication Details
Creative Director William Mullen
Art Director Nancy Kruger Cohen
Designers Duane Thomas,
Nancy Kruger Cohen
Photo Editor Greg Pond
Photographer Max Vadukul
Publisher Condé Nast Publications Inc.
Issue July 1997
Category Portrait/Spread

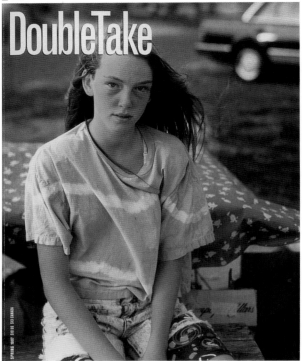

DoubleTake

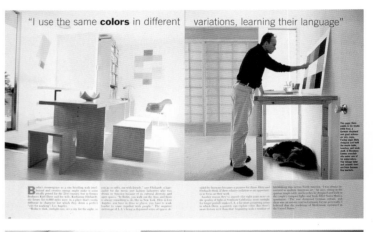

ZEN PALETTE

Two former **Berliners** discover that life in sun-kissed **L.A.** is quite to their liking

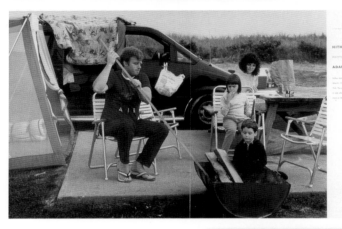

ESSAY

HITHER HILLS

PHOTOGRAPHS BY
ADAM BARTOS

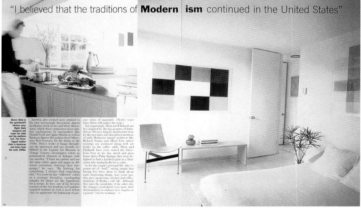

"I use the same **colors** in different variations, learning their language"

"I believed that the traditions of **Modern**ism continued in the United States"

■ 435
Publication DoubleTake
Design Director Molly Renda
Photo Editors Alex Harris, Robert Coles
Photographer Adam Bartos
Publisher Center for Documentary Studies
Issue Spring 1997
Category Reportage & Travel/Story

■ 436
Publication Elle Decor
Art Director Nora Sheehan
Designer Nora Sheehan
Photo Editor Quintana Dunne
Photographer Edina van der Wyck
Publisher Hachette Filipacchi Magazines, Inc.
Issue August 1997
Category Still Life & Interiors/Story

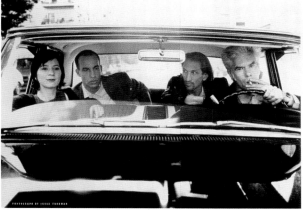

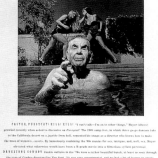 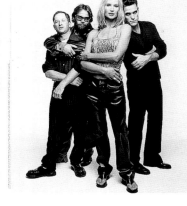

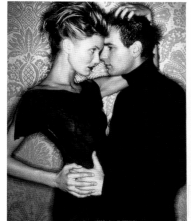

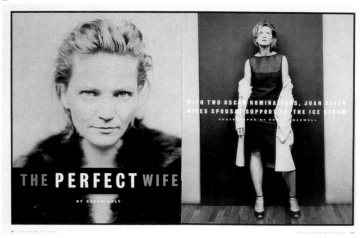

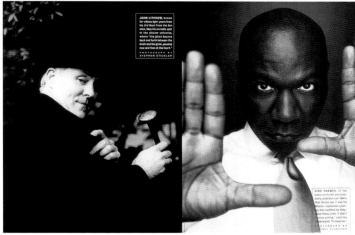

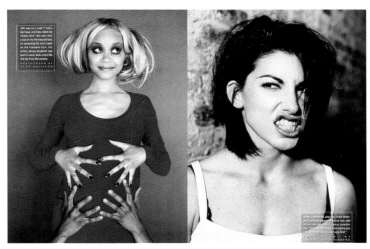

PHOTOGRAPHY MERIT ■

■ 437
Publication Entertainment Weekly
Design Director John Korpics
Art Director Lisa Wagner
Photo Editors Sarah Rozen, Michael
Kochman, Mary Dunn
Photographers Jeffrey Thurnher,
Jess Frohman, Mary Ellen Mark,
Andrew Brusco
Publisher Time Inc.
Issue September 1997
Category Portrait/Story

■ 438
Publication Entertainment Weekly
Design Director John Korpics
Designer John Korpics
Photo Editors Sarah Rozen,
Mary Dunn
Photographer Robert Maxwell
Publisher Time Inc.
Issue October 10, 1997
Category Portrait/Spread

■ 439
Publication Entertainment Weekly
Design Director John Korpics
Art Director John Walker
Photo Editors Sarah Rozen,
Mary Dunn
Photographer Lorenzo Aguis
Publisher Time Inc.
Issue October 24, 1997
Category Portrait/Story

■ 440
Publication Entertainment Weekly
Yearbook 1997
Art Director Don Morris
Designers Jennifer Starr, Josh Klenert
Photo Editors Julie Mihaly
Studio Don Morris Design
Publisher Time Inc.
Issue 1997
Category Portrait/Story

Why I Pray

By Rick Moody

Hire Great People Fast

It's the toughest—and most important—challenge in business today. Lessons from Netscape, Cisco, and Yahoo on how to find the right people and get them up to speed—fast.
By Bill Birchard Photographs by Fredrik Broden

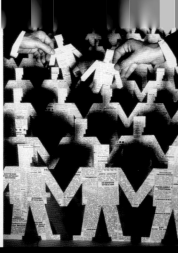

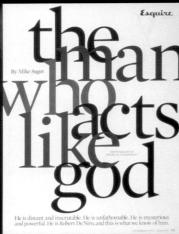

Esquire

the man who acts like god

By Mike Sager

PHOTOGRAPH BY
FRANK W. OCKENFELS 3

He is distant and inscrutable. He is unfathomable. He is mysterious and powerful. He is Robert De Niro, and this is what we know of him.

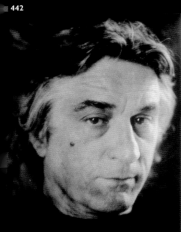

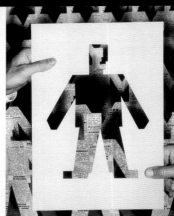

Build the Buzz

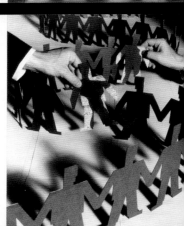

How Cisco Makes Friends

Never Settle for Less

The LAST COP STORY

By Mike McAlary

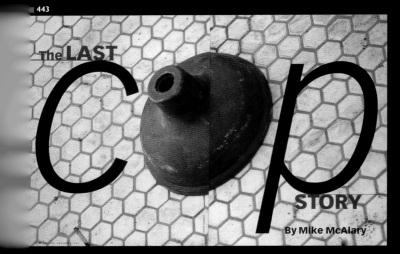

441
Publication Esquire
Design Director Robert Priest
Art Director Rockwell Harwood
Designer Dina White
Photo Editor Danielle Place
Photographer Matt Mahurin
Publisher The Hearst Corporation-Magazines Division
Issue October 1997
Category Photo Illustration/Spread

442
Publication Esquire
Design Director Robert Priest
Art Director Rockwell Harwood
Designer Joshua Liberson
Photo Editor Danielle Place
Photographer Frank W. Ockenfels 3
Publisher The Hearst Corporation-Magazines Division
Issue December 1997
Category Portrait/Spread

443
Publication Esquire
Design Director Robert Priest
Art Director Rockwell Harwood
Designer Laura Harrigan
Photo Editor Danielle Place
Photographer Jason Schmidt
Publisher The Hearst Corporation-Magazines Division
Issue December 1997
Category Photo Illustration/Spread

444
Publication Fast Company
Art Director Patrick Mitchell
Designer Patrick Mitchell
Photographer Fredrik Brodén
Issue August/September 1997
Category Photo Illustration/Story

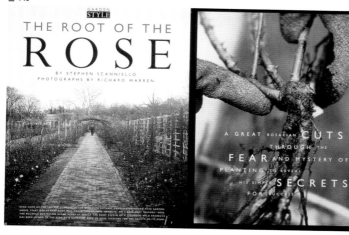

GARDEN STYLE

THE ROOT OF THE
ROSE

BY STEPHEN SCANNIELLO
PHOTOGRAPHS BY RICHARD WARREN

A GREAT ROSARIAN CUTS THROUGH THE FEAR AND MYSTERY OF PLANTING TO REVEAL HIS SIMPLE SECRETS FOR SUCCESS

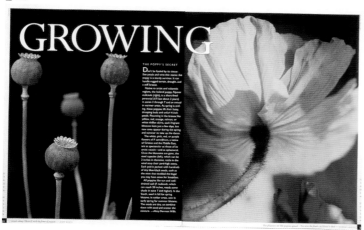

GROWING

THE POPPY'S SECRET

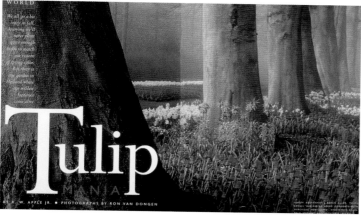

WORLD

Tulip
MANIA

BY R. W. APPLE JR. • PHOTOGRAPHS BY RON VAN DONGEN

LIFE BEGINS IN THE GARDEN · The Bulb Basics · Top Hotel Gardens · Party Out-of-Doors

GARDEN DESIGN

SPECIAL ISSUE

A World of Ideas

OUR GLOBE-TROTTING GUIDE TO 75 GREAT GARDENS IN HOLLAND, BALI, SCOTLAND, THE USA—AND BEYOND

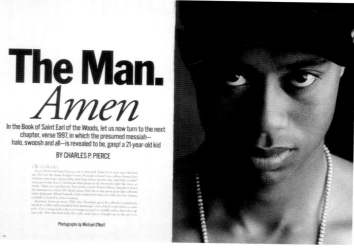

The Man.
Amen

In the Book of Saint Earl of the Woods, let us now turn to the next chapter, verse 1997, in which the presumed messiah—halo, swoosh and all—is revealed to be, gasp! a 21-year-old kid

BY CHARLES P. PIERCE

Photographs by Michael O'Neill

costa del soul

A

PHOTOGRAPHED BY LISA LIMER

PHOTOGRAPHY MERIT ■

■ 445
Publication Garden Design
Creative Director Michael Grossman
Art Director Christin Gangi
Designer Neal Boulton
Photo Editor Lauren Hicks
Photographer Richard Warren
Publisher Meigher Communications
Issue April 1997
Category Still Life & Interiors/Spread

■ 446
Publication Garden Design
Creative Director Michael Grossman
Art Director Christin Gangi
Designer Christin Gangi
Photo Editor Lauren Hicks
Photographers John Peden, Christopher Hirsheimer
Publisher Meigher Communications
Issue May 1997
Category Still Life & Interiors/Spread

■ 447
Publication Garden Design
Creative Director Michael Grossman
Art Director Christin Gangi
Designer Neal Boulton
Photo Editor Lauren Hicks
Photographer Ron van Dongen
Publisher Meigher Communications
Issue October 1997
Category Reportage & Travel/ Spread

■ 448
Publication Garden Design
Creative Director Michael Grossman
Art Director Christin Gangi
Designer Christin Gangi
Photo Editor Lauren Hicks
Photographer Ron van Dongen
Publisher Meigher Communications
Issue October 1997
Category Reportage & Travel/ Single Page

■ 449
Publication GQ
Design Director George Moscahlades
Art Director Kay Spear Gibson
Photo Editor Karen Frank
Photographer Michael O'Neill
Publisher Condé Nast Publications Inc.
Issue April 1997
Category Portrait/ Spread

■ 450
Publication Golf & Travel
Art Director Nazan Akyavas
Designer Nazan Akyavas
Photo Editor Nazan Akyavas
Photographer Lisa Limer
Publisher Turnstile Publishing Co.
Issue Summer 1997
Category Reportage & Travel/ Spread

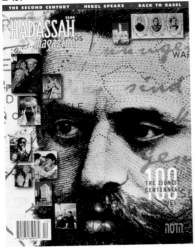

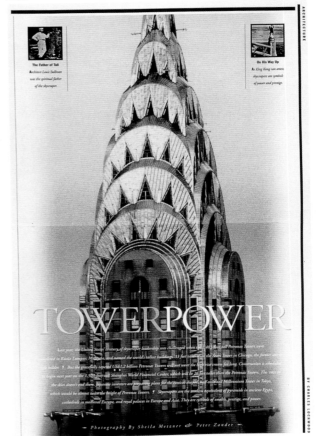

After Japanese photographer Masao Yamamoto has printed one of his serene, Zen-like images, he frays its edges. Bent, torn, and stained, the photos—most are no more than 4 x 6 inches—become more than their subject: They remind us of postcards, or of snapshots, records of intimate, wordless moments

MASAO YAMAMOTO

that are at once fleeting and eternal. True to his unembellished aesthetic, Yamamoto often exhibits his photographs simply taped to the wall or invites viewers to browse through stacks of pictures placed in an old leather satchel. Like pebbles, they sink through the clear water of our perception; like ocean waves, they ruffle our horizons. The teachings of Zen tell us that "form is only emptiness; emptiness is only form." Yamamoto's haunting emptiness is dense with our own memories and dreams.

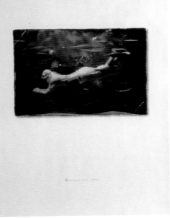

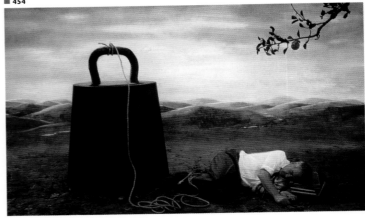

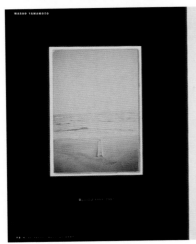

Publication Hadassah Magazine
Art Director Jodie Berzin
Designer Jodie Berzin
Illustrator Les Jörgensen
Photo Editor Leah Finkelshteyn
Publisher
Hadassah Zionist Org. of America
Issue December 1997
Category Photo Illustration/Spread

Publication Hemispheres
Art Director Jaimey Easler
Designer Jaimey Easler
Photographer Maseo Yamamoto
Publisher Pace Communications
Client United Airlines
Issue January 1997
Category Photo Illustration/Story

Publication Hemispheres
Art Director Jaimey Easler
Designer Jaimey Easler
Photographer Peter Zander,
Sheila Metzner
Publisher Pace Communications
Client United Airlines
Issue September 1997
Category Reportage & Travel/
Single Page

Publication LIFE
Design Director Tom Bentkowski
Designer Sharon Okamoto
Photo Editor Alison Morley
Photographer Teun Hocks
Publisher Time Inc.
Issue Fall 1997
Category Still Life & Interiors/ Spread

■ 455

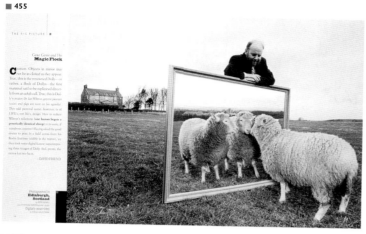

■ 456

■ 457

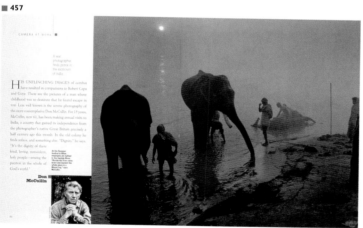

■ 458

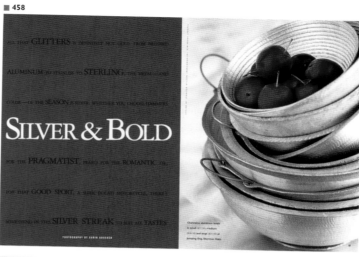

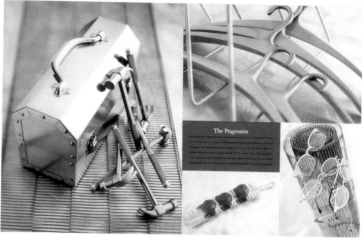

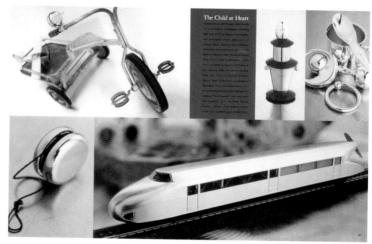

PHOTOGRAPHY MERIT ■

■ 455
Publication LIFE
Design Director Tom Bentkowski
Designer James Elsis
Illustrator Steve Walkowiak
Photo Editor David Friend
Photographers Remi Benali,
Stephen Ferry
Publisher Time Inc.
Issue May 1997
Category Reportage & Travel/Spread

■ 456
Publication LIFE
Design Director Tom Bentkowski
Designer James Elsis
Photo Editor David Friend
Photographer Derek Hudson
Publisher Time Inc.
Issue June 1997
Category Reportage & Travel/Spread

■ 457
Publication LIFE
Design Director Tom Bentkowski
Designer Melanie deForest
Photo Editor David Friend
Photographer Don McCullin
Publisher Time Inc.
Issue August 1997
Category Reportage & Travel/ Spread

■ 458
Publication Los Angeles
Art Director Jane Frey
Designer Myla Sorensen
Photo Editor Kate Schlesinger
Photographer Carin Krasner
Publisher Fairchild Publications
Issue December 1997
Category Still Life & Interiors/Story

187

■ 459 A

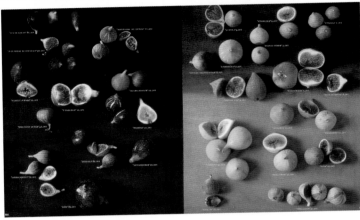

■ 461

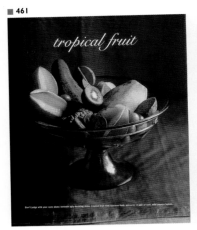

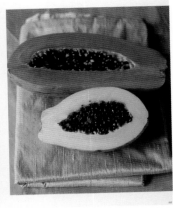

tropical fruit

■ 460

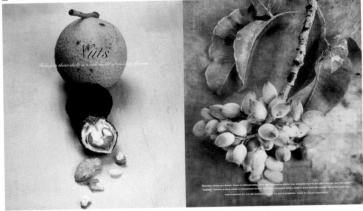

■ 462

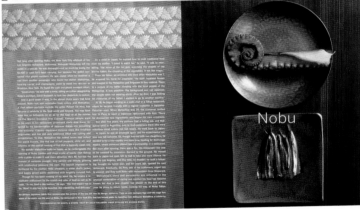

Nobu

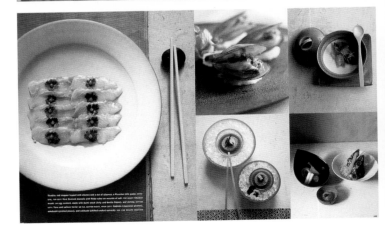

■ 459
Publication Martha Stewart Living
Creative Director Gael Towey
Designers Frances Boswell, Gael Towey
Photo Editor Heidi Posner
Photographer Maria Robledo
Publisher Martha Stewart Living Omnimedia
Issue September 1997
Categories Still Life & Interiors/ Story
 A Still Life & Interiors/Spread

■ 460
Publication Martha Stewart Living
Design Director Eric A. Pike
Art Director Claudia Bruno
Designer Claudia Bruno
Photo Editor Heidi Posner
Photographers Victor Schrager, Susan Sugarman
Publisher Martha Stewart Living Omnimedia
Issue November 1997
Category Still Life & Interiors/Spread

■ 461
Publication Martha Stewart Living
Design Director Eric A. Pike
Art Director Agnethe Glatved
Designers Frances Boswell, Ayesha Patel, Agnethe Glatved
Photo Editor Heidi Posner
Photographer Maria Robledo
Publisher Martha Stewart Living Omnimedia
Issue February 1997
Category Still Life & Interiors/Story

■ 462
Publication Martha Stewart Living
Design Director Eric A. Pike
Art Director Claudia Bruno
Designers Claudia Bruno, Ayesha Patel, Susan Spungen, Nobuyuki Matushisa
Photo Editor Heidi Posner
Photographer Gentl + Hyers
Publisher Martha Stewart Living Omnimedia
Issue May 1997
Category Still Life & Interiors/Story

463

465

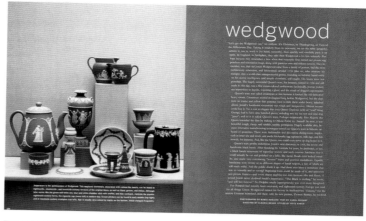

wedgwood

464 A

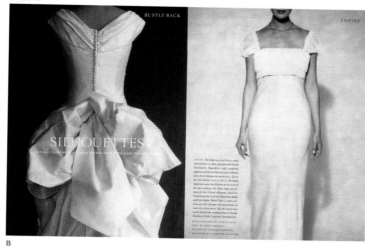

SILHOUETTES

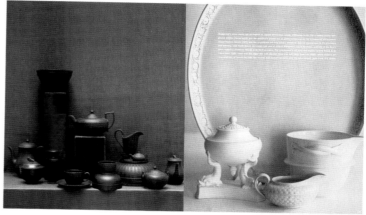

B

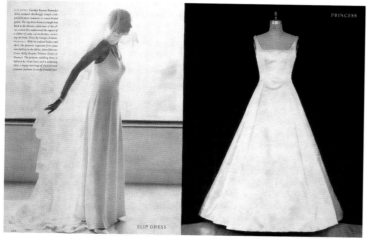

466

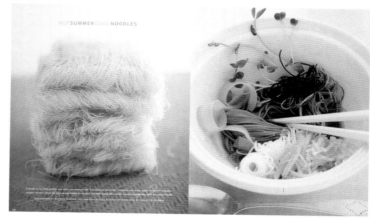

HOT SUMMER COOL NOODLES

463
Publication Martha Stewart Living
Design Director Eric A. Pike
Art Director Claudia Bruno
Designer Claudia Bruno
Photo Editor Heidi Posner
Photographer Gentl + Hyers
Publisher Martha Stewart Living Omnimedia
Issue February 1997
Category Still Life & Interiors/Spread

464
Publication Martha Stewart Living
Design Director Eric A. Pike
Art Director Agnethe Glatved
Designer Agnethe Glatved, George Cortina, Darcy Miller
Photo Editor Heidi Posner
Photographer José Picayo
Publisher Martha Stewart Living Omnimedia
Issue Summer/Fall 1997
Categories Fashion & Beauty/Story
 A Fashion & BeautySpread
 B Fashion & BeautySpread

465
Publication Martha Stewart Living
Design Director Eric A. Pike
Art Director Claudia Bruno
Designers Fritz Karch, Claudia Bruno
Photo Editor Heidi Posner
Photographer Maria Robledo
Publisher Martha Stewart Living Omnimedia
Issue April 1997
Category Still Life & Interiors/Story

466
Publication Martha Stewart Living
Design Director Eric A. Pike
Art Director Scot Schy
Designers Fritz Karch, Susan Spungen, Scot Schy
Photo Editor Heidi Posner
Photographer Gentl + Hyers
Publisher Martha Stewart Living Omnimedia
Issue June 1997
Category Still Life & Interiors/Spread

467 A

Jean Dieuzaide El descubrimiento

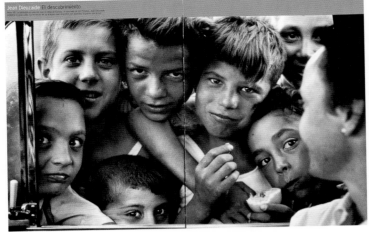

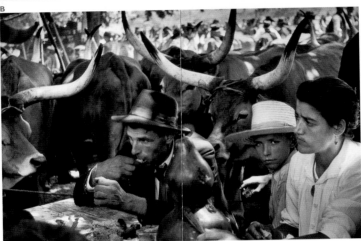

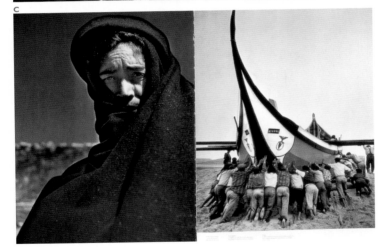

468

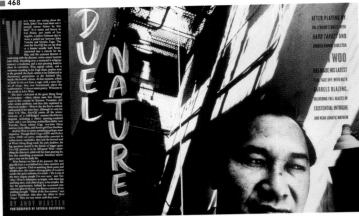

DUEL NATURE

469

LOST HORIZON

FOR BRAD PITT, FILMING THE EPIC 'SEVEN YEARS IN TIBET' WAS A PERSONAL AND ARTISTIC HIGH POINT. BUT HE COULDN'T STAY ON THE MOUNTAIN FOREVER.

PHOTOGRAPHED BY ANDREW MACPHERSON

BY CHRISTINE SPINES

470

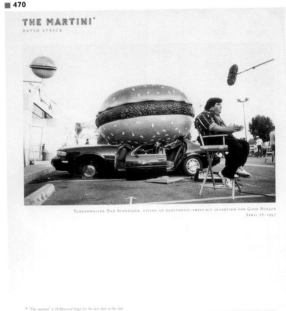

THE MARTINI*
DAVID STRICK

SCREENWRITER DAN SCHNEIDER, GIVING AN ELECTRONIC-PRESS-KIT INTERVIEW FOR GOOD BURGER
APRIL 28, 1997

* "The martini" is Hollywood lingo for the last shot of the day.

112 PREMIERE · AUGUST 1997

■ **467**
Publication Matador
Art Director Fernando Gutiérrez
Designers María Ulecia, Xavi Roca,
Emmanuel Ponty, Pablo Martín, Fernando Gutiérrez
Photo Editor Luis de las Alas
Photographer Jean Dieuzaide
Studio GRAFICA
Publisher La Fábrica, S.L.
Issue October 25, 1997
Categories Feature Story

 A Reportage & Travel/Spread
 B Reportage & Travel/Spread
 C Reportage & Travel/Spread

■ **468**
Publication Premiere
Art Director David Matt
Photo Editor Chris Dougherty
Photographer
Antonin Kratochvil
Publisher Hachette Filipacchi
Magazines, Inc.
Issue July 1997
Category Portrait/Spread

■ **469**
Publication Premiere
Art Director David Matt
Photo Editor Chris Dougherty
Photographer
Andrew Macpherson
Publisher Hachette Filipacchi
Magazines, Inc.
Issue November 1997
Category Portrait/Spread

■ **470**
Publication Premiere
Art Director David Matt
Photo Editors
Chris Dougherty, Jennifer Martin
Photographer David Strick
Publisher Hachette Filipacchi
Magazines, Inc.
Issue August 1997
Category Reportage & Travel/
Single Page

190

I CAN SEE CLEARLY NOW

LASER EYE SURGERY IS A MEDICAL SENSATION. BUT CAN WE TRUST THE SUBWAY ADS? A "FLAP AND ZAP" SURVIVOR EXPLAINS WHY SEEING IS BELIEVING. BY MELINDA BLAU

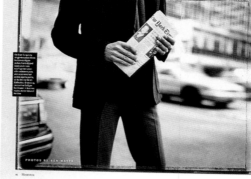

ALL DRESSED DOWN

When casual Fridays are a cause for concern, smart businessmen go shopping

BY SCOTT OMELIANUK

Shall We Dance?

Back to ballroom—a new generation picks up where Fred and Ginger left off

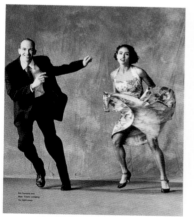

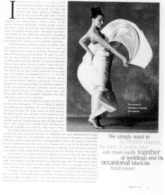

We simply want to be better dancers. The kind of people who can move easily together at weddings and the occasional black-tie fund-raiser.

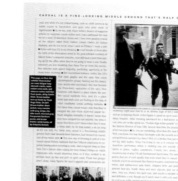

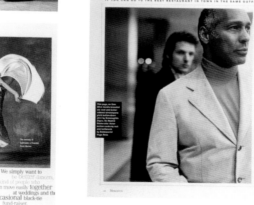

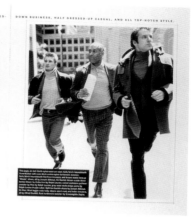

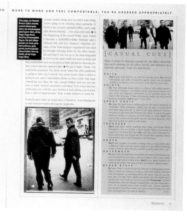

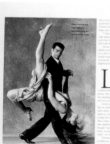

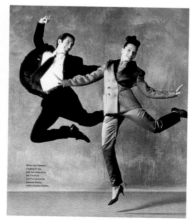

By lesson three we are turning, doing a funny twelve-count underarm walkout in which I am chastised for my tendency to spin.

■ 471
Publication New York
Design Director Robert Newman
Art Directors Florian Bachleda, Jennifer Gilman
Photo Editor Margery Goldberg
Photographer Max Aguilera-Hellweg
Publisher K-III Publications
Issue March 10, 1997
Category Reportage & Travel/Spread

■ 472
Publication Mercedes Momentum
Creative Director Robb Allen
Art Director Palma McGowan
Designer Patricia Ryan
Photo Editor Andrea Jackson
Photographer Lois Greenfield
Publisher Hachette Filipacchi Magazines, Inc.
Issue January 1997
Category Fashion & Beauty/Story

■ 473
Publication Mercedes Momentum
Creative Director Robb Allen
Art Director Kevin Fisher
Designer Patricia Ryan
Photo Editor Andrea Jackson
Photographer Ben Watts
Publisher Hachette Filipacchi Magazines, Inc.
Issue Fall 1997
Category Fashion & Beauty/Story

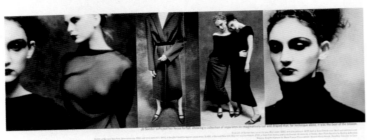

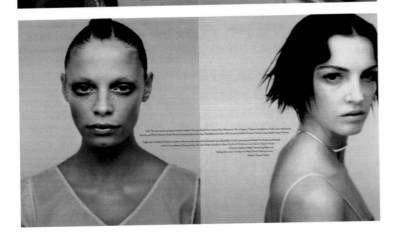

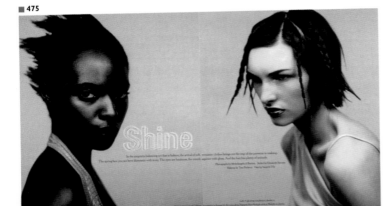

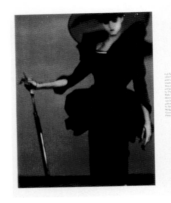

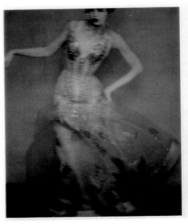

The New Look of Liberalism on the Court

RUTH BADER GINSBURG is the Justice who best typifies the centrist, incremental philosophy of the President who appointed her. Carefully, pragmatically, she is revolutionizing what it means to be progressive.

BY JEFFREY ROSEN

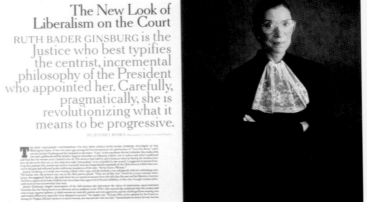

■ 474
Publication
The New York Times Magazine
Art Director Janet Froelich
Designer Lisa Naftolin
Photographer Michael Woolley
Stylist Franciscus Ankoné
Publisher The New York Times
Category Fashion & Beauty/Story

■ 475
Publication
The New York Times Magazine
Art Director Janet Froelich
Designer Lisa Naftolin
Photographer
Michelangelo di Battista
Stylist Elizabeth Stewart
Publisher The New York Times
Category Fashion & Beauty/Story

■ 476
Publication
The New York Times Magazine
Art Director Janet Froelich
Designer Catherine Gilmore-Barnes
Photo Editor Kathy Ryan
Photographer Sarah Moon
Stylist Franciscus Ankoné
Publisher The New York Times
Issue March 16, 1997
Category Fashion & Beauty/Story

■ 477
Publication
The New York Times Magazine
Art Director Janet Froelich
Designer Catherine Gilmore-Barnes
Photo Editor Kathy Ryan
Photographer
Timothy Greenfield-Sanders
Publisher The New York Times
Issue October 5, 1997
Category Portrait/Spread

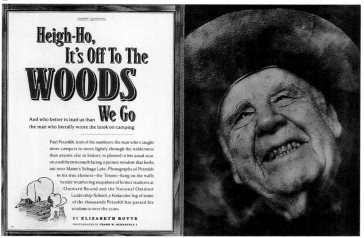

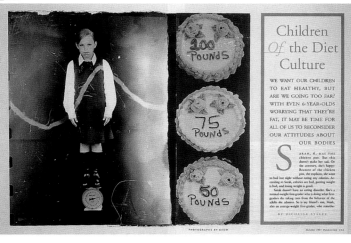

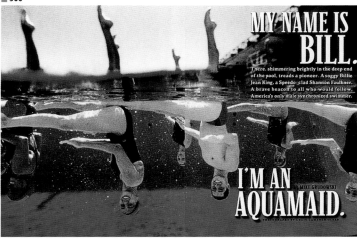

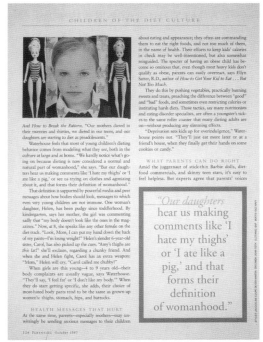

■ 499
Publication Outside
Creative Director Susan Casey
Art Director Dave Allen
Designer Dave Allen
Photo Editor Susan B. Smith
Photographer Frank W. Ockenfels 3
Publisher Mariah Media, Inc.
Issue April 1997
Category Portrait/Spread

■ 500
Publication Outside
Creative Director Susan Casey
Designer Susan Casey
Photo Editor Susan B. Smith
Photographer
Craig Cameron Olsen
Publisher Mariah Media, Inc.
Issue December 1997
Category Portrait/Spread

■ 501
Publication SmartMoney
Art Director Amy Rosenfeld
Designer Donna Agajanian
Photo Editor Jane Clark
Photographers Jana Leôn,
Heidi Yockey
Publisher Dow Jones & Hearst Corp.
Issue March 1997
Category Information Graphics

■ 502
Publication Parenting
Art Director Susan Dazzo
Designer Susan Dazzo
Photo Editor Kate Sullivan
Photographer Jody Dole
Publisher Time Inc.
Issue June/July 1997
Category Photo Illustration/Spread

■ 503
Publication Parenting
Art Director Susan Dazzo
Designer Joshua Liberson
Photo Editor Kate Sullivan
Photographer Exum
Publisher Time Inc.
Issue October 1997
Category Photo Illustration/Story

THE FENCING IN OF AFRICA

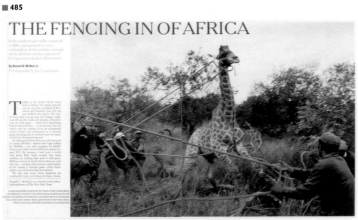

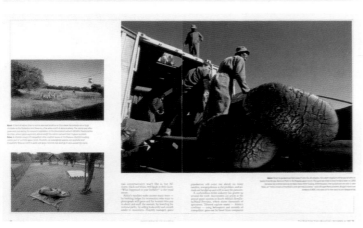

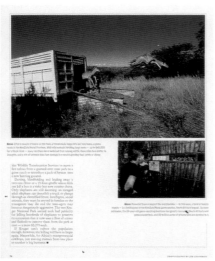

A
MOSQUITO
BITES BACK

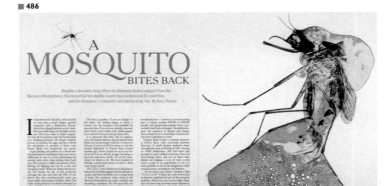

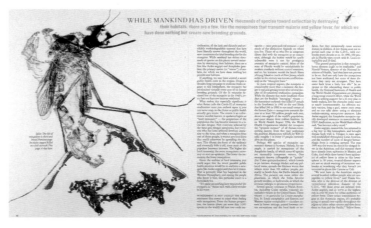

WHILE MANKIND HAS DRIVEN thousands of species toward extinction by destroying their habitats, there are a few, like the mosquitoes that transmit malaria and yellow fever, for which we have done nothing but create new breeding grounds.

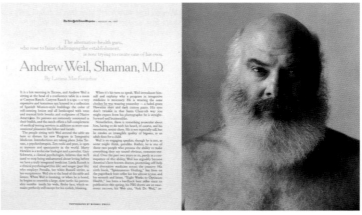

Andrew Weil, Shaman, M.D.

What Is Janet Reno Thinking?

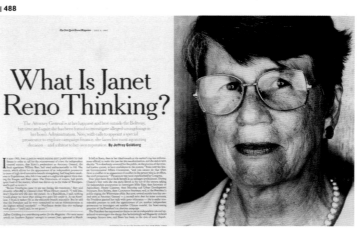

PHOTOGRAPHY MERIT ■

■ 485
Publication
The New York Times Magazine
Art Director Janet Froelich
Photo Editor Kathy Ryan
Photographer Jim Leachman
Publisher The New York Times
Issue December 14, 1997
Category Reportage & Travel/Story

■ 486
Publication
The New York Times Magazine
Art Director Janet Froelich
Designer Lou Di Lorenzo
Photo Editor Kathy Ryan
Photographer Tom Schierlitz
Publisher The New York Times
Issue August 24, 1997
Category Reportage & Travel/Story

■ 487
Publication
The New York Times Magazine
Art Director Janet Froelich
Designer Joel Cuyler
Photo Editor Kathy Ryan
Photographer Michael O'Neill
Publisher The New York Times
Issue August 2, 1997
Category Portrait/Spread

■ 488
Publication
The New York Times Magazine
Art Director Janet Froelich
Photo Editor Kathy Ryan
Photographer Ralph Mecke
Publisher The New York Times
Issue July 6, 1997
Category Portrait/Spread

■ 504

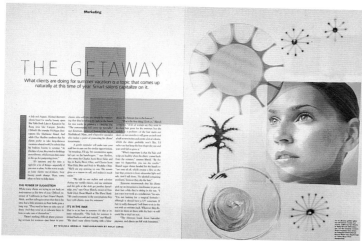

THE GETAWAY

What clients are doing for summer vacation is a topic that comes up naturally at this time of year. Smart salons capitalize on it.

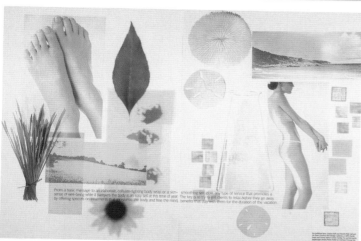

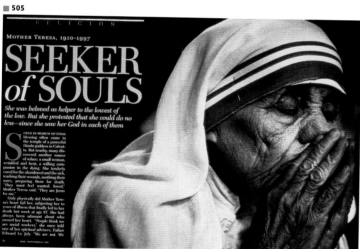
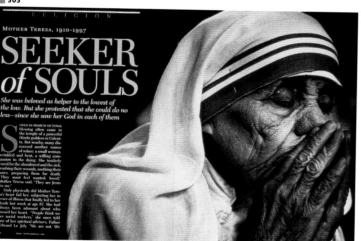

■ 505

RELIGION

MOTHER TERESA, 1910–1997

SEEKER of SOULS

She was beloved as helper to the lowest of the low. But she protested that she could do no less—since she saw her God in each of them

■ 506

Timeless Paris

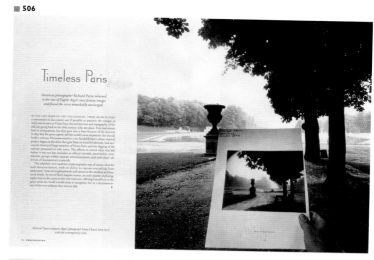

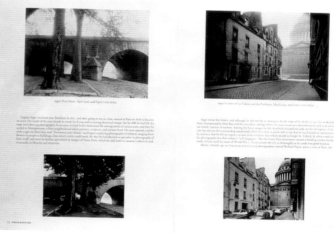

■ 507

INVESTING IN TECHNOLOGY

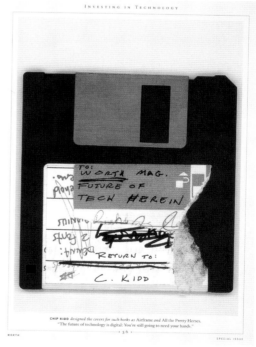

CHIP KIDD designed the covers for such books as Airframe and All the Pretty Horses.
"The future of technology is digital: You're still going to need your hands."

WORTH · 56 · SPECIAL ISSUE

■ 504
Publication Salon News
Creative Director Victoria Maddocks
Design Director Jean Griffin
Designer Victoria Maddocks
Photographer Nola Lopez
Publisher Fairchild Publications
Issue July 1997
Category Photo Illustration/Story

■ 505
Publication TIME
Art Directors Susan Langholz, Arthur Hochstein
Designer Susan Langholz
Photographer Ragau Rai
Publisher Time Inc.
Issue September 15, 1997
Category Portrait/Spread

■ 506
Publication Preservation
Art Director Brian Noyes
Designer Brian Noyes
Photographers Richard Payne, Atget
Publisher National Trust for Historic Preservation
Issue July/August 1997
Category Reportage & Travel/ Story

■ 507
Publication Worth
Art Director Philip Bratter
Designer Deanna Lowe
Illustrator Chip Kidd
Publisher Capital Publishing L. P.
Issue August 1997
Category Photo Illustration/Single Page or Spread

■ 508

■ 510

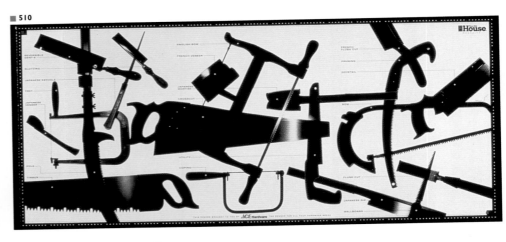

■ 511

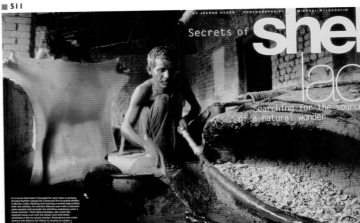

■ 509

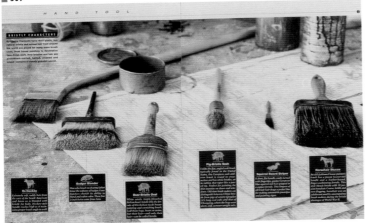

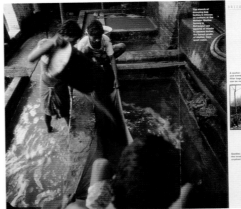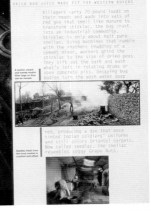

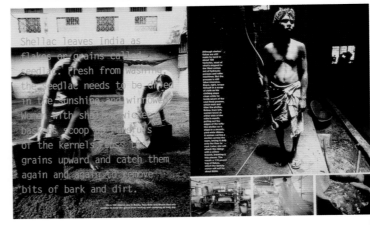

■ 508
Publication This Old House
Design Director Matthew Drace
Art Director Tim Jones
Photographer Gary Hush
Publisher Time Inc.
Issue July/August 1997
Category Still Life & Interiors
Single Page

■ 509
Publication This Old House
Design Director Matthew Drace
Designer Bob O'Connell
Illustrator Clancy Gibson
Photographer Anthony Cotsifas
Publisher Time Inc.
Issue September/October 1997
Category Still Life & Interiors/Single
Page or Spread

■ 510
Publication This Old House
Design Director Matthew Drace
Designer Mo Flan
Photographer Bill White
Publisher Time Inc.
Issue November/December 1997
Category Still Life & Interiors/Single
Page or Spread

■ 511
Publication This Old House
Design Director Matthew Drace
Designer Mo Flan
Photographer Micheal McLaughlin
Publisher Time Inc.
Issue September/October 1997
Category Reportage & Travel/Story

■ 512

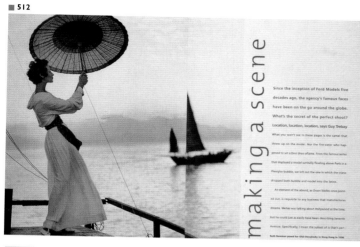

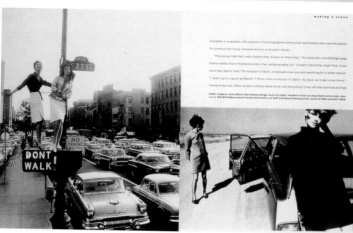

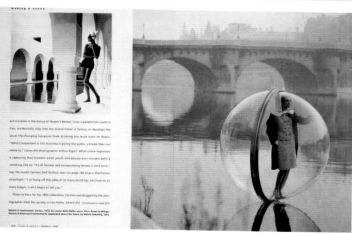

■ 513

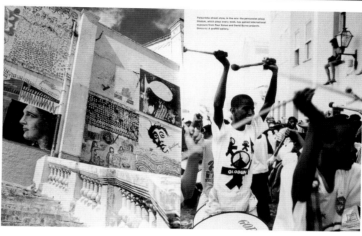

Rhythm of the City of All Saints

by daisann mclane photographed by john huba

Bahia, the spiritual center of Brazil, emerges from obscurity with a spruced-up colonial quarter and a powerful backbeat

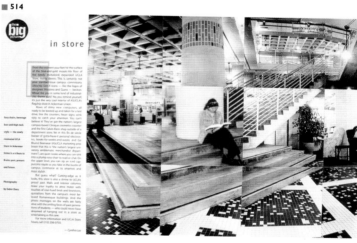

■ 514

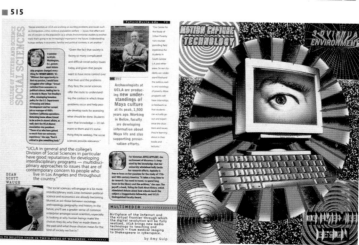

■ 515

■ 512
Publication Travel & Leisure
Design Director Pamela Berry
Designer Pamela Berry
Photo Editor Jim Franco
Photographer Arthur Elgort
Publisher
American Express Publishing
Issue October 1997
Category Reportage & Travel/Story

■ 513
Publication Travel & Leisure
Design Director Pamela Berry
Designer Pamela Berry
Photographer John Huba
Publisher
American Express Publishing
Issue December 1997
Category Reportage & Travel/Story

■ 514
Publication UCLA Magazine
Creative Director Charles Hess
Designers Dana Barton,
Jackie Morrow
Photo Editor Charles Hess
Photographer Gabor Ekecs
Studio C. Hess Design
Publisher UCLA
Issue Spring 1997
Category Still Life & Interiors/Spread

■ 515
Publication UCLA Magazine
Creative Director Charles Hess
Designers Dana Barton,
Jackie Morrow
Illustrator Amy Guip
Photo Editor Charles Hess
Photographer Amy Guip
Studio C. Hess Design
Publisher UCLA
Issue Spring 1997
Category Photo Illustration/Spread

■ 516

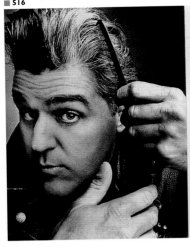

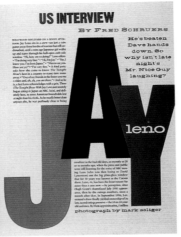

US INTERVIEW
BY FRED SCHRUERS

He's beaten
Dave hands
down. So
why isn't late
night's
Mr. Nice Guy
laughing?

JAY
leno

photograph by mark seliger

■ 518

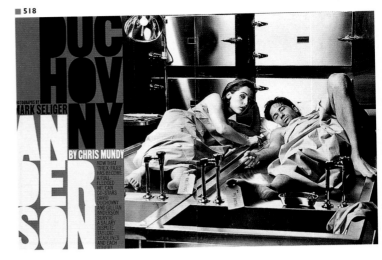

DUC
HOV
NY
AN
DER
SON

PHOTOGRAPHS BY
MARK SELIGER

BY CHRIS MUNDY

NOW THAT
THE X-FILES
HAS BECOME
A FULL-
FLEDGED
HIT, CAN
CO-STARS
DAVID
DUCHOVNY
AND GILLIAN
ANDERSON
SURVIVE
A SALARY
DISPUTE,
TABLOID
HEADLINES
AND EACH
OTHER?

■ 517

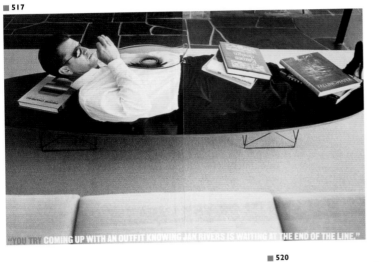

"YOU TRY COMING UP WITH AN OUTFIT KNOWING JAN RIVERS IS WAITING AT THE END OF THE LINE."

■ 519

Unusual suspect:
The offbeat British
actor keeps
audiences guessing
in 'Deceiver'

TIM
R TH

By Steve Pond
Photograph
by Len Irish

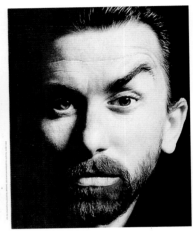

■ 520

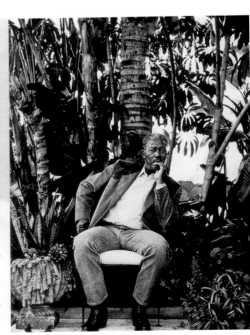

Morgan
FREEMAN

By ROBERT ABELE

*His ability to
bring prestige
to a film,
not to mention
his knack for
picking hits,
has turned this
60-year-old
actor into
Hollywood's
most valuable
player*

Photographs by
ROBERT
PAUL
MAXWELL

■ 516
Publication US
Art Director Richard Baker
Designer Bess Wong
Photo Editor Jennifer Crandall
Photographer Mark Seliger
Publisher US Magazine Co., L. P.
Issue January 1997
Category Portrait/Spread

■ 517
Publication US
Art Director Richard Baker
Photo Editors Jennifer Crandall,
Rachel Knepfer
Photographer Brigitte Lacombe
Publisher US Magazine Co., L. P.
Issue September 1997
Category Portrait/Spread

■ 518
Publication US
Art Director Richard Baker
Designer Daniel Stark
Photo Editor Jennifer Crandall
Photographer Mark Seliger
Publisher US Magazine Co., L. P.
Issue May 1997
Category Portrait/ Spread

■ 519
Publication US
Art Director Richard Baker
Designer Rina Migliaccio
Photo Editors Jennifer Crandall,
Rachel Knepfer
Photographer Len Irish
Publisher US Magazine Co., L. P.
Issue December 1997
Category Portrait/Spread

■ 520
Publication US
Art Director Richard Baker
Designer Bess Wong
Photo Editors Jennifer Crandall,
Rachel Knepfer
Photographer Robert Maxwell
Publisher US Magazine Co., L. P.
Issue May 1997
Category Portrait/Spread

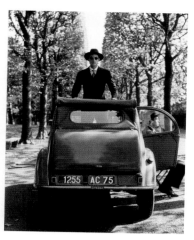

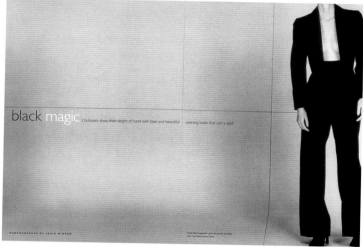

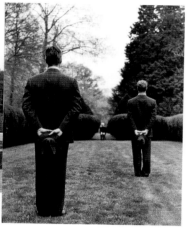

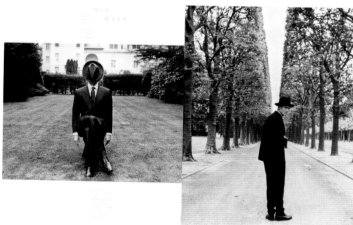

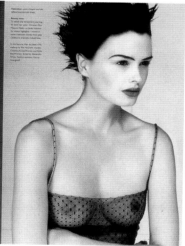

■ 521
Publication Travel & Leisure Golf
Design Director Tom Brown
Designer Tom Brown
Photo Editor Leora Kahn
Photographer Rodney Smith
Publisher American Express Publishing
Category Fashion & Beauty/Story

■ 522
Publication W
Creative Director Dennis Freedman
Design Director Edward Leida
Art Director Kirby Rodriguez
Designer Marcella Bove-Huttie
Photographer Craig McDean
Publisher Fairchild Publications
Category Fashion & Beauty/Story

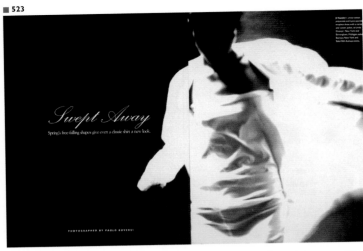

Swept Away

Spring's free-falling shapes give even a classic shirt a new look.

PHOTOGRAPHED BY PAOLO ROVERSI

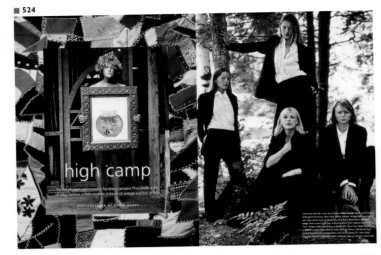

high camp

PHOTOGRAPHED BY BRUCE WEBER

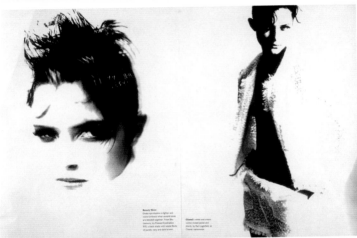

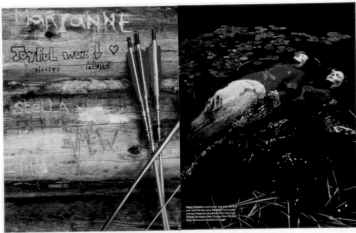

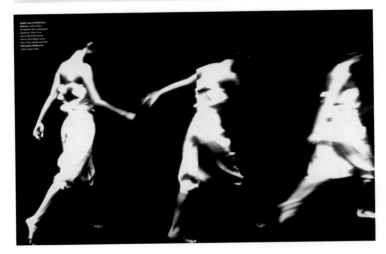

■ 523
Publication W
Creative Director Dennis Freedman
Design Director Edward Leida
Art Director Kirby Rodriguez
Designers Marcella Bove-Huttie, Barbara Reyes
Photographer Paolo Roversi
Publisher Fairchild Publications
Category Fashion & Beauty/Story

■ 524
Publication W
Creative Director Dennis Freedman
Design Director Edward Leida
Art Director Kirby Rodriguez
Designers Marcella Bove-Huttie, Barbara Reyes
Photographer Bruce Weber
Publisher Fairchild Publications
Category Fashion & Beauty/Story

Hothouse Flower

Steamy summer beauty - it's all about glistening skin and strong, sultry makeup.

PHOTOGRAPHED BY NATHANIEL GOLDBERG

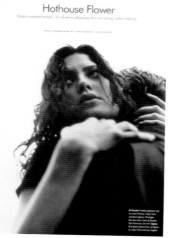

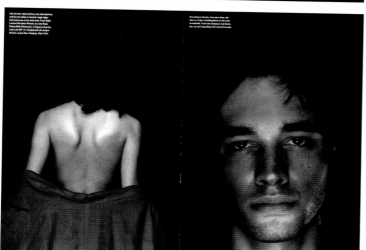

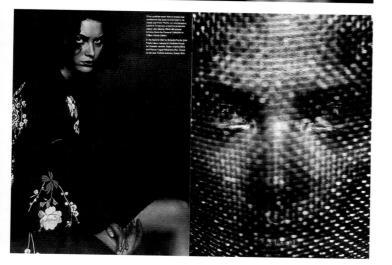

Sun Kitsch

Martin Parr, who made his name at home in England photographing a seaside resort, brings his camera to America's beaches for the first time. "I'm fascinated by tourism," says the photographer, whose book on the subject, *Small World*, was published in 1995. "I'm attracted to the idea of what other people are finding attractive." Parr spent six days in southern Florida—Miami, Fort Lauderdale and Palm Beach—shooting for *W* what he describes as "the scenes within the scene," from bronzed muscle boys playing on the sand to leather-skinned senior citizens baking in the sun. "My quest is to photograph the most ordinary things possible and make them look interesting," he says. "America is a great place for that because so much of America is so fantastically bland."

PHOTOGRAPHED BY MARTIN PARR

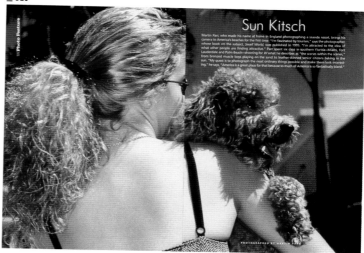

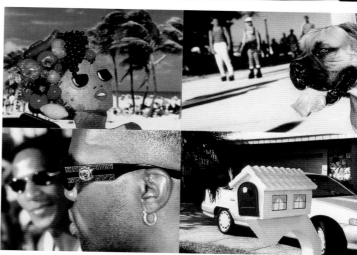

■ 525
Publication W
Creative Director Dennis Freedman
Design Director Edward Leida
Art Director Kirby Rodriguez
Designer Marcella Bove-Huttie
Photographer Nathaniel Goldberg
Publisher Fairchild Publications
Category Fashion & Beauty/Story

■ 526
Publication W
Creative Director Dennis Freedman
Design Director Edward Leida
Art Director Kirby Rodriguez
Designer Marcella Bove-Huttie
Photographer Martin Parr
Publisher Fairchild Publications
Category Fashion & Beauty/Story

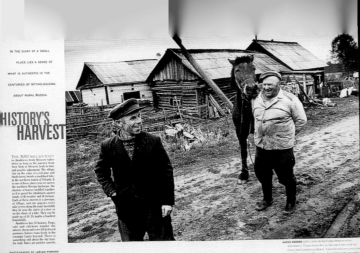

IN THE DIARY OF A SMALL

PLACE LIES A SENSE OF

WHAT IS AUTHENTIC IN THE

CENTURIES OF MYTHOLOGIZING

ABOUT RURAL RUSSIA

HISTORY'S HARVEST

PHOTOGRAPHS BY LUCIAN PERKINS

TEXT BY MARGARET PAXSON

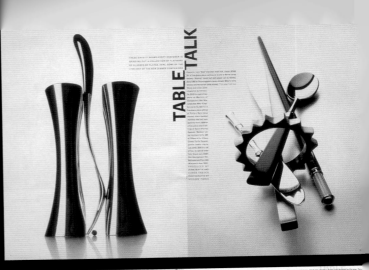

<div style="text-align:right">TABLE TALK</div>

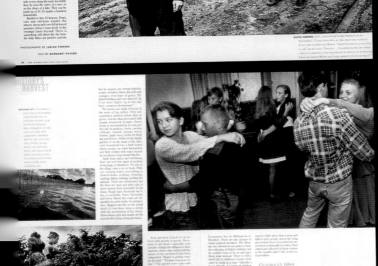

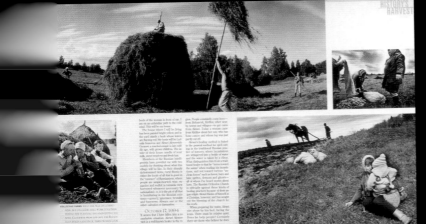

■ 529

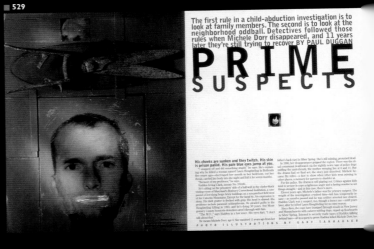

The first rule in a child-abduction investigation is to look at family members. The second is to look at the neighborhood oddball. Detectives followed those rules when Michele Dorr disappeared, and 11 years later they're still trying to recover BY PAUL DUGGAN

PRIME
SUSPECTS

PHOTO ILLUSTRATIONS BY GARY TANHAUSER

■ 527
Publication
The Washington Post Magazine
Art Director Kelly Doe
Designer Kelly Doe
Photo Editor Crary Pullen
Photographer Lucian Perkins
Publisher The Washington Post Co.
Issue January 5, 1997
Category Reportage & Travel/Story

■ 528
Publication
The Washington Post Magazine
Art Director Kelly Doe
Designer Lisa Schreiber
Photo Editor Karen Tanaka
Photographer Richard Pierce
Publisher The Washington Post Co.
Issue October 5, 1997
Category Still Life & Interiors/Story

■ 529
Publication
The Washington Post Magazine
Art Director Kelly Doe
Designer Kelly Doe
Photo Editor Crary Pullen
Photographer Gary Tanhauser
Publisher The Washington Post Co.
Issue August 10, 1997
Category Photo Illustration/Story

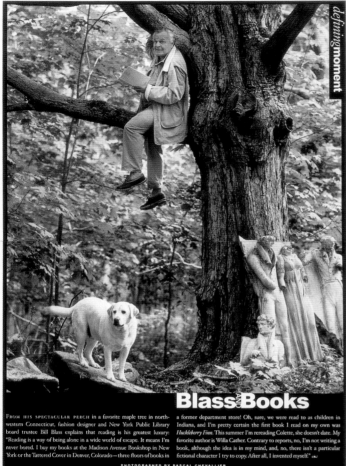

defining moment

From his spectacular perch in a favorite maple tree in north-western Connecticut, fashion designer and New York Public Library board trustee Bill Blass explains that reading is his greatest luxury: "Reading is a way of being alone in a wide world of escape. It means I'm never bored. I buy my books at the Madison Avenue Bookshop in New York or the Tattered Cover in Denver, Colorado—three floors of books in

a former department store! Oh, sure, we were read to as children in Indiana, and I'm pretty certain the first book I read on my own was *Huckleberry Finn*. This summer I'm rereading Colette, she doesn't date. My favorite author is Willa Cather. Contrary to reports, no, I'm not writing a book, although the idea is in my mind, and, no, there isn't a particular fictional character I try to copy. After all, I invented myself."

Blass and Books

PHOTOGRAPHED BY PASCAL CHEVALLIER

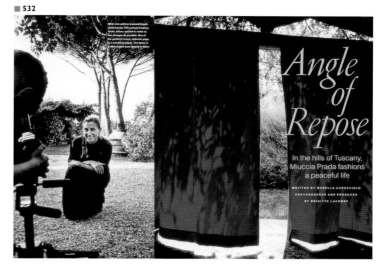

Angle of Repose

In the hills of Tuscany, Miuccia Prada fashions a peaceful life

WRITTEN BY MARELLA CARACCIOLO
PHOTOGRAPHED AND PRODUCED BY BRIGITTE LACOMBE

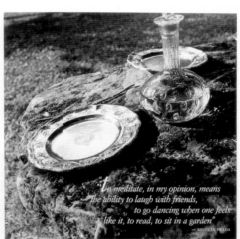

"To meditate, in my opinion, means the ability to laugh with friends, to go dancing when one feels like it, to read, to sit in a garden."
— MIUCCIA PRADA

THE LUXURY OF *color*

Jewel Tones

Combining the lush palettes of Italy and India, interior designer Lucretia Moroni makes magic in the New York apartment of jewelry designer Annalu Ponti

PRODUCED BY CYNTHIA FRANK · WRITTEN BY AKIKO BUSCH
PHOTOGRAPHED BY MELANIE ACEVEDO

Hiro's Palace Coop

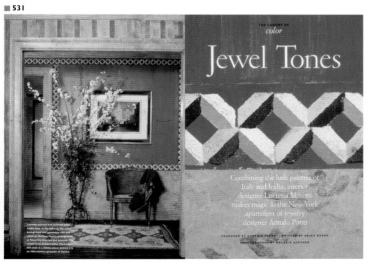

defining moment

PHOTOGRAPHED BY HIRO

530
Publication
Condé Nast House & Garden
Art Director Diana LaGuardia
Designer Diana LaGuardia
Photo Editor Dana Nelson
Photographer Pascal Chevallier
Publisher Condé Nast Publications Inc.
Issue September 1997
Category Portrait/Single Page

531
Publication
Condé Nast House & Garden
Art Director Diana LaGuardia
Designer Audrey Razgaitis
Photo Editor Dana Nelson
Photographer Melanie Acevedo
Publisher Condé Nast Publications Inc.
Issue September 1997
Category Still Life & Interiors/Spread

532
Publication
Condé Nast House & Garden
Art Director Diana LaGuardia
Deputy Art Director
Nancy Brooke Smith
Photo Editor Dana Nelson
Publisher Condé Nast Publications Inc.
Issue November 1997
Category Reportage & Travel/Story

533
Publication
Condé Nast House & Garden
Art Director Diana LaGuardia
Designer Diana LaGuardia
Photo Editor Dana Nelson
Photographer Hiro
Publisher Condé Nast Publications Inc.
Issue September 1997
Category Reportage & Travel/Spread

■ 534

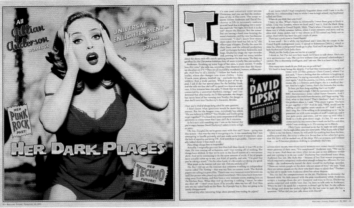

■ 536

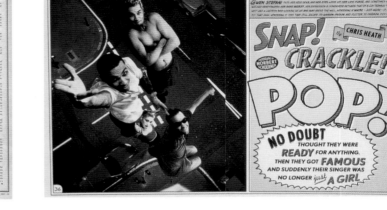

■ 535 A

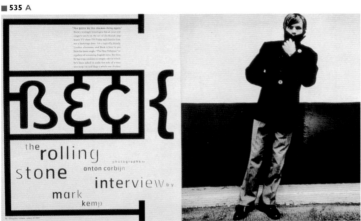

B

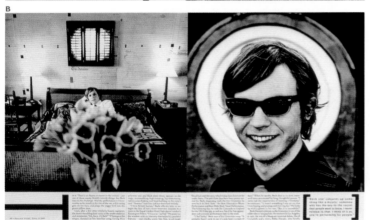

■ 537

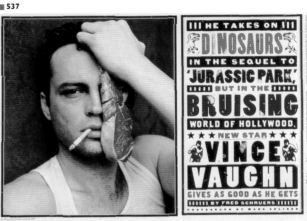

■ 538

■ 534
Publication Rolling Stone
Art Director Fred Woodward
Designer Gail Anderson
Photo Editor Jodi Peckman
Photographer Matthew Rolston
Typographer Eric Siry
Publisher Wenner Media
Issue February 20, 1997
Category PortraitSpread

■ 535
Publication Rolling Stone
Art Director Fred Woodward
Designer Geraldine Hessler
Photo Editor Jodi Peckman
Photographer Anton Corbijn
Publisher Wenner Media
Issue April 17, 1997
Categories Portrait/Story
　　　　A Portrait/Spread
　　　　B Portrait/Spread

■ 536
Publication Rolling Stone
Art Director Fred Woodward
Designers Fred Woodward, Gail Anderson
Photo Editor Jodi Peckman
Photographer Norbert Schoerner
Typographer Eric Siry
Publisher Wenner Media
Issue May 1, 1997
Category Portrait/Spread

■ 537
Publication Rolling Stone
Art Director Fred Woodward
Designer Lee Bearson
Photo Editor Jodi Peckman
Photographer Mark Seliger
Publisher Wenner Media
Issue June 12, 1997
Category Portrait/Spread

■ 538
Publication Rolling Stone
Art Director Fred Woodward
Designer Geraldine Hessler
Photo Editor Jodi Peckman
Photographer Matthew Rolston
Publisher Wenner Media
Issue September 18, 1997
Category Portrait/Spread

■ 539

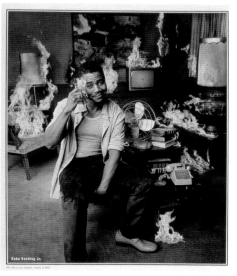

Cuba Gooding Jr.

■ 541

RAVI SHANKAR
By Al Weisel

■ 542

"Death to Hootie!"
Trent Reznor Makes a Case for Danger

■ 540

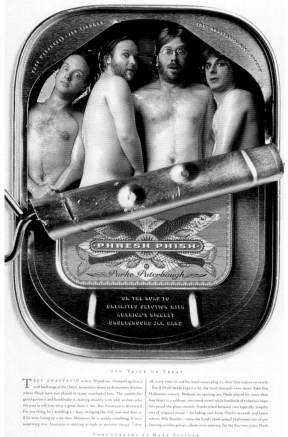

PHRESH PHISH
Parke Puterbaugh

ON THE ROAD TO
UNLIMITED DEVOTION WITH
AMERICA'S BIGGEST
UNDERGROUND JAM BAND

"Is Trick or Treat"

PHOTOGRAPHS BY MARK SELIGER

■ 543

BY JANCEE DUNN

Cosmic girl

PHOTOGRAPHY MERIT ■

■ 539
Publication Rolling Stone
Art Director Fred Woodward
Photo Editor Jodi Peckman
Photographer Mark Seliger
Publisher Wenner Media
Issue April 13, 1997
Category Portrait/Single Page

■ 540
Publication Rolling Stone
Art Director Fred Woodward
Designers Fred Woodward, Geraldine Hessler
Photo Editor Jodi Peckman
Photographer Mark Seliger
Publisher Wenner Media
Issue February 20, 1997
Category Portrait/Spread

■ 541
Publication Rolling Stone
Art Director Fred Woodward
Photo Editor Jodi Peckman
Photographer Frank W. Ockenfels 3
Publisher Wenner Media
Issue May 15, 1997
Category Portrait/Single Page

■ 542
Publication Rolling Stone
Art Director Fred Woodward
Designers Fred Woodward, Lee Bearson
Photo Editor Jodi Peckman
Photographer Dan Winters
Publisher Wenner Media
Issue March 6, 1997
Category Portrait/Single Page

■ 543
Publication Rolling Stone
Art Director Fred Woodward
Designers Fred Woodward, Gail Anderson
Photo Editor Jodi Peckman
Photographer Brigitte Lacombe
Publisher Wenner Media
Issue November 13, 1997
Category Portrait/Spread

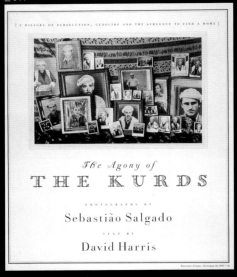

A HISTORY OF PERSECUTION, GENOCIDE AND THE STRUGGLE TO FIND A HOME

The Agony of
THE KURDS

PHOTOGRAPHS BY
Sebastião Salgado

TEXT BY
David Harris

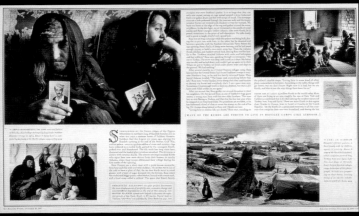

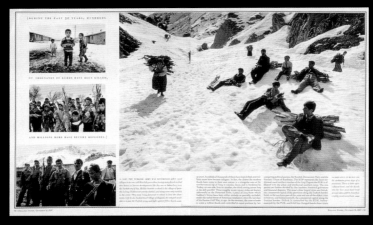

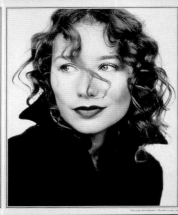

Tori Amos

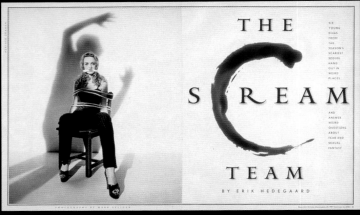

THE SCREAM TEAM

SIX YOUNG DIVAS FROM THE SEASON'S SCARIEST SEQUEL HANG OUT IN WEIRD PLACES AND ANSWER WEIRD QUESTIONS ABOUT FEAR AND SEXUAL FANTASY

BY ERIK HEDEGAARD

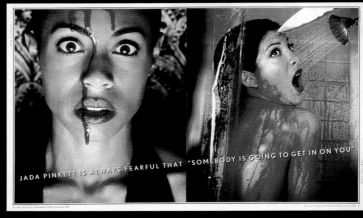

JADA PINKETT IS ALWAYS FEARFUL THAT "SOMEBODY IS GOING TO GET IN ON YOU"

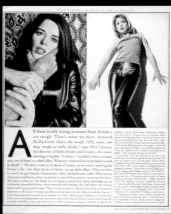

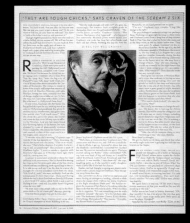

■ 544
Publication Rolling Stone
Art Director Fred Woodward
Designers Fred Woodward,
Gail Anderson
Photo Editor Jodi Peckman
Photographer Sebastião Salgado
Publisher Wenner Media
Issue October 16, 1997
Category Reportage & Travel/Story

■ 545
Publication Rolling Stone
Art Director Fred Woodwardk
Designers Fred Woodward,
Gail Anderson
Photo Editor Jodi Peckman
Photographer Brigitte Lacombe
Publisher Wenner Media
Issue November 13, 1997
Category Portrait/Spread

■ 546
Publication Rolling Stone
Art Director Fred Woodward
Photo Editor Jodi Peckman
Photographer Mark Seliger
Publisher Wenner Media
Issue December 25, 1997
Category Portrait/Story

■ 547

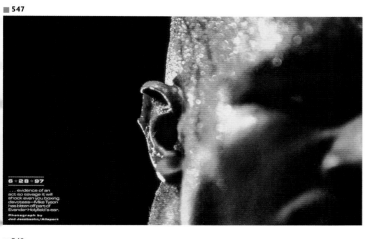

■ 548

■ 549

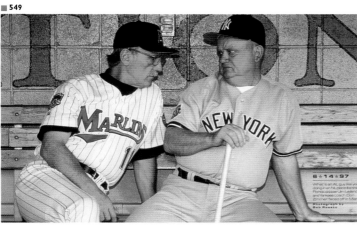

■ 550

■ 551

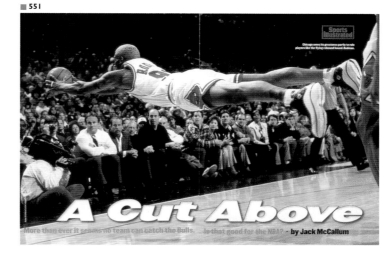

A Cut Above
More than ever it seems no team can catch the Bulls. Is that good for the NBA? – by Jack McCallum

■ 552

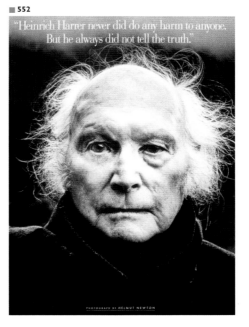

"Heinrich Harrer never did do any harm to anyone. But he always did not tell the truth."

PHOTOGRAPH BY HELMUT NEWTON

■ 547
Publication
Sports Illustrated Presents
Art Director Craig Gartner
Designer Michael Schinnerer
Photo Editor Jeff Weig
Photographer Jeff Jacobsohn
Publisher Time Inc.
Issue 1997
Category Reportage & Travel/ Spread

■ 548
Publication
Sports Illustrated Presents
Art Director Craig Gartner
Designer Michael Schinnerer
Photo Editor Jeff Weig
Photographer John Iacono
Publisher Time Inc.
Issue 1997
Category Reportage & Travel/ Spread

■ 549
Publication
Sports Illustrated Presents
Art Director Craig Gartner
Designer Michael Schinnerer
Photo Editor Jeff Weig
Photographer Bob Rosato
Publisher Time Inc.
Issue 1997
Category Reportage & Travel/ Spread

■ 550
Publication
Sports Illustrated Presents
Art Director Craig Gartner
Designer Michael Schinnerer
Photo Editor Jeff Weig
Photographer Heinz Kluetmeier
Publisher Time Inc.
Issue 1997
Category Reportage & Travel/ Spread

■ 551
Publication Sports Illustrated
Creative Director Steven Hoffman
Designer Craig Gartner
Photographer Sam Forenlich
Publisher Time Inc.
Issue March 10, 1997
Category Reportage & Travel/ Spread

■ 552
Publication Vanity Fair
Design Director David Harris
Photo Editors Susan White, Sunhee Grinnell
Photographer
Helmut Newton
Publisher Condé Nast Publications Inc.
Issue October 1997
Category Portrait/Single Page

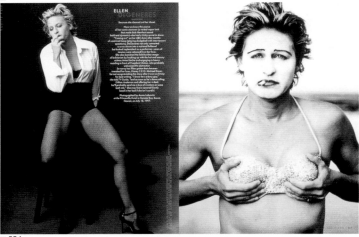

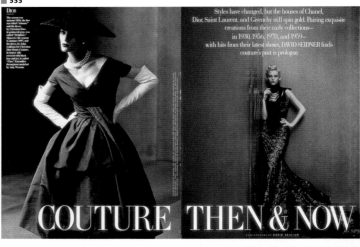

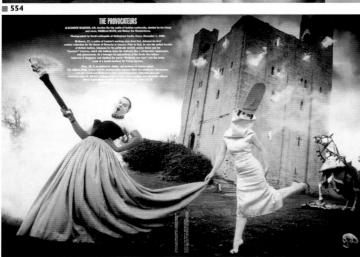

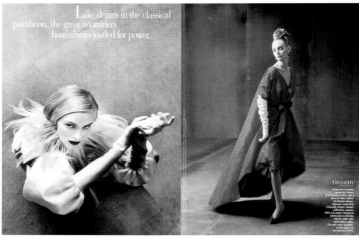

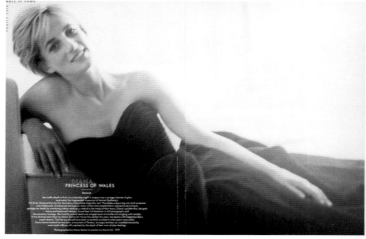

■ 553
Publication Vanity Fair
Design Director David Harris
Photo Editors Susan White,
Lisa Berman
Photographer Annie Leibovitz
Publisher Condé Nast Publications Inc.
Issue December 1997
Category Portrait/Spread

■ 554
Publication Vanity Fair
Design Director David Harris
Photo Editors Susan White,
Lisa Berman
Photographer David LaChapelle
Publisher Condé Nast Publications Inc.
Issue March 1997
Category Portrait/Spread

■ 555
Publication Vanity Fair
Design Director David Harris
Art Directors David Harris,
Gregory Mastrianni
Photo Editor Susan White
Photographer David Seidner
Publisher Condé Nast Publications Inc.
Issue June 1997
Category Fashion & Beauty/Story

■ 556
Publication Vanity Fair
Design Director David Harris
Photo Editors Susan White,
Lisa Berman
Photographer Annie Leibovitz
Publisher Condé Nast Publications Inc.
Issue December 1997
Category Portrait/Spread

■ 557
Publication Vanity Fair
Design Director David Harris
Designer Gregory Mastrianni
Photo Editor Susan White
Photographer Mario Testino
Publisher Condé Nast Publications Inc.
Issue December 1997
Category Portrait/Spread

Setting The Tone For Police Reform

By Frank Serpico

In the 25 years since I testified before the Knapp Commission about my odyssey to combat police corruption, I have occasionally been credited with spurring profound changes within the New York Police Department. It's a flattering way to be remembered, but the unfortunate reality — as recent events in Brooklyn's 70th Precinct confirm — is that nothing about police culture has significantly changed since I left the force in 1972. The department continues to tolerate unacceptable behavior, making an atrocity like the alleged abuse of Abner Louima virtually inevitable.

One of the most telling developments in the recent calamity is that Eric Turetzky, the police officer credited with toppling the "blue wall of silence" by stepping forward to identify the precinct's rogue officers, now finds himself in need of police protection — from other police.

In 1972, I tried to make clear to the Knapp Commission a point that continues to elude — or be ignored by — the highest ranks of the department.

"The problem is that the atmosphere does not yet exist in which an honest police officer can act without fear of ridicule or reprisal from fellow officers," I said. "Police corruption cannot exist unless it is at least tolerated at higher levels in the department. The most important result ... is a conviction by police officers, even more than the public, that the department will change."

Both Police Commissioner Howard Safir and his predecessor, William Bratton, reportedly scoffed at the story of crooked police in the new film "Cop Land," dismissing it as sheer fantasy. It may be fiction, but I believe the movie contains more truth about New York's Finest than the entire Mollen investigation report. Especially painful (and on the mark) is a scene in which an Internal Affairs officer, played by Robert De Niro, explodes with frustration after ignoring a phone call from politically motivated superiors shutting down his investigation of crooked officers. No single police administration

Why little has changed in 25 years.

bears the brunt of the blame for this sorry state of affairs, but no one's off the hook, either. Twenty years after the Knapp Commission, Sgt. Joseph Trimboli lost his health and spirit trying to bring to justice a crooked officer named Michael Dowd. After many years of resisting Sergeant Trimboli's investigation, the department was finally forced to acknowledge his efforts when Mr. Dowd was arrested on drug charges in Suffolk County in 1992.

Invariably, the news media lump Sergeant Trimboli and me together with other police officers involved in major corruption stories. But there's a difference. Most of the others were crooked cops trying to save their own necks.

And as long as the culture of the department remains the same, the thousands of good, decent cops who see police malfeasance every day will continue to end their shifts in silence, disillusioned.

In the long run, the people get the police they deserve. The average citizen doesn't care how much force a police officer uses in arresting a suspect, whether for a serious crime or a simple violation, as long as the officer is effective in combating crime. Don't count on meaningful changes to occur without prolonged public pressure. Voters have to demand of elected officials an honest police force. The press could do much to improve matters by returning to stories long after they have fallen off the front pages and monitoring the change or, more likely, the lack of change.

In the past few days, many ideas have surfaced to help insure that police brutality never shames the New York Police Department again. Among them are the use of video cameras to monitor station houses and patrol cars and the improvement of training techniques.

I don't quibble with any of these. But they are trivial compared with the greater challenges of holding top brass accountable and creating an environment that encourages, applauds and rallies behind the removal of bad cops — before they are allowed to do harm.

Frank Serpico, a retired New York City police detective, has written an afterword to the republication of Peter Maas's "Serpico."

Op-Art
HOWARD HOROWITZ

Manhattan

The island's tip
was sliced by a ship
canal that tamed the
Spuyten Duyvil shoals,
but severed Marble Hill
from Inwood. Medieval
tapestry unicorns grace
the Cloisters; a flag-
pole and stockade mark
old Fort Tryon. Lofty
crags overlook the
broad Hudson River
as bedrock & history
anchor the Heights to
the George Washington Bridge. Walk east
toward the Bronx across High Bridge;
gaze to the south
from Sugar Hill,
where trumpeters
and tap dancers
stepped up into
the sun. Ages ago
Iapetus (an older
Atlantic Ocean)
closed; the kiss
with Africa heated
a melting pot. Lava
was injected in veins
of rock and coagulated
to form Palisade cliffs.
The legacy of Algonquian
life is hidden in our place
names and our meals. The new-
comers (first the Dutch, then
English, African, Irish, German,
Italian, Jewish, Chinese, Greek,
Ukrainian, Armenian, Puerto Rican,
Pakistani, Cuban, Dominican, Haitian,
Filipino, and all) have shed blood in a
thousand places, but millions live. Legends
of Gotham: Father Knickerbocker, Boss Tweed,
Emma Lazarus, Fiorello, the roar of the El,
the blizzard of '47, Giants at the Polo Grounds.
Offshore, barges ply swirling brown water near
North River sewage pipes, as striped bass and
shad swim up "the river that flows both ways" : a
tidal reach of the sea all the way up to Albany.
Brownstone, bodega, ball court & bus stop: on warm
nights in Harlem, noisy streets and quiet rooftops.
Kids splash around a hydrant as lovers embrace on a
Riverside Park bench and rush-hour traffic is stalled on the Triborough Bridge.
Some uptown options: gospel choir on Sunday, sooty
Grant's Tomb, hiphop the Apollo, ribs at Sylvia's,
law at Columbia, mangos in El Barrio, peace garden
in the Cathedral, rowboat on the Meer, pub-crawl the
West Side, listen to poetry at the 92nd St. Y, nosh at
Zabar's, spiral up the Guggenheim, tour Gracie Mansion.
Songbirds alight in leafy woods as a turtle lays eggs
near a pond in Central Park. Grand museums flank the
green with dinosaur bones and Egyptian tombs. When it
snows, we ramble out to Sheep Meadow & the Great Lawn;
in sunshine, to Strawberry Fields, the Lake, & the Zoo.
Buy hot dogs from pushcarts near Madison boutiques, or
hear grand opera at the Met. Step down to the world of
subways. (Take the A train, ride the Lexington line,
or change at 59th Street for the IRT. Catch the F out to Queens.)
Gneiss but full of schist, the bedrock sparkles with
mica. It bears the weight of midtown: skyscrapers
at Columbus Circle, Fifth Avenue, and Park Avenue.
Attend concerts at Carnegie, ice skating down at
Rockefeller Center, Mass at St. Patrick's Cathedral.
Our eyes are drawn up to a blue slice of sky as
vertical walls enclose us. 100 gridlocked taxis honk
at police blockades as Fidel speaks at the U.N.
Revelers jam Times Square on New Year's Eve, to
jostle and sing as the ball drops. Buses come in
.(the Lincoln Tunnel) to Port Authority, trains to Grand Central. The
lion-flanked public library was once a reservoir;
we love the Art Deco classic Chrysler spire. From
Hell's Kitchen walk to Broadway, buy tickets for
"Showboat" or "Cats"—hey, the Knicks won at the
buzzer in the Garden! See Macy's float parade, then
gape from atop the Empire State, where mighty Kong
took a fall. Diamond jewelers join fur-clad window
shoppers as herds of jaywalkers cross against the
light in the Garment District. Graffiti-scrawled
boards near the Flatiron Building enclose pits
of unconsolidated sediment Consolidated Edison
must dig. Workers repair Gramercy Park cables,
reroute Chelsea steam pipes, plug a burst main
flooding streets by Union Square. (Tap water
flows down from the Catskills in deep tunnels;
garbage is hauled to a landfill at Fresh Kills.)
The riverfront was filled for barnacle-crusted
piers, and Minetta Brook wetlands became lots
in Greenwich Village. A sweatshop horror: 146
locked-in women lost their lives in the Triangle
Shirtwaist fire. Watch skateboard demons cavort
among panhandlers as old men play chess near the
arch in Washington Square. N.Y.U. students, art
film fans, coffee drinkers, & East Village poets
crowd smoky joints on Saturday night; some cross
(the Holland Tunnel) back out to New Jersey. Cheap gallery space
is a memory in SoHo; cast-iron lofts rent high,
as do TriBeCa warehouses. A bag lady seeks warmth
huddled over a sidewalk grate on New Amsterdam, where
Stuyvesant's farm once spread in old New Amsterdam.
The original steal (this island, traded for $24 in
beads) lies plastered in myth and concrete, obscured
like the African Burial Grounds. A Lower East Side
delicatessen sells good chicken soup; enjoy zuppa di
pesca at the Festival of San Gennaro, or bird's nest
soup in Chinatown. Marchers to City Hall cross the Brooklyn Bridge
to demonstrate, as tourists at South Street Seaport
eat lunch with a view. The Fulton Fish Market is
mobbed before dawn. Precambrian stocks bond the
upper crust with solid foundations below the
Trade Towers, Trinity Church and Wall Street.
Ferryboats to Staten Island, Ellis
Island, the Statue of Liberty,
and Governor's Island
depart from wind-
swept docks
at Battery
Park.

Howard Horowitz is a poet and professor of geography at Ramapo College.

Liberties
MAUREEN DOWD

Pow! Splat! Spin!

WASHINGTON
I'm sure there were times when George Bush would have liked to gnaw on Pat Buchanan or Ross Perot. But that Greenwich breeding and Yale sportsmanship always kicked in before any incidents of cannibalism could occur.

It's hard to imagine the patrician President and the brutish boxer having the same corner man. But Sig Rogich, the Las Vegas crisis management guru who used to work at the White House polishing Mr. Bush's image, has been hired by Don King to polish Mike Tyson's image.

"I will handle it with the same aplomb that I handled the re-election of George Bush," Mr. Rogich says dryly. (We're counting on it.) He's being paid a fortune, but how much? "None of your beeswax," he says.

The bite meets the sound bite.

Mr. Rogich, a poor kid who became a multimillionaire doing P.R. in Vegas, stood out in the "Hi, where'd you prep?" Bush Administration. He had worked for Frank Sinatra and was a pal of Wayne Newton — even though he calls "Danke Schön" "a stupid song." He was the only guy there who had pants with pleats, Bally loafers and a $3,000 Bertolucci watch. He called the Cabinet "beautiful people" and hugged startled colleagues. In an effort to fit in, he traded his $100,000 Mercedes for a $50,000 Land Rover. A native of Iceland, he changed his name from Sigfus to Sigmund in college, but everyone called him "Sig" anyway.

He tried to create "moments," fretting over the setting and the look. But he could play rough. He produced the 1988 "tank ad" with news footage that made Michael Dukakis look more Snoopy than Patton.

That ad was the political equivalent of biting your competitor's ear. Still, rehabilitating a convicted rapist and proven carnivore will require Herculean bobbing and feinting.

"I would never take him to lunch with reporters," said Paul Costello, who handled press for Rosalynn Carter and Kitty Dukakis.

Mr. Rogich does not want his duties with Mr. Tyson to offend women or interfere with his future in Nevada politics or his desire to help George W. Bush, the Governor of Texas, become President.

"I certainly make no excuses for the rape thing, goodness knows; that was long before I came on board," he says. "And no one is making any excuses for what happened in the boxing ring. He lost his cool and is paying the price for it. Every time I talk to him, he says he regrets it. He knows that he humiliated himself."

Mr. Rogich, a former member of the Nevada State Athletic Commission, wrote Mr. Tyson's apology to the panel that fined the boxer $3 million and revoked his license. The publicist is keeping Mr. Tyson away from the media until he can prepare a groveling comeback strategy.

"Juan Marichal took a baseball bat and clubbed the catcher over the head," he says. "Roberto Alomar spit in an umpire's face. Hockey games are measured in part by how hard they bash the other guy. The Knicks and the Heat got into a slugfest at Madison Square Garden. The problem is a boxing ring is that there are only two people, so the focus is on one of the two."

True, but aren't you supposed to punch, not munch? Even Mr. Rogich's friends are dubious. "This is stupid for Siggie to do, if he wants to run for senator or governor someday," said Ed Rollins, the former amateur boxer and strategist who has had his share of debacles. "People see Tyson as an animal, not an athlete."

When I ask David Remnick, who wrote the brilliant New Yorker account of the bite fight, if Mr. Tyson can be redeemed, he laughs.

"Rehabilitation is irrelevant," he replies. "It's not wanted that Tyson should be Rebecca of Sunnybrook Farm or even Floyd Patterson. Muhammad Ali was funny and beautiful but his artistry obscured a lot of what boxing is, which is hitting another guy so hard in the head that it causes temporary brain damage and he falls down and can't get up. In Mike Tyson, we are waiting to see something wild, knowing that he will hurt somebody very badly within three to six minutes. It titillates us and it disgusts us, and then we go on with our lives."

Of course, even in a society that thrives on titillation and celebrity, sin and redemption, where failure and miscreants can recreate themselves instantly, even in an era when perception trumps action, there has to be a limit to the restorative powers of illusion.

Mike Tyson, you're no Dick Morris.

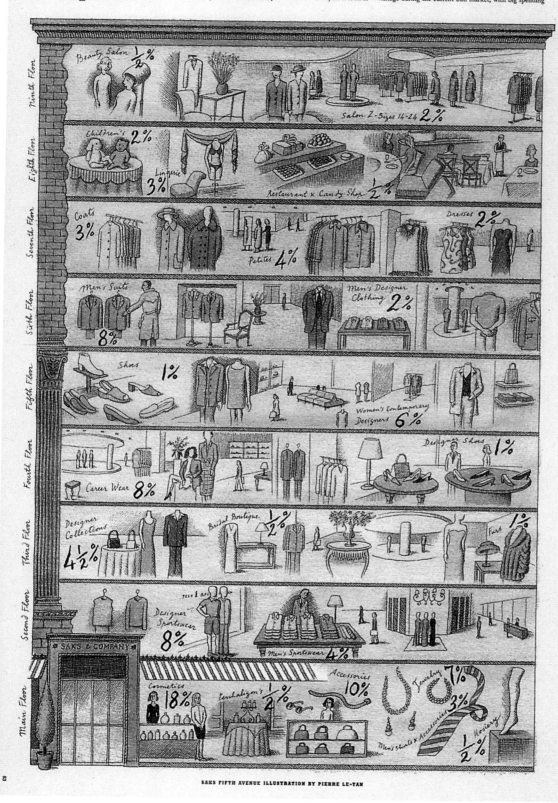

The
MONEY
Department

A floor-by-floor look at where Saks Fifth Avenue makes its profit.
(You have to start at the bottom.) **By Jennifer Steinhauer**

IF YOU THINK OF A DEPARTMENT STORE AS A PYRAMID, THE base is where the money is. It is certainly profitable to sell a Gucci dress at full price upstairs, but it is hardly routine. The gleaming lipsticks, belts and handbags on the ground floor are what fatten the bottom line.

As a sterling example, consider Saks Fifth Avenue's flagship store in Manhattan, pictured below. Last year it took in

$420 million in revenues — and, analysts estimate, about a third of the company's $110.4 million in operating profit. Nearly 40 percent of that profit is produced on the first floor.

Technically speaking, Saks — like Neiman Marcus and Bergdorf's — isn't really a department store but a fashion specialty store. That distinction works very much to its advantage during the current bull market, with big spending

SAKS FIFTH AVENUE ILLUSTRATION BY PIERRE LE-TAN

ILLUSTRATION GOLD

■ 559
Publication The New York Times
Art Director Nicholas Blechman
Illustrator Howard Horowitz
Publisher The New York Times
Issue August 30, 1997
Category Spread

■ 560
Publication The New York Times Magazine
Art Director Janet Froelich
Designer Nancy Harris
Illustrator Pierre Le-Tan
Publisher The New York Times
Category Information Graphics

THE BEST AND WORST | VIDEO

ILLUSTRATION BY PHILIPPE LARDY

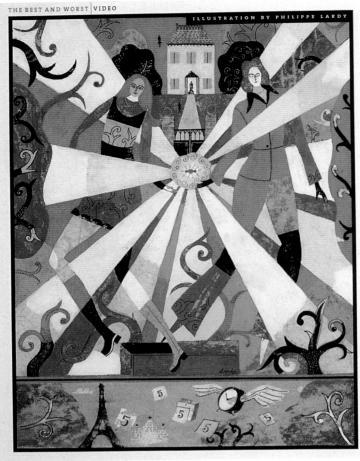

VIDEO | THE BEST AND WORST

CÉLINE & JULIE GO Boating

{video by TY BURR}

1 (*New Yorker, unrated*) All right, it's a 23-year-old, 187-minute French film that makes *Seinfeld* look like it's about Something. But one of home video's continuing pleasures is the way it coughs up shimmering gifts from out-of-the-way corners of movie history. And simply put, there was no richer, sunnier, better video released this year than Jacques Rivette's long-lost cult film about two women's journey down the rabbit hole of fantasy. ◆ The plot is as casual as a child's game of dress up. Julie (Dominique Labourier, red-haired and decisive) and Céline (Juliet Berto, sloe-eyed and dreamy) meet in lazy, off-season Paris and circle around each other like playful alter egos. Gradually, they stumble into a mystery:

VIDEO of the YEAR

a quiet suburban house within which the same turgid melodrama plays out day after day, involving two frail sisters (Bulle Ogier and Marie-France Pisier), a hunky widower (*Reversal of Fortune* director Barbet Schroeder), and a doomed little girl. In short, this is a house of Fiction, and our two heroines determine to bust open the cloistered narrative and rescue the child. It's a little as if *Thelma and Louise* had got stuck in *Groundhog Day* and were eyeing the exits with dangerous grins. ◆ It also unwinds slowly, so slowly as to exasperate moviegoing metabolisms weaned on MTV shock cuts. Stay with it, though—think of it as a daydream unreeling while you tan on a Montmartre bench—and you'll discover a tale that reflects back on the way we watch movies and a comedy wise enough to recharge your soul. Oh, and you'll never look at hard candy the same way again.

2 MESSAGE TO LOVE: THE ISLE OF WIGHT—THE MOVIE (*Sony Music, unrated*) If *Woodstock* is the hippie utopia of '60s concert films and *Gimme Shelter* the bad-acid nightmare, then *Message* is the embarrassingly brain-dead reality. The last of the era's multi-day music happenings, 1970's Isle of Wight festival was a botch from the get go: Some performers refused to play unless paid in cash, the stage caught on fire, and a mob of radical groovers turned the event into an increasingly idiotic "people's festival." Yes, here's Jimi Hendrix scorching the strings 18 days before his death—plus the Doors, the Who, Joni Mitchell, and many others. More to the point, here's festival emcee Rikki Farr whining from the stage, "We put this festival on—you *bastards*—with a lot of love!" When your kids ask what the '60s were like, show them this—if you dare.

A

THE BEST AND WORST | BOOKS

BOOK OF THE YEAR

Cold MOUNTAIN

{books by...}

ILLUSTRATION BY PHIL HULING

BOOKS | THE BEST AND WORST

B

ALBUM of the YEAR

THE BEST AND WORST | MUSIC

OK COMPUTER (*Capitol, album*) Contemplating the world around him through squinty eyes, Thom Yorke, lead singer and songwriter of Radiohead, would rather tune himself out.

Radio HEAD

{music by...}

1

2 DIG YOUR OWN HOLE The Chemical Brothers

ILLUSTRATION BY GEOFFREY GRAHN

MUSIC | THE BEST AND WORST

■ 561
Publication Entertainment Weekly
Design Director John Korpics
Art Director Joe Kimberling
Illustrators Brian Stauffer,
Phil Huling, Geoffrey Grahn, Philippe
Lardy, Tim Bower, House Industries
Publisher Time Inc.
Issue December 26, 1997
Categories Story
 A Spread Merit
 B Spread Merit

A Little Help From Serotonin

Could a single brain chemical hold the key to happiness, high social status and a nice, flat stomach?

BY GEOFFREY COWLEY AND ANNE UNDERWOOD

FOR RHESUS MONKEYS, LIFE IN THE WILD IS A little like high school. Some animals—call them losers—slouch around looking aggrieved. They're volatile and bellicose, slow to form alliances and loath to reconcile after a spat. One in five dies during the passage to adulthood. But while the losers scrap over bits of chow, other animals—call them winners—stay busy grooming each other. They maintain wide networks of allies. They deflect challenges without resorting to violence, and 49 out of 50 survive to produce offspring. Why do they fare so well? The answer is no doubt complicated, but the monkeys' spinal fluid provides an intriguing clue. In study after study, researchers at the National Institute on Alcohol Abuse and Alcoholism have found that the winners' nervous systems are loaded with serotonin.

As the 20th century winds down, we humans seem increasingly convinced that serotonin is the key to a good life—and it's easy to see why. This once obscure neurotransmitter is the secret behind Prozac, the drug that revolutionized the pursuit of happiness 10 years ago this winter. Prozac and its mood-altering cousins all work by boosting serotonin's activity in the brain. So do Redux and fenfluramine, the blockbuster diet drugs that were pulled off the market this fall due to safety concerns. Even Imitrex, the hot new migraine treatment, works its magic via serotonin. Somehow serotonin is implicated in just about everything that matters to us—from winning friends and wielding power to managing anxiety and controlling appetites and impulses. So what is serotonin? How does it work? And why is it in such short supply? Those issues are still murky, but science is yielding some clues.

Serotonin is so basic to life that even worms and sea slugs make it. The substance abounds in our bloodstreams, but our brains produce separate supplies via cells known as raphe nuclei. Rooted near the base of the skull, these specialized neurons extend like branching vines through the brain and spinal cord, each one maintaining links with a half-million target cells. When a nerve impulse reaches a branch ending, the neuron releases serotonin into a tiny space, or synapse. Serotonin molecules then lock into receptors on the target cell, transmitting a message that travels through the nervous system. Microseconds later, the neuron that released the chemical takes it back in—a process known as reuptake.

What does serotonin say during its moment in the synapse? It depends on the target. Our nervous systems harbor at least 14 classes of serotonin receptors, each tailored to a distinct piece of the molecule. Since different types of brain cells sport different receptors, their re-

ILLUSTRATIONS BY BRIAN CRONIN

562
Publication Newsweek
Creative Director Lynn Staley
Art Director Janet Parker
Designer Janet Parker
Illustrator Brian Cronin
Publisher Newsweek
Issue December 29, 1997

when

Each September, as if by magic, Paris

paris

transforms itself into something suddenly and

comes

entirely new. In his words and drawings,

home

artist Donald Sultan prepares for the fall season

f

paris

August 1997 · Travel & Leisure · 79

82 · Travel & Leisure · August 1997

August 1997 · Travel & Leisure · 83

Continued on page 100

563
Publication Travel & Leisure
Design Director Pamela Berry
Designer Dan Josephs
Illustrator Donald Sultan
Publisher American Express Publishing
Issue August 1997
Category Story

new york's
return to romance From

cocktails to Cole Porter,
what's old is new again—and nowhere
has the age of elegance made a bolder comeback
than in Manhattan

By David Black

Illustrated by Demetrios Psillos

Making a grand entrance at the Carlyle.

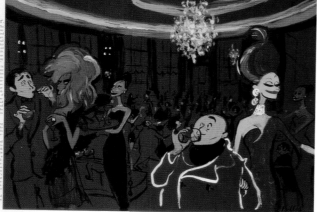

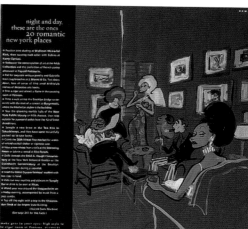

■ 564
Publication Travel & Leisure
Design Director Pamela Berry
Designer Pamela Berry
Illustrator Demetrios Psillos
Publisher American Express Publishing
Issue November 1997
Category Story

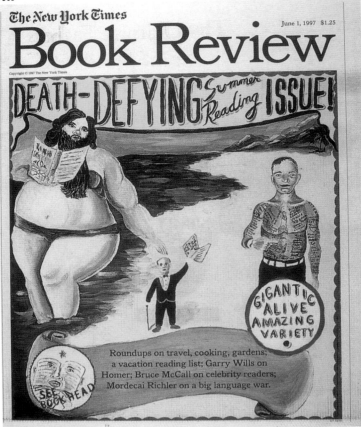

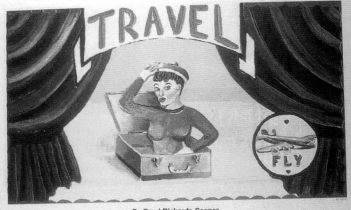

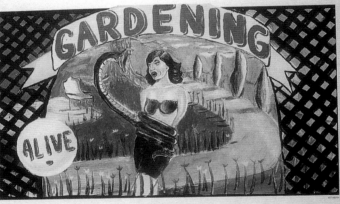

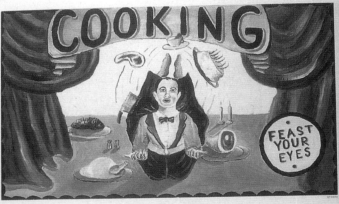

■ 565
Publication The New York Times Book Review
Art Director Steven Heller
Illustrator Kit Keith
Publisher The New York Times
Issue June 1, 1997
Category Story

SILVER ILLUSTRATION

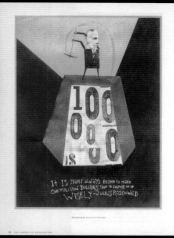

Ready When You Are, MR. GATES

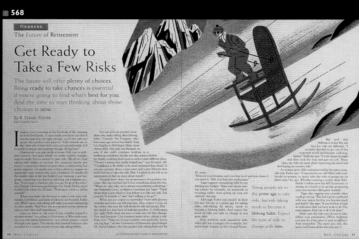

For too long, women and doctors have maintained an uneasy silence about what goes on below the beltline. It's time we got comfortable with our own anatomy.
our health depends on it
By Beth Howard

YourSexualLandscape

finances
The Future of Retirement

Get Ready to Take a Few Risks

The future will offer plenty of choices. Being ready to take chances is essential if you're going to find what's best for you. And the time to start thinking about those choices is now.
By R. Daniel Foster

health

TAMING the Fire Inside

All about heartburn, and the best treatment strategies.
By Timothy Gower

Approximately 60 million Americans feel heartburn at least once a month, a quarter of them every day.

ILLUSTRATION MERIT

■ 566
Publication
The American Benefactor
Creative Director Hans Teensma
Art Director Katie Craig
Illustrator David Plunkert
Studio Impress Inc.
Publisher Capital Publishing L. P.
Issue Spring 1997
Categories Story
 A Spread

■ 567
Publication
American Health for Women
Art Director Syndi C. Becker
Designer Syndi C. Becker
Illustrator Anders Wenngren
Publisher R.D. Publications, Inc.
Issue April 1997
Category Spread

■ 568
Publication Best Choices
Design Director Lloyd Ziff
Designer Charles Wallace
Illustrator Brian Cronin
Publisher Time Inc. Custom Publishing
Issue Spring/Summer1997
Category Spread

■ 569
Publication Best Choices
Design Director Lloyd Ziff
Designer Charles Wallace
Illustrator Alison Seiffer
Publisher Time Inc. Custom Publishing
Client Nationwide Ins. Enterprise
Issue Fall/Winter 1997
Category Spread

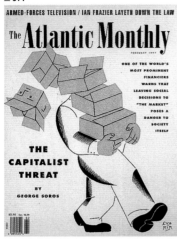

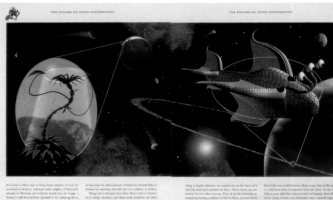

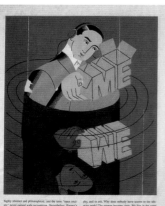

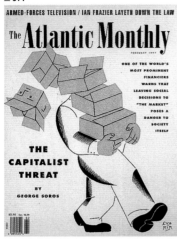

571
Publication The Atlantic Monthly
Art Director Judy Garlan
Illustrator Brian Cronin
Publisher The Atlantic Monthly
Issue February 1997
Category Story

572
Publication The Atlantic Monthly
Art Director Judy Garlan
Illustrator Giacomo Marchesi
Publisher The Atlantic Monthly
Issue November 1997
Category Story

■ 573

A Short Story

Click

BY JOHN BARTH

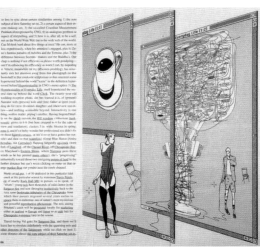

■ 574

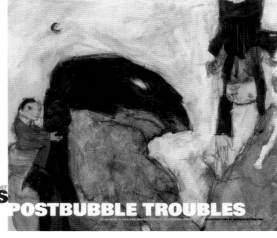

SCANDAL AND
DEREGULATION FORCE
JAPAN'S BIGGEST BROKER
TO CHANGE ITS WAYS

WILL THE BANG
BE BIG ENOUGH?
JAPAN'S POSTBUBBLE TROUBLES

ILLUSTRATIONS BY NATALIE ASCENCIOS

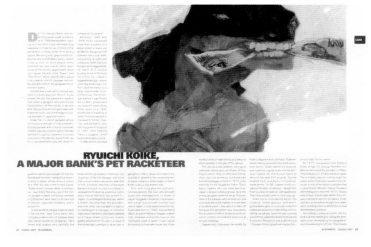

RYUICHI KOIKE, A MAJOR BANK'S PET RACKETEER

■ 575

Are You a Performance
Pig ?

BY MARY ROWLAND

Illustrations by Barry Blitt

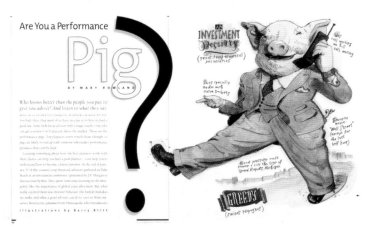

AN INVESTMENT
Destiny

GREED$

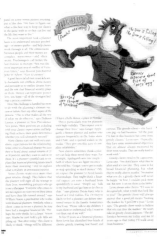

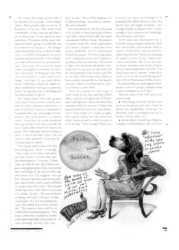

■ 573
Publication The Atlantic Monthly
Art Director Judy Garlan
Illustrator Istvan Banyai
Publisher The Atlantic Monthly
Issue December 1997
Category Story

■ 574
Publication Bloomberg
Art Director Carol Macrini
Designer Carol Macrini
Illustrator Natalie Ascencios
Publisher Bloomberg L. P.
Issue October 1997
Category Story

■ 575
Publication Bloomberg Personal Finance
Art Director Carol Layton
Designer Carol Layton
Illustrator Barry Blitt
Publisher Bloomberg L. P.
Issue May/June 1997
Category Story

ILLUSTRATION MERIT ■

■ 576

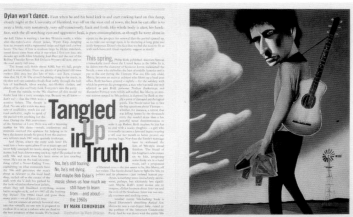

■ 579

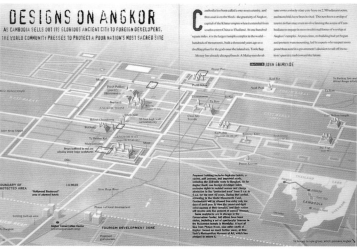

■ 577

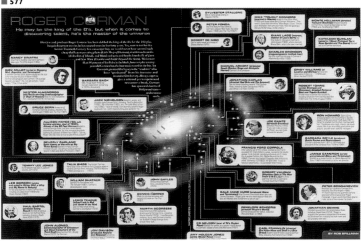

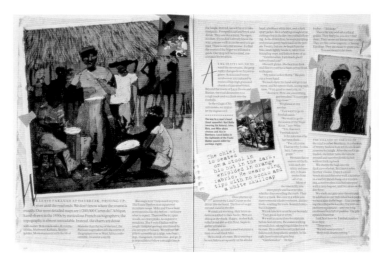

■ 578

■ 580

■ **576**
Publication Civilization
Art Director David Herbick
Designer Maggie Gamboa
Illustrator Mark Ulriksen
Publisher Capital Publishing L. P.
Issue October/November 1997
Category Spread

■ **577**
Publication Details
Art Director Sam Chick
Designer Sy-Jeng Cheng
Illustrator Giacomo Marchesi
Publisher Condé Nast Publications Inc.
Issue February 1997
Category Information Graphics

■ **578**
Publication Drawing SVA
Art Director Paul Davis
Designers Paul Davis, Chalkley
Calderwood, Chantal Fredet
Illustrator Gig Wailgum, Bob Hagel
Publisher School of Visual Arts
Issue December 1997
Category Spread

■ **579**
Publication Condé Nast Traveler
Design Director Robert Best
Art Director Carla Frank
Designers Robert Best, Carla Frank
Publisher Condé Nast Publications Inc.
Issue August 1997
Category Story

■ **580**
Publication Condé Nast Traveler
Design Director Robert Best
Art Director Carla Frank
Designer Robert Best
Illustrator John Grimwade
Publisher Condé Nast Publications Inc.
Issue January 1997
Category Information Graphics

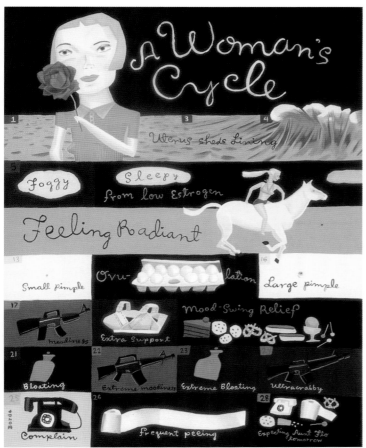

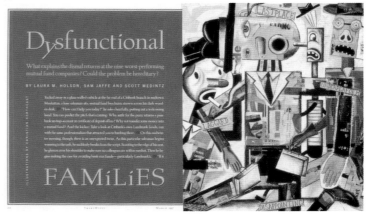

■ 581
Publication Jump
Creative Director Kathy Nenneker
Art Director Chrystal Falcioni
Designer Chrystal Falcioni
Illustrator Juliette Borda
Publisher Weider Publications, Inc.
Issue September/October 1997
Category Story

■ 582
Publication NFPA Journal
Art Director
Wendy Chadbourne Simpson
Illustrator Philippe Weisbecker
Publisher
National Fire Protection Association
Issue September/October 1997
Category Spread

■ 583
Publication SmartMoney
Art Director Amy Rosenfeld
Designer Robin Terra
Illustrator Christian Northeast
Publisher Dow Jones & Hearst Corp.
Issue March 1997
Category Spread

■ 584
Publication Nickelodeon
Art Director Alexa Mulvihill
Designer Vanessa Johnson
Illustrator Chip Wass
Publisher Nickelodeon, MTV Networks
Issue March 1997
Category Single Page

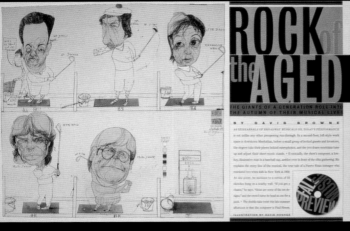

POWER 1 0 1

ILLUSTRATION BY WILLIAM JOYCE

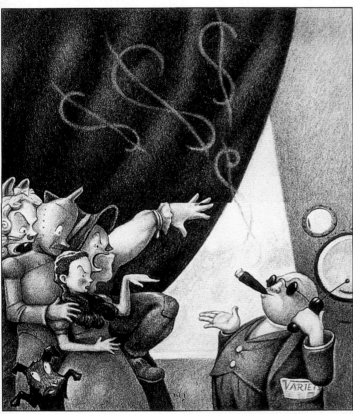

WAKE UP, DOROTHY, WE'RE DEFINITELY NOT IN KANSAS ANYMORE. Welcome to ENTERTAINMENT WEEKLY's eighth annual Power Issue. This year, we rip back the curtain on that smoggy Emerald City known as Hollywood and reveal a power list as twisted as Dorothy's tornado. Directors, actors, and talk-show hosts—oh, my!—are taking their seats alongside the suits. ◆ Why? In a journey much like Dot's, Hollywood's most powerful awoke from sweet dreams of mergers and acquisitions to discover that there's no person like Spielberg or Cruise or Winfrey when you're paving a yellow brick road. ◆ From Jerry Seinfeld trumping the tin hearts at NBC to Sarah McLachlan's spellbinding Lilith tour, we expose the underpinnings of a whole new Oz. Which, by the way, has a foggy counterpart in London, this year's creative hot zone. ◆ It's all here, from Girl Power to Austin Powers. And if it's too hot to handle, baby, we've got a lexicon to help you tell a Malibu Barbie from an OTB. We even hear from long-lost Munchkin Michael Ovitz, who tells us about life in retirement land. ◆ So come out of the woods, step into the light—we're off to meet the wizards....

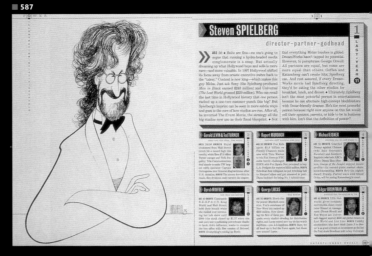

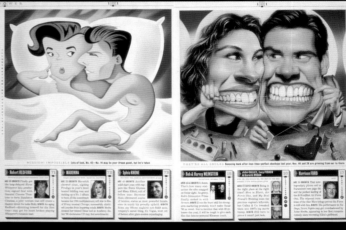

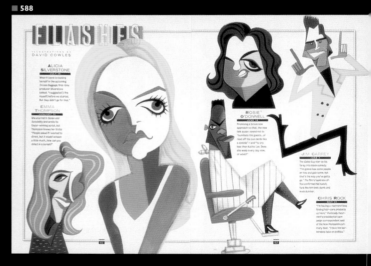

585
Publication Entertainment Weekly
Design Director John Korpics
Designer Dirk Barnett
Illustrator David Hughes
Publisher Time Inc.
Issue October 3, 1997
Category Spread

586
Publication Entertainment Weekly
Design Director John Korpics
Art Director Geraldine Hessler
Illustrator William Joyce
Publisher Time Inc.
Issue October 31, 1997
Category Single Page

587
Publication Entertainment Weekly
Design Director John Korpics
Art Director Geraldine Hessler
Illustrators Tim Bower, Mark Ulrikson, Mark Matcho, Drew Friedman, Robert Risko, Everett Peck, Anita Kunz, Edmund Guy, Mark Ryden, Robert DeMichiell, Owen Smith, Eric Palma, Dan Adel, Gary Kelley, Mark Fredrickson, C.F. Payne, Al Hirschfeld, William Joyce
Publisher Time Inc.
Issue October 31, 1997
Category Story

588
Publication
Entertainment Weekly Yearbook
Art Director Don Morris
Designers Josh Klenert, Jennifer Starr
Illustrator David Cowles
Studio Don Morris Design
Publisher Time Inc.
Issue 1997 Yearbook
Category Spread

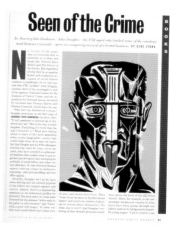

Seen of the Crime

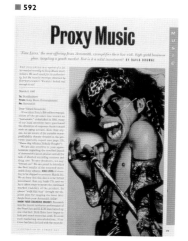

Proxy Music

CULTURAL CARNIVORE

Ron Rosenbaum

The Coming Crisis

In the new literature of love, orgasms are increasingly solo contendere

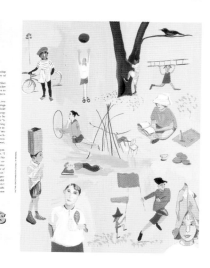

BRAD HOLLAND

48 ESQUIRE SEPTEMBER 1997

HAS hollywood LOST IT?

BY BENJAMIN SVETKEY

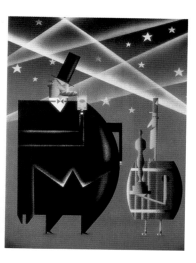

And Away She Goes

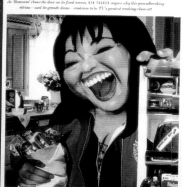

HOW TO LET KIDS BE KIDS

Managing after-school activities

by Michele Herman
Illustrations by Maira Kalman

ILLUSTRATION MERIT

■ 589
Publication Entertainment Weekly
Design Director John Korpics
Art Director Joe Kimberling
Illustrator Brian Cronin
Publisher Time Inc.
Issue February 7, 1997
Category Single Page

■ 590
Publication Entertainment Weekly
Design Director John Korpics
Art Director Rina Migliaccio
Illustrator Terry Allen
Publisher Time Inc.
Issue March 14, 1997
Category Spread

■ 591
Publication Entertainment Weekly
Design Director John Korpics
Art Director Joe Kimberling
Illustrator Edmund Guy
Publisher Time Inc.
Issue May 2, 1997
Category Spread

■ 592
Publication Entertainment Weekly
Design Director John Korpics
Designer Alisha Drucks
Illustrator Edmund Guy
Publisher Time Inc.
Issue March 14, 1997
Category Single Page

■ 593
Publication Esquire
Design Director Robert Priest
Art Director Rockwell Harwood
Illustrator Brad Holland
Publisher The Hearst Corporation-
Magazines Division
Issue September 1997
Category Single Page

■ 594
Publication Family Life
Art Director Tracy Stora
Designer Michele Tessler
Illustrator Maira Kalman
Publisher Hachette Filipacchi
Magazines, Inc.
Issue September 1997
Category Spread

■ 595

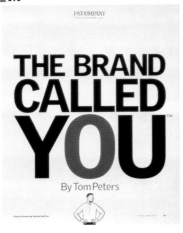

■ 596

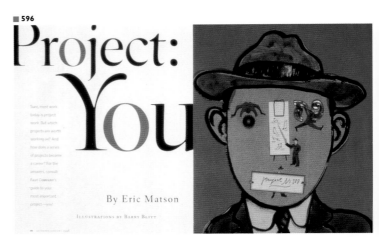

■ 597

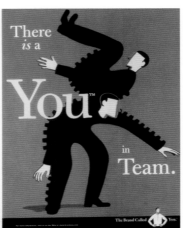
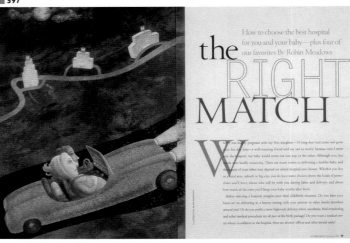

■ 595
Publication Fast Company
Art Director Patrick Mitchell
Illustrator Alison Seiffer
Issue August/September 1997
Category Story

■ 596
Publication Fast Company
Art Director Patrick Mitchell
Illustrator Barry Blitt
Issue December/January 1997
Category Spread

■ 597
Publication Fit Pregnancy
Creative Director Kathy Nenneker
Art Director Stephanie Birdsong
Designer Stepanie Birdsong
Illustrator Blair Drawson
Publisher Weider Publications, Inc.
Issue Summer 1997
Category Spread

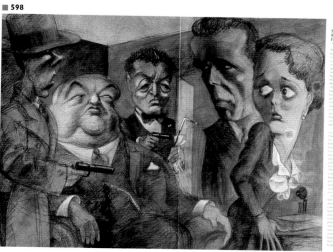

The Maltese Falcon

The Power of Laughter

MEMBERS OF THE LAUGHING CLUBS OF INDIA
GET A DAILY DOSE OF CLOWNISH COMEDY THAT
HELPS THEIR BLOOD PRESSURE, REVS THEIR IMMUNE SYSTEM,
AND HELPS THEM TO SLEEP BETTER AT NIGHT.

THEY'VE GOT TO BE JOKING!

BY MARY ROACH

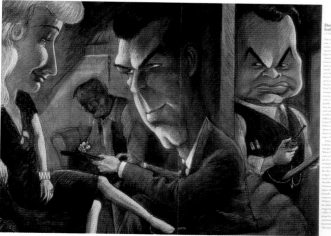

Double Indemnity

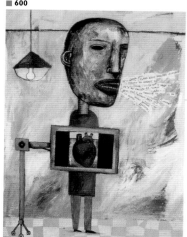

It's not working less or simplifying our lives.

The real stress solution, new research suggests,

is finding out what we're really afraid of.

talk about stress

BY BENEDICT CAREY

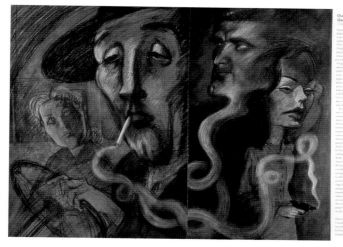

Out of the Past

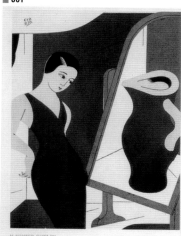

Making Peace
WITH THE BODY
In the Mirror

MIRED IN A CONFLICT BETWEEN
REALITY AND THE DESIRE TO BE THIN,
A PSYCHOLOGIST EXAMINES THE
DISTORTED THINKING THAT HAUNTS
SO MANY WOMEN.

by Martha Manning

ILLUSTRATION BY BRIAN CRONIN

ILLUSTRATION MERIT

■ 598
Publication GQ
Design Director
George Moscahlades
Art Director John Boyer
Designer John Boyer
Illustrator Edward Sorel
Publisher Condé Nast Publications Inc.
Issue December 1997
Category Story

■ 599
Publication Hippocrates
Art Director Jane Palecek
Designer Steven Powell
Illustrator Christian Clayton
Publisher Time Inc.
Issue January 1997
Category Spread

■ 600
Publication Hippocrates
Art Director Jane Palecek
Designer Steven Powell
Illustrator Jordin Isip
Publisher Time Inc.
Issue February 1997
Category Spread

■ 601
Publication Hippocrates
Art Director Jane Palecek
Designers Jane Palecek, Alan Avery
Illustrator Brian Cronin
Publisher Time Inc.
Issue October 1997
Category Spread

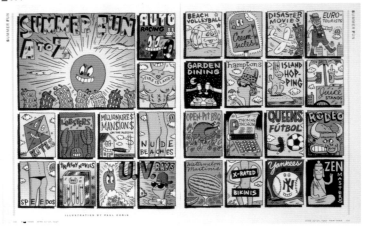

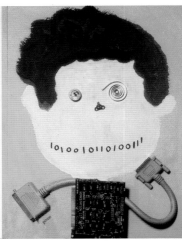

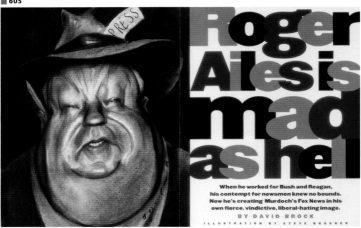

■ 604
Publication New York
Design Director Robert Newman
Art Director Florian Bachleda
Illustrator Paul Corio
Publisher K-III Publications
Issue June 23-30 1997
Category Spread

■ 605
Publication New York
Design Director Mark Michaelson
Art Director Florian Bachleda
Illustrator Steve Brodner
Publisher K-III Publications
Issue November 17, 1997
Category Spread

■ 606
Publication New York
Design Director Florian Bachleda
Art Director Jennifer Gilman
Designer Jill Tashlik
Illustrator Greg Clarke
Publisher K-III Publications
Issue August 18, 1997
Category Spread

■ 607
Publication New York
Design Director Florian Bachleda
Art Director Jennifer Gilman
Designer Vita Parrino
Illustrator Hanoch Piven
Publisher K-III Publications
Issue August 4, 1997
Category Story

■ 608
Publication New York
Design Director Mark Michaelson
Art Director Florian Bachleda
Illustrator Mark Zingarelli
Publisher K-III Publications
Issue October 20, 1997
Category Single Page

Semilla solar

Deep End

China

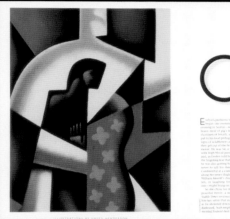

The Other Mother

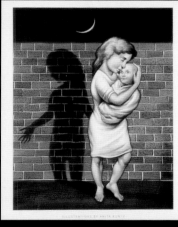

■ 609
Publication Matador
Art Director Fernando Gutiérrez
Designers María Ulecia, Xavi Roca, Emmanuel Ponty, Pablo Martín, Fernando Gutiérrez
Illustrator Ross Lovegrove
Studio GRAFICA
Publisher La Fábrica, S.L.
Issue October 25, 1997
Category Story

■ 610
Publication Modern Maturity
Design Director Cynthia Friedman
Art Director Gregory T. Atkins
Designers Gregory T. Atkins, Cynthia Friedman
Illustrators Hayes Henderson, Peter Sis, Anita Kunz, Jody Hewgill
Photographers Rich Frishman, Sue Barker, Anne Hauersky
Publisher AARP
Issue July/August 1997
Category Story

ILLUSTRATION MERIT ■

■ 611

by Herbert Hadad

Journey through the Land of the GAELS

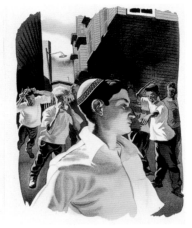

I WAS SMALL AND WRETCHED, ALL THE MORE SO FOR BEING ATTACHED TO THE STRONG LEFT HAND of my noble mother as she rapped at the curtained glass door of our Dorchester neighbor. A tall, sullen man opened up. "Your son is twice the size of mine," said my mother. "Why did he and his freedoms want to beat up my boy?" The man turned angry but remained silent. My mother punched me hard on the arm. "Look. Doesn't it hurt? Don't you think we cry? Don't you think we bleed? Be our friend or leave us alone," she said. As the span us off the porch and back down the street, my mother whispered, "You have my permission. Next time his bag of a son bothers you, grab a board, a stone, anything, and let him have it." Thus was my introduction to Jewish-Irish relations in the city of Boston in the peace-loving years following World War II.

[body text continues, illegible]

ILLUSTRATIONS BY JEFFREY SMITH

■ 612

CENTER Confronts a

DEFINING Disabilities
Cultural Controversy

By lauren long

ILLUSTRATIONS by pol turgeon

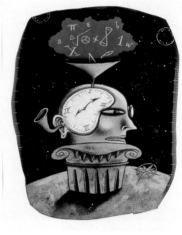

A learning disability is a specific difficulty in taking in, retaining, or expressing information despite adequate

intelligence.

[body text columns, illegible]

a disability

"A learning disability is going to be a disadvantage in an industrial environment. That's why they call it

■ 613

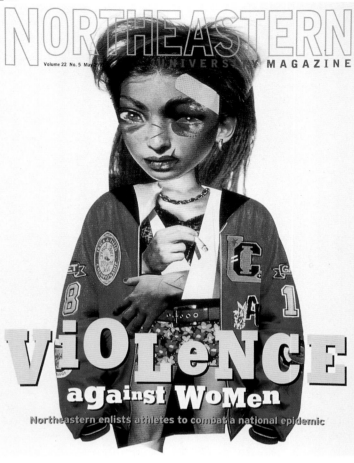

NORTHEASTERN
UNIVERSITY MAGAZINE
Volume 22 No. 5 May 1997

ViOLeNCe against WoMen

Northeastern enlists athletes to combat a national epidemic

ON A SLATE-GRAY TUESDAY IN ROXBURY, A STEADY drizzle is pelting Madison Park High School. David Kay, a twenty-something guy from Northeastern's Center for the Study of Sport in Society, passes through the school's blue metal detectors and heads for a windowless fourth-floor classroom. There, eight freshmen, most of them African American, slouch at their desks beneath poster advocating sexual abstinence, racial tolerance, and violence prevention. One poster declares: "OUR TOLERANCE FOR VIOLENCE IS ZERO OR LESS"

[body text continues, illegible]

The Mentors *in* Violence Prevention *program enlists athletes to combat violence against women*

MOST VALUABLE PROGRAM

By Jeff Kantrowitz / Illustration by Edmund Guy

■ 611

Publication
Northeastern University Magazine
Design Director John Sizing
Art Director Osamu Takahashi
Illustrator Jeffrey Smith
Studio JS Publication Design
Publisher Northeastern University
Issue September 1997
Category Spread

■ 612

Publication
Northeastern University Magazine
Design Director John Sizing
Designer Osamu Takahashi
Illustrator Pol Turgeon
Studio JS Publication Design
Publisher Northeastern University
Issue September 1997
Category Story

■ 613

Publication
Northeastern University Magazine
Design Director John Sizing
Art Director Gregorio Amaro
Illustrator Edmund Guy
Studio JS Publication Design
Publisher Northeastern University
Issue May 1997
Category Story

Mutiny in the **Body**

FOR AUTOIMMUNE DISEASE

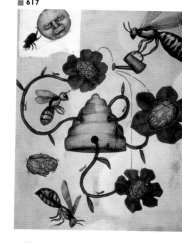

This story begins with more excitement than most. It's not just the subject: the cells called glia that fill about half the volume of our brain. And it's not just the recent discoveries of what glia can do: form nerve cell connections in the brain, organize nerve cells for the fast transmission of messages, and even transmit their own messages.

filled with **glia**

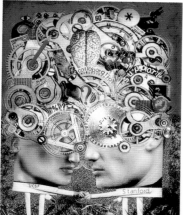

bug **off**
imaginary creatures **devour**
the
peace
of
mind
of the
troubled
few
afflicted with
delusions of
parasitosis.

BY BARBARA BOUGHTON

dealing
with
depression

stanford
researchers
are
striving
for
new
drugs,
new
treatments
and new
understanding
of the
debilitating
mood
disorder

by
Heather
Rock
Woods

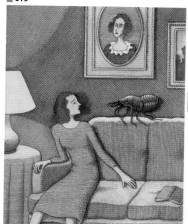

meetings
of the **minds**
collaborations
can't help but gel
between
medical researchers
at Stanford
and at the
University of California,
San Francisco.

By Ruthann Richter

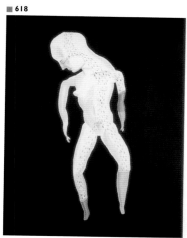

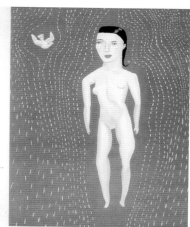

Ten years
ago if
you were
seriously
depressed,
the
medications...
were less
likely to be
tolerated.
The prognoses
were worse. Now
the medications are
safer and better
tolerated.

■ 614
Publication Stanford Medicine
Art Director David Armario
Illustrator Christian Northeast
Studio David Armario Design
Issue Winter 1997
Category Spread

■ 615
Publication Stanford Medicine
Art Director David Armario
Illustrator Pierre Le-Tan
Studio David Armario Design
Issue Fall 1997
Category Spread

■ 616
Publication Stanford Medicine
Art Director David Armario
Illustrator Janet Woolley
Studio David Armario Design
Issue Winter 1997
Category Spread

■ 617
Publication Stanford Medicine
Art Director David Armario
Illustrator Jason Holley
Studio David Armario Design
Issue Winter 1997
Category Spread

■ 618
Publication Stanford Medicine
Art Director David Armario
Illustrator Juliette Borda
Studio David Armario Design
Issue Winter 1997
Category Story

ILLUSTRATION MERIT ■

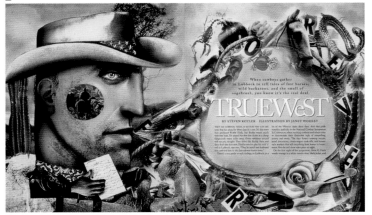

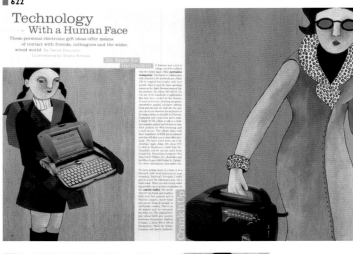

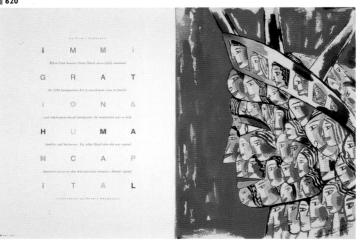

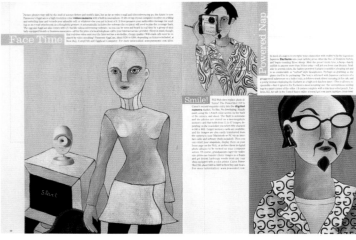

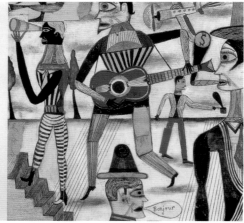

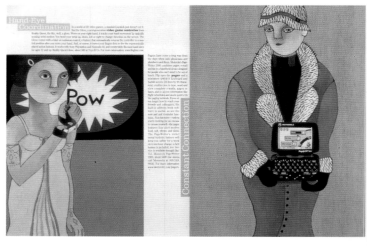

■ 619
Publication Unlimited
Creative Director Robb Allen
Art Director Eugene Wang
Designer Jamie Ferand
Illustrator Janet Woolley
Publisher Hachette Filipacchi
Magazines, Inc.
Issue February 1997
Category Spread

■ 620
Publication Utah Business
Designer Ryan Mansfield
Illustrator Robert Neubecker
Publisher Olympus Publishers
Issue May 1997
Category Spread

■ 621
Publication The Washington Post
Magazine
Art Director Kelly Doe
Designer Kelly Doe
Illustrator Christian Northeast
Publisher The Washington Post Co.
Issue June 1, 1997
Category Spread

■ 622
Publication The Washington Post
Magazine
Art Director Kelly Doe
Designer Kelly Doe
Illustrator Trisha Krauss
Publisher The Washington Post Co.
Issue December 7, 1997
Category Story

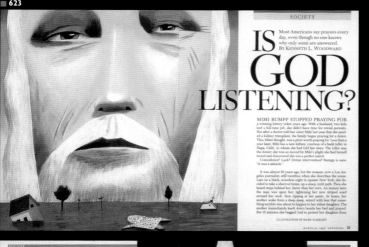

IS GOD LISTENING?

Most Americans say prayers every day, even though no one knows why only some are answered.
BY KENNETH L. WOODWARD

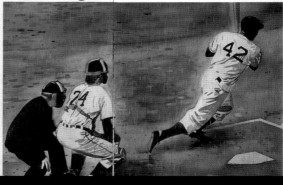

The Breakthrough

by William Nack

Fifty years ago, over fourteen games in May, Jackie Robinson erased any doubt that he belonged in the majors, clearing the path for other black players

623
Publication Newsweek
Creative Director Lynn Staley
Art Director Janet Parker
Designer Janet Parker
Illustrator Mark Ulriksen
Publisher Newsweek
Issue March 31, 1997
Category Story

624
Publication Sports Illustrated
Creative Director Steven Hoffman
Designer Craig Gartner
Illustrator Julian Allen
Publisher Time Inc.
Issue May 5, 1997
Category Story

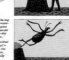

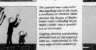

Save Sigmund Freud
What we can still learn from a discredited, scientifically challenged wrong idea.
By Mark Fabinowalmer

Why They Kill Their Newborns
A mother who murders her baby commits an immoral act, but not necessarily a pathological one. Neonaticide may be a product of maternal wiring.
By Steven Pinker
Illustration by Anita Kunz

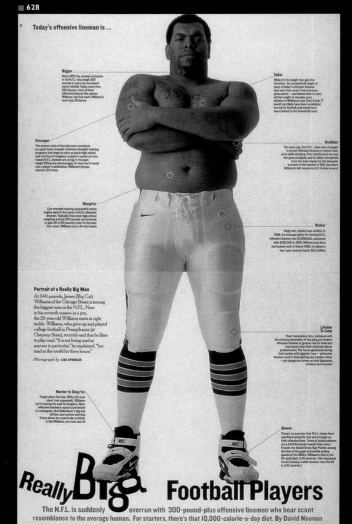

Today's offensive lineman is ...

Really Big Football Players
The N.F.L. is suddenly overrun with 300-pound-plus offensive linemen who bear scant resemblance to the average human. For starters, there's that 10,000-calorie-a-day diet. By David Noonan

■ 625
Publication The New York Times Magazine
Art Director Janet Froelich
Designer Joel Cuyler
Illustrator Edward Gorey
Publisher The New York Times
Issue December 21, 1997
Category Story

■ 626
Publication The New York Times Magazine
Art Director Janet Froelich
Designer Joel Cuyler
Illustrator Thomas Woodruff
Publisher The New York Times
Issue July 13, 1997
Category Spread

■ 627
Publication The New York Times Magazine
Art Director Janet Froelich
Designers Joel Cuyler, Catherine Gilmore-Barnes
Illustrator Anita Kunz
Publisher The New York Times
Issue November 2, 1997
Category Spread

■ 628
Publication The New York Times Magazine
Art Director Janet Froelich
Designer Joel Cuyler
Photographers Lisa Spindler, Davies + Starr
Publisher The New York Times
Category Information Graphics

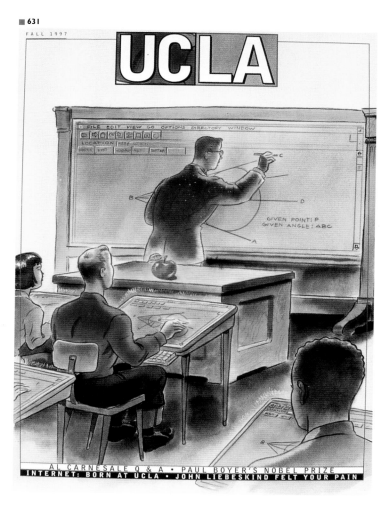

■ 629
Publication UCLA Magazine
Creative Director Charles Hess
Designers Jackie Morrow, Dana Barton
Illustrator Karen Barbour
Studio C. Hess Design
Publisher UCLA
Issue Spring 1997
Category Spread

■ 630
Publication UCLA Magazine
Creative Director Charles Hess
Designers Jackie Morrow, Dana Barton
Illustrator Riccardo Vecchio
Studio C. Hess Design
Publisher UCLA
Issue Spring 1997
Category Spread

■ 631
Publication UCLA Magazine
Creative Director Charles Hess
Designers Jackie Morrow, Dana Barton
Illustrator Ross MacDonald
Studio C. Hess Design
Publisher UCLA
Issue Fall 1997
Category Single Page

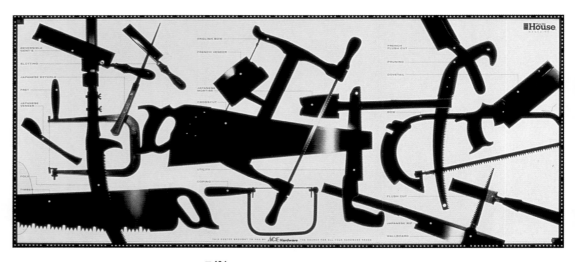

BITES
of PASSAGE

MEMORABLE

*meals have marked
this pilgrim's
progress through
gastronomy and life*

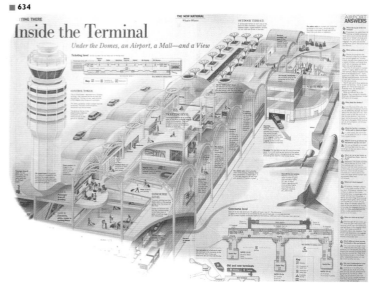

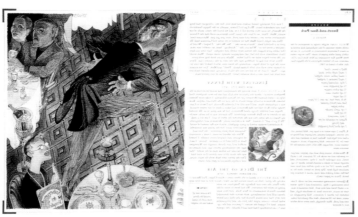

632
Publication This Old House
Design Director Matthew Drace
Designer Mo Flan
Photographer Bill White
Publisher Time Inc.
Issue November/December 1997
Category Information Graphics

633
Publication Saveur
Creative Director Michael Grossman
Art Director Jill Armus
Designer Jill Armus
Illustrator Jack Unruh
Publisher Meigher Communications
Issue July/August 1997
Category Story

634
Publication The Washington Post
Art Director Jackson Dykman
Illustrator Laura Stanton
Publisher The Washington Post Co.
Issue July 16, 1997
Category Information Graphics

■ 635

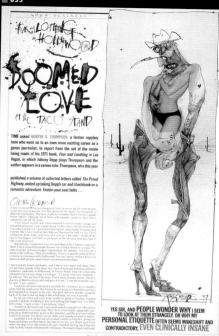

■ 636

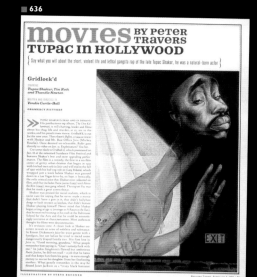

■ 639

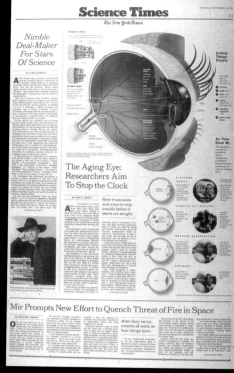

■ 637

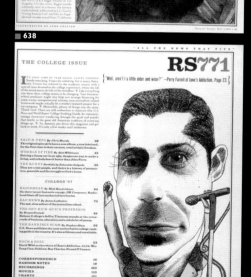

■ 640

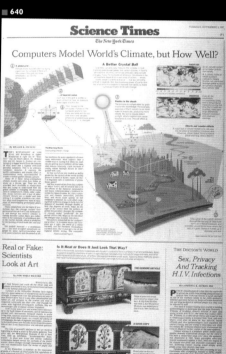

■ 638

635
Publication TIME
Art Directors Kristin Fitzpatrick, Arthur Hochstein
Illustrator Ralph Steadman
Publisher Time Inc.
Issue November 10, 1997
Category Single Page

636
Publication Rolling Stone
Art Director Fred Woodward
Illustrator Steve Brodner
Publisher Wenner Media
Issue February 6, 1997
Category Single Page

637
Publication Rolling Stone
Art Director Fred Woodward
Illustrator John Collier
Publisher Wenner Media
Issue May 1, 1997
Category Single Page

638
Publication Rolling Stone
Art Director Fred Woodward
Illustrator John Springs
Publisher Wenner Media
Issue October 16, 1997
Category Single Page

639
Publication The New York Times
Art Director Michael Valenti
Illustrator Charles M. Blow
Publisher The New York Times
Issue October 14, 1997
Category Single Page

640
Publication The New York Times
Art Director Michael Valenti
Illustrator Megan Jaegerman
Publisher The New York Times
Issue November 4, 1997
Category Single Page

ILLUSTRATION

237

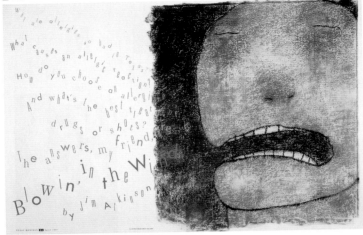

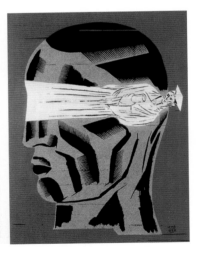

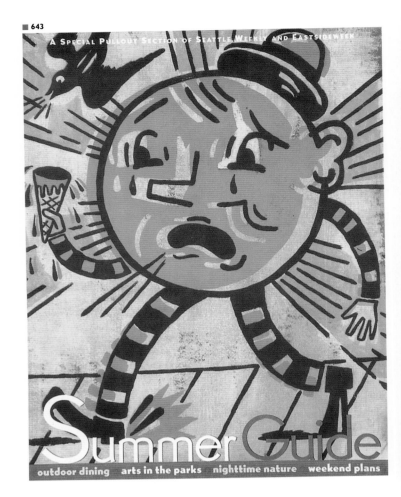

■ 641
Publication Texas Monthly
Creative Director D. J. Stout
Publisher Texas Monthly
Issue April 1997
Category Story

■ 642
Publication Texas Monthly
Creative Director D. J. Stout
Illustrator Brian Cronin
Publisher Texas Monthly
Issue December 1997
Category Spread

■ 643
Publication Seattle Weekly
Art Director Karen Steichen
Illustrator Christian Northeast
Publisher Seattle Weekly
Issue May 21, 1997
Category Single Page

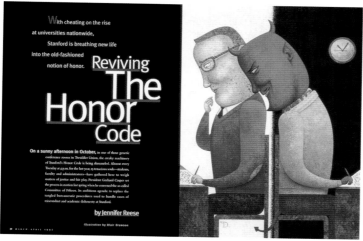

FAITH

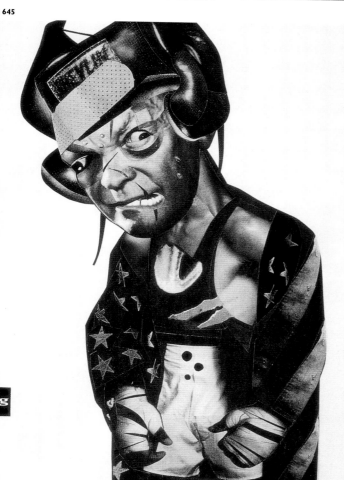

eg

■ 644
Publication Stanford Magazine
Art Director Paul Carstensen
Designer Paul Carstensen
Illustrator Blair Drawson
Publisher Stanford Alumni Association
Issue March/April 1997
Category Spread

■ 645
Publication Forbes ASAP
Art Director Tony Lane
Illustrator Edmund Guy
Publisher Forbes
Issue June 1997
Category Single Page

■ 646
Publication Wired
Creative Director John Plunkett
Design Director Thomas Schneider
Designer John Plunkett
Illustrator John Plunkett
Publisher Wired Ventures
Issue August 1, 1997
Category Spread

■ 647
Publication Golf Journal
Art Director Donna Panagakos
Illustrator Jeffrey Smith
Publisher United States Golf Association
Issue March/April 1997
Category Spread

spots

The SPOTS competition recognizes the little masterpieces that work so hard to communicate big ideas in a small amount of space. It was established in 1987 in order to allow smaller illustrations to compete against others of a similar dimension.

A jury of five top art directors judged over 1350 entries from the United States and abroad in four categories and selected 127 winners, the originals of which were exhibited at the Society of Illustrators Museum of American Illustration in May and June or 1998.

● **CHAIRPERSON**

Ina Saltz,
Design Director, Golf Magazine
(center)

● **JUDGES**
(top row, left to right)

Michael Grossman
Creative Director, Meigher Communications

Cynthia Currie
Art Director, Kiplinger's Personal Finance

Francesca Messina
Senior Art Director, BusinessWeek

Mark Michaelson
Art Director, New York

Audrey Razgaitis
Art Director, Time for Kids
(not pictured)

photography by **John Abbott**

■ 649

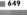

■ 651

■ 653

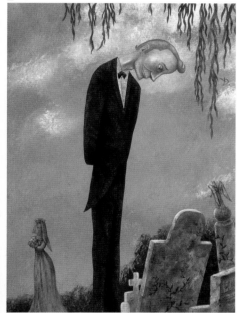

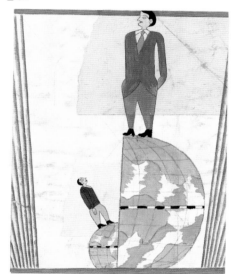

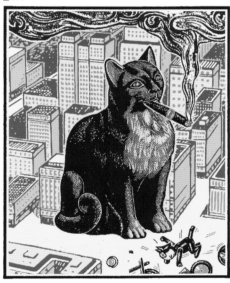

SPOTS

■ 648
Publication TIME
Illustrator Michelle Chang
Art Directors Joe Aslaender, Arthur Hochstein
Title Madeleine Albright/Time Spotlight
Issue September 22, 1997
Publisher Time Inc.

■ 649
Publication The Atlantic Monthly
Illustrator Blair Drawson
Art Directors Judy Garlan, Robin Gilmore-Barnes
Title Visitations
Issue July 1997
Publisher The Atlantic Monthly

■ 650
Publication Worth
Illustrator Jonathon Rosen
Art Directors Philip Bratter, Cynthia Eddy
Title Foretasting the Future
Issue July/August 1997
Publisher Capital Publishing L. P.

■ 651
Publication Worth
Illustrator Philippe Weisbecker
Art Directors Philip Bratter, Deanna Lowe
Title The Real World
Issue March 1998
Publisher Capital Publishing L. P.

■ 652
Publication Worth
Illustrators Geof Kern, Melinda Beck
Art Director Philip Bratter
Title How to Invest a Million
Issue March 1997
Publisher Capital Publishing L. P.

■ 653
Publication Worth
Illustrator John Craig
Art Director Philip Bratter
Title Small-Cap Carnage
Issue September 1997
Publisher Capital Publishing L. P.

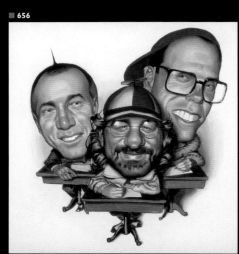

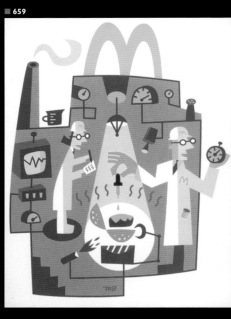

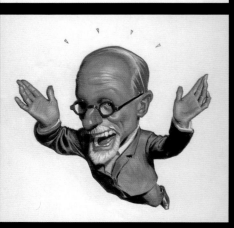

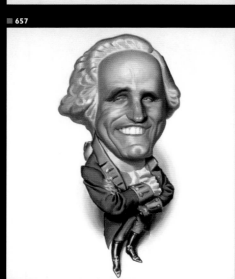

■ 654
Publication Bloomberg Personal Finance
Illustrator Daniel Adel
Art Directors Carol Layton, Owen Edwards
Title Support from the Sidelines
Issue March 1998
Publisher Bloomberg L. P.

■ 655
Publication Entertainment Weekly
Illustrator Daniel Adel
Art Director John Korpics
Title Celebrities Ink
Issue October 3, 1997
Publisher Time Inc.

■ 656
Publication Entertainment Weekly
Illustrator Daniel Adel
Art Director John Korpics
Title Needs Improvement
Issue October 17, 1997
Publisher Time Inc.

■ 657
Publication New York
Illustrator Daniel Adel
Art Directors Mark Michaelson, Andrea Dunham
Title Giuliani Appeal
Issue November 10, 1997
Publisher K-III Publications

■ 658
Publication Outside
Illustrator Michael Bartalos
Art Director Sarah Horwitz
Title Supernatural Hawaii
Issue December 1997
Publisher Mariah Media, Inc.

■ 659
Publication Saveur
Illustrator Michael Bartalos
Art Director Jill Armus
Title Did You Have a Happy Meal?
Issue April 1997
Publisher Meigher Communications

■ 660

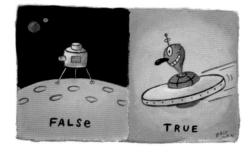

■ 662

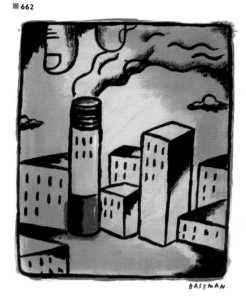

■ 663

■ 664

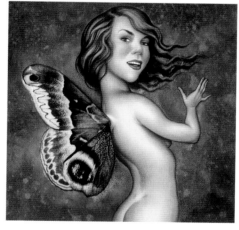

■ 661

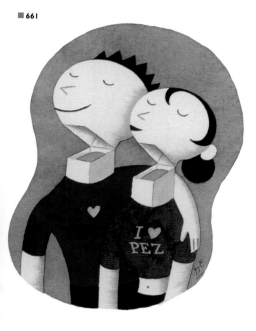

■ 665

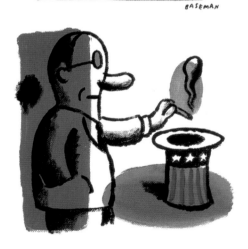

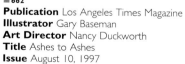

SPOTS

■ 663
Publication UCLA Magazine
Illustrator Gary Baseman
Art Director Charles Hess
Title Ask Mr. Science
Issue Fall 1997

■ 660
Publication Good Housekeeping
Illustrator Greg Clarke
Art Director Scott Yardley
Title The Mating Game
Issue February 1998

■ 661
Publication ZD Internet
Illustrator Greg Clarke
Art Director Patricia McGovern
Title Pez People
Issue July 1997

■ 662
Publication Los Angeles Times Magazine
Illustrator Gary Baseman
Art Director Nancy Duckworth
Title Ashes to Ashes
Issue August 10, 1997

■ 664
Publication The Atlantic Monthly
Illustrator Joyce Hesselberth
Art Directors Judy Garlan, Robin Gilmore-Barnes
Title Zoot
Issue August 1997
Publisher The Atlantic Monthly

■ 665
Publication Entertainment Weekly
Illustrator Anita Kunz
Art Director John Korpics
Title Mariah Carey
Issue September 26, 1997
Publisher Time Inc.

243

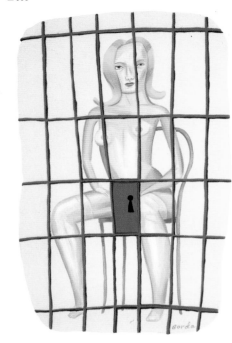

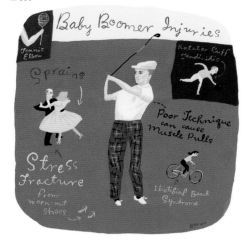

■ 666
Publication Kiplinger's Personal Finance
Illustrator Juliette Borda
Art Director Cynthia L. Currie
Title Baby Boomer Injuries
Issue September 1997

■ 667
Publication Shape
Illustrator Juliette Borda
Art Director Donna Giovannitti
Title Arc of the Diver
Issue July 1997
Publisher Weider Publications Inc.

■ 668
Publication Esquire
Illustrator Juliette Borda
Art Director Rockwell Harwood
Title Wife Guarding
Issue October 1997
Publisher The Hearst Corporation-Magazines Division

■ 669
Publication Jump
Illustrator Juliette Borda
Art Director Chrystal Falcioni
Title Hereditary Acne
Issue September/October 1997
Publisher Weider Publications, Inc.

■ 670
Publication Bloomberg Personal Finance
Illustrator Brian Cronin
Art Directors Carol Layton, Frank Tagariello
Title Do More with Less
Issue March 1998
Publisher Bloomberg L. P.

■ 671
Publication Worth
Illustrator Brian Cronin
Art Directors Philip Bratter, Deanna Lowe
Title Can the Old Country Learn New Tricks
Issue October 1997
Publisher Capital Publishing L. P.

THE GUY WHO RUNS THE TRENDIEST AA MEETING IN HOLLYWOOD. IS THERE A MORE HOPELESS JOB THAN TRYING TO KEEP YOUNG STARS LIKE ROBERT DOWNEY JR. AND CHRISTIAN SLATER ON THE WAGON?

ELIZABETH BERKLEY. EVER SINCE *SHOWGIRLS*, BERKLEY (SHOWN HERE AUDITIONING FOR A ROLE IN *AMISTAD*) CAN'T SEEM TO GET DIRECTORS TO TAKE HER SERIOUSLY.

CARLOS LEON. THE STUDLY PHYSICAL TRAINER MAY HAVE FATHERED MADONNA'S LOVE CHILD, BUT THAT NEW ACTING CAREER HE WAS HOPING FOR HASN'T QUITE MATERIALIZED.

■ 673

■ 674

■ 675

■ 676

SPOTS

■ 672
Publication Details
Illustrator Drew Friedman
Art Director Marlene Sezni
Title The 10 Least Powerful People in Hollywood
Issue March 1997
Publisher Condé Nast Publications Inc.

■ 673
Publication TIME
Illustrator Drew Friedman
Art Directors Arthur Hochstein, Joe Aslaender
Title That's a Good Boy
Issue December 22, 1997
Publisher Time Inc.

■ 674
Publication Garden Design
Illustrator Nick Dewar
Art Director Christin Gangi
Title Sad Sack
Issue April 1998
Publisher Meigher Communications

■ 675
Publication Bloomberg Personal Finance
Illustrator Nick Dewar
Art Directors Carol Layton, Frank Tagariello
Title Hook Some little Gems
Issue October 1997
Publisher Bloomberg L. P.

■ 676
Publication Shape
Illustrator Nick Dewar
Art Director Yvonne Duran
Title A Metabolism Boosting Gene
Issue April 1998
Publisher Weider Publications Inc.

680

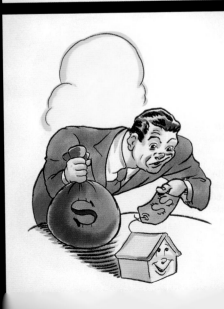

677
Publication Kiplinger's Personal Finance
Illustrator Edwin Fotheringham
Art Director Cynthia L. Currie
Title Make Them Serve You With a Smile
Issue March 1998

678
Publication Details
Illustrator Edwin Fotheringham
Art Director Marlene Sezni
Title Put My finger Where?
Issue October 1997
Publisher Condé Nast Publications Inc.

679
Publication The Boston Globe Magazine
Illustrator Michael Klein
Art Director Susan Levin
Title Lost in Space
Issue May 11, 1997

680
Publication U. S. News & World Report
Illustrator Michael Klein
Art Director Kris Mehuron
Title The Corporate Welfare Queens
Issue May 19, 1997

681
Publication Men's Living
Illustrator Ross MacDonald
Art Directors Lloyd Ziff, Chris Teoh
Title The Best Money Moves for Every Event
Issue Winter 1997

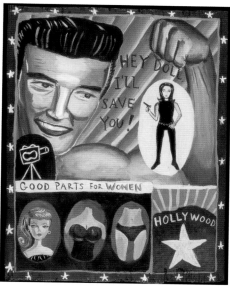

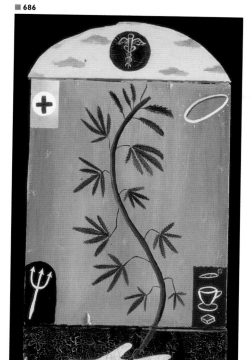

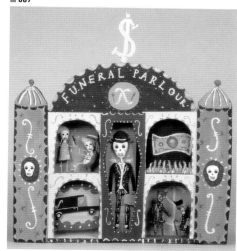

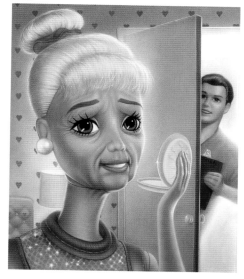

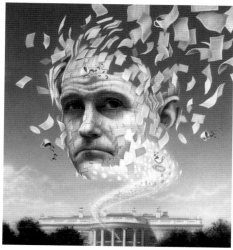

SPOTS

■ 684
Publication New York
Illustrator Ross MacDonald
Art Directors Mark Michaelson, Florian Bachleda
Title 3rd Stock from the Sun
Issue January 19, 1997
Publisher K-III Publications

■ 685
Publication Premiere
Illustrator Sue Saas
Art Director David Matt
Title Script Tease
Issue March 12, 1997
Publisher Hachette Filipacchi Magazines, Inc.

■ 686
Publication Shape
Illustrator Sue Saas
Art Director Yvonne Duran
Title The Straight Dope
Issue November 1997
Publisher Weider Publications Inc.

■ 687
Publication Harper's
Illustrator Sue Saas
Art Director Angela Riechers
Title Funeral Industry
Issue November 1997

■ 682
Publication TIME
Illustrator Tim O'Brien
Art Directors Arthur Hochstein, Ken Smith
Title 50 + Year Old Barbie
Issue December 1997
Publisher Time Inc.

■ 683
Publication TIME
Illustrator Tim O'Brien
Art Directors Arthur Hochstein, Ken Smith
Title Paper Trails
Issue December 1997
Publisher Time Inc.

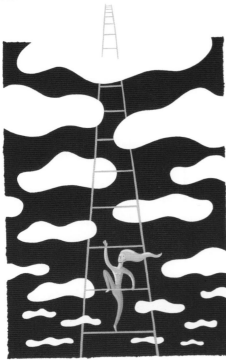

■ 688
Publication Walking
Illustrator Dan Yaccarino
Art Director Lisa Sergi
Title The Secrets of Motivation
Issue February 1998

■ 689
Publication Parenting
Illustrator Dan Yaccarino
Art Director Susan Dazzo
Title Interruption Busters
Issue March 1998
Publisher Time Inc.

■ 690
Publication Details
Illustrator Hanoch Piven
Art Director John Giordani
Title Steven Tyler
Issue October 1997
Publisher Condé Nast Publications Inc.

■ 691
Publication Details
Illustrator Hanoch Piven
Art Director John Giordani
Title Hank Hill
Issue December 1997
Publisher Condé Nast Publications Inc.

■ 692
Publication Details
Illustrator Hanoch Piven
Art Director John Giordani
Title Denis Leary
Issue January 1998
Publisher Condé Nast Publications Inc.

■ 693
Publication Details
Illustrator Hanoch Piven
Art Director John Giordani
Title Tommy Hilfiger
Issue March 1998
Publisher Condé Nast Publications Inc.

■ 694
Publication Self
Illustrator Hanoch Piven
Art Directors Richard Ferretti, Kayo Der Sarkissian
Title Dietary Guru: Andrew Weil
Issue February 1998
Publisher Condé Nast Publications Inc.

■ 697

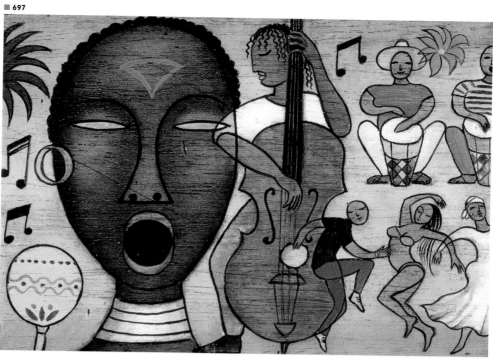

■ 698

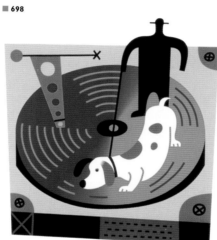

■ 699

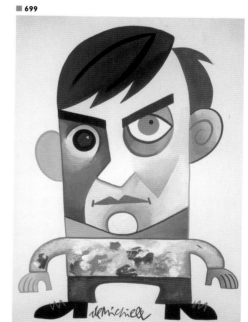

SPOTS

■ 695
Publication Bloomberg Personal Finance
Illustrator J. D. King
Art Directors Carol Layton, Frank Tagariello
Title Ride 'Em Cowboy!
Issue January/February 1998
Publisher Bloomberg L. P.

■ 696
Publication Bloomberg Personal Finance
Illustrator Luba Lukova
Art Directors Carol Layton, Frank Tagariello
Title Home Sweet Haven
Issue September 1997
Publisher Bloomberg L. P.

■ 697
Publication BusinessWeek
Illustrator Stefano Vitale
Art Director Christine Silver
Title Personal Business Cultural Guide
Issue June 23, 1997
Publisher BusinessWeek

■ 698
Publication BusinessWeek
Illustrator Doug Ross
Art Directors Don Besom, Malcom Frouman
Title Faultless File Finder
Issue February 3, 1997
Publisher BusinessWeek

■ 699
Publication Boston
Illustrator Robert de Michiell
Art Director Jeffrey Osborne
Title I Remember Papa
Issue September 1997
Publisher Boston Magazine

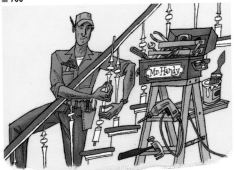

■ 700

■ 704

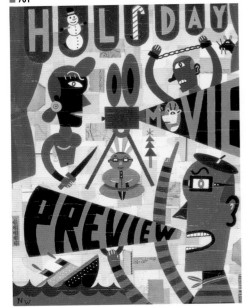

■ 701

■ 702

■ 703

■ 705

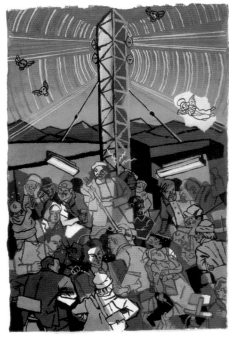

■ 706

■ 700
Publication Condé Nast House & Garden
Illustrator Robert Clyde Anderson
Art Director Stephanie Sterling
Title In Your Dreams
Issue September 1997
Publisher Condé Nast Publications Inc.

■ 701
Publication Entertainment Weekly
Illustrator Noah Woods
Art Director Joe Kimberling
Title Holiday movie preview
Issue December 1997
Publisher Time Inc.

■ 702
Publication Guitar World
Illustrator PJ Loughren
Art Director Peter Yates
Title Gettin' in Tune
Issue October 1997

■ 703
Publication Harper's
Illustrator Victoria Kann
Art Director Angela Riechers
Title In the Garden of Tabloid Delight
Issue August 1997

■ 704
Publication Harper's
Illustrator Richard Beards
Art Director Angela Riechers
Title Chekhov Stories
Issue November 1997

■ 705
Publication Harper's
Illustrator Tim Bower
Art Director Angela Riechers
Title Phone Psychics
Issue February 1998

■ 706
Publication Harper's
Illustrator John H. Howard
Art Director Angela Riechers
Title Unapproved Minutes
Issue April 1998

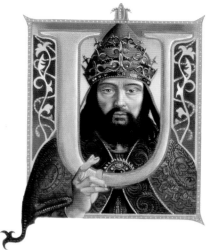

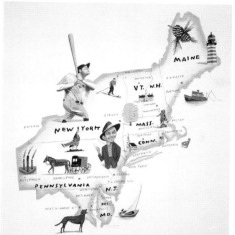

SPOTS

Publication Kiplinger's Personal Finance
Illustrator David Bowers
Art Director Cynthia L. Currie
Title Investing by the Book
Issue July 1997

Publication Kiplinger's Personal Finance
Illustrator Mark Ulriksen
Art Director Cynthia L. Currie
Title Notheast Tax Tidings-State Tax Survey
Issue June 1997

Publication Kiplinger's Personal Finance
Illustrator Gregory Manchess
Art Director Cynthia L. Currie
Title Magazine Spot
Issue April 1998

Publication Macworld
Illustrator Gérard Dubois
Art Director Sylvia Chevrier
Title Sounds from a Can
Issue August 1997

Publication Internet Computing
Illustrator James Yang
Art Director Patricia McGovern
Title A Well-Balanced Web
Issue March 1998

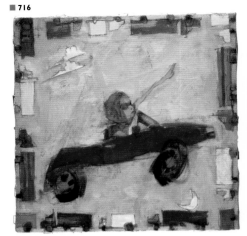

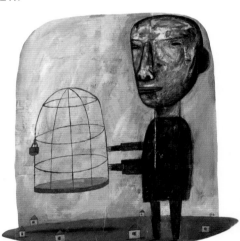

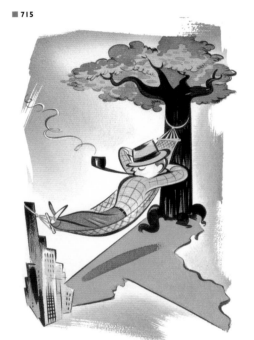

■ 712
Publication Modern Maturity
Illustrator Steven Kroniger
Art Directors Gregory T. Atkins, Cynthia Friedman
Title Good Looks
Issue September/October 1997
Publisher AARP

■ 713
Publication New York
Illustrator Scott Menchin
Art Directors Mark Michaelson, Andrea Dunham
Title Liars Club
Issue February 9, 1997
Publisher K-III Publications

■ 714
Publication New York
Illustrator Ingo Fast
Art Directors Mark Michaelson, Anton Loukhnevets
Title South Street Seaport
Issue December 1, 1997
Publisher K-III Publications

■ 715
Publication New York
Illustrator Eric Palma
Art Directors Mark Michaelson, Andrea Dunham
Title Paradise, Part-time
Issue December 22, 1997
Publisher K-III Publications

■ 716
Publication New York
Illustrator Natalie Ascencios
Art Directors Florian Bachleda, Andrea Dunham
Title Road Warrior
Issue September 22, 1997
Publisher K-III Publications

■ 717
Publication New York
Illustrator Jordin Isip
Art Director Andrea Dunham
Title The Hard Cell
Issue June 9, 1997
Publisher K-III Publications

■ 718

■ 720

■ 721

■ 722

■ 719

■ 723

■ 718
Publication Saveur
Illustrator Jonathan Carlson
Art Directors Jill Armus, Toby Fox
Title Cooking to the Radio
Issue January/February 1998
Publisher Meigher Communications

■ 719
Publication Saveur
Illustrator Michael Witte
Art Directors Jill Armus, Toby Fox
Title Dueling Toques
Issue July/August 1997
Publisher Meigher Communications

■ 720
Publication Rolling Stone
Illustrator Hadley Hooper
Art Director Fred Woodward
Title Portrait of Nortorious B.I.G.
Issue January 1998
Publisher Wenner Media

■ 721
Publication Parenting
Illustrator Istvan Banyai
Art Director Susan Dazzo
Title Some Assembly Required
Issue December 1997/January 1998
Publisher Time Inc.

■ 722
Publication Playboy
Illustrator Dave Calver
Art Director Tom Staebler
Title Men: Zen Golf
Issue July 1997

■ 723
Publication Sales & Marketing Management
Illustrator Adam McCauley
Art Directors Victoria Beerman, Zakima Goldsmith
Title A Level Playing Field
Issue February 23, 1997

■ 724

■ 726

■ 725

■ 727

■ 724
Publication Seventeen
Illustrator Jesse Hartland
Art Directors Florence Sicard, Ron Gabriel
Title The Sibling Files
Issue March 1998

■ 725
Publication SmartMoney
Illustrator Jamie Hogan
Art Director Amy Rosenfeld
Title A Debt in the Family
Issue March 13, 1997
Publisher Dow Jones & Hearst Corp.

■ 726
Publication PC World
Illustrator David Plunkert
Art Directors Robert Kanes, Barbara Adamson
Title Consumer Watch: Don't Get Mad, Get Online
Issue October 1997

■ 727
Publication New York
Illustrator Chip Wass
Art Directors Mark Michaelson, Pino Impastato
Title The Pied Professor
Issue February 9, 1997
Publisher K-III Publications

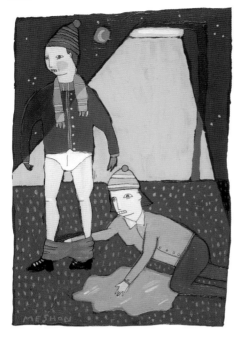

■ 728
Publication The New York Times Magazine
Illustrator Lou Beach
Art Director Janet Froelich
Title Frankel Columns
Publisher The New York Times

■ 729
Publication YM
Illustrator Stan Goldberg
Art Director Marilu Lopez
Title Jerk Alert
Issue September 1997

■ 730
Publication YM
Illustrator Aaron Meshon
Art Directors Marilu Lopez, Marci Papineau
Title Say Anything
Issue Winter 1997

■ 731

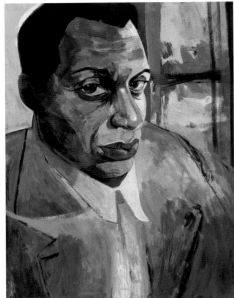

■ 732

■ 733

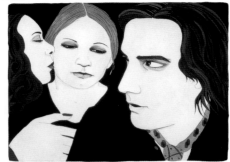

■ 734

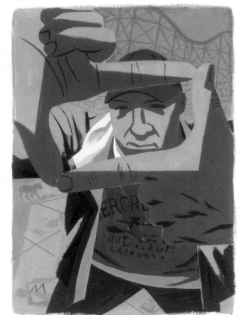

■ 735

■ 736

■ 731
Publication The New Yorker
Illustrator Riccardo Vecchio
Art Director Owen Phillips
Title Paul Robeson
Issue January 26, 1998
Publisher Condé Nast Publications Inc.

■ 732
Publication The New Yorker
Illustrator Stephen Savage
Art Director Christine Curry
Title Hail to the Chief:
Harrison Ford in "Air Force One"
Issue July 28, 1997
Publisher Condé Nast Publications Inc.

■ 733
Publication The New Yorker
Illustrator Lara Tomlin
Art Director Owen Phillips
Title French film" The Mother & the Whore
Issue December 22, 1997
Publisher Condé Nast Publications Inc.

■ 734
Publication The New Yorker
Illustrator David Mazzucchelli
Art Director Christine Curry
Title Stabile
Issue August 11, 1997
Publisher Condé Nast Publications Inc.

■ 735
Publication The New Yorker
Illustrator Zohar Lazar
Art Director Owen Phillips
Title At Bryant Park, Joshua Logan's Picnic
Issue July 14, 1997
Publisher Condé Nast Publications Inc.

■ 736
Publication The Progressive
Illustrator Joe Ciardiello
Art Director Patrick J.B. Flynn
Title Janet Rosenberg Jagan
Issue February 1998

■ 737

■ 738

■ 739

■ 740

■ 741

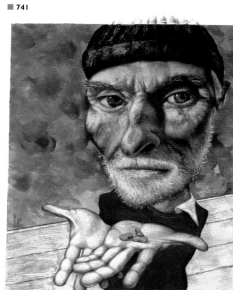

■ 737
Publication The New York Times Magazine
Illustrator Terry Allen
Art Director Janet Froelich
Title On Language Columns
Publisher The New York Times

■ 738
Publication The New York Times Magazine
Illustrator Ward Sutton
Art Directors Janet Froelich,
Catherine Gilmore-Barnes
Title Hollywood Violence
Issue November 16, 1997
Publisher The New York Times

■ 739
Publication The New York Times Book Review
Illustrator David Johnson
Art Director Steven Heller
Title Samuel Beckett
Issue August 3, 1997
Publisher The New York Times

■ 740
Publication The New Yorker
Illustrator Maira Kalman
Art Director Christine Curry
Title Nannies
Issue November 10, 1997
Publisher Condé Nast Publications Inc.

■ 741
Publication Breakaway
Illustrator Scott Laumann
Art Director Jerry Price
Title Outstretched Hands
Issue November 29, 1997

students

Established in 1995, this competition honors the life and work of B.W. Honeycutt. It recognizes exceptional design by students with awards and three cash prizes. The B.W Honeycutt Award of $2500 and second and third prizes of $1000. These cash prizes are possible due to the success of the annual SPD art auction, where original artworks have been donated for auction by the industry's leading photographers and illustrators. Proceeds from this event and others have enabled the SPD to significantly increase scholarship grants as well as to extend our outreach programs to art colleges and schools of design.

● **CO-CHAIRS**

Christine Curry
Editorial Art Director
The New Yorker

Paul Roelofs
Art Director
InStyle

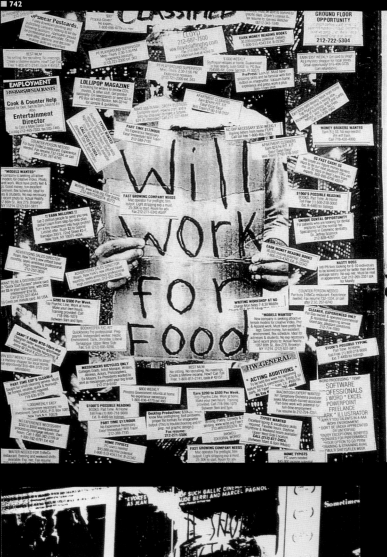

Binder was preparing something spectacular for Big.

Rumors have been swirling around the circus industry this year. I was getting a lot of phone calls all summer...

Cirque du Soleil; that founder and producer Paul

...pple's 20th anniversary. In August, I caught the

Amtrak to White River Junction, VT, to join up with

the tour in Hanover, NH.

continued...
36

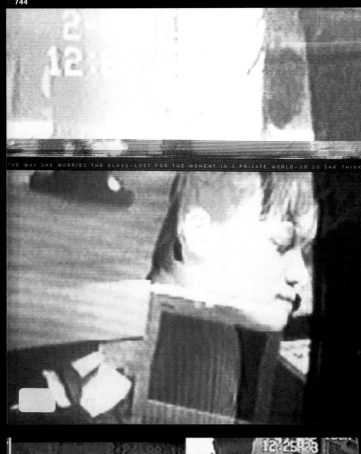

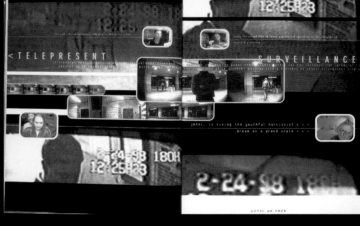

743
Designer Bree Pappas
Title Time Life Wheels
School
NC State University School of Design
Instructor Joani Spadaro,
Edwin Utermohlen

744
Designer Dave Steinert
Title Glass
School
NC State University School of Design
Instructor Andrew Blauvelt,
Martha Scotford, Joani Spadaro,
Edwin Utermohlen

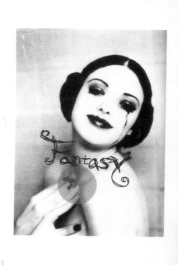

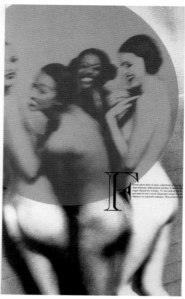

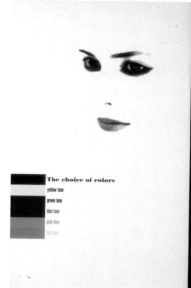

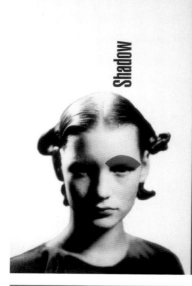

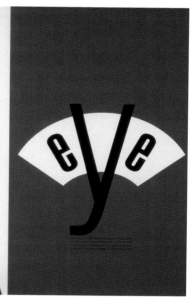

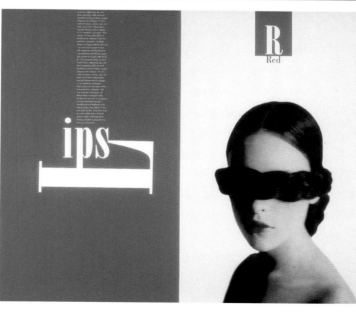

■ 745
Designer Mei ling Chen
Title Fantasy, Color, Shape, Glamour
School School of Visual Arts
Instructor Terry Koppel

■ 746
Designer Mei ling Chen
Title Color Scale
School School of Visual Arts
Instructor Terry Koppel

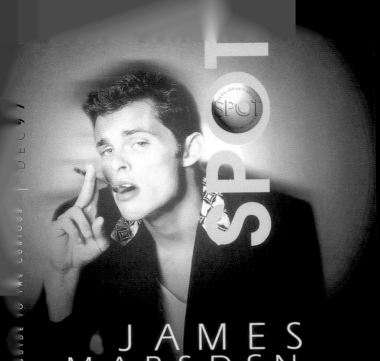

SPOT

A GUIDE TO THE CURIOUS | DEC 97

JAMES MARSDEN
(caught in the Act)

+ SWEETS TREATS

$4.50 US / $5.00 CAN

holiday issue

0 7440 73971

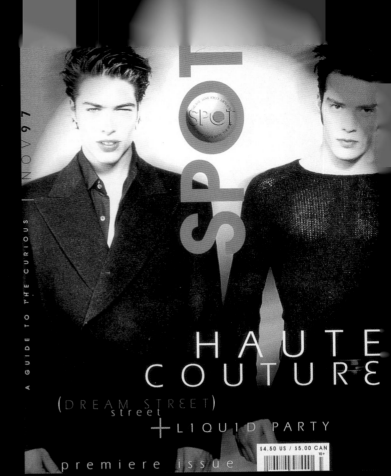

SPOT

A GUIDE TO THE CURIOUS | NOV 97

HAUTE COUTURE
(DREAM STREET)
street

+ LIQUID PARTY

$4.50 US / $5.00 CAN

premiere issue

premiere issue

 + (CONTENTS)
events

A GUIDE TO THE CURIOUS | NOV 97

④

748

A HAPPENING LIFE: ENDLESS DESIGN

bell hooks

THE 3RD HARWELL HAMILTON HARRIS LECTURE
NORTH CAROLINA STATE UNIVERSITY, SCHOOL OF DESIGN

FEBRUARY 24, 1997

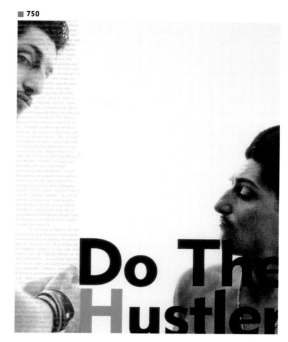

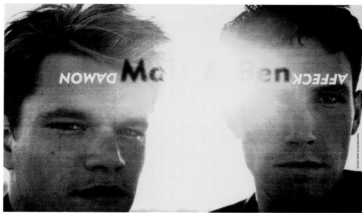

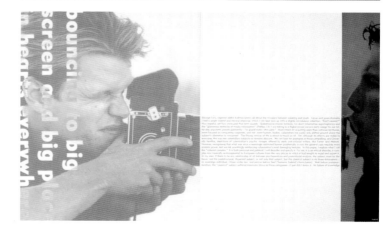

■ 749
Designer Rafael Soberal
Title D is for DOS
School School of Visual Arts
Instructor Carin Goldberg

■ 750
Designer Meeyoung Shin
Title Spin
School School of Visual Arts
Instructor Paula Scher

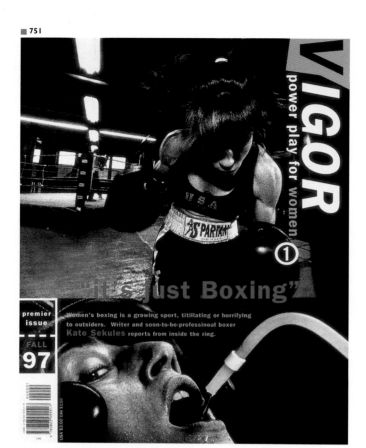

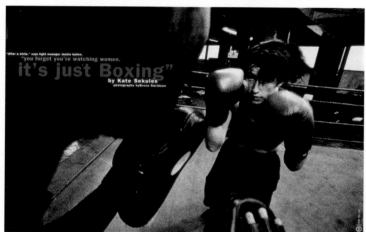

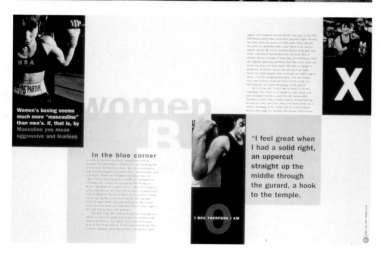

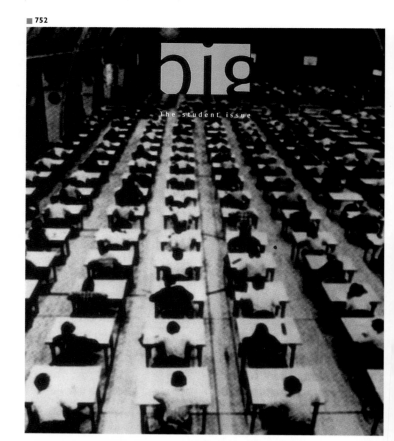

■ 751
Designer Daisuke Endo
Title Vigor
School School of Visual Arts
Instructor Robert Best

■ 752
Designer Kjersti Iversen
Title Big
School School of Visual Arts

index

■
This book was set in Gill Sans.
Designed by Eric Gill in 1928, it was modeled on Edward Johnston's
1918 alphabet for the London Transport Railway.